ENTERING THE PICTURE

In 1970, Judy Chicago and fifteen students founded the groundbreaking Feminist Art Program (FAP) at Fresno State. Drawing upon the consciousness-raising techniques of the women's liberation movement, they created shocking new art forms depicting female experiences. Collaborative work and performance art—including the famous Cunt Cheerleaders—were program hallmarks. Moving to Los Angeles, the FAP produced the first major feminist art installation, *Womanhouse* (1972).

Augmented by illustrations and color plates, this interdisciplinary collection of essays by artists and scholars, many of whom were eyewitnesses to landmark events, relates how feminists in multiple locales engaged in similar collaborations, creating vibrant new bodies of art. Articles on topics such as African American artists in New York and Los Angeles, San Francisco's Las Mujeres Muralistas and Asian American Women Artists Association, and exhibitions in Taiwan and Italy showcase the artistic trajectories that destabilized traditional theories and practices and reshaped the art world. An engaging editor's introduction explains how feminist art emerged within the powerful women's movement that transformed America.

With contributions by: Nancy Azara, Tressa Berman, Darla Bjork, Katie Cercone, Judy Chicago, Ying-Ying Chien, Gaia Cianfanelli, Lydia Nakashima Degarrod, Lillian Faderman, Jill Fields, Joanna Gardner-Huggett, Paula Harper, Caterina Iaquinta, Jo Anna Isaak, Jennie Klein, Karen LeCocq, Gail Levin, Laura Meyer, Nancy Marie Mithlo, Beverly Naidus, Gloria Feman Orenstein, Phranc, Terezita Romo, Moira Roth, Sylvia Savala, Miriam Schaer, Valerie Smith, Faith Wilding, and Nancy Youdelman.

Jill Fields is Professor of History at California State University, Fresno. She is the author of *An Intimate Affair: Women, Lingerie, and Sexuality.*

NEW DIRECTIONS IN AMERICAN HISTORY

ENTERING THE PICTURE

Judy Chicago, the Fresno Feminist Art Program, and the Collective Visions of Women Artists

Edited by Jill Fields

Routledge
Taylor & Francis Group

NEW YORK AND LONDON

First published 2012
by Routledge
711 Third Avenue, New York, NY 10017

Simultaneously published in the UK
by Routledge
2 Park Square, Milton Park, Abingdon, Oxon OX14 4RN

Routledge is an imprint of the Taylor & Francis Group, an informa business

© 2012 Taylor & Francis

Library of Congress Cataloging in Publication Data
A catalog record has been requested

ISBN: 978–0–415–88768–7 (hbk)
ISBN: 978–0–415–88769–4 (pbk)
ISBN: 978–0–203–80419–3 (ebk)

Typeset in Bembo and Stone Sans
by Florence Production Ltd, Stoodleigh, Devon

Printed and bound in the United States of America on acid-free paper
by Sheridan Books, Inc.

This book is dedicated to my mother

Valerie Fields

for inspiring a love of the arts in her children and grandchildren,

for working to make the arts flourish in Los Angeles while serving as Mayor Tom Bradley's Education and Cultural Affairs Liaison (1973–1993),

and for championing arts education for all the children of Los Angeles as a member of the L.A. Unified School District Board (1997–2001).

CONTENTS

PLATES AND FIGURES

Plates

Figures

PREFACE AND
ACKNOWLEDGMENTS

In late spring of 2000, during my first year of teaching at California State University (CSU) Fresno, I picked up *Sexual Politics: Judy Chicago's* Dinner Party *in Feminist Art History* in search of images for my women's history class lecture on the 1970s. Though I had bought the book at the 1996 Armand Hammer Museum exhibit of *The Dinner Party*, I hadn't noticed before the "Feminist Chronology" compiled by Laura Meyer at the back. As I began to read through it, I was jolted by a 1970 entry: "Judy Chicago establishes the Feminist Art Program at Fresno State College, with fifteen students participating. The curriculum includes feminist consciousness-raising and performance workshops; research into women's history, art and literature; and radical artistic experimentation." The revelation that feminist art history itself, let alone the internationally renowned feminist artist Judy Chicago had anything to do with Fresno, astonished me. I also quickly realized that the thirtieth anniversary of this momentous event was upon us, and I became in that instant determined to do something to about it.

I knew exactly whom to contact. I threw down the book, leapt up from my couch, and called Linda Garber and Jackie Doumanian, who both immediately agreed that we should celebrate the thirtieth anniversary of the Fresno Feminist Art Program (FAP). Linda was then chair of Women's Studies; Jackie is an artist, yoga teacher, and businesswoman whom I had chatted with briefly while standing in line at the lingerie department of Macy's shortly after I moved to Fresno, and then unexpectedly saw again at the twenty-fifth anniversary celebration for Gallery 25, the women's art gallery I was surprised to find in town. Jackie said she would call around to see if others were interested (they were), and I began to think about what our event should look like. I knew I wanted to invite Judy Chicago and all her Fresno students to speak. At some point we decided to hold the event during women's history month, March 2001.

During the summer, I went on my planned research trip to Rutgers to consult the Feminist Art Institute archives for the epilogue on feminist intimate apparel art in my then-in-process book, *An Intimate Affair: Women, Lingerie, and Sexuality*. Somehow I found out Judy Chicago was going to be in Manhattan for a book signing while I was there. I went to the bookstore, introduced myself, and told Judy what I hoped to do. Delighted to meet a feminist historian from Fresno, she easily signed on, "Sure, I'll come to Fresno."

Fall brought a frenzy of activity. Planning meetings included about a dozen women: artists, curators, museum administrators, and women's studies professors (Joyce Aiken, Jen Bracy, Jackie Doumanian, Kathryn Forbes, Linda Garber, Loretta Kensinger, Jerrie Peters, Jacqueline Pilar, Judy Rosenthal, Sylvia Savala, Suzanne Sloan Lewis, Gina Strumwasser, and Nancy Youdelman). I applied for grants and developed the two-day symposium, while the artists and gallery and museum people went wild and planned six simultaneous exhibits: "Judy Chicago, Prints and Drawings" at the Phoebe Conley Gallery and "Inside: Art by Women in Chowchilla Prison" curated by CSU Fresno dance professor Ruth Griffin at the Richhuti Gallery, both on campus; "Then and Now: The Women of the 1971 Feminist Art Program" shown at the Fresno Art Museum; "Artists from the Feminist Years" at Gallery 25, "Feminist Art in the 21st Century" at Arte Americas; and even "Feminist Art at the Airport," at the Fresno Yosemite International Airport, an especially apt intervention due to the famous Cunt Cheerleaders airport performance thirty years earlier. As if that weren't enough, planning committee members arranged five additional lectures and events that took place throughout the month of March at a variety of Fresno galleries and museums.

The symposium began with Judy Chicago's keynote address, followed by a panel discussion by Fresno FAP students Nancy Youdelman, Karen LeCocq, Janice Lester, Shawnee Johnson, Christine Rush, and Dori Atlantis recounting their experiences. Youdelman's and LeCocq's essays in *Entering the Picture* are their subsequent written reflections. Former Fresno FAP student Suzanne Lacy contributed a multi-media presentation on her large-scale public performance work. Joyce Aiken, who directed the Feminist Art Program after Chicago and then her replacement Rita Yokoi left, delivered the second keynote of the symposium. Her talk was augmented by recollections by three of her students, Jackie Doumanian, Jerrie Peters, and Joy Johnson. Laura Meyer provided contextualization with her paper, "From Finish Fetish to Feminism, Fresno Style, or How Judy Chicago and Fifteen Young Women at a Rural California Campus Changed the Course of Art History." Connections between Fresno and the larger feminist art movement were also assessed by Yolanda Lopez, who spoke about her work in "Explorations: Feminism, Art, Citizenship," and Gloria Orenstein, who presented on the salons she created in New York City. The symposium ended with a performance at Arte Americas of women's and girl's poetry curated by Sylvia Savala, whose essay in this volume describes her path to becoming a Chicana feminist artist in Fresno in the 1990s.

I wish to acknowledge the participation of all these women in making the symposium and thus this publication possible. The symposium and book projects benefited from grants awarded by the California Arts Council, the Harry C. Mitchell Trust, and CSU Fresno. It has taken some time to develop the book beyond the symposium, and Routledge senior editor Kimberly Guinta's patience, professionalism, and good will—and that of her assistant Rebecca Novack—aided me enormously during the transition from proposal to manuscript to book. I am especially appreciative of Eileen Boris, Alice Echols, Lillian Faderman, Andrea Pappas, Lynn Sacco, and Jessica Weiss who read the introduction to this book on short notice at various stages of its development. My email exchanges with them, along with all of the book's contributors and sticker genius Sheila de Bretteville, created a wonderful feminist, collaborative structure of feeling that evoked the sensibilities *Entering the Picture* describes. I am grateful also to have many reasons to continue to thank another generous feminist historian, Lois Banner, for her unflagging support and mentorship. My Fresno colleagues in Africana Studies, Chicano and Latin American Studies, History, and Women's Studies especially David Berke, Loretta Kensinger, DeAnna Reese, Malik Simba, Bill Skuban, Jan Slagter, and Victor Torres, have always provided assistance when asked. In addition, my graduate student Melissa Morris's aid with the permissions process was vital. I appreciate too the steadfast support and council of Andrea Scott, Stephanie Barish, Marty Bridges, Dorothy Brinckerhoff, Meryl Geffner, Mary Jean, Laura Della Vedova, and Dorrit Vered. Emily Feigenson, Valerie Fields, Jerry K. Fields, and Constance Young provided editorial assistance at critical moments, as per usual. I am thankful for the interest in my work of the entire Fields, Mate, and extended Barish-Chamberlin families. Ken Mate's editorial expertise, keen visual sensibilities, enthusiasm, sense of humor, and love of Hercules, cooking, traveling, and me (not necessarily in that order) makes so much more possible.

I dedicate this book to my mother Valerie Fields, who instilled a love of the arts in her children through museum visits, conversations about literature, listening to music at home, and trips to the theater and ballet. She made us aware not only of arts appreciation, but arts criticism when she explained her favorite Robert Frost poem, pointed out a Gilbert and Sullivan lyric, took us to the Watts Towers, and commented on Martin Landau's excellent acting in an episode of *The Outer Limits*. Many more people benefited when, as a member of Los Angeles Mayor Tom Bradley's staff throughout his entire twenty-year tenure (1973–1993), she served as Bradley's liaison to education, the Commission on the Status of Women (which she shepherded from committee to commission), and cultural affairs. In the latter capacity particularly, and with impeccable integrity and boundless optimism and energy, she shaped public arts policy and fostered civic support for the arts, especially for the museum created during the Bradley administration, the Los Angeles Museum of Contemporary Art. Then, after her election to the Los Angeles Unified School District Board in 1997, she brought this wealth of professional and life experience to leading a successful fight to restore arts funding

for all the children of Los Angeles. She accomplished much more than I have space here to detail. However, the recognition she received from the arts community, public employees' unions, colleagues, elected officials, school administrators, teachers, students, parents, and neighborhood groups upon her retirement further testifies to her numerous civic achievements. We love you Valerie!

INTRODUCTION

Jill Fields

> Instead of beauty and power occasionally, I want . . . to achieve a world where
> it's there all the time in every word and every brush stroke.
> —Shulamith Firestone, 1967

The Feminist Art Program founded in 1970 at Fresno State by visiting art professor
Judy Gerowitz (soon to rename herself Judy Chicago), and begun with the fifteen
female students she recruited, is not as well known as the program launched a
year later at the California Institute of the Arts (CalArts) in Valencia. Yet surely
the exuberant success of that initial program prompted painter and CalArts
professor Miriam Schapiro to invite Chicago to bring the Feminist Art Program
(FAP) to Southern California. Schapiro had seen for herself in Fresno the startling
new feminist art forms and teaching methods Chicago and the "Fresno Girls"
were creating, and had also visited with them during their trip to Los Angeles-
area museums, galleries, and studios.[1]

Schapiro was not alone in being drawn to Fresno during that historic
1970–1971 school year. Women artists and film makers (and some men) from
around the state, in addition to high profile feminist activists like Ti-Grace
Atkinson, who flew in to Fresno Air Terminal from New York City, were eager
to find out more about the exciting developments taking shape in—of all places—
California's rural San Joaquin Valley. As an up-and-coming LA-based artist of
note, Chicago's activities drew attention; word also got out after Chicago's own
visits to New York City during her Fresno residency. A 1971 special issue of the
art journal *Everywoman* on the FAP spread the news further. By the time 4,000
people viewed the collaborative installation *Womanhouse*, the signal art project
presented in January and February 1972 during the Feminist Art Program's tenure

at CalArts, and thousands more read about it in *Time* magazine in March, the isolated work of a few dozen female artists had cohered into a fully fledged movement—the feminist art movement. Building upon this rapid trajectory, the feminist art movement has had an enormous impact on the media, forms, and visual imagination of contemporary art and on the status of women artists throughout the world.[2]

It is often difficult to pinpoint moments of origin, and at times even folly to try. Searching for such moments can lead to the construction of a singular, orderly narrative that, despite presenting accurate facts, may lose sight of larger truths and omit events that undermine its cohesiveness. The suggestion by French social theorist Michel Foucault that we instead investigate "genealogies" to understand the past has been utilized effectively since the 1980s, especially by historians who study marginalized social groups and topics relevant to women and gender such as the history of sexuality. Previously, investigating such subjects had been hampered because sources were scattered or fragmentary, and the research findings that made use of them challenged neat, conventional historical narratives and thus lay outside their typical boundaries. Yet even before Foucault's work was widely known, feminist historians had already begun to tell untold stories and investigate hidden histories by drawing on the methods of social history, which directed attention to everyday life and built upon an expansive definition of resistance. They then further developed and deployed feminist and postmodern theories that illuminate the lives of the dispossessed and the disrespected, recuperate subjugated knowledge, and give voice to multiple stories and sources from the past that dominant paradigms excluded. Questions about how to synthesize the results of all this work remain. Nevertheless, despite the difficulties of fully accounting for the multiple voices of the past and integrating new approaches, and whatever our methodology in exploring historical events and cultural texts, facts still matter. Moreover, what makes facts powerful is their analysis and contextualization. Thus, more is revealed in this book than just the facts surrounding the beginnings of feminist art education and the feminist art movement in Fresno.[3]

The essays by artists and scholars collected in this book describe and assess the feminist art movement from its beginnings through today, with particular focus on collective projects, voices, and visions. Section I provides first-hand accounts and later reflections by participants and art historians of the Feminist Art Programs in Fresno and Los Angeles. The importance of Fresno as a significant location and moment in the emergence of the feminist art movement deserves attention not only to set the record straight, but also for the difference this recognition makes in how we think about the development and significance of feminist artists' contributions to contemporary culture, especially in the places they live and work. In addition, the essays in the second and third sections of this volume suggest that remembering the Fresno Feminist Art Program augments understandings about the relationship between the larger women's movement and the feminist art

movement it spawned and was enlarged and enriched by. Furthermore, focusing on what Judy Chicago calls the "Fresno experiment" challenges our thinking about the relationship between the local and the global, a loaded dynamic that typically emphasizes the power and importance of people and events located in large cities. This is especially the case in the realm of art criticism and history, in the stories we are used to hearing about where new cultural forms begin and where artistic production matters.[4]

So, why does Fresno matter? What confluence of circumstances made this Central California city the location for the feminist art innovations recounted in the first section of this book? Couldn't the feminist art movement have "begun" elsewhere—or anywhere? Perhaps, but it is more fruitful to ask why Fresno became the site for Judy Chicago's pedagogical experiments and why what she and her students achieved had the enormous impact that they did.

In 1970, Fresno was not only the agricultural, rural heartland—some would say backwater—it is often mistakenly still considered to be. Some trends have come to Fresno later, but others have begun there, for better or worse. For example, CSU Fresno was originally set up in 1911 on the site of the first two-year college established in the state of California. As Fresno's higher education ambitions took shape, the city was also a hotbed of labor activism by the well-known anarchist union the Industrial Workers of the World (IWW), who organized agricultural laborers and fought for First Amendment rights while enduring illegal police surveillance and disruption in the 1910s and 1920s.[5] The struggles between the owners and workers in agriculture never ceased. In the 1930s, diverse female cannery workers across California, including Fresno, joined the progressive United Cannery, Agricultural, Packing, and Allied Workers of America. Three decades later, Cesar Chavez and the United Farm Workers successfully challenged Central Valley farmers to increase the pay and improve the working conditions of farm laborers, most of whom had immigrated from Mexico. In 1996, CSU Fresno erected the first statue in the United States of Chavez in the campus Peace Garden, which also honors Gandhi, Martin Luther King, Jr., and Jane Addams. However, police surveillance of Fresno pacifists persisted; an example of their undercover investigations is memorialized in Michael Moore's 2006 documentary *Fahrenheit 9/11*. The city police force also has been sued successfully for its destruction of homeless encampments, and has been unable to shake the city's reputation as a "meth capital" despite its Special Weapons and Tactics arsenal and the Central Valley's central place in California's well-funded prison-industrial complex. Environmentalists have not faired much better: *Forbes* magazine ranks the self-described "Best Little City in America" third on its list of most toxic US cities for its high levels of airborne particulates and water contaminants.[6]

Fresno is also known for its high unemployment rates even in boom times. But however inequitably distributed, the wealth generated by agriculture and development interests, whose respective captains dominate local politics though

they've clashed occasionally as farmland transformed into suburbia, promoted the arts in Fresno.[7] Nurtured by the growing presence of college professors and their students, the community embraced a full spectrum of the arts, including music, from the initial 1911 Fresno Normal School Glee Club to the passionate patronage of the Fresno Philharmonic founded in 1954,[8] active classical and jazz university music programs, and a number of thriving alternative clubs; modern art at The Fresno Art Museum founded in 1948 and numerous galleries that today host a bi-monthly Art Hop, and performance arts in a lively theater scene that produced Tony winner Audra McDonald. Fresno also prides itself as a place of cultural merit by embracing the legacies of photographer Ansel Adams, and writers like William Saroyan and others who find wide audiences, such as David Mas Masumoto. A flourishing poetry scene emerged in the 1960s, and many fine poets—such as US Poet Laureate Philip Levine—settled in for lengthy careers at Fresno State. Cherished cultural institutions include the African American Historical and Cultural Museum of the San Joaquin Valley founded in 1993, the prominent Arte Americas founded in 1987, and the Underground Gardens, a remarkable, unique, and beautiful maze of underground tunnels and rooms dug by Sicilian immigrant Baldesare Forestiere as his life's work over four decades until his death in 1946.[9]

Public art and architecture also has a prominent role in Fresno history. In 1964, Fresno inaugurated the award-winning Fulton Mall, a walking street designed by noted modernist architect Garrett Eckbo. Fulton Mall is graced by twenty sculptures and fountains that, with the exception of *Washer Woman* by Renoir, are contemporary works by a surprisingly diverse group of artists, many of them locals such as Joyce Aiken, whose interview with Lillian Faderman is included in this book. A recent proposal to destroy the Fulton Mall in a misguided plan for downtown "revitalization" has been countered successfully by Aiken and others, though the fight to "save Fulton Mall" carries on and Aiken is not optimistic. Similarly, though a stunning city hall was erected in 1992, a magnificent Victorian courthouse was torn down in 1966 and replaced by a poorly designed building. And, upon my arrival in 1999, I was delighted to see a fabulous Googie diner on main drag Blackstone Avenue, and dismayed to drive by a few weeks later and see it being demolished. It was replaced by a used car lot. Such are the contradictions of Fresno as ahead, behind, and of its times.[10]

In 1970, the year the Feminist Art Program began, campus unrest was rampant at Fresno State as elsewhere around the country. This disquiet stemmed from the Vietnam War, and also to the challenges university students had been making to the purpose and content of their curriculum since Students for a Democratic Society issued the "Port Huron Statement" in 1962, and established itself as a prime force for social change on college campuses nationwide. The successful opposition to university administrators organized by students 180 miles north of Fresno at UC Berkeley during the Free Speech Movement (FSM) of 1964–1965 built on student activism in the Civil Rights Movement and laid the groundwork for the anti-war protests that grew in number and intensity as the war

escalated. "Free Speech Areas" remain a common legacy of the FSM on many of the twenty-three CSU campuses, including Fresno, Chico, Dominguez Hills, and Los Angeles. The related articulation by students of the urgent need for a "relevant" curriculum led to the creation of alternative university programs across America, including an Experimental College at Fresno State set up in the mid-1960s, and infused plans for the new University of California campus in Santa Cruz, a popular coastal vacation spot for Fresnans. Students and faculty nationwide also fought for new majors in Black, Chicano/a, Ethnic, and Women's Studies. San Francisco State was the site of numerous confrontations beginning in 1967 by anti-war and Black Studies activists, some of whom spoke on the Fresno campus in spring 1968.[11]

Two years later, Fresno State's reactionary administration fired faculty, expelled students, and locked professors out of their offices during the most turbulent year in campus history. Recently created ethnic studies programs were abolished, and then re-established after resistance by students and community supporters. Anti-war and ethnic studies protests and administrative responses included the destruction and seizure of property; subsequent lawsuits against the university reinstated many of the students and faculty who had been dismissed. In 1971, a year after San Diego State founded the first women's studies department in the United States, Fresno State's Women's Studies Program won approval; Lillian Faderman was named its first Coordinator in 1972.[12]

In addition to the catalysts provided by the civil rights, anti-war, and black and ethnic studies movements, the larger women's movement fueled the creation of women's studies as an academic field and as a space for feminist scholars, research, and teaching on university campuses. The 1963 publication of Betty Friedan's *The Feminine Mystique*, release of the President's Commission on the Status of Women Report, and the Equal Pay Act passed by Congress that same year, sparked the return of feminist concerns to mainstream discussion after they had faded in the decades since the suffrage movement's hard-fought success in mobilizing for the Nineteenth Amendment granting women the right to vote in 1920. Afterward labor unions continued the fight for equal pay and treatment through collective bargaining, venerable suffragist Alice Paul found support for the Equal Rights Amendment among groups like the Business and Professional Women, and diverse women continued to organize for peace and other causes important to their communities. However, the 1966 founding of the National Organization for Women (NOW) by Friedan, Pauli Murray, Aileen Hernandez, and a few others launched new legal challenges to workplace gender discrimination that could be imagined because of the judicial successes of the National Association for the Advancement of Colored People (NAACP) fighting racial discrimination, and that could be won because of provisions in the 1964 Civil Rights Act that made gender discrimination a federal concern.[13]

NOW's subsequent high profile advocacy for women's rights coincided with the emergence of women's liberation organizations, many of which were formed by university students in the late 1960s. Some of these groups, which became

known as consciousness-raising or CR groups as they quickly spread nationwide, self-consciously distinguished themselves from NOW in terms of their intention-ally small-group structure, their intense discussions of personal experiences, their debate and publication of feminist theories, and their counter-cultural proclivity toward direct action which at times incorporated humor as well as anger. CR groups and the wider women's movement also spawned a creative rush of feminist institution building, including women's health collectives, rape crisis centers, feminist bookstores, and battered women's shelters. The transformations these institutions quickly brought to the lives of women who worked in and were served by them, and their critical role in long-term and profound social changes in the United States should not be underestimated.[14]

The creation of the Fresno Feminist Art Program at a university where a CR group had just been formed by two women who applied for and joined the first FAP—Suzanne Lacy and Faith Wilding—and where at least some faculty had already begun discussing how to create a women's studies program, underscores the overlapping people, themes, and goals of the young, ambitious, energetic, experienced, and hopeful women who forcefully challenged the status quo and sought to improve women's lives—their own lives—on so many fronts at once.

Lacy and Wilding's experiences of moving between CR-style group activism and artistic pursuits were not unique to the development of the women's movement nationwide. Yet the significant presence of artists among the founders of women's liberation is one aspect of the early days of the movement that has been overlooked thus far in the important and growing number of historical studies on this topic. For example, sculptor Kate Millett joined NOW in 1966; Shulamith Firestone was an art student when she joined the Chicago Women's Liberation Union in 1967, initially called the Westside Group and identified as the first women's liberation organization in the United States. Later that year Firestone moved to New York City and co-founded New York Radical Women (NYRW); in 1969 she was a founding member of the influential feminist collective Redstockings and then New York Radical Feminists. Artist Florika became a member of NYRW, and participated in 1968 at the first Miss America protest—which incorporated what could be termed performance art—before joining WITCH (Women's International Terrorist Conspiracy from Hell), formed in 1969. Artists Irene Peslikis and Pat Mainardi joined NYRW after hearing about the Miss America protest in a WBAI radio report, and were also founding members of Redstockings; artist Louise Fishman joined Redstockings, then WITCH, and later became active in the New York Feminist Art Institute (NYFAI). Nancy Azara, another Redstocking member, was a co-founder of NYFAI as was Peslikis. Painter and activist Faith Ringgold participated in the 1970 Whitney Museum protest demanding greater inclusion of female and black artists, and joined the National Black Feminist Organization (NBFO), founded in 1973.[15]

One reason for this feminist turn for those who were students, Pat Mainardi explains, is that female artists who hoped to find in art school a space for self-

expression where they could avoid oppressive circumstances, found instead blatant discrimination. The extraordinary 1997 film *Shulie*, by artist Elizabeth Subrin, a shot-by-shot recreation of a 1967 documentary on the "Now Generation" that features then twenty-two-year-old art student Shulamith Firestone, for example, depicts the patronizing critique by her male teachers of Firestone's paintings. At the New York City art school where Mainardi met Peslikis, administrators openly stated that only male students would get scholarships; female students would pay tuition. Then, upon graduation, they, like other women in their mid-twenties with college degrees who became feminists, couldn't find jobs. Judy Chicago similarly experienced gender discrimination at UCLA, where she earned an M.A. in painting and sculpture in 1964, and afterwards, in the Los Angeles art scene.[16]

As the history of the women's movement that began in the 1960s is more widely studied, artists' participation deserves a closer look; further research could explain its causes and effects. Moreover, the interplay between female artists and women's rights activists may be traced from the nineteenth century, when, after the end of the Civil War, "women's urgent desire to become artists," as historian Kirsten Swinth puts it, led by 1900 to an "extensive network of female artists seeking . . . to exhibit their work." This phenomenon, and the 1889 founding of the still-active National Association of Women Artists, coincided with the further intensification of suffrage mobilization. By the early twentieth century, female artists like Fresno native Marguerite Zorach could mingle among avant-garde circles in Paris, Greenwich Village, and Los Angeles that included artistic innovators, free love advocates, political radicals, and suffragists. Not only did "virtually all the artists" in these circles engage with feminism, but the "great, mass suffrage campaign of the teens received universal support among women artists." For example, New York modernist painter Theresa Bernstein went to meetings often attended by National American Woman Suffrage Association president Carrie Chapman Catt, participated in suffrage parades, and "recorded her involvement in the suffrage campaign" in a series of paintings. She was not alone in contributing images for the cause—political cartoons were an important suffrage strategy, as were the public performances of carefully planned suffrage parades. In a similar vein, African American artist and club woman Meta Warrick Fuller created politically-informed sculptures after she returned from Paris, such as her 1919 condemnation of lynching, *Mary Turner (A Silent Protest against Mob Violence)*. In 1920, Georgia O'Keeffe joined the National Women's Party (NWP) as a founding member, and at an NWP event in 1926 articulated the difficulties women artists faced: "They have objected to me all along; they have objected strenuously. It is hard enough to do the job without having to face the discriminations, too. Men do not have to face these discriminations."[17]

The concern about cultural representations of women voiced by feminist leaders and organizations who are primarily identified with struggles for equality in work, politics, education, and reproductive rights takes on a new light when reckoning

with the presence of artists within the movement in the later twentieth century as well. Though her main focus is employment and a central target is misguided psychiatric treatment of women, in chapters like "The Happy Housewife Heroine" and "The Sexual Sell" from her bestseller *The Feminine Mystique*, Betty Friedan critiqued the image of women and constructions of femininity in popular culture. In the NOW Statement of Purpose she penned three years later, Friedan put these issues on the feminist agenda in a strongly worded passage:

> In the interests of the human dignity of women, we will protest, and endeavor to change, the false image of women now prevalent in the mass media, and in the texts, ceremonies, laws, and practices of our major social institutions. Such images perpetuate contempt for women by society and by women for themselves. . . . We believe that women will do most to create a new image of women by acting now.[18]

Friedan's understanding of culture as a key aspect of women's oppression in social, economic, and political spheres echoes concerns voiced by Elizabeth Cady Stanton in the nineteenth century, and is a view also shared by artist Shulamith Firestone, who wrote her groundbreaking 1970 book *The Dialectic of Sex: The Case for Feminist Revolution* after earning a B.F.A. in painting from the Art Institute of Chicago in 1967. Firestone's book became what Ann Snitow terms a "demon text" of anti-feminists in the 1970s for its now-prescient advocacy of reproductive technologies.[19] However, Firestone's views on motherhood were just one part of a far-reaching analysis that included critiques of Freud, racism, love, and ecology. Her chapters on "(Male) Culture" and "Dialectics of Cultural History" explicitly addressed the male-dominated art world in Europe and the United States. Building upon Simone de Beauvoir's breakthrough *The Second Sex*, published in English in 1953, Firestone outlines how representations of women have been central to Western culture, though women remained marginalized as creators of culture:

> women, and those men who were excluded from culture, remained . . . fit subject matter . . . [P]ainting was male; the nude became a *female* nude . . . But what about the women who have contributed directly to culture? There aren't many. And in those cases where individual women have participated in male culture, they have had to do so on male terms . . . they saw women through male eyes . . . It would take a denial of all cultural tradition for women to produce even a true "female" art.[20]

Though Firestone saw even male avant-garde artists as marginalized, and was skeptical that contemporary artists' use of plastics, mixed media, and happenings was "unreservedly" progressive, she believed she was living "in the transitional pre-revolutionary period" that would lead to the "creation of an androgynous culture" formed by male technology and female aesthetics.[21]

In *Further Adventures of* The Dialectic of Sex, a 2010 collection that thoughtfully reappraises *Dialectic*'s contributions without overlooking its instances of "contradiction, misjudgment, or affront," Stella Sandford acknowledges the binary constructions, which readers today likely identify in the passages quoted above, but also the possibilities Firestone articulated for feminist transformation of gender; thus Firestone relies on a contradictory understanding of gender difference both as biological and unchanging as well as a political, constructed view. Mandy Merck similarly stresses Firestone's eclectically-based advocacy of abolishing sexual distinction, concluding that the book is not "quite the biological reduction so often described, since her concern is how bodies matter culturally."[22] These insights also can be applied to assessing Firestone's views on art and image, which anticipated theorization of a "male gaze," and contributed to the dynamic field of feminist art history and criticism launched in the 1970s. Its beginnings include Judy Chicago's Feminist Art Program project to excavate and reclaim the history of female artists.[23]

Sisterhood Is Powerful is another critical text published in 1970 that included criticism of images of women and essays by artists. Edited by Robin Morgan, the section on "psychological and sexual repression" includes "Media Images 1: Madison Avenue Brainwashing—The Facts," by Alice Embree, an assessment of mass marketing techniques on women, and artist Florika's still provocative "Media Images 2: Body Odor and Social Order." Florika's deconstruction of hair spray, deodorant, insecticide, and cleaning products begins, "The aerosol spray container reveals that the roles of the policeman and the middle-class housewife are interchangeable."[24] The anthology also includes essays by artists and Redstocking members Irene Peslikis and Pat Mainardi, "Resistances to Consciousness," and the much reproduced "The Politics of Housework," respectively. Peslikis explains how to transcend common counterrevolutionary misperceptions, such as "*Thinking that individual solutions are possible*" and "*Thinking that women's liberation is therapy.*" Mainardi's humorous and cutting deconstruction of the methods husbands employ to avoid housework and dismiss feminism similarly lists common justifications, such as "Housework is too trivial to even talk about," and "Women's liberation is not really a political movement." In the poetry section, Karen Lindsey's "Elegy for Jayne Mansfield, July 1967" mourns the objectification of this actress before and after her accidental death. In the "historical document" section, which includes statements from Redstockings, WITCH, and The Feminists, an excerpt from Warhol-shooter Valerie Solanas' *SCUM Manifesto*—positioned between the NOW Bill of Rights and the New York Radical Women Principles—has received more attention than other emergent feminist arts commentary due to the Solanas' extreme formulations and notoriety. Nonetheless, radical feminists clearly prioritized representations of women as a problem requiring feminist solutions, and art as a significant strategy in their repertoire.[25]

In addition to their writing, artists Florika, Peslikis, and Mainardi created graphics, posters, and visual art to critique sexism and promote feminist

mobilization. Florika's reworking of a Women's Army Corps recruitment poster is one of two art works in *Sisterhood is Powerful*; the other is a line drawing by Diane Losch that conveys women's isolation in the home and an interior life of suffering. A late 1960s drawing by Peslikis reproduced in *Dear Sisters* urges "Women must control the means of reproduction" by depicting a dystopian reproductive assembly line that uses technology not to liberate women as Firestone hoped, but to exploit them.[26] Feminist poster art flourished in a context of anti-war, Black Power, La Raza, and Third World Liberation counter-cultural artistic production, which included work by artists such as Yolanda Lopez and Betty Kano in San Francisco. The art of these movements drew upon the longer practice and iconography of radical politics that had been intrinsic to twentieth-century revolutions and progressive organizing before and during the New Deal. Moreover, public critique of denigrating images had been identified as a significant tool in opposing racism and anti-Semitism and promoting diversity from the early twentieth century by the NAACP founded in 1909 and the Anti-Defamation League founded in 1913.[27]

This necessarily brief and partial account of artists' participation in the fight for women's rights and the long-held concern by women's rights activists about how representations impact opportunities for social change in some ways has replicated the first wave/second wave periodization that has been an important topic of debate since the mid-1990s. As texts such as the recent collection *Breaking the Wave: Women, Their Organizations, and Feminism, 1945–1985* show, the waves formulation tends toward elision of women's activism between 1920 and 1963 and later periods of conservative, anti-feminist backlash. Other works have highlighted how wave periodization emphasizes the contributions of white women and thus relegates feminists of color to an inaccurate, background role.[28] However, Benita Roth counters the latter perspective by discussing second wave feminisms in the plural and arguing that women's movements "from the beginning, largely organized along racial/ethnic lines. . . . feminisms were articulated in diverse political communities." Though black, Chicana and white women may have taken "separate roads to feminism" via their distinctive organizations, women's second wave activism as a whole included diverse groups, perspectives, and definitions of feminism. In addition, dynamic exchanges among diverse women fomented change. For example, Lisa Gail Collins compares the black arts and feminist art movements, finding it was "Judy Chicago who most intently wrestled with [de Beauvoir's] findings on the problems of women creators throughout Western history in relation to the struggles of contemporary women artists," though Chicago was inspired to do so in part because of the Black Power movement.[29]

In *Entering the Picture*, these separate roads by participants in the feminist art movement are explored in Section II by Valerie Smith, "Abundant Evidence: Black Women Artists of the 1960s and 1970s" and Terezita Romo, "A Collective History: Las Mujeres Muralistas," and in Section III by Sylvia Savala, "How I

Became a Chicana Feminist Artist," Lydia Nakashima Degarrod, "Searching for Catalyst and Empowerment: The Asian American Women Artists Association, 1989–Present," and Tressa Berman and Nancy Marie Mithlo, "'The Way Things Are': Curating Place as Feminist Practice in American Indian Women's Art." Moreover, Phranc's essay, "'Your Vagina Smells Fine Now Naturally,'" and Nancy Azara and Darla Bjork, "Our Journey to the New York Feminist Art Institute," highlight the integral contributions of lesbians to the women's and feminist art movements. Jewish women's feminist art and activism is present in information by and about Judy Chicago, in essays by Gloria Feman Orenstein and Miriam Schaer, and art works by Chicago, Schaer, and contributor Beverly Naidus.[30]

Overall, the essays in this book suggest methodologies, research topics, and ways to evaluate the intertwined histories of the women's movement and the feminist art movement. Each of the three sections has distinctive elements and moves us forward in time, though their overlapping genealogies, chronologies, and motifs link the sections together. For example, all three sections narrate the unique history of feminist art in Fresno, which flourished after Judy Chicago left, and incorporate essays by feminist artists and feminist art teachers that provide practical examples of pedagogical techniques and exercises for classroom or individual use. And throughout the book, essays explore feminist institution building and collaborative projects, and address issues such as differences among women, intersectionality, the meaning of place, the gendered nature and impact historically of the art/craft distinction, the importance of small-group organization to feminist activism, the strategic articulation of women's experiences, and the tensions between individual and collective accomplishments.

Grappling with the participants' reflections and later considerations of the Fresno and CalArts Feminist Art Program in Section I, for example, raises questions about important movement history themes such as the proliferation, deployment, and results of consciousness-raising, the provocative role of early second wave publications, and the significance of separatist activities. More specifically, differing perspectives on Judy Chicago's early 1970s teaching methods that emerge in the essays by Laura Meyer and Faith Wilding, and recollections by Nancy Youdelman, Karen LeCocq, and Suzanne Lacy, speak to the difficulties and psychological toll feminists and all counter-hegemonic activists may experience when challenging fundamental inequities and entrenched interests. Judy Chicago's upbringing in a leftist, Jewish home, encounters with sexism in art school, fierce determination to become a professional artist in an era when few women succeeded in doing so, and entrée in 1960s Los Angeles to a boys' club of up-and-coming artists who themselves cultivated tough-guy personas led to the image if not necessity of confident combativeness so vividly depicted in the 1971 art exhibit announcement where she posed in a boxing ring, with boxing gloves, boots, and shorts. Yet Chicago's move to Fresno—and subsequent teaching—signal her commitment to helping other women enter that struggle better prepared and not leave it

prematurely, and to helping herself by forming a community of women artists so she would not have to battle alone and where their revolutionary art representing female identity and experiences could find receptive audiences (see Plate 1). Some of Chicago's 1970s students responded better than others to the unprecedented, experimental structure she devised and to her urban radical personality. Certainly, it is important to recognize, as Chicago does in Chapter 6 of this book, that the teacher/student relationship holds a different power dynamic than the collective organizing experiences of radical feminists who chose to be involved in new organizations of their own creation. Yet as the history of those organizations' intense theoretical and practical debates, personal clashes, mistakes, achievements, splintering, and flourishing illustrates, even the entirely voluntary and purportedly egalitarian work of intense 1970s feminist mobilization took a toll on some of its most courageous participants. Moreover, though the excess of feminists generally is one well-worn line of attack, what is fascinating in regard to Chicago is the excess ascribed to her from multiple directions: too confrontational, too celebratory; too kitsch, too invested in traditional, Western notions of artistic genius; too narrow, too assimilationist. These criticisms also speak to tensions within feminism about women as leaders of collective actions and their accomplishments as individuals.[31]

Section I begins with an excerpt from Gail Levin's biography of Judy Chicago, which details the artist's move from Los Angeles to Fresno and the initial phase of the Feminist Art Program she began there. Although described by Levin and throughout *Entering the Picture*, Laura Meyer and Faith Wilding's following essay more explicitly outlines some of the key themes of influential and contested FAP-initiated feminist art practices, such as collaboration, "the quest for new kinds of female body imagery" (cunt art), and the use of media associated with femininity, including costume. Additional elements in Fresno FAP artists Nancy Youdelman, Karen LeCocq, and Suzanne Lacy's recollections, and in Paula Harper's 1985 assessment that includes a detailed description of *Womanhouse*, are the development and significance of performance art, the challenge of feminist art to the high art/women's craft tradition distinction, and the attention to domesticity and violence against women by feminist artists. Judy Chicago's essay ends this section with reflections on her teaching philosophy and experiences that incorporate useful descriptions of the types of work her students have undertaken.[32]

Section II moves beyond the Feminist Art Program, beginning with Valerie Smith's important history of black women artists in the 1960s and 1970s. Smith describes artwork and activism that predates, and was also coterminous to events in Fresno and Los Angeles, such as Faith Ringgold's politicized art-making in 1960s New York, more explicitly feminist art focus of the 1970s, and the 1971 founding of "Where We At" Black Women Artists (WWA) by women "marginalized by both the predominantly male Black Arts Movement . . . and the largely white feminist (and feminist art) organizations." In Southern California, Betye Saar's paintings offered revolutionary challenges to popular culture

stereotypes of African American women such as Aunt Jemima at the same time FAP students and teachers were planning and exhibiting their challenges to dominant notions of domesticity and constructions of white femininity at *Womanhouse*. Smith's essay thus enriches our understandings of African American women's artistic and collaborative contributions, underscores the complexities of feminist genealogies, and brings attention to diversity within feminist histories and movements.[33]

Jennie Klein's chapter on Rita Yokoi's tenure as Fresno FAP director after Chicago and her students left for CalArts, and Lillian Faderman's interview with Joyce Aiken, who took the reins from Yokoi, relates the surprising—and what may seem the unlikely—story of how feminist art and support for women artists flourished in Fresno at the university and in the community for decades. In addition, the intensive efforts Klein and I undertook to track down information about Yokoi show that reclaiming even recent women's art history continues to be a vital enterprise. There is an ironic element at work here too, as Yokoi herself incorporated such research (begun by Chicago) into her curriculum, and also because one of Chicago's aims in setting up the FAP was to teach female artists how to sustain their professional artistic careers. In addition, Judy Chicago's recruitment of Yokoi as program director provides more evidence about Chicago's concern for maintaining feminist art education in Fresno and other locales, though she moved elsewhere. Joyce Aiken's recollections about her long career as a feminist artist and teacher, and her interactions with feminist artists in New York and nationally, explain the persistence and reputation of the program in Fresno. Aiken also describes how the Fresno FAP heightened opportunities for women artists in the community as its graduates launched Gallery 25, a cooperative women's art gallery, in 1974. In addition, the Fresno Art Museum became the first museum in the United States to devote an entire year to exhibitions by women in 1986–1987, and afterward established an annual one-woman show.[34]

Moving again to Los Angeles, Phranc's lively and wistful recollections of her mid-1970s experiences at the Feminist Studio Workshop and Woman's Building, both co-founded by Judy Chicago, Arlene Raven, and Sheila DeBretteville in 1973, provide insight into the significance of new feminist institutions for those who were welcomed by them.[35] The essays that follow in Section II continue to explore feminist art collaboration and institution building in ever expanding locations, first in San Francisco in Terezita Romo's appreciative assessment of the mid-1970s Chicana women's mural collective, Las Mujeres Muralistas, who created large-scale neighborhood murals that gave prominence to female-centered themes and imagery. Next, Joanna Gardner-Huggett discusses Artemisia, a women's art gallery founded in Chicago in 1973, including the collaborations of women in the mid-west with artists and art workers from both the west and east coasts.[36] Section II ends with three articles focused on collective feminist art projects in New York City. Gloria Feman Orenstein's memoir of the Woman's Salons she organized explains how these gatherings brought women artists and writers

together to share their work and ideas, and her later, similar efforts in international contexts. Orenstein's talk on this topic at the 2001 feminist art symposium in Fresno was so inspiring that Lillian Faderman, Phyllis Irwin, Joyce Aiken, and Jackie Doumanian began hosting salons at their Fresno homes. Katie Cercone recounts the history of the New York Feminist Art Institute (NYFAI) from 1979 to 1990; Nancy Azara and Darla Bjork reflect on their experiences as members and teachers there. Azara, along with Miriam Schapiro and Irene Peslikis, among others, co-founded the NYFAI, attended some of the salons Orenstein organized, and participated in discussions with Shapiro and Judy Chicago in New York about collaboration. Bjork also recalls Chicago's NYFAI workshop on her then-in-development *Birth Project*. Cercone, Azara, and Bjork thus importantly document the exchanges between feminist art organizations and prominent women artists, such as Louise Bourgeois, that are not widely known, and the overlapping of east and west coast feminist art circles, which are often presented as distinct, if not at odds. Azara and Bjork's contribution ends with Azara's instructive overview of her innovative and effective Visual Diary feminist art teaching tool.

Though some chapters in Section III begin in the periods and places covered in previous sections, overall the essays take us further ahead in time and further afield in location. Section III begins with Sylvia Savala's account of becoming a Chicana feminist artist outside of organized feminist institutions and conventional cultural centers, and her later collaborations with Fresno's Gallery 25 and Arte Americas. Savala's engaging essay relays her personal struggles and triumphs with reference to issues of gender, class, and ethnicity, and interrogates the critical question of the difference between women's and feminist art. In an intriguing coincidence, the Asian American Women Artists Association (AAWAA) was founded exactly one hundred years after the National Women Artists Association. Lydia Nakashima Degarrod's exploration of her own multi-faceted identity and the importance of this Asian American women's organization brings forward themes explored in this book about the power of collaboration, the importance of place, and women as sources of inspiration.[37] Miriam Schaer's "Notes of a Dubious Daughter: My Unfinished Journey Toward Feminism," playfully references Simone de Beauvoir's *Memoirs of a Dutiful Daughter*, and thus also the importance of this influential writer to second wave feminism. However, though Schaer may qualify as generationally second wave, her life narrative and art—like many of the feminist artists profiled here and elsewhere—challenge assumptions, if not stereotypes, about what feminist work can encompass and what sensibilities feminists of different age groups may share. Like the wide age range of AAWAA members, Schaer's twenty-first-century feminist art collective is composed of younger and older artists.

Tressa Berman and Nancy Marie Mithlo's essay on Native American women's art addresses issues of identity, place, and gender. The two artists they focus on, Colleen Cutchshall and Shelley Niro, each holds a collective identity grounded

in a specific location, culture, and history. Yet as these authors and artists move from place to place, their work transforms the spaces they inhabit and challenges gendered claims to tribal culture (Cutchshall's installation), and to popular culture and commercialized appropriation of Native values and representations (Niro's film).[38] The next two articles focus on the collaborations of feminist art curators, championed as art workers by art critic Lucy Lippard. Although transformations in just what constituted art and "artistic labor" were already underway, the feminist art movement broadened their definitions considerably.[39] Inspired by the 1996 Los Angeles *Sexual Politics* exhibit featuring Judy Chicago's *The Dinner Party* to curate a similar show in Taiwan, Ying-Ying Chien displayed art by Chicago and by women from Korea, Japan, and Taiwan in a transnational exhibition that focused on women's labor. In her assessment of the exhibit, Chien finds "striking concordances" in materials and themes among the diverse women's art, though also differences in emphases.[40] Jo Anna Isaak contextualizes the resurgence of US and European feminist art exhibitions in the twenty-first century by drawing out a longer history of group exhibitions, including those she curated in the 1980s and 1990s. Italian feminist art curators Gaia Cianfanelli and Caterina Iaquinta describe START, their innovative arts organization that has mounted large-scale exhibitions of work by women across Italy, and provide historical background on the distinctive approaches of Italian feminism and feminist art that inform their work.[41] Here too, we see feminist disregard for center/periphery distinctions. From the Pacific Northwest, feminist artist and teacher Beverly Naidus ends the book with an account of her feminist history and activist art teaching methods at the University of Washington, Tacoma. Naidus describes assignments and exercises that have supported both male and female students to represent their gendered experiences and social criticism. Like Joyce Aiken in Fresno, Naidus is a singular presence on her regional campus, though she aims to encourage others to try her teaching strategies and focus on making art for social change.

Though the essays in this book don't all directly address ways to rethink the role of artists in the women's movement and the impact of collaboration on the feminist art movement, they do suggests new avenues of research. For example, although consciousness-raising groups played a profound role in fomenting activism in so many directions, there have yet to be full studies of their proliferation across America, and their methods, theories, and effects. More community studies, like Judith Ezekiel's about Dayton, Ohio, and Anne Valk's on Washinton, D.C. will surely shed light on this and other topics. The production and dissemination of feminist poster art, visual culture, and journals need further investigation as well. The women's gallery movement deserves the kind of sustained attention scholars have brought to examinations of women's health collectives, as does the relationship between feminist efforts to reclaim knowledge about and explore the pleasures of their bodies with artists' use of vaginal imagery.[42] In addition, comparative studies of how various strands of feminism created women's culture and feminist institutions and also promoted

women's entry into male dominated arenas would further illuminate collective achievements as well as conflicts among women. The depth, breadth, and geographic sweep of the women's movement suggest new frameworks are needed to analyze, for example, multiple and synchronous events such as the 1969 founding of Women Artists in Revolution (WAR) in New York and Dayton Women's Liberation in Ohio; the August, 1970 launching of the Fresno Feminist Art Program and NOW's organization of the massive Women's Strike for Equality, and the protest of black and female artists' exclusion from the Whitney Museum in New York a few months later. Moreover, including feminist art within discussions of wider movement history may challenge, but could sustain, second wave periodizations and notions of generational conflict. Certainly, feminist artists' humor, ironic commentary, development and dissemination of cunt art, confrontational performance art and museum protests, and reworking of feminine artifacts, also known today as "girly culture," undermine generalizations about second wave feminists as staid or narrow-minded and draw connections to innovations sometimes attributed to feminists who came of age in or after the 1990s.[43]

Kirsten Swinth argues that the unprecedented artistic activity by women from 1870 to 1930 transformed the art world. In those decades, female artists contended with concepts of individual self-expression that were marked by essentialist notions of femininity. Nonetheless, as these artists claimed, represented, and exhibited their subjectivity, they reworked gendered conceptions of culture. Women artists, therefore, were critical to the shaping of modernity, even as it retained a masculinist character.[44] Judith Brodsky and Ferris Olin similarly argue that "feminist art pioneered post-modernism" and call for the recognition of "the formative contributions of feminist cultural production" that began in the 1970s. They fear that feminist "innovations have become so thoroughly embedded in contemporary perspectives that their role in introducing these ideas is in danger of being erased," or misattributed to men like the work of women artists in past centuries. Feminist artists' "contributions to a revolution in modes of representations" include:

> the use of specific events, personal experience, and narratives drawn from daily life to challenge abstract expressionism; the use of pleasure and play to protest the oppressions of the status quo; art inspired by and responsive to social, cultural, scientific, and political conditions rather than art for art's sake; the development of embodied narratives tied to the temporalities of daily life rather than art linked to notions of transcendent form; art that plays with scale, foregrounding the human through ludic proportions; complex forms of art making such as installation, site-specific art, video, photography, and books rather than traditional painting and sculpture; art as collaborative practice rather than the product of individual male genius; and art that blurs the boundaries between craft, popular culture, and high art.[45]

Understanding more about the genealogies and locations of these innovations within the context of the larger women's movement is vital for a fuller accounting of feminist history and more nuanced analysis of the conflicts about the place of cultural activism that have shaped feminist movements and their historiography.[46] As feminist artists and new forms of representing women's experiences entered the picture, feminist activism—whether by small group, separate, or conventional organizations, or expressed in foundational texts, posters, feminist institutions, and performance actions—incorporated concerns about images of women, and feminist artists were there.

Notes

1 Chicago's appointment was for one year. Judy Chicago, *Through the Flower: My Struggle as a Woman Artist* (New York: Doubleday, 1975), 68. See also Gail Levin, Chapter 1 of this book.

2 "Miss Chicago and the California Girls," *Everywoman* 2:7 (May 1971); "Bad Dream House," *Time* (March 20, 1972); *Womanhouse: Exhibition of the Feminist Art Program* (Valencia: California Institute of the Arts, 1972). See also Section I of this book.

3 See for example, Michel Foucault, "Nietzsche, Genealogy, History," in Paul Rabinow, ed., *The Foucault Reader* (New York: Vintage, 1984), 76–100. There are many feminist evaluations of Foucault.

4 Chicago, *Through the Flower*, p. 96; Laura Meyer, ed., *A Studio of Their Own: The Legacy of the Fresno Feminist Experiment* (Fresno: CSU Fresno Press, 2009); articles by Faith Wilding, Arlene Raven, and Norma Broude and Mary Garrard in Broude and Garrard, eds., *The Power of Feminist Art* (New York: Harry Abrams, 1994), Part I; and Hillary Robinson, ed., *Feminism-Art-Theory: An Anthology, 1968–2000* (Oxford: Blackwell, 2001). I am grateful to Laura Meyer for generously sharing her FAP image files.

5 http://www.fresnocitycollege.edu/index.aspx?page=230, accessed 2–27–11. A plaque commemorates the 1911 IWW free speech fight in Fresno on the city's Fulton Mall. See also www.iww.org/culture/articles/DJones1.shtml, accessed 2–27–11.

6 Vicki Ruiz, *Cannery Women, Cannery Lives: Mexican Women, Unionization, and the California Food Processing Industry, 1930–1950* (Albuquerque: New Mexico University Press, 1987); www.aclunc.org/news/press_releases/fresno_homeless_residents_win_settlement_over_citys_destruction_of_personal_property.shtml, accessed 2–20–11; Ruth Gilmore, *Golden Gulag: Prisons, Surplus, Crisis, and Opposition in Globalizing California* (Berkeley: University of California Press, 2007); www.csufresno.edu/peacegarden/monuments.htm, accessed 2–27–11; Morgan Brennan, "America's 10 Most Toxic Cities," *Forbes* (February 28, 2011), accessed on forbes.com 3–4–11.

7 One unfortunate measure of their power is the Central Valley's deadly air pollution—Fresno is one of the three worst places in the United States annually for particulate and ozone levels—caused by suburban sprawl, traffic on Highway 99, and agribusiness lobbying that delayed regulation of dairy and farm machinery emissions until 2004. Valley agribusinesses also garner tens of millions of federal dollars annually through farm subsidies that go primarily to recipients of rural corporate welfare: large dairies and major cultivators of corn, wheat, and cotton. In 2009, Fresno County's subsidies totaled $54,551,171; from 2005 to 2009, it was $689,633,639. http://farm.ewg.org/region.php?fips=06019&progcode=total, accessed 2–26–11. Fresno is just one of several San Joaquin Valley counties that receive subsidies. Fresno and Tulare are the two highest agricultural-producing counties nationwide. www.tulcofb.org/index.php?page=agfact, accessed 6–23–11.

8 www.csufresno.edu/music/about/history.shtml, accessed 2–27–11.

9 www.undergroundgardens.com; www.museumsusa.org/museums/info/1152779; http://arteamericas.org/about.html, all accessed 2–27–11.

10 Email from Joyce Aiken, 2–13–11; John Ellis, "$107m Revamp of Courts Planned," *Fresno Bee* (February 12, 2011). John Ellis, "Fresno Courthouse Façade Has Its Fans," *Fresno Bee* (March 1, 2011) includes a 1966 photo of the wrecking ball demolishing the courthouse.

11 http://foundsf.org/index.php?title=S.F._STATE_STRIKE_1968_69_CHRONOLOGY, accessed 2–27–11.

12 Kenneth Seib, *The Slow Death of Fresno State: A California Campus under Reagan and Brown* (Palo Alto: Ramparts Press, 1979). Seib's important account does not mention the FAP. For a listing of Women's Studies programs, including seventeen CSU and eight UC campuses, see http://userpages.umbc.edu/~korenman/wmst/programs.html, accessed 3–4-11. Emails from Loretta Kensinger, Chair, and Kathryn Forbes, Associate Professor, Women's Studies Program, CSU Fresno (9–1-2010). Fresno's record on women's issues is mixed: the FAP continued until Joyce Aiken's retirement in 1992; the Women's Studies Program thrives. However, despite Fresno State's women's softball team national championship win in 1998, the university's record on Title IX compliance and sexual harassment is troubling. In 2008, for example, three Title IX lawsuits brought successfully against the university for gender discrimination by the female basketball coach, volleyball coach, and longtime athletics administrator resulted in $23 million awards for the plaintiffs. See www.fresnobee.com for more on these suits.

13 Ruth Rosen, *The World Split Open: How the Modern Women's Movement Changed America* (New York: Viking, 2000); Myra Marx Ferree and Beth Hess, *Controversy and Coalition: The New Feminist Movement Across Four Decades of Change* (New York: Routledge, third edition, 2000); and Sara Evans, *Tidal Wave: How Women Changed America at Century's End* (New York: Free Press, 2003) provide movement overviews. Kathleen Laughlin and Jacqueline Castledine, *Breaking the Wave: Women, Their Organizations, and Feminism, 1945–1985* (New York: Routledge, 2011) includes case studies and bibliographies on women's activism between 1920 and 1963.

14 Estelle Freedman, "Separatism as Strategy: Female Institution Building and American Feminism, 1870–1930," *Feminist Studies* 5 (Fall 1979), 512–529 and Alice Echols, *Daring to Be Bad: Radical Feminism in America, 1967–1975* (Minneapolis: University of Minnesota Press, 1989). Recent studies on feminist collectives include Sandra Morgen, *Into Our Own Hands: The Women's Health Movement in the United States, 1969–1990* (New Brunswick: Rutgers University Press, 2002); Kathy Davis, *The Making of* Our Bodies, Ourselves: *How Feminism Travels Across Borders* (Durham: Duke University Press, 2007); Junko Onosaka, *Feminist Revolution in Literacy: Women's Bookstores in the United States* (New York: Routledge, 2006); and Nancy Janovicek, *No Place to Go: Local Histories of the Battered Women's Shelter Movement* (Vancouver: UBC Press, 2007).

15 Echols, *Daring to Be Bad*, p. 317, n. 70; Barbara Love, ed., *Feminists Who Changed America, 1963–1975* (Urbana: University of Illinois Press, 2006), 152 (Florika), 294 (Mainardi), 315 (Millet), 357–358 (Peslikis), 384 (Ringgold); Becky Thompson, "Multiracial Feminism: Recasting the Chronology of Second Wave Feminism," in Nancy Hewitt, *No Permanent Waves: Recasting Histories of U.S. Feminism* (New Brunswick: Rutgers University Press, 2010), p. 42; Catherine Lord, "Notes Toward a Calligraphy of Rage," in Lisa Mark, ed., *WACK! Art and the Feminist Revolution* (Los Angeles: MOCA, 2007), 444. The NBFO employed consciousness-raising in 1974: Combahee River Collective, "A Black Feminist Statement," in Cherríe Moraga and Gloria Anzaldúa, eds., *This Bridge Called My Back: Writings by Radical Women of Color* (Latham, NY: Kitchen Table, 1981), 216.

16 Author interview with Mainardi, 2–28–11. Mainardi wrote the first feminist appraisal of quilts, "Quilts: The Great American Art," *The Feminist Art Journal* (Winter 1973),

18–23. Elizabeth Subrin, *Shulie* (1997). I viewed *Shulie* at Otis Parsons library in August 2010, and in October at *Shifting the Gaze: Painting and Feminism*, The Jewish Museum, New York City (9/2010–1/2011). For more on the 1968 Miss America protest, including Florika's participation, see www.redstockings.org feature, "The Miss America Pageant," accessed 3–4-11.

17 Kirsten Swinth, *Painting Professionals: Women Artists and the Development of Modern American Art, 1870–1930* (Chapel Hill: University of North Carolina Press, 2001), 1, 115, 173–179. See also Andrea Pappas's review of Swinth, http://h-net.org/reviews/showrev.php?id=6748; Alice Sheppard, "Suffrage Art and Feminism," *Hypatia* 5:2 (Summer 1990); Deborah Cherry, "Women Artists and the Politics of Feminism, 1850–1900," in Clarissa Orr, ed., *Women in the Victorian Art World* (Manchester: Manchester University Press, 1995), 49–69; and Margaret Finnegan, *Selling Suffrage: Consumer Culture and Votes for Women* (New York: Columbia University Press, 1999). Lisa Farrington, *Creating Their Own Image: The History of African American Women Artists* (New York: Oxford University Press, 2005), 65–71. Chapter 3 details the racial and gender discrimination artists in Fuller's era contended with.

18 Betty Friedan, *The Feminine Mystique* (New York: Norton, 1963); NOW 1966 Statement of Purpose, http://www.now.org/history/purpos66.html, accessed 2–27–11.

19 Ann Snitow, "Feminism and Motherhood: An American Reading," *Feminist Review* 40 (Spring 1992), 34. See also Lauri Umansky, *Motherhood Reconceived: Feminism and the Legacies of the Sixties* (New York: NYU Press, 1996).

20 Shulamith Firestone, *The Dialectic of Sex: The Case for Feminist Revolution* (New York: William Morrow, 1970), 156–159 (page numbers refer to Bantam edition, 1971).

21 Ibid., 188, 190.

22 Mandy Merck and Stella Sandford, eds., *Further Adventures of* The Dialectic of Sex: *Critical Essays on Shulamith Firestone* (New York: Palgrave, 2010), 7, 14. See also chapters 6 and 9 by each co-editor, respectively.

23 As autobiographical elements of Simone de Beauvoir's *The Second Sex* has yielded insights of that text, it seems germane to consider *The Dialectic of Sex* with reference not only to the then twenty-five-year-old Firestone's rebellion against her religious Jewish upbringing and family pressures, but also in light of her nascent artistic career. Elizabeth Fallaize, ed., *Simone de Beauvoir: A Critical Reader* (London: Routledge, 1998); Ruth Evans, *Simone de Beauvoir's* The Second Sex: *New Interdisciplinary Essays* (Manchester: Manchester University Press, 1998); Toril Moi, "The Adulteress Wife," *London Review of Books* 32:3 (February 11, 2010), 3–6.

24 Robin Morgan, ed., *Sisterhood is Powerful: An Anthology of Writings from the Women's Liberation Movement* (New York: Bantam, 1970), 191.

25 Ibid., pp. 337, 450, 496, 514–519. For an appreciation of Solanas as a proto-third wave feminist who anticipated the sex/gender distinction, see Catherine Lord, "Wonder Waif Meets Super Neuter," *October* 132 (Spring 2010), 135–163. Lord states "the ideas articulated in *SCUM* did not cause Solanas to make an attempt on a man's life. The shooting derived from the logic of psychic disintegration, *not* from the logic of satire. To insist upon a feminist reading of *SCUM* is neither tantamount to condoning murder nor a dismissal of queer theory" (154). Moreover, Lord argues the reputations of William Burroughs, Norman Mailer, Louis Althusser, and Carl Andre were not similarly tarnished by their violent behavior (158). However, Firestone in "I Remember Valerie," in her *Airless Spaces* (New York: Semiotext(e), 1998), 130, states, "I thought it was a big mistake to recognize Valerie as one of us, a women's liberationist, let alone to embrace her book as serious feminist theory."

26 Losch's drawing is untitled; Florika's is captioned "Actual U.S. Army Ad Brought to a Higher Level of Struggle by Florika," *Sisterhood is Powerful* first insert page, front and back; Rosen, *The World Split Open*, p. 225. She interviewed Peslikis, pp. 46, 134, 200. Irene Peslikis, "Women Must Control the Means of Reproduction" and "Friends of the Fetus," in Rosalyn Baxandall and Linda Gordon, eds., *Dear Sisters: Dispatches from*

the Women's Liberation Movement (New York: Basic Books, 2000), 134, 148. Author interview with Pat Mainardi, 2–28–11. Susan Brownmiller, *In Our Time: Memoir of a Revolution* (New York: Dell, 1999), 49, 55, 65, notes meetings at Pesliskis' loft and describes Florika's collages "putting Vietnamese women in an ad for Chanel No. 5. [Florika] also led an action against Revlon's corporate headquarters, called Revlon Napalm."

27 Karen Davalos, *Yolanda M. Lopez* (Los Angeles: UCLA Chicano Studies Research Center, 2008), 31; Julia Bryan-Wilson, *Art Workers: Radical Practice in the Vietnam War Era* (Berkeley: University of California Press, 2009); Carlos Francisco Jackson, *ProtestARte: Chicana and Chicano Art* (Tucson: University of Arizona Press, 2009); T.V. Reed, *The Art of Protest: Culture and Activism from the Civil Rights Movement to the Streets of Seattle* (Minneapolis: University of Minnesota Press, 2005); Bradford Martin, *The Theater Is in the Street: Politics and Performance in Sixties America* (Amherst: University of Massachusetts Press, 2004); Helen Langa, *Radical Art: Printmaking and the Left in 1930s New York* (Berkeley: University of California Press, 2004).

28 Joanne Meyerowitz, ed., *Not June Cleaver: Women and Gender in Postwar America, 1945–1960* (Philadelphia: Temple University Press, 1994); recent works include Bettye Collier-Thomas and V.P. Franklin, *Sisters in the Struggle: African American Women in the Civil Rights-Black Power Movement* (New York: NYU Press, 2001); Hewitt, *No Permanent Waves*; Hasia Diner, Shira Kohn, and Rachel Kranson, *A Jewish Feminine Mystique? Jewish Women in Postwar America* (New Brunswick: Rutgers University Press, 2010); Laughlin and Castledine, *Breaking the Wave.* Eileen Boris proposes feminist "strands" in Laughlin et al., "Is it Time to Jump Ship: Historians Rethink the Waves Metaphor," *Feminist Formations* 22:1 (Spring 2010), 79, 86, 90–97.

29 Benita Roth, *Separate Roads to Feminism: Black, Chicana, and White Feminist Movements in America's Second Wave* (Cambridge: Cambridge University Press, 2004). See also, for example, Alma García, *Chicana Feminist Thought: The Basic Historical Writings* (New York: Routledge, 1997); Sonia Shah, ed., *Dragon Ladies: Asian American Feminists Breathe Fire* (Boston: South End Press, 1997); Deborah Gray White, *Too Heavy a Load: Black Women in Defense of Themselves* (New York: W.W. Norton, 1999), Annie Valk, *Radical Sisters: Second-Wave Feminism and Black Liberation in Washington, D.C.* (Champaigne-Urbana: University of Illinois Press, 2008); Vicki Ruiz with Ellen Carol DuBois, eds., *Unequal Sisters: An Inclusive Reader in U.S. Women's History* (New York: Routledge, fourth edition, 2008).

30 See also Harmony Hammond, *Lesbian Art in America: A Contemporary History* (New York: Rizzoli, 2000); Lord, "Notes"; Lisa Bloom, *Jewish Identities in American Feminist Art: Ghosts of Ethnicity* (New York: Routledge, 2006); Joyce Antler, "'We Were Ready to Turn the World Upside Down': Radical Feminism and Jewish Women," in Diner et al., *Jewish Feminine Mystique*, pp. 210–234.

31 Jennifer Baumgardner, "That Seventies Show," *Dissent* (Summer 2002), www.dissentmagazine.org/article/?article=586, accessed 3–4–11; Bloom, *Jewish Identities*, chapter 2; Gail Levin, *Becoming Judy Chicago* (New York: Harmony Books, 2007). Lucy Lippard similarly considered herself "one of the boys" when she became a professional art critic before identifying as a feminist in 1970. Bryan-Wilson, *Art Workers*, pp. 129–130, 153. See also *!Women Art Revolution*, directed by Lynn Hershman Leeson (New York: Zeitgeist Films, 2010).

32 See also Laura Cottingham, *Seeing Through the Seventies: Essays on Feminism and Art* (Amsterdam: G+B Arts, 2000) and *Womanhouse* (directed by Johanna Demetrakas, 1974).

33 For more on this topic, see for example, Lisa Gail Collins, *The Art of History: African American Women Artists Engage the Past* (New Brunswick: Rutgers University Press, 2002), Lisa Farrington, *Creating Their Own Image: The History of African American Women Artists* (New York: Oxford University Press, 2005).

34 www.fresnoartmuseum.org/about/council_of_100.htm, accessed 3–4–11.

35 See also Laura Meyer, "The Los Angeles Woman's Building and the Feminist Art Community, 1973–1991" in David James, ed., *The Sons and Daughters of Los: Culture and Community in L.A.* (Philadelphia: Temple University Press, 2003), 39–62; Terry Wolverton, *Insurgent Muse: Life and Art at the Woman's Building* (San Francisco: City Lights, 2002).

36 For related works, see Karen Mary Davalos, *Yolanda M. López* (Los Angeles: UCLA Chicano Studies Research Center, 2008); Laura Pérez, *Chicana Art: The Politics of Spiritual and Aesthetic Altarities* (Durham: Duke University Press, 2007); and, on Judy Baca among others, Amalia Mesa Bains, "Calafia/Califas: A Brief History of Chicana California," in Diana Burgess Fuller and Daniela Salvioni, eds., *Art/Women/California, 1950–2000* (Berkeley: UC Press, 2002): 123–140.

37 See also Karen Higa, "What Is an Asian American Woman Artist?" in Fuller and Salvioni, *Art/Women/California*, pp. 81–94; Valerie Matsumoto, "Asian American Artists in California," in Gordon Chang, Mark Dean Johnson, Paul J. Karlstrom and Sharon Spain, eds., *Asian American Art: A History, 1850–1970* (Palo Alto: Stanford University Press, 2008), 169–199.

38 See also Jolene Rickard, "Uncovering/Recovering: Indigenous Artists in California" and Theresa Harlan, "Indigenous Visionaries; Native Women Artists in California," in Burgess and Salvioni, *Art/Women/California*, pp. 187–200.

39 Bryan-Wilson, *Art Workers*, pp. 127, 129, 138, 151.

40 See also Maura Reilly and Linda Nochlin, eds., *Global Feminisms: New Directions In Contemporary Art* (London: Merrell, 2007).

41 See also Judith Russi Kirshner, "Voices and Images of Italian Feminism," in Mark, *WACK!*, pp. 384–399.

42 Lisa Hogeland, *Feminism and its Fictions: The Consciousness-Raising Novel and the Women's Liberation Movement* (Philadelphia: University of Pennsylvania Press, 1998); Judith Ezekiel, *Feminism in the Heartland* (Columbus: Ohio State University Press, 2002); Valk, *Radical Sisters*; Anne Enke, *Finding the Movement: Sexuality, Contested Space, and Feminist Activism* (Durham: Duke University Press, 2007). Judith Brodsky, "Exhibitions, Galleries, and Alternative Spaces," in Broude and Garrard, *Power of Feminist Art* and Joanna Inglot, *WARM: A Feminist Art Collective in Minnesota* (Minneapolis: Weisman Art Museum, 2007) includes information about galleries nationwide. A chronology of all-women group exhibitions follows Jenni Sorkin, "The Feminist Nomad: The All-Woman Group Show," in Mark, *WACK!*, pp. 458–472, 473–499.

43 Cristine Rom, "One View: The Feminist Art Journal," *Woman's Art Journal* 2:2 (Fall 1981), 19–24. Ezekiel, *Feminism in the Heartland*, p. 1. See also Section II, Broude and Garrard, *Power of Feminist Art* and works by the Guerrilla Girls.

44 Swinth, *Painting Professionals*, pp. 1–4, 168, 201–206.

45 Judith Broksky and Ferris Olin, "Stepping out of the Beaten Path: Reassessing the Feminist Art Movement," *Signs* 33:2 (2008), 330–331.

46 E.g., Echols, *Daring to be Bad*; Redstocking feminists thought Women's Caucus for Art members were opportunists because they narrowly focused on finding opportunities to exhibit their work. Mainardi interview, 2–28–2011.

SECTION I

Emerging: Views from the Periphery

1

BECOMING JUDY CHICAGO

Feminist Class

Gail Levin
Abridged by Melissa Morris

A new twist in a typical old-boy network transplanted the urban activist, idealist, and budding feminist—Judy Gerowitz—from sprawling, restless Los Angeles to the more compact and centered Fresno. Isolated amid the densely cultivated fields, orchards, and monster dairies of the Central Valley, Fresno was a stark contrast to Los Angeles. Calibrated to georgic and bucolic industry, Fresno State College had grown from its origin in 1911 as a normal school—training mostly women as teachers for the prosperous farming region. [. . .] The department of fine arts was favored by a local philanthropist and trustee who worked in ceramics herself and had facilitated a new edifice for the arts building that was under construction when Judy came on the scene. The art department's men—both traditionalist and more vanguard—could hardly have foreseen that her ambitious drive would transform their classrooms and campus so dramatically.

Heinz Kusel had chaired the art department since 1967, just three years after it granted him the master's degree.[1] [. . .] Kusel had imported such talents as Wayne Thiebaud and Vija Celmins only to see them move on, leaving him with two vacancies to fill. When the department organized a group show in July 1969, it included an unconventional sculptor from UCLA, Oliver Andrews. Though invited to give a talk, Andrews delivered a demonstration, flying one of his "sky fountains" made from Mylar and balloons. The spectacle so impressed the faculty that they asked him to recommend any students of his to fill their vacant positions. He had been a favorite teacher of Gerowitz, whom he suggested, along with her classmate and friend Susan Titelman. Both received and accepted offers, Gerowitz beginning in the 1970 spring term.[2]

It says a lot about the influence of Andrews and Kusel's principled daring that Kusel would hire someone who came across as "a very aggressive, very hostile feminist," acting on his judgment very specifically that "she was nonetheless

interesting and dynamic." Indeed, he used his power as chair to overrule his colleagues' objections and give his new hire free rein in her teaching. He also prided himself on the result: "Despite severe opposition, I decided she would be good for the department and I hired her. I allowed her to create a strictly Women's Art Program. It became the first of its kind in any university and a key contribution to the beginnings of the whole feminist movement in America."[3]

[. . .]

Gerowitz interpreted the move as a further logical step in building a life understood as unfolding through successive stages. First came "values and attitudes, my sense of what I could and what I couldn't do [that] were developed in the 50s when I was a teenager." On top of that came "the whole advent of the hippies and the revolution and the Left . . . the Panthers, the Blacks," which she saw "had really changed the nature of our society and our values"—change that dictated change, also for her: "I felt that I had built my identity and my art-making as a person—as an artist—on the framework of reality that I had been brought up in, and now that framework had changed, so I wanted some time out, to look around, and find out what was appropriate now. I sensed that what I could do now differed from what could be done twenty years ago."[4]

Judy had responded strongly to the early writings of the women's movement, which confirmed and seemed to valorize her own feelings. She described how she "shuddered with terror reading Valerie Solanas's book and some of the early journals. . . ." She admitted that she found Solanas "extreme" but "recognized the truth of her observations. . . ."[5] " 'Great Art' is great because male authorities have told us so," wrote Solanas in 1968 with satirical hyperbole, having just referred to " 'Great Art,' almost all of which, as the anti-feminists are fond of reminding us, was created by men."[6]

Judy's quest for a new "framework of reality" began with a critique of the old: "it has been the male experience that has always stood for the human condition . . . like Hamlet or Godot." A different premise and goal would shape her quest: "In terms of my aspirations as an artist, I needed to find a way to embody the human condition in terms of female experience, and that required that I study women's art. I wanted to find out if other women had left clues in their work that could help me. I wanted to explore my experiences as a woman openly and somehow wed those to the sophisticated techniques and skills I had as an artist."[7]

As a first step this new aim "required moving away from the male-dominated art scene and being in an all-female environment where we could study *our* history separate from men's and see ourselves in terms of our own needs and desires, not in terms of male stereotypes of women."[8] On another occasion she described her new mission in bluntly personal terms: "I . . . tried to begin to undo the damage I'd done myself competing in the male art world. I wanted to make my paintings much more vulnerable, much more open."[9]

[. . .]

Her feminist agenda and her outspoken manner did not escape the men who perceived her as hostile and aggressive when she began teaching at Fresno in early 1970. Her first lectures, one eyewitness recalls, were booed by some of the guys: "People hated Judy; they were so threatened."[10] [. . .] Her developing feminism shaped both her art and her teaching. In her mixed classes that first term, she tried saying, "Okay now, none of the men talk; only the women talk."[11] From this she would move to the next stage in her quest and create "a year-long class for girls who wished to be artists."[12]

[. . .]

A woman in that first class, Fresno-native Vanalyne Green recalls "Judy asked us what images we wanted to make work out of. I had an image of a female manikin on a circular track, going around and around. She asked if I knew that was a woman's image and I lied and said yes, I did. Of course at that stage I didn't have a clue what feminism was. I was mesmerized by Judy. Later I asked to be part of the Feminist Art Program she was starting. She accepted me but warned that we would have conflicts," which they did. Green rebelled, says a fellow student, Laurel Klick, when really challenged by her teacher, who retorted: "Don't be mad at me. I'm not your mother." Klick recalls too how that first class suffered attrition, as students one by one dropped out because the teacher demanded so much: "She took us seriously and made us accountable."[13]

By late spring Judy's mother reported: "She seems to be somewhat recharged in her role as professor, especially as she feels that she can make a contribution to women who are trying to become 'liberated.'"[14]

[. . .]

Early in the summer, Gerowitz legally adopted the name Judy Chicago "as an act of identifying myself as an independent woman."[15] Her mother spread the news to her friend Pearl, expressing amazement. She was also impressed that Judy had taken out an ad in *Artforum* announcing why she had done it.[16]

The *Artforum* ad in October 1970—a full page placed by the Jack Glenn Gallery for her show at the still relatively new California State College at Fullerton, Orange County—featured a head shot (shown twice, once reversed) of Chicago wearing a headband and dark glasses with a companion text: "Judy Gerowitz hereby divests herself of all names imposed upon her through male social dominance and freely chooses her own name: Judy Chicago."[17] Beneath this box another one reads: "Judy Gerowitz One Man Show Cal State Fullerton October 23 THRU November 25." The name "Gerowitz," was crossed out and the name "Chicago" was written above it in script. Likewise, "Man" was crossed out and "Woman" written above it in script.

A second ad in *Artforum*—run without charge by the editors—followed in the December 1970 issue.[18] This one used the photograph of her posed in a boxing ring, her dealer listed as "Manager, Jack Glenn." Five years later Chicago recalled the boxing pose with what her male interviewer called a "vehement giggle": "It was a joke, but it took on mythic proportions . . . It was like, 'Hold

on guys, here they come!'"[19] The poster had meant to spoof the macho announcements, posters, and ads typical of some of the "wild men" who showed at the notorious Ferus Gallery.

The new name and the Fullerton show unhinged *Los Angeles Times* critic William Wilson, who earlier had had appreciative things to say about works by Judy Gerowitz. He led with the changed name, quoted the bit about "divesting" herself of "all names imposed upon her through male social dominance," and then indulged himself in the first of what would swell in the years ahead into a chain of petulant sneers: "It is a nice gesture of liberation. I hope its seriousness is not diluted when she is introduced socially as Miss Chicago. Well, it's not as touchy as if she had picked Judy America."[20] Then he tried getting back on track: "Enough of that. Despite feminist statements in the catalogue, Judy Chicago's art bears no relationship to names or Women's Lib. Its exhibition has been installed with economy and brilliance by Cal State Fullerton gallery director Dextra Frankel."[21]

[. . .]

The name change was right in your face, an unmistakable target, but the catalog, though ignored by Wilson, provided plenty of further feminist content. Frankel described Chicago as "a leader in the vanguard West coast art scene" and under-scored her feminist quest. Chicago furnished a "Dedication to the Grinsteins" (Stanley and Elyse, her devoted patrons in Los Angeles), followed by a list compiled from her reading in women's history. The first of many honor rolls of both contemporary and historical women with ties to feminist thought, it reached its fullest form nine years later in *The Dinner Party*.

Although the list was still in formation, Chicago clearly had already focused on women who struggled to abolish slavery: Susan B. Anthony, Lucretia Mott, Elizabeth Cady Stanton, Lucy Stone, Sojourner Truth, Harriet Tubman, and the Grimké sisters, who called female slaves their "sisters" and affirmed, "Women ought to feel a peculiar sympathy in the colored man's wrong, for like him, she has been accused of mental inferiority, and then denied the privileges of a liberal education."[22] Chicago, imbued with her father's values, had started with civil rights and the NAACP before broadening her concern to include equal rights for women as well. Her own background and experience prepared her to absorb Shulamith Firestone's argument in *The Dialectic of Sex: The Case for Feminist Revolution*, which declared women's need to "face their own oppression."[23] This first list also reveals her concern with women artists, such as contemporary painters DeFeo and O'Keeffe and filmmakers Clarke, Varda, and Zetterling. She would expand the lists into a virtual canon as she kept reading classic and contemporary fiction by women along with feminist texts.

[. . .]

The new name and emphatic agenda riled not only Wilson but an *Artforum* reviewer, Thomas H. Garver, who declared that Chicago had "taken advantage of a California law which permits anyone to have one alias without complex court approval."[24] Turning to the display—"The paintings, fifteen in all, dominate

the exhibition although they are not her best work." With a manner condescending at best, he pontificated, "One tends to regard Judy Chicago as more an intuitive than intellectual artist, and the other works in the exhibition demonstrate this quality more adequately."[25] He compared her domes on tabletops to a male artist—"suggestive of the pearlescent lacquered plastic forms of Craig Kauffman"—using the comparison to put her down.[26]

To protest Garver's inaccuracies, Chicago wrote to editor Phil Leider: "It is important to note that I changed my name legally. I did not use an alias. I elected to use the legal process because married women are nonpersons legally and I wanted a name of my own."[27] As for the women cataloged, "The list of women's names included painters, writers, political activists and women who have distinguished themselves by struggling for the rights, dignity, and identity of women in and out of the arts. I consider these women as representatives of my history and was proposing in the catalog that my work must be understood within the context of this struggle."[28] Never slack to explain where others erred or traduced, Chicago brought her unfolding creed as a woman and artist up to date:

> These misperceptions and omissions arise from a misunderstanding of my art and of the way my femaleness relates to my art. In my work, my name change and my catalogue I make explicit my commitment to an Art that is emotional, direct, sensate and derives from my psychic and emotional struggle to realize myself as a female. I believe that *Pasadena Lifesavers*, the fifteen paintings included in my show, fully fulfill my commitment. To understand these paintings, one must approach them with a willingness to experience reality through the physical and emotional framework of a female.[29]

While male reviewers seemed to operate by the rule "If you don't like the message, shoot the messenger," artist Miriam Schapiro—an acquaintance and a teacher at CalArts—"brought her class to my show," Chicago later recalled, welcoming an evident rapport: "it was obvious that she could 'read' my work, identify with it, and affirm it"[30]—not a simple accomplishment, since Chicago saw the *Pasadena Lifesavers* as "reflecting the range of my own sexuality and identity, as symbolized through form and color, albeit in a neutralized format." Although in fact they were opaque to male viewers, she herself had felt "frightened by the images, by their strength, their aggressiveness."[31]

Schapiro had arrived at her feminist insight and outlook by a circuitous route. After the birth of her son and only child in 1955, she struggled to reconcile her dual desires to be both mother and artist.[32] Resuming work in 1957, Schapiro took part in the *New Talent Exhibition* at the Museum of Modern Art, showing canvases painted in a gestural abstract expressionist style. Yet because her work in the abstract expressionist mode left her discontented, she began searching for a more personal style, experimenting in the early 1960s with a series of hard edged shrine paintings that embody female forms such as the egg.

[. . .]

Meanwhile the 1970 fall semester opened at Fresno State, and Chicago launched her pioneering art program for women. Her growing sense that dominant male structures and attitudes inhibited women from expressing their female perspective in art had led her to get Kusel's permission to conduct fulltime a separate course of study open to women alone. She and fifteen recruits would eventually seek and renovate an old off-campus site—"a space of our own," as she called it after Virginia Woolf's *A Room of One's Own*—to escape "the presence and hence the expectations of men" and to explore connections between women's history and visual work.[33]

For recruits, Chicago sought women determined to become artists who were "aware of themselves as women" and "able to be emotionally honest with themselves & others."[34] For the first two months Chicago focused on helping her students deal with "the ways in which their conditioning as 'women' prevented them from setting real life goals, from achieving, from acting on their own needs."[35] Nancy Youdelman remembers a lot of talk about sex, bad experiences, and how men took advantage of women. Other students, Chris Rush and Doris Bigger (aka Dori Atlantis), who describe themselves as "hicks from Fresno," remember that Chicago "was pretty confrontational with everybody."[36] At the term's first meeting, which was held off campus in the basement of a student's home, everybody was just chit-chatting when Judy "blew up" and rebuked them: "If you were a group of men artists, you'd be discussing your work. You'll have to change."[37] Rush describes the year in the program as "like a whirlwind—the most exciting of my life."[38]

[. . .]

By contrast, Vanalyne Green recalls, "As with some of the other women in the group, I believe that I suffered from post-traumatic shock syndrome for several years afterward. This is not to negate the great parts of the experience of working with Judy. I have often wondered if I would have found my way of out a provincial life in Fresno, California, without the experience of being in a year and a half of classes with Judy."[39]

Chicago's experimental pedagogy kept inviting comparisons with the consciousness-raising practiced in the women's movement—a group activity in which each participant "shares and bears witness to her own experience in a non-judgmental atmosphere. It is a political tool because it teaches women the commonality of their oppression and leads them to analyze its causes and effects."[40] Yet Chicago "didn't know about classical consciousness raising then" and prefers to describe her own practice as "going around the circle and including everyone, which is something I started doing when I first started teaching in the sixties, prior to the women's movement." For her, this carefully controlled activity is "connected to content search in terms of art-making," while it also enables each participant to be heard uninterrupted and to have her say. It became central to the work produced in the Fresno program. "I was really pushing those girls. I

was really demanding of them that they make rapid changes in personality. . . .
I gave the girls an environment in which they could grow."[41]

According to Vanalyne Green, "I want to think that such aggressive tactics
wouldn't have been necessary—the phrase 'personality reconstruction,' for
example, that Judy used to describe her pedagogy, resonates with my experience.
I called in sick one day, and Judy asked me what was wrong. I wasn't actually
sick at all; I was lying. I didn't want to go because I was so uncomfortable with
the class. She suggested that either one or the other students could bring some
food for me or that one of them could come and get me. Such tactics terrified
me, although now I see the reasoning. She was suggesting that we be accountable,
that we communicate rather than withdraw."[42]

Chicago devoted the third and fourth months of the school year to finding
and equipping a studio so that the students could literally isolate themselves from
the men and work in a female environment. [. . .] Once they settled on a cavernous
old theater at the intersection of Maple and Butler on the edge of town, the
students—dressed in their boots—began to transform it. During the week students
were expected to work in the studio from four to eight hours each day, besides
having individual conferences with Chicago. A group met on Mondays to read
novels by women as well as the "works of Ti-Grace Atkinson, Roxanne Dunbar,
Simone de Beauvoir, Anaïs Nin, and other women writers."[43] Chicago was "also
brilliant about historical context," recalls [Suzanne] Lacy. "The woman read inces-
santly. Whenever she wants to know about something, she sits down and plows
through scores of books."[44] In the reading group they focused on how the novels
served them in terms not only of literature but of their "personal struggle for
identity" and "an understanding of our history as women."[45]

[. . .]

The studio space—some five to six thousand square feet, Karen LeCocq
remembers—included a big kitchen where Wednesday-night dinners took place
and what they called the "rap room," with carpet samples glued to the floor and
varicolored pillows, where discussion kept on after meals.[46] The rap room could
make you feel both uneasy and at ease, report LeCocq. She recalled the experience
as "soul searching, gut wrenching, tumultuous, cleansing, exhausting, exhilarating"
and the space as "suffocating and uncomfortable one moment and nurturing and
comforting just a short time later."[47]

[. . .]

Chris Rush also felt intimidated by Judy, whom she recalls stressing both a
"commitment to art" and "pressure not to be too feminine, not to shave your
legs."[48] Another student, Jan Lester, agrees that the students in the Fresno
program dressed in work boots and coveralls and refrained from wearing makeup,
shaving their legs, or plucking their eyebrows. The situation was "something almost
cultlike . . . We had this sense that we were doing something important," adding,
"Judy made everyone in the program believe that they could do whatever they
wanted to do."[49]

[. . .]

In the months before they got the studio ready, nobody made much art, a student recalled, but they were encouraged to write autobiographies and derive images, using any medium they wished—drawing, painting, sculpture, mime, dance, performance—from their own experience, "e.g. being used sexually, walking down the street & being accosted, etc."[50] The experiment produced results that astonished its designer: when the women "talked about feeling invaded by men," Chicago reported, she had them "make images of those feelings. They brought this work to the class, and I nearly fainted. Everything was so direct. It was imagery that had to do with a whole area of female experience we had never talked about . . . like really feeling raped and violated and used and all that."[51]

That fall Chicago assigned a research project in art history. Each student was told to select a woman artist from history whom she would research and then act out in a performance. [. . .] The students began their research in the fall, several months before January 1971 when art historian Linda Nochlin's now classic article "Why Have There Been No Great Women Artists?" appeared in *ARTnews*, which some of the students recall reading.[52] [. . .] Already in December 1970 a few of Chicago's students performed for a graduate art seminar at the University of California at Berkeley. By then some of them were progressing, while others lagged.

The occasion prompted Chicago to articulate a programmatic point: "That night after the seminar I told them I wasn't going to relate to them on an emotional level anymore," she recounted to an interviewer. "I had begun to understand that it's very easy for girls to continually be involved with their feelings, and it's much harder for them to move over to a work ground."[53] She intended for the students to transfer their dependency from her to "the structure of the group itself," wanting "to build an environment for women to function in—not a hierarchy with me as leader. In fact, the whole point was to move away from that kind of structure."[54] If the group environment worked, it would benefit and sustain not only the students but her own artistic growth. "I wanted to do what no woman has ever done," Chicago wrote, "& that is to transcend my femaleness—to ascend to a level of *human* identity that women have been unable to reach because they are frozen into the roles of women as enumerated by a patriarchal social structure."[55]

[. . .]

The experiment with transferring responsibilities from teacher to students triggered insecurity, and Chicago found herself faced with unexpected and seemingly uncontrollable "crying jags, depressions, and self-deprecating remarks." When the laboratory seemed to spin out of control Chicago turned to Schapiro: "I just laid it all on her, everything that had happened that day and how terrible and how scary it was."[56] The resulting talk really helped, Chicago felt, and laid the groundwork for the ensuing "partnership" of the pair.

In November, Schapiro made a well-documented visit to Fresno, where she spoke to Chicago's students and observed the new program for herself. "Judy and I spent a lot of time talking about the problems of teaching. She was . . .

breaking down the role barriers between teacher and student." Schapiro was impressed by the students' performance pieces expressing their feelings, "their environmental works made out of autobiographical material," and their development of "new definitions of female iconography."[57]

[. . .]

For Schapiro the students put on a "rivalry play," written by Nancy Youdelman, in which "a glamorous hooker and the fat matron" confront each other violently at a bus stop, when the hooker drops cigarette ash in the matron's popcorn. [. . .] The players dressed fit-to-kill thanks to Youdelman's fascination with costumes—ever since high school she had collected Victorian clothes. She and Jan Lester had dressed up and posed for photographs, which won Chicago's encouragement. [. . .] Part of the Fresno program's big studio became the costume area, and costumed performances became routine.

[. . .]

Besides recourse to Schapiro and the dramatic therapy of the visit, Chicago addressed her students' tension with five assignments: "evaluate in writing the course and one's own growth in it; read Simone de Beauvoir's *The Second Sex* and relate this to one's own struggle; formulate goals for personal growth for the remainder of the year; decide on a work project for the coming month; and make a calendar of daily activities for that month."[58] Chicago then met with each student individually to discuss the assignments and repeated the meetings each month.

[. . .]

Trips to Los Angeles also ensued. Vanalyne Green recalls "an experience that completely opened me to becoming an artist. Judy took us on a field trip to the then Pasadena Museum of Art. I knew zilch about contemporary art, and stood in front of a Kenneth Noland painting, stymied and intimidated. I asked her to help me understand the painting. She told me to stand there and see how the painting made me feel. It was the beginning of my life as an artist and art lover (though the artist part took a long while to develop)."[59] Chicago's impact on her student's development was much greater than she realized at the time, as Green says: "Suddenly I realized that I didn't need critics or interpreters to comprehend art: I had my own sensate responses to form and color, and I could have a direct relationship with a work of art. This was a staggering realization. Pure liberation. You could hear the doors opening, and I was stone sober."[60]

Among the most memorable destinations was Miriam Schapiro's studio in Santa Monica. Faith Wilding drove her VW bus down from Fresno, packed with students. That night Jan Lester remembers that they visited the charming Spanish house where Schapiro and Brach lived. One of the students asked "'What's that wonderful smell?' It was the scent of orange blossoms, but Schapiro replied: 'money.'" This, Lester recalls, was "the moment when Schapiro suggested that Chicago bring the Feminist Art Program to CalArts."[61]

The story was not so simple. Chicago's husband had already been teaching at CalArts when Schapiro's husband, Paul Brach, the dean, asked her if she would

like to teach there too. Her reply—"Yes, but I would teach only women"—provoked his immediate refusal and the query, was she out of her mind? His wife's reports from Fresno and further reflection changed his mind. Chicago recalls that they decided to bring her program to CalArts, and "Mimi began preparing the way, talking to the deans and getting it accepted as an idea."[62] At some point, Chicago's initiative got the name that would prove historic: Feminist Art Program.

The ferment of the experiment in Fresno inspired Chicago, who with characteristic self-awareness determined to start her first journal—precisely on March 8, 1971—its first page headed in firm script, "*This book belongs to Judy Chicago*," along with the Kingsburg address. A second thought betrays itself in capitals printed above "Judy Chicago"—"COHEN"—the asterix referring down to a note: "*who changed her name but not her fundamental identity.*"[63] By then—little over a year after starting the new curriculum at Fresno—she was growing ever more aware that she had created a radical new departure that needed to be recorded and merited a place in history rather than women's usual fate of getting erased: "I want to begin to establish regular contact with the growth of the first Feminist Art ever attempted," she wrote in what could be the first documented use of the phrase.[64]

Chicago framed the experiment at Fresno and her own development in the wider cultural context, realizing that "the Women's Liberation Movement represented (for me) support to make overt all the feelings, beliefs, and ideas I had lived with covertly since the day I had begun to consciously make art and consciously to struggle with my conditioning as a woman in order to make art."[65] In that moment "it finally occurred to me that I could say what had been unsayable and do what had been undoable. I was going to try to come out of hiding into the bright light of the day and expose what it *really* was to be female in a society that held the female in contempt."[66]

[. . .]

Chicago's primal desire was "to build an environment *based* on my needs as a woman and as an artist." She explains, "My first step was to change my name—thereby seizing control of my identity and making it my own. My second step was to give several lectures in which I told of my struggle as an artist and the difficulties I had encountered because I am a woman." In one of these, delivered at California State College (Los Angeles) in early 1969, she had introduced metaphoric comparison with male combat, declaring that she was "preparing to go to war against the culture."[67]

[. . .]

The very success of the experiment with her students also created a dilemma that Chicago would feel ever more acutely in varying forms in the following years: the imperative to be in her studio making her own art and yet the want, commitment, and need to be with her students in the supportive environment of their collaborative work. She began to wonder where her primary loyalty was. "I keep feeling like I *should* be working. The idea that one's *whole life* is one's

work is very difficult to come to terms with."[68] Yet at the moment even her work owed something to the collective, for she was producing a series of collages based on "cunt" images that she felt were influenced by her student Faith Wilding's drawings. These eventually became a series of twenty-six alphabet collages, one for each letter, using the cunt form—entered as a landmark in the journal: "It's a breakthrough for me to move from cunt as subject to cunt as formal device."[69] Wilding has recalled that her "cunt art" began when they tried to "analyze, confront, and articulate our common social experiences; it was not a set of predetermined images based on essentialist notions about women's sexuality."[70] (See Plate 2.)

[. . .]

Both Chicago and the collective took encouragement from the other artists and feminist writers who came to Fresno to speak or perform. Roxanne Dunbar, who came on March 22, was touring college campuses, speaking about "women's liberation, capitalist exploitation, racism, the Vietnam War, other national liberation movements, and the necessity for revolution."[71]

Feminist writer Ti-Grace Atkinson followed Dunbar by two days. Suzanne Lacy recalls that she recruited four women (Doris Bigger, Cay Lang, Vanalyne Green, and Susan Bond), who dressed as cheerleaders in pink—similar to one of their earlier performances spoofing themselves—with letters across their chests spelling "C-U-N-T." "Off the plane came forty or so Shriners as we were screaming, 'Give us a C, give us a U,'" recalls Lacy. "Ti-Grace Atkinson stood there sort of bemused while we were performing madly for her. It was quite a night."[72]

At the all-women party after the talk, the feisty, diminutive hostess took issue with the statuesque guest, in a clash of proportions epic enough to merit space in the new journal—"a ferocious argument which ended in my telling her to fuck off. I do, of course, deeply respect her. She is a strong, courageous woman. . . . Nonetheless she made me furious. She put us all down & came on with a holier-than-thou number."[73] Core dissent in regard to men contributed to the tiff. Lacy remembers that Atkinson was "very down on men," while "Judy has never been down on men; she has seen feminism as a two-gendered activity. Most of us had made choices to lives with a man."[74]

[. . .]

At about this time too Chicago completed her *Cock and Cunt Play*, in which two women wear outlandish costumes designed to personify a giant Cunt and a colossal Cock, both sewn in pink vinyl by Shawnee Wollenman.[75] In the film Faith Wilding dons the Cock costume and Jan Lester the Cunt. Chicago continued work on her *Cunt Alphabet* collages and some abstract paintings on plastic, even though Lloyd told her he thought abstract art was "counter-revolutionary." She was not yet dissuaded, not yet able, in her own words, to "'transcend' the cunt."[76] (See Plate 3.)

Chicago used this same language in a letter to the admissions committee at CalArts, justifying the need for the school to accept a critical mass of her students

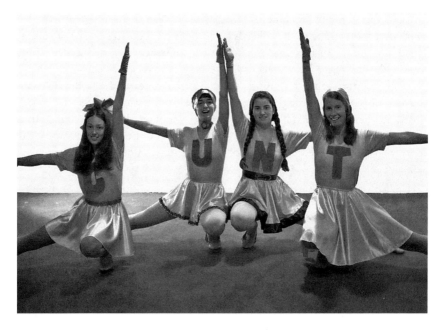

FIGURE 1.1 *Cunt Cheerleaders* (1971). L–R: Cay Lang, Vanalyne Green, Dori Atlantis, Sue Boud. Photograph by Dori Atlantis. Reprinted with permission of Nancy Youdelman and Dori Atlantis.

from Fresno: "We all have to begin together . . . We must unearth the buried and half-hidden treasures of our cunts and bring them into the light and let them shine and dazzle and become Art."[77] She went on: "With Miriam Schapiro as my partner, I am going to bring down the program for women that I began this year at Fresno State College. I went away from Los Angeles to start this program because I was afraid that no one in Los Angeles would give me a chance to do what I wanted to do, i.e., to begin to build an environment in which women could feel free to make the art that derives from their beings."[78]

To justify bringing her students from Fresno into the program at CalArts, Chicago documented some of her results: "To go on with what we have begun, we have to bring all of our beginnings with us. We cannot afford to let go of anything we have begun—not of our work in the studio, not of our films, or our tapes, not of our studies of women writers, nor of that starting of a Female Art History, and most of all we cannot let go of each other. For we are the beginning of a new world, a world in which women can be together and be themselves and let themselves be seen in the world."[79]

[. . .]

As the first year of what had come to be called the Feminist Art Program was winding down, Judith Dancoff . . . together with Chicago, Schapiro, and the students, worked up a special issue of the newspaper, *Everywoman*. Chicago

explained her willingness to experiment in so many areas: she credited "the women's movement—new options were opened so that I could actually think about using my talent in a variety of ways which had simply not been possible before."[80] To the movement she had already given credit as a supportive context in which to realize herself, and about the Fresno experiment, she would reflect, "I became aware of the women's liberation movement, and I immediately understood what that meant . . . I realized that I could actually begin to put out all this information I had about my own struggle, my own perceptions, and I also understood that the structure as it existed in the art world and the world as a whole had no provisions for that kind of information."[81]

In mid-April the program staged a Rap Weekend, inviting visitors to observe the work produced. Chicago expressed anxiety lest the women who came might think less than well of what had been achieved in the course of a year. In the end Chicago judged the Rap Weekend very stimulating but "exhausting." [. . .] On display was Faith Wilding's environment, which she had made by "creating a life sized figure of herself dressed as a bride with her midsection cut open with cow guts spilling out. With each showing of the piece, she had to go back to the slaughterhouse and obtain fresh cow guts. Another feature of her environment was the bloody Kotexes that trimmed the walls at ceiling height."[82] There followed plays, films, slides, and art history testimony that "resurrected women artists from the past & let them tell their stories," along with a history lecture on women artists.

Afterward came informal raps—brief discussions—then dinner, followed by a performance by Vicki Hall, who had recently received her B.A. and M.A. in sculpture from UCLA and was teaching introductory sculpture at Fresno. Chicago recalls that Hall "cast penises and applied them to the women performers, then had them all lift their operating gowns (it involved medical procedures). I thought the audience was going to have a collective heart attack."[83] About two hundred people were there.

"At the time I was in Fresno I didn't know much about feminism," says Hall, "but the idea of protesting my treatment at UCLA really appealed to me, and from there I came up with various performances and installations that explored, among other things, women's victimization. . . ."[84] "I am sure," she adds, "the question about women's position, which was something that had always bothered me, was more on my mind because of Judy and the Feminist Art Program." [. . .]

On balance, the enthusiasm of the spectators—mainly other women artists—and the aesthetic accomplishments of the students pleased Chicago, who understood that the theatrics were not meant to be formal theater but rather a mingling of "live action & performance with films, slides voices, taped voices, sounds, music, light."[85] The results reaffirmed her program to "recreate women from the Past whose lives have been distorted by men's history books. I want women from all ages to mingle on the stage, telling their stories, comforting each other."[86]

Chicago concluded that "the really exciting part of this is over for me. I have done what I set out to do. I have begun the structure whereby women's work will finally be able to reveal in itself & women will be able to assume their rightful place. It's real now—I don't doubt it any more. From now on, I hope that it will grow quickly. Several women at the weekend were turned on to starting classes for women. I was only 1 person in the Fall, there are probably 12 or 15 of us now."[87]

Moving some of the students to CalArts while leaving others behind was proving problematic. Although Chicago considered some of those left behind less serious about their work, she made an effort to train her successor at Fresno, Rita Yokoi. While meeting with those who would remain, Chicago admitted to being tired of dealing with everyone's emotional problems. One student had become intimately involved with at least two of the male professors in the art department—exactly the kind of behavior that Chicago had hoped to prevent when she created the program.[88] She wanted her students to become artists themselves instead of falling into the more typical roles of wives or mistresses for the male artists. Schapiro advised her to "de-escalate," and she told herself that she had to do so now. She wrote in her journal: "GRRRRRRRR! It is both a privilege & a pain in the ass to have been born a woman at this time in History—a privilege because we may change History—a pain in the ass because I'd like to be *FREE*!"

[. . .]

Chicago had already begun to plan with some of her students the "structure for artmaking next year" and "begun to implement it. I & the girls have begun the creation of 25–30 female characters, either from history or representative of fantasy images of women. We *will* prepare costumes, characterizations, & testimony for each one, & then let them mingle in an environment of high level emotional intensity." She had in mind to stage "the trial of Joan of Arc with a jury of her peers—i.e. women from all times in history."[89] She saw this leading "not only to theater but to films, books, slide images, photo pieces, etc. That part of my work is going well. I love it. I've found myself."[90]

[. . .]

In the meantime Chicago planned a trip to New York, where she would meet Schapiro and they would spend time together with "the radical women" and go see a show of women artists organized by Lucy Lippard, now an established critic, whom Chicago had known since her stay in New York in 1959.[91]

On their last day in New York, Chicago, Schapiro, Lippard, and sculptor Jackie Winsor went with Grace Glueck, an art reporter for *The New York Times*, to see a show organized by Lippard at the Aldrich Museum of Contemporary Art in Ridgefield, Connecticut of twenty-six New York women who had never been shown before. After her write-up of the Aldrich show, Glueck, who claimed that she saw "unmistakable gynecological references" in some of the "biomorphic abstractions," gave the Feminist Art Program its first mainstream publicity in the

East: "Meanwhile, back to the Misses Schapiro and Chicago (a show of work by the former has just closed at the André Emmerich Gallery here). Both teach at the big Disney-backed California Institute of the Arts in Valencia; both are pioneering in a brand-new art endeavor titled—brace yourself—Feminist Art Program." Her article continued: "The program, which *has* to be the world's first, deals with women artists' 'reality as women,' says Miss Schapiro, who is married to Paul Brach, painter and dean of the art school. Designed to provide a framework for the understanding of women's art, it will involve such disciplines as art history, art criticism, art making and art education." Glueck went on to highlight issues raised by the new program: "'We've been asked why we want to start a ghetto,' says Judy Chicago, a sculptor married to a sculptor, Lloyd Hamrol. 'But we're not interested in "high" art, built on male tradition. It's the beginning of education for women, by women, about women. We'd like, in fact, to take over women's colleges and blast their male structures.'"[92] Glueck went on to describe how the two artists worked with students on research for women's art history, quoting Schapiro that she and Chicago had gotten so far into it that they would have opened up an office someplace else had CalArts not come through with funding for their program.

The day and entire sojourn closed with a cocktail party at Whitney curator Marcia Tucker's loft, where Chicago was pleased to learn Tucker would be starting a small program for women artists at the School of Visual Arts in New York the next fall. She was hopeful that such programs would "pop up everywhere."[93] There were already other links between Chicago's feminist activities and those taking place in New York. With Lippard she had organized the W.E.B. (West-East Bag), "an information network for women in the art world," with branches in a number of cities and slide registries on the work of women artists in New York, L.A., and San Francisco.[94]

[. . .]

Perhaps it was age, but Chicago was growing ever more aware of "the limits of existence": "My femaleness is every day being revealed to me as a scar on my humanity in the sense that until the ideas of 'masculine' & 'feminine' are wiped out of our consciousness there is no possibility to be free. The constant resistance, antipathy, hostility, which erupts against every action of ours sometimes becomes overwhelming. It is as if the whole society is bent upon preventing women from gaining their rightful place in the world."[95]

Uneasy insight fueled resolve to renew her quest for a path of her own forged by experimenting with her female collaborators and not dictated by men in advance, at whatever risk: "I understand that for women to be truly free would mean the total restructuring of the society so as to enfranchise the half of the world that remains disenfranchised. [. . .] If I make art like I used to I will be merely going around & around about the nature of female identity. If I ignore that issue or put it aside I could make Art qua Art as men have defined it, e.g. dealing with ideas, the nature of materials, etc. & that really is not interesting to

me."[96] As a way out, she saw that she needed to "pursue the path I have begun this year—to make Art out of it. In doing that, we will at least feel at peace while we work, but we will alienate many people who, at first, supported us, for ideas about women reach to the deepest level of the psyche & produce irrational responses. There is no where to go but on, but I am afraid."[97]

As before, Chicago gave combat to fear by way of intellectual growth. She was reading deeper into the work of Simone de Beauvoir, whose work she initially had not liked. She concluded: "the battle to become visible is indeed what it's all about. We seem to attract attention when we dispute our role, because then we're in dialogue tacitly with men, but we're invisible when we deal with our own reality & address other women. Oh, to be free of the implications of my body form!"[98]

[. . .] Themes raised in the Rap Room had given her a glimmer of what she wanted to do in her own future paintings: "images that would be angry, painful, speaking of brutalization & invasion & destruction of self." She expected to draw upon those feelings in the next year's female collective and then make images out of them.[99]

[. . .]

Back in L.A., Chicago and Schapiro found themselves overwhelmed when some sixty women out of the total two hundred on campus turned up to apply for the Feminist Art Program at CalArts in the fall. Later Brach telephoned and screamed at Chicago, under pressure from other faculty who felt threatened by women wanting power at the school. What the women wanted was control of admissions to their own program and some help learning to use some of the available equipment "without being put down." They also requested a female film crew in the film department, "a couple of workshops in critical studies" to accompany their program, and a sector directed by Sheila de Bretteville in the design department.[100] CalArts was divided about the new program, with some faculty and students supporting it and others hating the very idea, but everyone was talking about it.

After this tussle Chicago returned to the Fresno studio for the students' final program. They had felt tremendous pressure because people from CalArts would attend. At dinner with the core group that was going on to CalArts, they faced the fact that the following fall they would no longer be able to function independently and do whatever they wanted as they had in Fresno. Now, with the program expanded, there would be a professional art historian, a designer, and others to deal with. As Chicago looked ahead, she sighed and told herself: "But we'll never have this year again, unfortunately."[101]

The final program, held on a Saturday night, drew about 150 men and women, including Allan Kaprow, John Baldessari, and others from CalArts. The students placed their art on exhibit, with environments by Wilding and LeCocq. Jan Lester recalls that she made a "very outré soft sculpture of a woman in a horrible shade

of pink. Her vagina was red velvet. Her face was an oval mirror, meant to suggest that men wanted sex as a reflection of themselves. It was rude, crude and sexually graceless. Baldessari came up and stuck his cowboy boot into her vagina."[102]

Also in the audience was Paula Harper, then a graduate student in art history at Stanford, who would eventually be hired as the art historian for their program at CalArts. The students' performances included the "C-U-N-T" cheerleading, which Harper recalls as "so hilarious, so bold, so funny . . . to me it was irresistible." The students then handed out "Friend of the Cunt Kisses:" to those men "who had supported us at Fresno State & at CalArts."[103] [. . .]

They did performance pieces, including Chicago's *Cock and Cunt Play* and the *Rivalry Play*, now amplified with a longer fight sequence before the final mutual murder. More mayhem ensued with a *Slaughterhouse* piece that "ended with Faith being strung up like a cow & covered with blood, then the last image was a slide superimposed on her body," with accompaniment by Chicago's voice, which became "the instrument of my rage."[104] The audience clapped and cheered.

Chicago was amazed at how rapt the audience was throughout the forty-five-minute art history lecture. She had previously received criticism that their art history of women had errors and was unprofessional. But having relied upon the information collected by the students in just a few months, she was proud that they finally had a "female art history" and confident that it could be perfected later on.

A performance piece by Vicki Hall was last and the most provocative, eliciting both praise and criticism from the audience and participants. Judy and Lloyd were in it, but Mimi and Paul declined to take part. Hall's idea was to have six males and six females of authority, who would, for the duration of the piece, relinquish their authority. Participants were tied up and blindfolded and had their mouths taped. They were then touched, kissed, or pinched. The idea was evidently to break down the barriers of the theater and give sensuous pleasure to the participants, but some of the gestures, perhaps inflected by latent hostility, began to look like sadism to the disturbed audience. Hall says that this was not her intention and that her basic concept was about "initiation and the barriers or prohibitions to touch, to experience and to act." Chicago was glad in the end that the piece really "struck nerve endings" that the other pieces did not.[105]

[. . .]

Harper recalls that she especially liked Chicago, appreciated her directness— "you never wondered what was really on her mind. She was brilliant, funny, fast, good-humored, temperamental, warm." She felt that Schapiro was "energized" by Chicago, who looked to Schapiro as having "made it in the art world."[106]

[. . .]

Hints of deeper and contrary currents would be set aside, deferred, so high were the expectations and hopes.

Notes

1 Heinz Kusel, *Heinz Kusel Between Experience and Reflection: The Story of a Painter as Told to Thomas Kusel* (Auburn, Calif.: Destiny, 2004), 297.
2 Oliver Andrews, "Los Angeles Art Community: Group Portrait." Interview by George M. Goodwin. Oral History Program Transcript, 82. UCLA, 1977. He referred to her by the name Judy Chicago. Her first surviving résumés, however, list "California State University (1969–1971)," JCCSL, Box 1, Folder 2; she again listed it on an early résumé as, "Fresno State College, Asst. Professor 1969–71," JCCSL, Box 16, Folder 8, for the Guggenheim grant application. Chicago may have believed that she had started in Fresno in the fall of 1969 (as on her CV for the "Lively Word" speakers' bureau, on which she listed "1969 Married Lloyd Hamrol. Became assistant professor at Fresno State College [until 1971]. Performed her first *Atmospheres*"). She may also have decided that starting her job in the fall of 1969 made her look better. This is also the date in the catalog Judy Chicago and Dextra Frankel, "Invisible Twenty-One Artists Visible," in Twenty-One Artists—Invisible/Visible (Long Beach, Calif.: Long Beach Museum of Art, 1972), 22. It may be that she wanted to indicate concisely that she had taught in Fresno for more than one school year.
3 Kusel, *Heinz Kusel*, 32.
4 Judy Chicago and Judith Dancoff, "Judy Chicago Interviewed by Judith Dancoff," *Everywoman* 2, no. 7, issue 18 (7 May 1971), 4.
5 Judy Chicago, *Through the Flower: My Struggle as a Woman Artist* (New York: Penguin Books, 1975), 59.
6 Valerie Solanas, *Scum Manifesto* (New York: Olympia Press, 1968), excerpted in *Feminism-Art-Theory: An Anthology, 1968–2000*, ed. Hilary Robinson (Oxford: Blackwell Publishers, 2001), 12.
7 Judy Chicago, "Two Artists, Two Attitudes: Judy Chicago and Lloyd Hamrol Interview Each Other," *Criteria: A Review of the Arts* 1, no. 2 (November 1974), 9.
8 Ibid.
9 Judy Chicago, "Judy Chicago Talking to Lucy Lippard," *Artforum* 13, no. 1 (September 1974), 60.
10 Nancy Youdelman to author, 6 December 2005. Youdelman recalls Faith Wilding (who was there) saying that there were hecklers—guys who were threatened and became angry and vocal. Youdelman is now a sculptor; Wilding is a performance artist.
11 Judy Chicago, "Interview by Hazel Slawson," typescript (c. 1972), 3, JCCSL.
12 Judy Chicago, *Personal Journal*, vol. 1, 3.
13 Vanalyne Green to author, 10 December 2005. Laurel Klick to author, 8 February 2006.
14 May Cohen to Pearl Cassman, 19 May 1970, JCCSL.
15 Chicago, *Through the Flower*, 62–63.
16 May Cohen to Pearl Cassman, 5 November 1970, JCCSL.
17 This ad appeared in *Artforum* 9, no. 2 (October 1970), 20.
18 Boxing photo ad, *Artforum* 9, no. 4 (December 1970), 36.
19 Judy Chicago quoted in Jonathan Kirsch, "The Flowering of the Artist," *Coast* 16, no. 6 (June 1975), 37. JCCSL, Box 1, Folder 42.
20 William Wilson, "Judy Chicago Exhibition at Cal State Fullerton Gallery," *Los Angeles Times*, 2 November 1970, pt. 4.
21 Ibid.
22 Gerda Lerner, *The Grimké Sisters from South Carolina: Pioneers for Women's Rights and Abolition* (New York: Shocken Books, 1971), 193, 161–62; see also Sara Evans, *Personal Politics: The Roots of Women's Liberation in the Civil Rights Movement and the New Left* (New York: Alfred A. Knopf, 1979), 26.
23 Shulamith Firestone, *The Dialectic of Sex: The Case for Feminist Revolution* (New York: William Morrow & Co., 1970), 29.

24 Thomas H. Garver, "Judy Chicago, Art Gallery, California State College, Fullerton," *Artforum* 9, no. 5 (January 1971), 92.
25 Ibid., 92–93.
26 Ibid., 93.
27 Judy Chicago to Phil Leider, n.d., January 1971, published March 1971, JCCSL, Box 9, Folder 8.
28 Ibid.
29 Ibid.
30 Chicago, *Through the Flower*, 64.
31 Ibid., 56.
32 Miriam Schapiro, conversation with author, July 1997.
33 Chicago, *Through the Flower*, 70–92; Judy Chicago, *Beyond the Flower: The Autobiography of a Feminist Artist* (New York: Penguin, 1996), 23.
34 Chicago, *Personal Journal*, vol. 1, 3.
35 Chicago, *Personal Journal*, vol. 1, 4.
36 Dori Atlantis and Chris Rush to author, 1 April 2004.
37 Ibid.
38 Chris Rush to author, 1 April 2004.
39 Vanalyne Green to author, 19 December 2005.
40 Faith Wilding, *By Our Own Hands: The Woman Artist's Movement in Southern California, 1970–1976* (Santa Monica, Calif.: Double X, 1977), 10.
41 Judy Chicago to author, 25 July 2005. Chicago, "Chicago Interviewed by Slawson," 8–9.
42 Vanalyne Green to author, 19 December 2005.
43 Susan Stocking, "Through the Looking Glass with Judy Chicago," *Los Angeles Times*, 9 July 1972, 44. JCCSL, Box 1, Folder 39.
44 Chicago, "Chicago Interviewed by Slawson," 17.
45 Chicago, *Personal Journal*, vol. 1, 7.
46 Karen LeCocq, *The Easiest Thing to Remember: My Life as an Artist, a Feminist, and a Manic Depressive* (Bloomington, Ind.: 1st Books, 2002), 54.
47 LeCocq, *Easiest Thing*, 62.
48 Chris Rush to author, 1 April 2004.
49 Jan Lester Martin to author, 7 April 2004.
50 Unidentified "Tape of a Conversation with Judy Chicago," JCCSL.
51 Ibid.
52 Linda Nochlin, "Why Have There Been No Great Women Artists?" *ARTnews* 69, no. 9 (January 1971), 23–39+. See Faith Wilding, "Women Artists and Female Imagery," *Everywoman* 2, no. 7 (7 May 1971), 18. Wilding notes that their research on women artists began "from the beginning of the [school] year."
53 Chicago, "Chicago Interviewed by Slawson," 15–16.
54 Chicago, *Personal Journal*, vol. 1, 4.
55 Ibid., 5.
56 Chicago, "Chicago Interviewed by Slawson," 13.
57 Miriam Schapiro, "Miriam Schapiro Interviewed by Judith Dancoff," *Everywoman* 2, no. 7, issue 18 (7 May 1971): 3. Chicago, "Chicago Interviewed by Slawson," 14.
58 Chicago, *Personal Journal*, vol. 1, 6–7.
59 Vanalyne Green to author, 19 December 2005.
60 Ibid.
61 Jan Lester Martin to author, 7 April 2004.
62 Chicago, "Chicago Interviewed by Slawson," 15.
63 Chicago, *Personal Journal*, vol. 1, 8 March 1971, 1.
64 Chicago, *Personal Journal*, vol. 1, 8 March 1971, 1. Historians have not yet identified who first used this phrase. Instead, Hilary Robinson postdated Chicago's article in

the Feminist Art Program's issue of *Everywoman* 7 from the spring of 1971 to 1972, making it seem a year later than it actually was. Hilary Robinson, *Feminism-Art-Theory: An Anthology, 1968–2000*, 294.

65 Chicago, *Personal Journal*, vol. 1, 8 March 1971, 2.
66 Ibid.
67 Chicago, "Chicago Interviewed by Slawson," 2.
68 Chicago, *Personal Journal*, vol. 1, 13 March 1971, 12.
69 Ibid., 22 March 1971, 15.
70 Faith Wilding, "The Feminist Art Programs at Fresno and CalArts, 1970–75," in *The Power of Feminist Art*, ed. Norma Broude and Marry Garrard (New York: Harry N. Abrams, 1994), 36.
71 Roxanne Dunbar-Ortiz, *Outlaw Woman: A Memoir of the War Years, 1960–1975* (San Francisco: City Lights, 2001), 317.
72 Nancy Youdelman to author, 6 April 2004. Cay Lang to author, 22 June 2006. Lang is now a photographer. Lacy, "Interviewed by Moira Roth," tape 1, side A.
73 Chicago, *Personal Journal*, vol. 1, 24 March 1971, 17.
74 Ibid. Suzanne Lacy to author, 9 January 2004.
75 Shawnee Wollenman Johnson to author, 29 July 2006.
76 Chicago, *Personal Journal*, vol. 1, 24 March 1971, 18–19.
77 Judy Chicago to the Admissions Committee (California Institute of the Arts), 27 March 1971, JCCSL, Box 11, Folder 17.
78 Ibid.
79 Ibid.
80 Judy Chicago and Ruth Iskin, "Judy Chicago in Conversation with Ruth Iskin," *Visual Dialog* 2, no. 3 (May 1977), 14.
81 Judy Chicago and Judith Dancoff, "Judy Chicago Interviewed by Judith Dancoff," *Everyowoman* 2, no. 7, issue 18 (7 May 1971), 4.
82 LeCocq, *Easiest Thing*, 59–60.
83 Chicago to author, 21 December 2005.
84 Vicki Hall to author, 16 November 2005. The following references are also from this date.
85 Chicago, *Personal Journal*, vol. 1, 53.
86 Ibid.
87 Ibid., 54.
88 Author interviewed this student, who wishes to remain anonymous.
89 Chicago, *Personal Journal*, vol. 1, 26 April 1971, 57–58.
90 Ibid.
91 Lucy R. Lippard, *Eva Hesse* (New York: New York University Press, 1976).
92 Grace Glueck, "The Ladies Flex Their Brushes," *New York Times*, 30 May 1971, D20.
93 Chicago, *Personal Journal*, vol. 1, 11 May 1971, 81.
94 Grace Glueck, "No More Raw Eggs at the Whitney?" *New York Times*, 13 February 1972, D21.
95 Chicago, *Personal Journal*, vol. 1, 13 May 1971, 84–85.
96 Ibid., 13 May 1971, 85.
97 Ibid.
98 Ibid., 13 May 1971, 86.
99 Ibid., 18 May 1971, 92.
100 Ibid., 27 May 1971, 98–99.
101 Ibid., 28 May 1971, 101.
102 Jan Lester Martin to author, 7 April 2004.
103 Paula Harper to author, 30 January 2004.
104 Chicago, *Personal Journal*, vol. 1, 1 June 1974, 104.
105 Ibid., 1 June 1971, 106–09. Vicki Hall to author, 7 December 2005.
106 Paula Harper to author, 20 January 2004.

2

COLLABORATION AND CONFLICT IN THE FRESNO FEMINIST ART PROGRAM

An Experiment in Feminist Pedagogy

Laura Meyer with Faith Wilding

The first university-level art class designed to establish and enact feminist pedagogical principles was founded in 1970 at Fresno State College (now University), in California's San Joaquin Valley. Working under the direction of visiting artist Judy Chicago, fifteen female students pooled their resources to rent and refurbish an off-campus studio space in downtown Fresno, where they could make and discuss their work "without male interference." In spring 1971 the class became a full-time fifteen-unit program, with participants spending most of their time together, frequently collaborating on artwork, taking turns leading reading groups and critiques, and even preparing and eating their meals in the feminist studio.

The Fresno Feminist Art Program (FAP) made a radical departure from traditional art pedagogy. Instead of pursuing assignments in a specified medium, such as oil painting or metal sculpture, students created artwork organized around a given concept or social issue. Performance artist and program alumna Faith Wilding recalls that ideas for class projects were often generated during group discussions organized along the lines of feminist consciousness-raising:

> The procedure was to "go around the room" and hear each woman speak from her personal experience about a key topic such as work, money, ambition, sexuality, parents, power, clothing, body image, or violence. As each woman spoke it became apparent that what had seemed to be purely "personal" experiences were actually shared by all the other women; we were discovering a common oppression based on our gender, which was defining our roles and [sense of] identity as women.

Thus the unspoken curriculum of the program was "learning to contend with manifestations of power: female, male, political, and social."[1]

The studio that housed the Fresno Feminist Art Program was the first in a historic lineage of California feminist art spaces: *Womanhouse*, Womanspace, the Woman's Building, and the Feminist Studio Workshop. In contrast to feminist activism aimed at achieving more equitable representation of women in existing art institutions, the Fresno FAP and its successors strategically circumvented the centers of power. It seemed necessary, at least temporarily, to shut out the received wisdom of traditional male power to allow women to hear themselves, and each other, speak. As Wilding put it:

> By taking ownership of the studio we demonstrated in real life Virginia Woolf's dictum that in order to be artists, women need to claim a space in which to think and work, locking the door against the domestic demands of the home and the patriarchal precepts of the university.[2]

In staking out a separate physical space, the Fresno FAP also laid claim to intellectual, emotional, and creative space for women.

It is important, now that a new generation of art historians is engaged in writing the history of the 1970s feminist art movement, to make sure that the significance of the Fresno FAP as one of the earliest experimental testing grounds for feminist collaboration is established. Many art history textbooks currently trace the beginnings of feminist art pedagogy and an organized feminist art movement to the Feminist Art Program founded at the California Institute of the Arts (CalArts) in 1971 and, especially, the month-long exhibition of *Womanhouse* (1972), a widely-publicized installation created by the CalArts group.[3] But the pedagogical principles that drove the CalArts FAP and *Womanhouse*—i.e. conceptualizing and producing artwork collectively, and developing "female" imagery and production techniques to communicate female content, were established in Fresno by trial and error during the first year of the Fresno FAP. At the end of that year, Chicago relocated to CalArts and co-founded a new feminist program there with Miriam Schapiro. Ten of the fifteen original Fresno FAP students applied and were accepted at CalArts, bringing the Fresno FAP's working methods with them. The production and display of *Womanhouse* marked the public culmination of the Fresno FAP as much as it did the beginning of the program at CalArts.

The collaborative structure of the Fresno FAP was far from harmoniously democratic. As much as Chicago pushed the FAP students to take responsibility for teaching—and learning from—each other, she also demanded recognition of her ultimate authority. Video artist and program alumna Vanalyne Green illustrates this contradiction with a memory of Chicago's response when she hung a painting at an unorthodox angle:

> Judy yelled, "It doesn't go that way." This was the paradox: to foster autonomy but under a particular set of terms. I was bewildered: if we were being allowed the freedom to learn in a progressive environment, why was Judy telling me how to hang my painting?[4]

Not only was there a power differential between teacher and students, power struggles also emerged among students. Group discussions in the studio "rap room" could be revelatory, but they could also turn into charged confrontations, with one or more members of the group criticizing another's attitudes or behavior. Sculptor and program alumna Karen LeCocq recalls:

> I was always a little afraid as I entered this room. It meant that I was about to be confronted on something that was too uncomfortable to talk about or I would have to witness someone else's discomfort . . . We experienced . . . soul searching, gut wrenching, tumultuous, cleansing, exhausting, exhilarating, and enlightening times in that one small room. It was a tiny, intimate space that was suffocating and uncomfortable one moment and nurturing and comforting just a short time later.[5]

Chicago actively encouraged confrontation, justifying it as a path to growth: "I was really pushing those girls. I was really demanding of them that they make rapid changes in personality . . . I gave the girls an environment in which they could grow."[6] Yet the students at times found Chicago's experimental methods wanting and unnecessarily painful. Thus, emphasizing the collaborative under-pinnings of the pedagogical and artistic principles worked out in the Fresno FAP means appreciating the successes, but also the costs of forging radically new, feminist modes of representation in the 1970s.

I highlight here two main pedagogical/art-making strategies developed in the Fresno FAP:

1. the quest for new kinds of female body imagery, or so-called cunt art; and
2. the use of unorthodox "female" media including costume, performance, and video.

Both became key strategies in the feminist art movement of the 1970s, and both came under heavy fire in the 1980s from critics who argued that they reinforced an essentialist view of women. I counter-argue here that these strategies were central to the collaborative basis of feminist pedagogy and activism and that they provided—and continue to provide—a valuable means of engaging multiple perspectives on women's widely varied bodily and social experience, affect, and thought.

A Studio of Their Own

Judy Chicago arrived at Fresno State in spring 1970 as a sabbatical replacement for tenured professor Joyce Aiken.[7] That spring she taught an innovative course on site-specific sculpture; then, for fall 1970, she proposed something even more radical. With the blessing of Art Department Chair Heinz Kusel, who deserves

credit for his willingness to encourage experimentation, Chicago initiated an all-women's class that would meet off-campus, at a spatial and ideological distance from the rest of the Art Department. Admission to the class was subject to permission from the instructor, who grilled interested applicants about their artistic ambitions and attitudes toward traditional sex roles. As students were accepted into the class, they were invited to participate in interviewing the remaining candidates. Ultimately, fourteen students joined the class first semester: Dori Atlantis, Susan Boud, Gail Escola, Vanalyne Green, Suzanne Lacy, Cay Lang, Jan Lester, Chris Rush, Judy Schaefer, Henrietta Sparkman, Faith Wilding, Shawnee Wollenman, Nancy Youdelman, and Cheryl Zurilgen. Karen LeCocq joined the following semester, in spring 1971.

Several of the founding members of the women's class, including graduate students Faith Wilding and Suzanne Lacy, were seasoned community organizers with considerable knowledge of Marxist and feminist theory. Wilding was a long-time member of Students for a Democratic Society (SDS), who had counseled young men, often minorities, on resisting the draft during her undergraduate years at the University of Iowa. Lacy had learned the non-violent resistance tactics practiced by the United Farm Workers movement in California. After earning a BA degree in zoology and chemistry at the University of California, Santa Barbara, she worked with Volunteers in Service to America (VISTA) inner-city poverty programs in 1968 and 1969 in Washington, DC. During her stint in VISTA, Lacy also met feminist organizers who introduced her to feminism and the politics of women's liberation. Together, Wilding and Lacy had organized a feminist consciousness-raising (CR) group on campus in 1969, using the CR rules published in *Notes from the Second Year*.[8]

Wilding recalls that conditions at Fresno State were auspicious for change:

> Our timing was obviously right because soon fifty eager women were meeting regularly in each other's homes, and openly discussing such intimate matters as sex and orgasm, feelings about our mothers, our resentments about men, our insecurities as students or faculty wives, and our dissatisfaction with our educations. The success of the CR group, and the obvious interest in feminist issues and student-initiated education (a crucial legacy of the US student movement) spurred me to propose a course, "The Second Sex: On Women's Liberation," to the Experimental College for the spring of 1970. When the course—along with most others with any political content—was banned as part of the first crackdown on the Experimental College and the English Department by the Fresno State administration, we reorganized it as a student activity in the Student Union.[9] By the time Judy Chicago arrived on the Fresno campus in the spring semester of 1970, there was [already] a group of women at the College actively working towards a women's studies department.[10]

Many Fresno State students had little experience of the world beyond the San Joaquin Valley, a largely rural, working-class region far removed from the cultural centers of Los Angeles and San Francisco. Yet widespread social activism in the 1960s had already begun to transform campus life. Founded as a teacher training and agricultural college, Fresno State had expanded rapidly during the early 1960s and, as Wilding observes,

> by 1969, was showing the full effects of the civil rights, student, and anti-war movements that had burned like wild-fire through the California state college and university campuses. The Fresno State Experimental College had been founded in 1966 in response to external and internal demands for a more relevant and contemporary curriculum. It stressed innovation and accepted proposals from both faculty and students. Courses were open to all students regardless of major or academic standing. Faculty and students pioneered many courses in black and Chicano studies, social and political movements, alternative psychology, ethnic studies, and women's studies.[11]

Teacher and FAP alumna Chris Rush remembers her interview for the feminist class, capturing the mixture of personal naïveté and social upheaval that characterized many students' lives at the time:

> That day of the interview, we were having an anti-war strike with bomb scares and tear-gas filling the hallways. It was scary and exciting. Dori and I were in the hallway together waiting to be interviewed by Judy, Faith, and Cherie. I went in first and told them about how much I hated my father and about my horrible sex life. They really responded positively to that and asked a lot of questions—seeming kind of tough and intimidating. I told Dori to do the same thing. She also got accepted.[12]

The "women's class" began meeting in fall 1970 in the homes of the students; soon, however, the group determined to find a studio space, and this became the first major class project. Wilding recalls:

> Finding that space, learning to deal with realtors, and figuring out how to fund and renovate the building proved a highly instructive aspect of our venture. In October, we signed a 7-month lease for the old Fresno Community Theater, a defunct WWII barracks. It was in a derelict part of town across from the adult movie theatre and miles from the college—but a place of freedom, a space of our own. Each student paid the (at that time quite considerable) sum of $25 a month toward rent, tools, and expenses.
> We set to work to make it a professional art studio, with space for research, experimentation and sociality. First we built a grand, smooth, white wall about 40' × 12' learning construction skills in the process, and how

to wield power tools, and mud, sand, and paint sheetrock. The "Wall" was as much symbolic as it was real; it defined our big exhibition/performance/studio space. Renovation of other rooms and spaces followed: a "rap" room, carpeted with samples from a carpet store, and furnished with oversize pillows on which we lolled for hours talking, crying, dreaming, holding "rap" groups, reading groups, and general meetings. There was an office with a telephone, a small library, and an art history research space where we began the first women's art history slide collection. Under Dori's direction a darkroom was built. Smaller spaces were partitioned off for site-specific installations and some individual studio spaces. Nancy set up a costume and "dress-up" area, with an industrial sewing machine for making props and soft sculptures. A favorite hangout was the rickety old porch on which we gathered to smoke, sun ourselves, and talk endlessly.

We organized the big kitchen for studio dinners, and to sustain ourselves during the long days we spent in the studio. I loved the kitchen with its large central wooden table where our Wednesday night dinners were held. There was a wooden keg of wine we would take to a local winery for periodic refills, and always coffee and tea—there were always small groups of us hanging in the kitchen talking nineteen to the dozen. We took turns cooking dinner on a $10 dollar budget limit for feeding about 17 people . . . Wednesday night dinners became an immediate tradition welcomed by some and feared by others. Dinner was usually followed by a "rap" session that sometimes turned into a harsh group critique of an individual and her work. Vanalyne remembers it this way: "[after the potluck dinner] we had a type of confrontational ritual, with a different person chosen each time for group criticism. Judy once threw a bottle of wine across the room when I said something that angered her. I dreaded those evenings and see them in my mind in solarized blues, browns, and blacks . . . Some of us . . . had less internal resources than others to withstand ego-shattering confrontations located around the dinner table or during a reading group or group critiques. . . ."[13]

Other nights we had lively discussions with guests such as Miriam Schapiro or Ti-Grace Atkinson who had given an impassioned speech on campus about marriage as legalized slavery.[14]

Initially, the "women's class" was planned as one course taught for four hours twice a week.

But it soon became clear that most of us wanted and needed to spend much more time at the studio, and indeed, had already begun to do so. Fortunately, Judy was able to arrange with Heinz Kusel that for spring 1971 students could sign up for up to 15 semester credits in the women's class— these could be spread over sculpture, photography, painting, art history,

and humanities core credits. Thus the class became a "Program" with all the implications attending that word. We were all required to sign contracts with Judy at the beginning of the semester, detailing our research plans, a reading list, and what visual art work we planned to accomplish for the amount of credit hours we were completing for the studio—and Judy held us to it.[15]

The daily rhythm at the studio included regular individual and group critiques and work meetings with Judy.

There were several weekly production and study group meetings for performance, film-making, photography, environments, reading and autobiography writing, and art history research. The most transformative aspect of the studio was how we began to claim and use the space. Since most of us worked and hung out there daily for many hours, we were able to see each other's work as it developed, to give suggestions, encouragement and critique, and collaborate technically and conceptually. This organic process of becoming collaborators in a space of our own was one of the secrets of the Program's astonishing success.[16]

%*@& Art

One of the most productive and controversial pedagogical strategies developed in the Fresno FAP involved a quest for new ways to represent the female body and, especially, women's sexual anatomy and feeling. The representation of female corporeality in any form has been criticized by some feminist thinkers for reinforcing the symbolic equation between female/body/debasement, as opposed to male/intellect/transcendence, in the binary terms of patriarchal culture. These criticisms, however, often fail to attend to the specific context in which such imagery was generated and consumed—by women and for women—in the Fresno FAP and other early feminist institutions. Creating and sharing their own iconography of women's bodily feeling and sexuality—in opposition to the dominant Western iconography of the female sex organs in medicalized or pornographic form—was a bold assertion of female agency.

Sexual imagery, dubbed "cunt art" by the Fresno students and later theorized as "central core imagery" by Chicago and Miriam Schapiro, was used to assert a wide range of powerful and often taboo feelings, from rage, to tenderness, desire, and humor.[17] The collective brainstorming process, as Wilding recalls, combined research with personal exploration:

in weekly reading discussions, and in the autobiography writing group, we explored our own and other women's bodily and social experiences, consciously looking for ways to use them in expressive visual forms. We studied

the contrasting visual representations of women by both male and female artists. We experimented tactically with media that would best embody the "feel" of the content—groping toward a phenomenology and aesthetics of our cultural experience of "becoming women."[18]

Chris Rush remembers:

> Our first assignment was to create something about "feeling invaded." Judy was very open to our personal choice of how to express this. I think this was the beginning of many different art choices, like performance, film-making, and environments, etc. I wrote a poem about my trip to Mexico City, about how a gang of boys surrounded me and taunted me and tried to grab me . . . The sharing of our mutual, emotional experiences bound me to these women and awakened me to the Feminist Movement. . . .[19]

Wilding worked for several months on a startling installation, *Sacrifice* (1971), that incorporated real animal guts heaped on an effigy of her body:

> I wanted to make a work that embodied some of the feelings of entrapment and sexual repression I experienced growing up on the Bruderhof (Society of Brothers), a patriarchal religious commune of German and European WWII refugees in Paraguay.[20] After leaving the commune, I had tried to hide my past history, and to appear as a wild, liberated child of the 1960s. With the encouragement given by the FAP, I began to wrestle with the deeply ambivalent feelings about the contradictions between the sacrificial, self-denying life in the Christian commune, and the libidinal drives of my young, ambitious, pleasure-seeking, pagan self. . . .
>
> *Sacrifice* was installed in an approximately 10' x 15' room. Its first iteration was a performance in which I lay like Sleeping Beauty as though dead or asleep on a low platform in front of an altar bearing a cross to which I had nailed the body of a road-kill pheasant. Candles burned on the altar. I was dressed in a lacy pinkish negligee, my long hair spread out around me, my eyes closed. Trimming the edge of the ceiling all the way around the room were bloody Kotex pads. Viewers came in to the room to look at me.
>
> After a group critique of this performance in which Judy and some of the students pointed out that the work was a cop-out as I had simply put a beautiful sleeping woman on view, I reworked the piece, making a sculpted figure of myself with a cast of my face, the bloodied mouth opened in a scream, and casts of my hands and feet. I dressed the life-size effigy in a white bridal gown, slit her torso open and peeled it back to form a wide, red velvet-lined wound or gash, which I filled with fresh cow guts fetched from the slaughterhouse every day—an image of disemboweling, or spilling

my guts . . . After only a few hours, the California heat raised an unbearable stench of rotting intestines mingled with the smell of burning candles and rose perfume, so that entering this environment all the senses were assaulted with sickening disgust.[21]

Karen LeCocq's *Soft Environment*, by contrast, created an inviting, otherworldly, womb-like space that literally enveloped the bodies of viewers:

My environment consisted of a bare white room with a four-inch thick polyurethane foam floor and a canvas ceiling with small plastic disks hanging from transparent threads that moved when a small fan was turned on. The best part was the door. It was made of polyurethane foam. It was slit down the center. To enter, you had to push through it—very cunt-like. The concept behind the soft, spongy foam covering the floor, the liquid movement on the ceiling, and the push-in, expanding-contracting door all deal with my experience as a woman. I am allowing the viewer, in a sense, to enter inside me, enjoying my softness, my liquidness, and my way of feeling.[22]

Wilding has aptly described the phenomenological experience of entering LeCocq's *Soft Environment* as an encounter with an active presence, "a welcoming space, a sensing, feeling space."[23]

Other cunt art productions exploited the power of humor to destabilize cultural assumptions.[24] Shawnee Wollenman designed and sewed oversized plush female and male genitalia for a satirical performance piece written by Chicago, the *Cock and Cunt* play. In this theatrical critique of traditional gendered divisions of labor, a "male" and "female" couple, played by Wilding and Jan Lester, appear in identical black tights and leotards, differentiated only by their genitalia props. An argument over the dinner dishes ensues when the "man" demands that the "woman" must perform this chore since "[her] cunt is round like a dish." The female character retorts that the dishes are just as much his as they are hers, and that she doesn't "see where it says that [I have to wash dishes] on my cunt."[25] Wollenman's soft sculpture *Cock and Cunt* props are precursors to the "central core" imagery of Chicago's *Dinner Party* plates.

Dori Atlantis, Susan Boud, Vanalyne Green, and Cay Lang formed a satiric performance group, the Cunt Cheerleaders:

Ladies on the toilet
Open that door,
You don't have to hide yourselves anymore,
Your cunt is a beauty,
We know you always knew it
So if you feel like pissing

> Just squat right down and do it!
> C U N T Cunt!
>
> > (FAP "Cunt Cheer" by Dori Atlantis, Susan Boud,
> > Vanalyne Green, and Cay Lang)

Shawnee Wollenman recalls the Cunt Cheerleaders' outrageousness as a source of pleasure for the whole group:

> We were thoroughly enjoying being outrageous. Ti-Grace Atkinson came to Fresno to speak and we utterly shocked her by meeting her at the Fresno airport with a cheerleading squad, with letters on their pink T-shirts that spelled C U N T. We wondered if that offended her so badly, how radical could she really be?[26]

Wilding recalls the scene a bit differently, but with equal pleasure:

> I remember Ti-Grace calling us "pretty ballsy" for doing this, especially since there was a large delegation of red-costumed Shriners coming off the same plane as Ti-Grace for a convention—it was probably Judy who was the most embarrassed about this event.[27]

Looking back on the emergence of cunt art at the beginning of the feminist art movement, Wilding maintains its radical impact on feminist consciousness:

> Although we did not fully theorize our attraction to cunt imagery at the time, we knew it was a catalyst for thinking about our bodies and about female representation. In current medical and biotechnological interventions into women's sexuality, reproduction and fertility, one still finds firmly in place antiquated ideas and language about the forms and functions of the female genitals. Meanwhile the feminist demands for excellent, free health and reproductive care are nowhere near achievement, and the women's health movement has been sadly eroded in the abortion battles of the 1980s.[28]
>
> "Cunt art," made for the female gaze, aimed to reverse the negative con-notations of a dirty word with a defiant challenge to traditional depictions of submissive female sexuality displayed for the male gaze. It was a form of body art that could not be absorbed by the (male) mainstream, for it questioned the definition of woman as a (mere) formless "hole" ("woman is the configuration of phallic lack, she is a hole" as Jane Gallop put it in *The Daughter's Seduction*). By laying claim to a juicy female sexuality expressed in an astonishing new lexicon of images, cunt art rejected the view of woman as a passive sexual object, all vagina willing to receive.[29] [see Plate 4].
>
> From our point of view in the FAP, the "morphology of cunt" was a new (and BIG) idea—we were indeed investigating unknown territory, seeing for ourselves, and contributing to the production of new knowledge.

Cunt art gave the female organs a life of their own, the part stood in for the whole (desiring body). Our investigative art began to show that there was a lot more to "cunt" than met the eye, for lo and behold, it turned out that cunt art was political, coming to the fore at the same time as the inception of the feminist women's health movement. The first issue of the Boston Women's Health Collective's *Our Bodies, Ourselves: A Book by and for Women* was published in 1971 and was already in our hands as required reading. It had unambiguous drawings of the vulva—including the hymen, the clitoris, the inner and outer lips, and the urinary, vaginal and anal openings. Female orgasm and how to achieve it was described in detail, and there were frank discussions of the many morphological differences between women's vulvas. Soon we were examining our own and other women's vulvas, vaginas, and cervixes, with mirrors and flashlights, and trying to depict—realistically, metaphorically, and poetically—what we saw and felt.[30]

Women's Work

A second key pedagogical and artistic strategy developed in the Fresno FAP, along with cunt art, was a search for new media that could effectively convey feminist content. Painting and sculpture, in 1970, carried the weight of millennia of male tradition. Vanalyne Green recalls that Chicago encouraged students to take up new media both because they represented the cutting edge of contemporary art and because they didn't carry the same cultural baggage as more traditional art forms.[31] The Fresno students made performance art, Super-8 films, and installations more often than they did paintings or sculptures (although these, too, were explored). They also transformed traditionally feminine chores, including needlework, costuming, and self-adornment, into vehicles for conceptually sophisticated artistic statements. In this chapter I refer to a wide range of experimental media—from needlework to dress-up to film-making—as female media, or "Women's Work."

Along with others in the 1970s, Fresno FAP students challenged traditional distinctions between female "craft" and male "art." Before coming to Fresno, Faith Wilding had studied with the pioneering fiber artist, Walter Nottingham. She worked on a series of hanging fiber sculptures on a large home loom throughout the first year of the Fresno FAP. Eventually these experiments led to the production of a fully three-dimensional fiber installation, the *Crocheted Environment* (or Womb Room) created for *Womanhouse*. Like Karen LeCocq's *Soft Environment*, Wilding's *Crocheted Environment* was meant to be entered and experienced from both inside and out. With its free-form crochet webbing and multiple tube-like passageways, it was simultaneously cosy and crazy, totally unexpected and wonderfully inviting. It was, in fact, so coveted, apparently, that it was stolen on the last day of *Womanhouse*—and had to be re-created for inclusion in the Division of Labor exhibition in 1995. (Wilding's re-created *Crocheted Environment* was also included in *WACK! Art and the Feminist Revolution*, in 2007.)

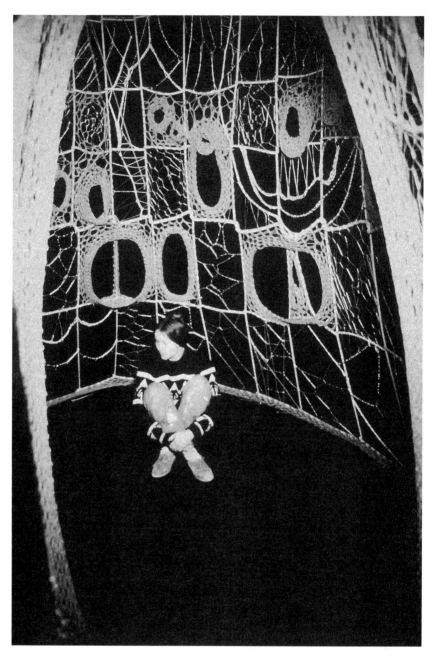

FIGURE 2.1 Faith Wilding, *Crocheted Environment* (*Womanhouse*, 1972). Rope, wool, twine. Reprinted with permission of the artist.

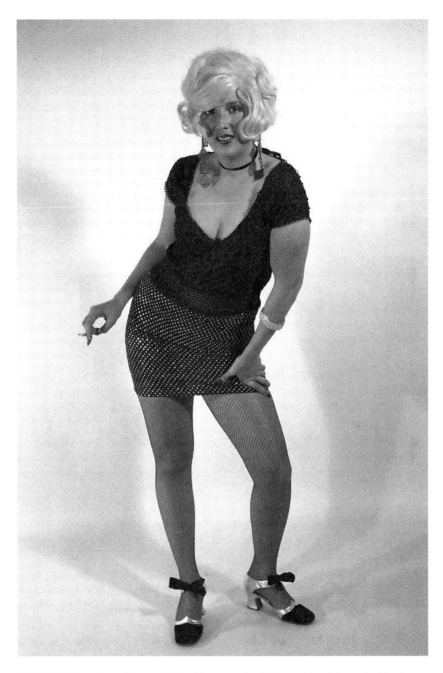

FIGURE 2.2 *Las Vegas Whore* (1971). Photograph of Nancy Youdelman by Dori Atlantis; costume by Nancy Youdelman. Reprinted with permission of Nancy Youdelman and Dori Atlantis.

Sculptor and program alumna Nancy Youdelman, who studied make-up and costume design before joining the Fresno FAP, established a costume room at the feminist studio that she kept stocked with hand-sewn garments and accessories. Delighting in the transformative power of clothing, Youdelman enjoyed dressing and making up other members of the FAP. At first she and friends collaborated on a series of invented personae in private at Youdelman's apartment, and took pictures with a cheap instamatic camera. She remembers worrying that Chicago might be angry and criticize the performances as sexist stereotypes. But Chicago was delighted with the work, and simply advised the artists to aim for the best possible production qualities by using more effective lighting, backdrop paper, and so forth. Dori Atlantis, who studied photography before joining the FAP, took over camera responsibilities. The resulting images embodying historical female types included the *Kewpie Doll*, *Victorian Whore*, *Las Vegas Whore*, *Bride*, *Veiled Woman*, and *Housewife*, predate Cindy Sherman's *Untitled Film Stills* by nearly a decade (see Plate 5).

These collaboratively produced Costume Images (or Images of Women) explore the tension between individual agency and the cultural limitations that inform the process of identity formation. While they allow imaginative identification with a variety of behaviors and roles, they also emphasize the pervasive effects of a depersonalized male gaze that seeks to control the female subject/object of desire. The *Kewpie Doll*, for example, variously performed by Judy Schaefer and Cheryl Zurilgen, spotlights the infantilization of female sexuality in many popular representations of women. It is actually an amalgam of two popular culture icons—the infant Kewpie doll, named for Cupid by creator Rose O'Neill at the turn of the century—and the sexy animated cartoon character, Betty Boop, first popularized in the 1930s. Schaefer's enactment of the role, with her crooked mouth and coarse artificial curls, poignantly shows the gap between her own flawed and profoundly human performance and the impossibly inhuman perfection of the model.

Performance art evolved organically in the Fresno FAP from many sources. Performance felt like a natural extension of role-playing, which Chicago introduced in consciousness-raising discussions as a means of examining and challenging traditional sex roles. In the reading group led by Wilding in the second semester, students also discussed Simone de Beauvoir's groundbreaking text, *The Second Sex*, with its trenchant thesis that "a woman is made and not born." Although it was not until years later that gender performance would be explicitly theorized by Judith Butler, Amelia Jones, Kate Linker, and others, the performative aspect of gender was already the implicit subject matter of many artworks created in the Fresno FAP.[32]

Film-making emerged, in part, as a logical extension of performance art. Interested students picked up skills from visiting film-maker Judith Dancoff, who decided to do her master's thesis on the Fresno FAP after seeing Chicago speak at UCLA.[33] Dancoff spent several months filming day-to-day activities at the

feminist studio in 1970–1971. Her documentary, *Judy Chicago and the California Girls*, was released in 2007. Karen LeCocq, Jan Lester, Shawnee Wollenman, and Nancy Youdelman, as well as Judy Chicago, produced Super-8 films documenting their performance art or as stand-alone artworks.

Jan Lester's film, *Steak* (1971), is an unapologetic celebration of physical appetites and pleasures. As the film begins we see a woman played by Youdelman reading in bed. Then the image of a steak appears in a thought bubble above her head. She springs up, hops on a bicycle, and swiftly pedals to the market, chased by a noisy dog. After carefully selecting and paying for a piece of steak, she pedals home and fries the meat with intense concentration. The film concludes with the woman enthusiastically devouring her meal, smiling, licking juice from her lips, and sighing with pleasure.

The Rivalry Play (1971), staged and shot by Nancy Youdelman, takes on the equally taboo topic of female aggression. It features two antagonists—an elegantly coiffed and dressed woman, perhaps a prostitute, played by Chris Rush, and a fat matron in a flowered housedress, played by Jan Lester—who find themselves together in a public place. Each attempts to assert superiority over the other by humiliating her rival (blowing smoke in her face, spilling food on her immaculate clothing). This battle of wills culminates in a physical fight that climaxes when the housewife chokes the prostitute who, meanwhile, stabs and kills the housewife before falling dead herself. In the film's final frames, the camera pans to the women's limp bodies lying inert amidst spilled popcorn and debris.

According to Youdelman, the fight scene in the *Rivalry Play* was based on memories of girl fights in elementary school and junior high. Girl fights could be vicious and frequently included spitting, hair pulling, and ripping off each other's clothing. Youdelman remembers being warned by a sixth grade classmate not to wear showy clothing with ribbons or bows because the "mean girls" would rip them off. To avoid being singled out for attack she should "just fade into the woodwork."[34]

The piece was also, in all likelihood, a response to simmering competition and aggression among the students in the Fresno FAP.[35] Several alumnae remember feeling painfully aware that there was an "in group" that enjoyed Chicago's favor and an "out group" that did not.[36] Designer and FAP alumna Jan Lester has characterized the class as "something almost cult-like . . . We had this sense that we were doing something important," adding, "Judy made everyone in the program believe that they could do whatever they wanted to do."[37] Chris Rush remembers feeling intimidated by Chicago "not to be too feminine, not to shave your legs."[38] In Green's view, the program "encouraged a Darwinian fight for life among the women students, and [students] often abandoned each other to gain [Chicago's] approval."[39]

New female media developed in the Fresno FAP—ranging from needlework, costume, and make-up to performance and film—gave participants a shared visual vocabulary not previously determined by male tradition. Rather than reinforcing

traditional expectations for gendered behavior, the Fresno FAP artists used female media to address previously taboo topics and illuminate the performative aspects of gender identity. However, the meaning of an artwork is never fixed or final; depending on viewers' expectations and the context of reception, different responses may be evoked. Wilding recalls, for example, how powerful performance art felt, but also how different it was to perform for other women as opposed to a mixed-gender group:

> Performance was a great way to work quickly and directly with the new content of performing femininity and gender. It aroused direct, powerful responses from audiences quite different from the ones evoked by our other visual work. . . . Performing for a women only group was a very different experience than performing for mixed gender groups. The performances implicated and involved different audiences in different ways, which taught us that performance could be a powerful tool for evoking intense affect and frank discussion. . . . By the time some of us left Fresno to found a Feminist Art Program at CalArts, we had established performance as an exciting and versatile pedagogical form for enacting feminist art's new content.[40]

Collaboration Across Generations

The pedagogical strategies tested in the Fresno FAP were developed by trial and error through a process of (imperfect) collaboration. Judy Chicago initiated the FAP with the conviction that art pedagogy must change to provide an adequate education for women; but the shape of that change remained to be determined. Each participant in the Fresno FAP brought her own unique history, talents, interests, and desires to the group, and each helped shape the group dynamic. Pedagogy and art making were inextricably intertwined. Research, self-examination, and discussion fed the art making process, and making art was a means of producing and sharing knowledge.

Collaboration is an inherently conflicted process; for this reason it is vital to attend to its dangers as well as its benefits. Feminist pedagogy is increasingly attuned to difference based on race, ethnicity, gender, sexual orientation, and faith. It is striking, however, that the students in the original FAP, most of whom were white women from working-class and lower middle-class families, experienced varying degrees of trauma and conflict in the group process despite their superficial similarities. Chicago wanted her students to make "great" art as well as effecting social change. And she believed that greatness depended on developing a new "personality structure." But her students had their own goals and their own personalities, which sometimes bristled or bruised under Chicago's confrontational style. Chicago set the collaborative dynamic of the FAP in motion, but its ultimate success as a model for feminist collaboration was, to some extent, achieved in spite of her.

Many of the original Fresno FAP alumnae are teachers now, themselves; their experiences in the FAP, both positive and negative, continue to impact their pedagogical practices. Installation artist, photographer, and FAP alumna Dori Atlantis reflects:

> One of the unique things about the FAP (especially in the Fresno State setting) was that we were a community—we spent most of that year together constantly—learning from each other as well as from our mentors. We saw how others solved problems, we collaborated on projects, we discussed our life issues and situations. The rap sessions were painful but perhaps I grew into a more thoughtful person through them. We were forced to question some deep-seated beliefs.
>
> As I teach and when I critique students' work, I try not to impose myself onto my students' work. I try to facilitate their growth as artists—for them to discover and/or nurture their unique voice.[41]

And Vanalyne Green, in a recent interview with John Reardon, states:

> I've always thought that teaching and thinking about pedagogy, and about how people learn, is part of citizenship.
>
> I don't think I'm a good teacher unless I'm doing my own work, and I don't think I can do my own work well unless I'm being inspired by my students. There's a kind of back-and-forth. I'm humbled by a lot of work that my students do, and I learn a lot from what they do.[42]

Next fall my graduate seminar on the legacy of the feminist art movement will, for the first time, experiment with "consciousness-raising" groups and combine readings with art making. In this post-feminist, post-colonial, post-postmodern era, which discussion topics will emerge as the "points of urgency?" How will we foster collaboration while respecting difference? Where am I taking my students, and where will they take me?

Notes

1 Faith Wilding, "The Feminist Art Programs at Fresno and CalArts, 1970–75," in Norma Broude and Mary D. Garrard, eds., *The Power of Feminist Art, The American Movement of the 1970s, History and Impact* (New York: Harry N. Abrams, 1994), 35.
2 Faith Wilding, "Gestations in a Studio of Our Own: The Feminist Art Program in Fresno, California, 1970–71," in Laura Meyer, ed., *A Studio of Their Own: The Legacy of the Fresno Feminist Experiment* (Fresno, CA: Fresno State Press, 2009), 88.
3 See, for example, H.H. Arnason and Peter Kalb (revising author), *History of Modern Art: Painting, Sculpture, Architecture, Photography*, 5th edition (Upper Saddle River, NJ: Prentice Hall, 2003), 600. See also Hal Foster, Rosalind Krauss, Yve-Alain Bois, and Benjamin H.D. Buchloh, eds., *Art Since 1900: Modernism, Antimodernism, Postmodernism, Volume 2, 1945 to the Present* (New York: Thames and Hudson, 2004), 570–571.

4 Vanalyne Green cited in Gail Levin, *Becoming Judy Chicago: A Biography of the Artist* (New York: Harmony Books, 2007), 149.
5 Karen LeCocq, *The Easiest Thing to Remember: My Life as an Artist, a Feminist, and a Manic Depressive* (Bloomington, Ind.: 1st Book Library, 2002), 62.
6 Judy Chicago cited in Levin, *Becoming Judy Chicago*, 146.
7 Aiken subsequently taught the feminist class at Fresno State from 1973 until her retirement in 1992. Aiken's students co-founded Gallery 25 in downtown Fresno as a women's cooperative exhibition space.
8 Wilding writes: "I still own a yellowed and tattered copy of Shulamith Firestone and Anne Koedt, eds., *Notes from the Second Year Women's Liberation: Major Writings of the Radical Feminists* (New York: Radical Feminism, 1970). It includes the important articles: Pat Mainardi, 'The Politics of Housework,' Anne Koedt, 'The Myth of the Vaginal Orgasm,' Kathie Sarachild, 'Consciousness Raising,' and Carol Hanisch, 'The Personal is Political'." Wilding, "Gestations in a Studio of Our Own," 101, ff. 8.
9 Wilding recalls "the booklist included Simone de Beauvior, the women's liberation issue of *Motive* magazine (March–April 1969), some of the writings on women's orgasm by Masters and Johnson, and Virginia Woolf's *A Room of One's Own*. My memory is that Suzanne did this with me, but she says not as she was already teaching a course in women's psychology. Ingrid Wendt, a young poetry professor, was the faculty sponsor of the course." Ibid., ff. 9.
10 Ibid., 82.
11 Ibid., 80–81. For a history of the Experimental College and the campus firings see Kenneth Seib, *The Slow Death of Fresno State: A California Campus under Reagan and Brown* (San Francisco: Ramparts Press, 1979).
12 Chris Rush, email to Faith Wilding, July 7, 2008.
13 Vanalyne Green, email to Faith Wilding, August 8, 2008.
14 Wilding, "Gestations in a Studio of Our Own," 87–88.
15 Ibid., 88.
16 Ibid., 88.
17 Judy Chicago and Miriam Schapiro, "Female Imagery," *Womanspace Journal* 1 (Summer 1973).
18 Wilding, "Gestations in a Studio of Our Own," 89.
19 Chris Rush, email to Faith Wilding, July 7, 2008. This assignment was made after an intense "rap" group session in which the subject had been how it feels to be hassled on the street.
20 To learn more about the Society of Brothers see www.Churchcommunities.org.
21 Faith Wilding, Journal entry, 1971.
22 Karen LeCocq, unpublished writings, 1971.
23 Wilding, "Gestations in a Studio of Our Own," 92.
24 Sigmund Freud argues that humour is an effective weapon against social controls of various kinds, breaking through listeners' resistance and inviting empathy instead of hostility. See Sigmund Freud, *Jokes and Their Relation to the Unconscious*, translated and edited by James Strachey (New York: Norton, 1963).
25 Judy Chicago, *Through the Flower: My Struggle as a Woman Artist* (New York: Penguin, 1975), 209. Johanna Demetrakas' 1974 film, *Womanhouse*, includes documentation of the performance as it was enacted by Lester and Wilding during the exhibition of *Womanhouse*.
26 Shawnee Wollenman, letter to Faith Wilding, 1993.
27 Wilding, "Gestations in a Studio of Our Own," 97.
28 Wilding writes, "Almost forty years later, researching an article about the aesthetic surgery of the vulva, I discovered that resculpting the vulva (female aesthetic surgery) is now the work of male plastic surgeons bent on using a scalpel to define an aesthetics of the vulva. See Faith Wilding, 'Vulvas with a Difference,' in Maria Fernandez, Faith

Wilding, and Michelle M. Wright, eds., *Domain Errors! Cyberfeminist Practices* (Autonomedia, 2003), 149–159. See also video *Vulva de/Re Constructa*, subRosa DVD (www.cyberfeminism.net). I also found new research on the morphology of the clitoris by Dr. Helen E. O'Connell and colleagues, who point out that even the nomenclature used for the female genital parts is still incorrect. See Dr. Helen O'Connell's conference paper, 'Female Sexual Anatomy: Discovery and Re-discovery,' 2003, at the International Society for the Study of Women's Sexual Health Conference, Amsterdam'." Wilding, "Gestations in a Studio of Our Own," 102, ff. 37.

29 Some of this text is adapted from Faith Wilding and Miriam Schapiro, "Cunts, Quilts, Consciousness," *Heresies* 24 (1989).

30 Wilding, "Gestations in a Studio of Our Own," 96.

31 Vanalyne Green to Laura Meyer, July 30, 2008.

32 Kate Linker, "Representation and Sexuality," in Brian Wallis, ed., *Art After Modernism: Rethinking Representation* (New York: Museum of Contemporary Art, 1984), 391–416; Judith Butler, *Gender Trouble: Feminism and the Subversion of Identity* (New York: Routledge, 1990); Amelia Jones, *Body Art/Performing the Subject* (Minneapolis: University of Minnesota Press, 1998).

33 Judith Dancoff to Laura Meyer, November 21, 2007.

34 Nancy Youdelman to Laura Meyer, July 1, 2008.

35 When I asked her about it, Youdelman confirmed this hunch.

36 This perception was repeatedly articulated to me in conversations with alumnae of the Fresno feminist experiment, both individually and in groups.

37 Jan Lester quoted in Levin, *Becoming Judy Chicago*, 148.

38 Chris Rush quoted in Levin, *Becoming Judy Chicago*, 148.

39 Vanalyne Green quoted in Levin, *Becoming Judy Chicago*, 149.

40 Wilding, "Gestations in a Studio of Our Own," 95.

41 Dori Atlantis, email to Laura Meyer, March 10, 2010.

42 Vanalyne Green, unpublished manuscript of an interview with John Reardon.

3

REFLECTIONS ON THE FIRST FEMINIST ART PROGRAM

Nancy Youdelman and Karen LeCocq

Nancy Youdelman

Judy Chicago taught the first feminist art class ever at Fresno State College (now California State University, Fresno). It began in the fall semester of 1970 and continued through the spring semester of 1971. I was a student in that groundbreaking class and would like to share some of my experiences.

I first heard about the class during the spring of 1970. I had seen a note taped to the wall in the art building that said something like, "If you are interested in being in an all-women sculpture class, sign up here." There was a place to sign your name; I was intrigued and signed up right away. As an art major I had taken drawing, painting, and photography classes but had avoided sculpture. At that time sculpture was taught with a minimalist approach, and classes focused on various techniques to create smooth geometric pieces devoid of emotion. Students were required to create a series of three-dimensional cubes, one of plaster, one of wood, then one of metal. You would have to build the wood cube, cast the plaster cube, and weld the metal cube. And of course all the instructors were men. I was not interested in making cubes; I did not see the point. Instead I had taken theater classes, mostly costume and makeup, which ended up preparing me for my early artwork—the costume and makeup pieces that I did in that first feminist art class in Fresno.

So, back to Judy's sign-up sheet—we were to be interviewed by Judy and she would decide whom she wanted in the class. That process was very unusual. During my interview, Judy asked me if I wanted to be a professional artist; I answered that I already was an artist. She replied back that I was not. I was stunned by her directness; quite frankly, I had never met anyone like her before. Later I realized that I had no conception of what being an artist really was before I met her. Needless to say, I was chosen to be in the class. I was happy to hear that my friends Jan Lester and Chris Rush were also chosen; it made a big difference

that some of us already knew each other. Altogether there were fifteen women chosen as students, and it was to be a year-long course.

The most amazing thing about our class, besides the fact that we were all women and had a fireball of a teacher, is that we rented a studio off-campus. The building was huge, barn-like. It was the old Community Theater in Fresno in a run-down section of town next door to a dilapidated pornographic movie theater which when I was in high school had been an "art house" where I saw many Fellini films. Now, one of the first things we had to do was create a workable studio space. Most of us had never done hard physical work like that—cutting wood, hammering nails, etc. We worked very hard. Looking back, what I (and most of us) mainly gained from that first year was how to take an idea, work very hard and complete it, no matter how difficult it was. And, sometimes, it was so difficult emotionally as well as physically that we thought we were just going to come apart. We got the studio ready by serious cleaning, building new walls, putting up sheetrock, and painting; we made a fantastic workable space for ourselves, and a safe work environment that was entirely ours and miles from the college. In one of the rooms, using scraps of colorful carpet, we created a cozy patchwork rug on the floor and filled the room with homemade pillows—we called it our *rap room*. We would have consciousness-raising meetings in there, with topics pertaining to ourselves as women, with lots of emotional sharing, confrontational dialogs and crying, as well as laughter. We also had a large kitchen with a dining table and enough chairs for everyone to sit and eat together. Once a week we would take turns cooking dinner for everyone. So, we became a community. In the beginning we were simply a class—then, as we all became much more involved, we gradually spent more and more time there. Eventually I had a whole costume area in the back, where I stored all sorts of dresses and props for my work, many of which I acquired at thrift stores where I could buy fabulous dresses from the 1940s, two for a quarter, or Victorian clothing, which was also cheap. I bought whatever supplies I could and actually acquired quite a lot of materials considering that I never had much money. It was a gradual unfolding of possibilities and a very exciting time for me. Having that huge space was energizing; we had room for everything. In the beginning, I remember Judy telling us the importance of a studio, that you could not do an eight-foot painting in your bedroom, because you would not be able to get it out; more importantly, *you wouldn't even conceive of doing it in such a confined space in the first place.* By having this huge space, we started getting big ideas; and we worked very hard to carry them through to completion.

Getting an idea and running with it was made possible by having both the space in which to work and a teacher like Judy who understood and encouraged the art-making process. Jan Lester and I began the very first costume images rather spontaneously. One night, in my apartment, we decided to just dress up and take pictures. We had an inexpensive instant camera with the little flash cubes that turned around. We had the pictures developed, but at first we were afraid to

show them to Judy. We thought she would say something like, "Oh, these are really sexist. This is not good." But when we did show them to her, she was enthusiastic. She said, "This is a great start; now, get a better camera, get better costumes and get back-drop paper." And that is what we did. My mother bought me a Pentax 35mm camera, which I still have today. In our newly renovated space, our huge studio that belonged only to us, a group of us—mainly Jan Lester, Shawnee Wollenman, Dori Atlantis, and me—worked on expanding the concept of these initial images together. Chris Rush and Karen LeCocq would join in also. I would costume them, Jan would costume them, or they would costume themselves; eventually Dori became the photographer of the group. When Miriam Schapiro came to visit our class, she requested that we dress her up— she loved doing it. The photo was a favorite of hers.

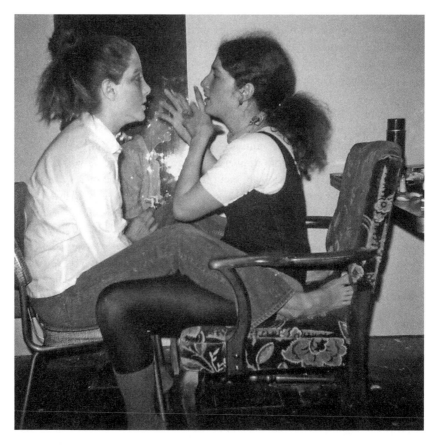

FIGURE 3.1 Nancy Youdelman applies Shawnee Wollenman's makeup for the *Death Piece* scene in an untitled Youdelman-produced film project (1970–71). Reprinted with permission of Nancy Youdelman.

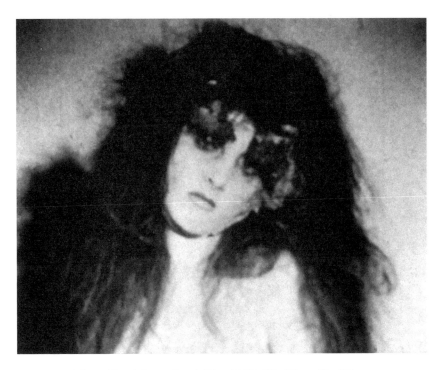

FIGURE 3.2 Nancy Youdelman, *Death Piece* (1970–71). Film still of Shawnee
 Wollenman. Reprinted with permission of Nancy Youdelman.

Getting back to that idea of the process of bringing a concept to physical
fruition, I cannot say enough about that—it is central to becoming an artist, and
Judy's teaching impressed that upon me. Becoming an artist is learning how to
take one step, then another, and another. Conceiving of ideas is one thing, but
planning their execution and then their presentation is what being an artist is
about—actually working to one's maximum capacity to fully realize the idea is
entirely separate from simply hatching the idea. This may seem obvious, but to
us as young women who thought we were "artists already," it was a revelation.
So, that first year we got a real taste of what it was like to have an artistic vision,
be able to sort it out, plan how to do it, refine it, and take it through to completion.
In the process, we all learned to do things we had never done before. Really,
that is the greatest gift a teacher can give students and that students can give to
each other, since much of what we did was collaborative.

Sometime during that first year in Fresno, Judy Chicago was invited to be in
a show at the Richmond Art Center; it was decided we would do a collaborative
piece, *Miss Chicago and the California Girls*, a photographic spoof on beauty contests.

Twelve of us participated and we each picked a city in California and made
banners we wore with the name of the city. If you look closely at the photographs

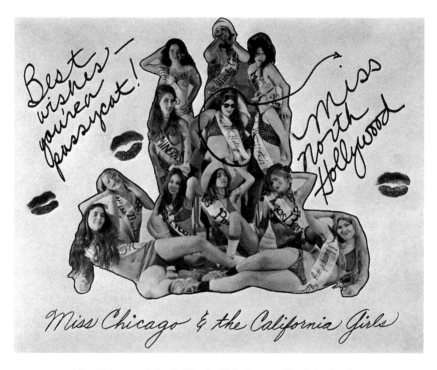

FIGURE 3.3 *Miss Chicago and the California Girls* (Fresno Feminist Art Program
poster, 1971). Reprinted with permission of Nancy Youdelman.

of us, you will see hairy legs, hairy armpits, work boots, and some out-of-the-
way city banners, like Weedpatch and Pinedale. We each signed one of the photos
with our "beauty contest title," such as "Miss North Hollywood," then we put
lipstick on thickly and kissed the photos, leaving big lipstick prints. In the front
row, left to right, are Dori Atlantis, Cay Lang, Chris Rush, Cheryl Zurilgen, and
Faith Wilding. In the second row, left to right, are Judy Schaffer (down a bit
lower), Shawnee Wollenman, Jan Lester, and Sue Boud. In the top row are
Henrietta Sparkman, Judy Chicago, and I. The twelve photos were framed
separately but exhibited together. We were working on this project while Judith
Dancoff, a UCLA film student, was making a documentary film about Judy. She
ended up titling her film, *Judy Chicago and the California Girls.*

One particular performance piece that I worked on was *The Rivalry Play.* I
came up with the idea, wrote it, and collaborated with Chris Rush and Jan Lester
Martin, who performed it. They were vital to the piece; I could not have written
it without them in mind. The performance started out with Chris, dressed in
black and sitting on a bus bench, very slender, very elegant, very beautiful, with
feathers and a veil on her hat. She is smoking a cigarette, gracefully blowing the

smoke up into the air. Then Jan's character enters and plops down on the bench, eating popcorn. They are opposites: Jan is overweight, her slip is showing, she is chewing really loudly, and relishing her popcorn. When she plops herself on the bench, she accidentally spills popcorn on Chris. Chris is irritated and blows smoke in Jan's face. Then Jan begins intentionally spilling popcorn on Chris; next she slams it all down at once, popcorn flying everywhere. Jan picks Chris up, throws her on the floor and rips off Chris's hat, then rips off Chris's false eyelashes and tears off her fake fingernails one at a time. Jan then viciously tears Chris's clothes off. I had taken apart the seams of Chris's costume and sewn in Velcro, so there were loud ripping noises. When her clothes are off, Chris is left wearing only a hot pink corset. Jan gets up and starts to walk away. Chris follows her, pulling a knife from her corset while making a loud hissing noise, to get Jan's attention. Jan spins around and starts choking Chris. While Jan is choking Chris, Chris is stabbing Jan in the chest, ending with them both dead and sprawled on the floor. The final scene is quite brutal, with both characters motionless on the stage, popcorn and bits of clothing strewn everywhere. We performed it about three or four times: at the Richmond Arts Center, for a graduate seminar in Berkeley, and at the "Rap Weekend" at our studio when we invited women from Los Angeles to come up to view our work and performances. Jan and Chris were quite fierce performers, often bruising each other and leaving the audience stunned by their passion and violence. I was thrilled by the power of this piece; my inspiration came partly from my knowledge of costuming, from the distinct personalities of Jan and Chris, and it also was a blatant telling of the intense abhorrence that women can have for each other.

In the fall of 1971, Judy Chicago collaborated with Miriam Schapiro to establish the Feminist Art Program at California Institute of the Arts, and about half of the students from that original class were accepted there as transfer students. Our first project was the internationally acclaimed *Womanhouse*, where Karen LeCocq and I collaborated on a room, *Lea's Room*.

We transformed one of the upstairs bedrooms into an elaborate antique-filled haven that was inspired by the character Lea, an aging courtesan in a novel by Colette. After 1973, most of us graduated and dispersed out into the world. I went to graduate school at UCLA and lived, worked, and exhibited in Los Angeles for twenty-two years before moving back up to Fresno in 1992. The amazing thing is the bond that we created—we live all over the country and often much time goes by without seeing each other; but when we get together, the years fall away. In 1999 we met at CalArts for the *F-Word Symposium* (the "F" meaning *feminism*) that was put together by a group of young women art students there who had unearthed the mostly forgotten history of the Feminist Art Program. A large group of us went to that symposium—during the dinner event in the evening, our table was the loudest. We had the most wonderful time being together. There is a strong bond that holds us together, created during our shared experience when we were birthing an art of our own.

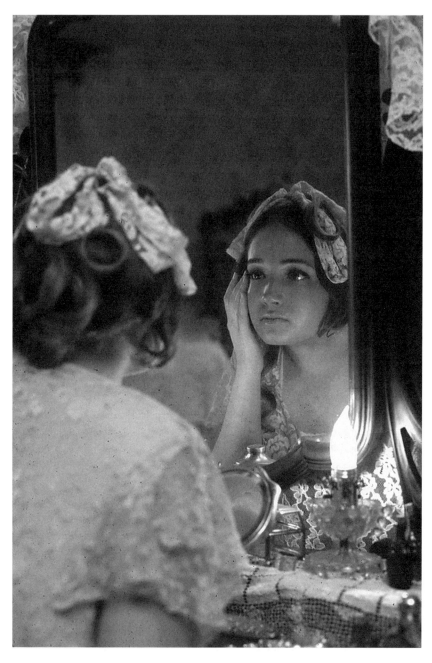

FIGURE 3.4 Nancy Youdelman and Karen LeCocq, *Lea's Room* (*Womanhouse*, 1972). Mixed media installation. Photograph by Lloyd Hamrol of Karen LeCocq reprinted with her permission.

Karen LeCocq

A male friend of mine once pointed out to me that my art was different from a man's. At the time I thought that was terrible, I was an artist first, a woman second. I didn't want it to be different; I wouldn't make it in the art world if it were. It was around that time Judy Chicago had the Feminist Art Program at Fresno State. I wrote her a letter and requested an independent study. A line in my letter stated, "When you first came to F.S.C. to set up a women's class, I thought, I've been trying hard to be just recognized as an artist, why mess it up by pointing out I am a woman." Judy contacted me a week later and we met in her studio one evening and talked. She told me that the relationship between her and the women in her program was not a "teacher-student thing," but a working community that could not be broken up by someone coming in and requesting an independent study. I was invited to their weekly Wednesday night dinner at their communal studio. I had heard about this studio and was curious and anxious to see it.

The studio was an old worn down building next to, of all things, an "adult" movie theater. It was on the opposite end of town from Fresno State and far away from the prying critical eyes of the male-dominated art department. The building had a huge green door with the paint peeling off. When you entered, it swung creakily into the space. The space was huge to me. Looking back, it must have been about five to six thousand square feet. The kitchen was large and well worn. The most dominant thing in the kitchen was a large wooden table where the Wednesday night dinners were held. There was a wooden keg of red wine that was refilled at the local winery every so often. That first night, I sat at the table attempting to size everyone up. Yet, it was very strange, I couldn't put them in any frame of reference I'd ever experienced. At the close of the dinner, one of the women, who was upset about something, threw her plate against the wall and it shattered with a loud crash. Judy said, "Go ahead, break all the plates if it makes you feel better." With that, the woman started picking plates off the table and hurtling them fast against the floor and walls. Each plate hit their mark with a loud crash and shattered into tiny pieces. I'd never seen anything like it. The emotional scene over, we moved into the studio where I proceeded to show them slides of my work, the only thing I felt secure in at that moment.

After an interview the next day, I was told I was in the program, if I wanted to be. I had many conflicting thoughts about joining. I could feel I was about to undergo a change and I could sense I was about to give something up, the life I had been leading, my perceptions and my relationships. I had been alone so long in my work and my struggle as an artist, I feared I would not be able to function in a group. I knew something was going to be demanded of me besides good art, but I didn't know what. Aside from those fears, I felt the program would help me change my attitude toward women. I realized whenever I needed reinforcement that I was loved, I went to men, whenever I needed to be told I was beautiful,

I went to men, whenever I needed a close intimate relationship, I went to a man, and whenever I opened up my true feelings it was to a man. I wanted and needed close female friendship and trust. I decided to join the class.

It would take me a good hour to ride to the studio by bicycle or a half hour by bus. As I entered the studio, strains of Leonard Cohen's music would drift to my ears. Judy would usually be at the back of the studio working at a large wooden table, creating three-dimensional "cunts" from colored mat board. Chris Rush would have a large piece of raw canvas on the floor, brushing many bright colors of acrylic paint that bled into the other colors. Nancy Youdelman would be dressing someone in an elaborate costume that reflected a role, some stereotype that women had played in society. Dori Atlantis would then photograph each woman in some kind of provocative pose. I was dressed up as a Victorian whore. This was fun for me. It felt like playing dress up as a child. I enjoyed being made up, having my hair piled high on the top of my head and wearing the delicate antique clothing. The corset, however, was not enjoyable. I could barely breathe and I wondered how women in those days managed to even smile. The image of the Victorian whore was largely ignored until about twenty-five years later when it was recognized as a precursor to Cindy Sherman's work in her retrospective catalog.

On other days at the studio, I'd see Faith Wilding constructing her environment, creating a life-sized figure of herself dressed as a bride with her midsection cut open with cow guts spilling out. With each showing of the piece, she had to go back to the slaughterhouse and obtain fresh cow guts. Another feature of her environment was the bloody Kotexs that trimmed the walls at ceiling height. I was at work on my own environment. I couldn't bring myself to be as graphic as some, but I did make a vagina, a subtle one, one that I thought if the males in the art department weren't looking for it directly, they might just think it was a piece of art.

I constructed a room seventeen feet by eight feet from sheet rock and two-by-fours. Judy had told me how walls were made. The walls were painted white. The ceiling was a large piece of canvas stretched over a two by two pine frame. Hanging from the ceiling were 120 pieces of nylon thread with round plastic discs attached to their ends. I covered the floor in four-inch-thick polyurethane foam. The entrance was four-inch-thick polyurethane foam as well with a slit down the center. The viewer had to slip through the opening to enter. In the four corners of the room I installed four crimson fifteen watt bulbs under the foam which cast a warm rich glow about the environment, and created light and shadows for the discs. A small fan was installed to move the discs. The moving discs created a liquid motion, a shimmering. I wrote about the piece:

> The concept behind the soft, spongy foam covering the floor, the liquid movement on the ceiling and the push-in, expanding contracting entrance, all deal with my experience as a woman. I am allowing the viewer, in a

sense, to enter inside me, enjoying my softness, my liquidness and my way of feeling.

One of the rooms in the feminist studio that always made me uncomfortable was the room everyone called "the rap room." It had an awful patchwork carpet that was composed of various carpet samples. The room was filled with oversized pillows that became our chairs as we slumped up against the walls. We would gather there for our consciousness-raising sessions. I was always a little afraid as I entered this room. It meant that I was about to be confronted on something that was too uncomfortable to talk about or I would have to witness someone else's discomfort on a subject that they found hard to examine. Either way, it was time to squirm. There were many emotional moments in there. We experienced many soul-searching, gut-wrenching, tumultuous, cleansing, exhausting, exhilarating and enlightening times in that one small room. It was a tiny, intimate space that was suffocating and uncomfortable one moment and nurturing and comforting just a short time later.

At some point, I began to realize just what a unique and powerful thing the program was and what it would mean to future women artists. I wrote to Judy, in my February 1971 evaluation,

> I am experiencing a growing insight into what this class is all about and what it will mean in the future, not only in the women's movement or in the art world, but later in history itself. It took me some time to realize that female art, Female Expressionism, or whatever they will call it in history books, could be the next major art movement. . . . Perhaps a better name would be the Female Realists because we are showing them what it is really like to be a woman.

It has taken me a good thirty years to truly appreciate what Judy had done in starting such a radical program in the conservative climate of Fresno in 1970. Now I can fully value what this woman created for herself and countless other women who would be influenced by her innovative teaching methods, her viewpoint and her courage. Judy entered a male-dominated art department and took on a group of young rebellious women when she was just a young woman herself. Her task was to help them to realize themselves as women and express their femaleness and new awareness in their art. She showed them what they needed to do to become professional artists and how to stand up and be strong to their ideals. And all this was attained while dealing with her own fears and the incessant criticism from everyone threatened by her methods, beliefs and what she was trying to accomplish.

What was it really like to be in the first Feminist Art Program? Strange is the first word that comes to my mind, painful is the next. There were many things that were hard for me to do, frightening for me to see. I did a lot of growing

up, a lot of ridding myself of the ideas that were inbred in me by the culture, my parents, my education, my peers, my former and present male friends and my former religious training. A lot of my anchors were being cut. I was entering a strange new world. Every time I entered the feminist studio, I had an uncomfortable feeling in the pit of my stomach, mixed with fear and excitement. We were treading on grounds not yet explored. We were doing things that surely would be ridiculed by the rest of the art world. We were doing and expressing the forbidden. I felt revolutionary and evil at the same time. I felt we could be just one step away from being locked up. The sense of community, the sense of family among the women was great. We had horrid fights and emotional outbursts, but we were a family. We could depend on one another and help one another. I don't think there was one among us that wanted it to go on forever, or could have stood it if it did. I don't think we missed it once it finally ended, because the bad times were too fresh in our minds. But looking back, now that time has passed, I can say that I'll never again experience anything remotely close to my experience in the Feminist Art Program. It is definitely something I would not want to relive but I am very grateful for the chance to have experienced it for that one glorious, painful and bizarre time.

The Second Feminist Art Program and *Womanhouse*

Our first project in the second Feminist Art Program at California Institute of the Arts was *Womanhouse*. This project encompassed twenty-five women artists and our instructors, Miriam Schapiro and Judy Chicago, working together to transform an abandoned mansion into an environment reflecting the dreams, ideas and emotions of women.

My first sight of the project's house was overwhelming. It was a huge mansion, large enough for everyone to have a space in which to create. It had a wonderful feel to it, a history, a faded elegance. Our first day there, we all rushed around in excitement, trying to decide which room we wanted. I deliberately chose to work collaboratively with another woman, Nancy Youdelman, instead of having my own room. I had always worked by myself, even during the Fresno Feminist Art Program, and I felt a real desire to share ideas, feelings and responsibility with another woman. I liked Nancy's work, her ideas, and her imagery. Moreover, I liked Nancy herself and I felt we could work well together. I also felt it was time I stopped being so possessive about my work.

Nancy and I decided to do a re-creation of Lea's bedroom from Colette's *Cheri*. We had selected the most beautiful bedroom in the house. It had a balcony, large windows and French doors. We went to one of the largest fabric stores in Los Angeles who said they would donate to our project. I believe Judy urged them to do so; she was good at that type of thing and we were learning from her. At first, the lady at the fabric store brought out some really cheap-looking velvet. Nancy and I took one look at it and said that wouldn't do. Lea was elegant,

extravagant, and would only accept the best. The room we were about to create had to look like it belonged to the most beautiful, wealthy and sensual courtesan of Paris. We wanted to overdo it, so one had the feeling of suffocation upon entering the room. The woman at the fabric store was reluctant to bring out "the good stuff," but she finally relented. We selected a rich burgundy velvet and some beautiful lace.

At the start of the project, much of the house needed a lot of work, doors taken off, walls removed. Another woman and I were "the destruction crew." Armed with crowbars and sledgehammers, we would attack walls and anything else that was in the way of the project. Doing this type of work was more fun than I had in years. Dressed in Levis, a blue work shirt and work boots and carrying my tools, I felt all this power and freedom, what I imagined it must feel like to be a man. I have a picture of myself on the balcony at *Womanhouse* with my hammer in my hand looking very satisfied and happy.

As our room progressed, Nancy and I found ourselves sanding, painting, wallpapering, floor finishing, sewing curtains, hanging chandeliers, creating a canopy for the bed and assembling furniture and numerous small details that went into creating an environment suitable for an aging courtesan in Paris in the 1800s. I was happy to be doing the project, though a small voice in me kept questioning, "What am I doing? This has nothing to do with my art. There isn't a bit of my art in this room." Some of the women were doing large versions of their art, like Mira Schor, who was painting a picture of herself and the moon in one of the closets. I thought perhaps I should have done my art as well. On the other hand, I liked what we were creating and I enjoyed working with Nancy. We were having fun and I was learning. I told myself there would be time for my individual art later.

Nancy and I traveled around to several antique dealers in search of the perfect furnishings for *Lea's Room*. It was difficult to explain to a retailer of expensive imported antiques the exact purpose for which he would be lending his merchandise. Our appearance undoubtedly didn't add much to the trust aspect of the situation. I believe we looked like two hippy construction workers. In the end, we found two dealers that were very good to us. I don't really think they had a clue as to what we were doing, but they loaned us some very nice pieces. When the house was on display, both dealers came to see our room. Understandably, they told us our room was the best, but we knew it was because ours was the only room they could relate to.

The dining room was a group project for any of the women who wanted to participate. Some of the women painted a very lovely carpet. There was a huge table with a brightly colored cloth upon which all manner of exotic handmade non-edible foods were placed. I created a soft vinyl, partially melted butter cube on a plate, a soft vinyl salad bowl and tongs, and a tall vinyl wine bottle with four wine glasses filled with red velvet wine. To give the room a touch of elegance I crafted a clear vinyl chandelier with individual prisms. I wired it electrically so it really worked.

A very enjoyable part for me in creating the dining room was painting a mural on the back wall with Faith Wilding and Miriam Schapiro. Our collaboration produced a lush fruit still life, a takeoff on an Anna Peale. It was a wonderful experience to be painting alongside two such lovely women. At its completion, we felt the mural needed a signature, but not three. Using the first two letters of each of our names, we invented Mikafa, a very exotic woman painter.

When Nancy and I were doing the finishing touches on *Lea's Room*, I began to feel the room should have an occupant during the showing. This occupant should be Lea, herself, the aging courtesan, sitting at her dressing table, applying layers and layers of makeup, trying to cover the fact that she was aging, losing her beauty, losing her livelihood and losing her identity. I decided to perform the piece every night that the house was open, January 30 through February 28, 1972.

At first I was excited about doing the piece and I enjoyed doing it. But as the performance nights went by, I began going into a severe depression. Confronting myself in the mirror became a nightmare. I could see my own vanity, my own fears of growing old, becoming less and less beautiful. It was a very painful piece to do. Sitting in front of a mirror, staring at myself for hours on end, I felt I was going through all this pain for no purpose, because many viewers didn't even look at me. Others would ask me questions about the wallpaper or the furniture. One person asked, "What's she doing in here?" Yet, when women did notice me and watch my performance for some length of time, some were moved to tears. That saddened me as well. I felt those women had undoubtedly been through so much pain and intimidation from a culture that says we are ugly instead of beautiful, old instead of young, that I shouldn't be giving them any more pain.

I have one fabulous memory from *Womanhouse*. That was the day Anais Nin came to view our creation. I can still see her standing in the doorway of *Lea's Room*, a look of delight on her face. She had loved Colette's books and she told Nancy and me that our room was a wonderful depiction of Lea's room. I told her I felt I knew her after reading her diaries and I put my arms around her and gave her a hug. She felt so tiny and frail, I thought I might crush her. Later, Judy told me Anais was very pleased at what I'd said and done. At that moment, I felt the project had definitely been worth all the pain and effort.

When *Womanhouse* was over, I experienced a great sense of relief, combined with a tremendous sense of loss. I had grown accustomed to driving there every day, working physically very hard, then traveling home with a sense of knowing I had accomplished something. What I didn't realize at the time was I had also grown so used to working with other women, it was a new fresh thing for me and I wanted it to continue. Yet, I was caught up in the general emotion the other women were expressing, "I'm glad it's over. Now I can get back in my studio and do my own work." I found myself saying that as well, convincing myself that was what I wanted, until I was back in my studio feeling empty and alone.

Looking back to the fall of 1972 when we created *Womanhouse*, I can truly say that it was one of the most intense, inspiring, aggravating, exhilarating, exhausting, depressing and rewarding times of my life. Lasting friendships and bonds were created that made us all stronger separately. Throughout the years since I was part of the program, every now and then, I'll remember and miss that group strength, support, the sharing of ideas, the acceptance and the absolute permission to do the outrageous.

4

INTERVIEW WITH SUZANNE LACY

Moira Roth
Abridged by Laura Meyer

One of the founding members of the Feminist Art Program established by Judy Chicago at Fresno State College in 1970, Suzanne Lacy was born in 1945 in Wasco, California. While criss-crossing the globe as an internationally recognized performance artist, Lacy continues to draw inspiration from her small town working class roots, creating conceptually elegant and socially provocative art "events" that work to empower and raise awareness among social groups outside the traditional centers of power.

In the following excerpts from an interview conducted by art historian Moira Roth in 1990 for the Smithsonian Archives of American Art, Lacy describes experiences in the Feminist Art Programs at Fresno State and the California Institute of the Arts, and her 1973 collaborative performance piece, *Ablutions*, which launched her public career as a feminist conceptual performance artist.

The full text of the interview is available online at www.aaa.si.edu by clicking on "oral history interviews."

SUZANNE LACY: I discovered feminism—this was in '69. I then applied to graduate school at Fresno State.

MOIRA ROTH: Why did you single out Fresno State?

SUZANNE LACY: I think I had a boyfriend going there. [laughing]. Some real profound reason. Fresno had a fairly decent grad program in psychology, and I got right in. Even though my undergraduate degree was zoology, I was asked to teach immediately because of my science background. At that point feminist organizing was beginning in psychology. I went to the founding meeting of The Women's Psychology Associates at an American Psychological Association annual conference in Washington, D.C. I met a lot of woman psychologists who were just starting to ask questions of Freud's

attitudes toward women, etc. In graduate school, I taught a course in feminist psychology, which was very new then, for my graduate peers, and rabble-roused as much as I could every time Freud came up in a class, and I was known as "that angry woman."

At Fresno, I ran into Faith Wilding, who was there as a graduate in English literature. Her husband was a teacher. We proceeded one day to stick up signs all over campus saying, "Feminist meeting tonight." There must have been over thirty or forty women who showed up. Faith and I sat there dumbfounded and looked at each other and said, "What do we do now?" We did what has become, I think, a kind of strategy. We began talking about sex.

We had a totally enthralled group of women, and the next thing you knew we had begun feminist organizing at Fresno State. In the meantime, Judy Chicago, looking for a way to start a feminist art program, came to Fresno from Los Angeles, approached Faith, and began to talk about organizing young women art students. I applied that spring, after a year of graduate school. I remember the interview with Judy sitting there with her straw hat and two or three of her little groupie girls around her. You know, I'd always done art, so I felt like this is a natural for me. She said, "No, I don't want you." I said, "What do you mean? I know all about creativity and I've always done art." She said, "That doesn't matter. You are on the

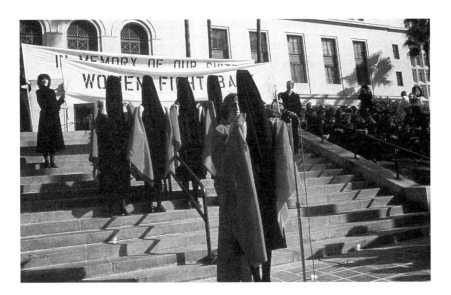

FIGURE 4.1 Suzanne Lacy and Leslie Labowitz, *In Mourning and In Rage* (1977). Performance at Los Angeles City Hall protesting violence against women. Photograph by Maria Karras reprinted with permission of Suzanne Lacy.

career track for psychology, and I'm only interested in working with women who will become professional artists." I didn't know what on earth she was talking about, but I did know I really wanted in that program. So Faith and I proceeded for the next several months to strategize how to get me into the program, which we eventually succeeded in doing.

MOIRA ROTH: Could you describe the program at Fresno that Judy Chicago ran? How it was run, who was in it, how she conducted it, how you felt about it.

SUZANNE LACY: I think one of the major things I got out of it was my first real encounter with female sensibility. I had always had women friends, but I had been trained academically with men, had identified with them, and had found some things about women quite provoking. Mostly, their lack of freedom and inability to experiment, go places, and do things (which I thought was what men did). But when I got involved with that program for the first time I began to appreciate not just particular women but all women. In terms of the structure, Judy brought about fifteen students together. We had to make a major commitment of time and (for us) money. That is, we could take anywhere between three and twelve units of school credit. For many of us, over fifty percent of our schooling was this program. The first thing she did was ask us to buy work boots. Then she taught us how to deal with realtors, as we canvassed Fresno to look for an abandoned space to make into our studio. We found this huge old theater outside of town and, with our work boots, began to transform it. Judy taught us carpentry. I was certainly familiar with tools and stuff, but I'd never learned how to sheetrock. We made flawless walls. We completely renovated this whole place. And in order to do that, we had to pay money; I think at that time it was twenty-five dollars a month, which was, given that I think my total income was two hundred, a rather major commitment. I was freaked out, as I've always been, since I've been an artist, about money. But nevertheless, we all did it to support the rent and utilities in our studio.

We had a series of courses. We had reading studies, feminist art history and studio art. That's when we first started discovering people like Frida Kahlo, Mary Cassatt, and other women artists, who were uncovered subsequently or simultaneously—I'm not sure which—by art historians. Several women we discovered by rooting through used book stores. I remember when Nancy Youdelman came to class one time with the book of the 1883 Chicago World's Fair and the first Women's Building. This was revolutionary to us. We pored over this and other books and found photographs in esoteric places. I emphasized feminist literature and tried to get the group more cognizant of the major themes, like racism, lesbianism, violence against women, etc., that were under discussion in the feminist movement (which Faith and I were more connected to than the other students). . . .

So we built ourselves an art studio, and we spent a lot of time working on our art. Judy would give us assignments having to do with topics, for example, like rage. You know, like, "How do you feel when you're walking down the street with men leering at you?" There was indeed a lot of anger that got expressed in those early performances. . . . People turned to performance almost intuitively. It wasn't as "sophisticated" as some of the conceptual performance works at the time. For the most part, we didn't know anything about that work and I don't think Judy knew a lot about it either. We were doing what I'd call skits. She intentionally steered us away from anything that was conceptual, that was removed from a direct engagement with our feelings. We made art of our experience. I remember I put up huge pieces of paper on the wall, eight feet by six feet, and I'd throw balloons full of paint at it, and slosh paint around. We were very physically engaged. As well, we had crits and we had consciousness-raising sessions.

MOIRA ROTH: In crits, were the standards whether one was emotionally engaged? Were there aesthetic judgments made?

SUZANNE LACY: There were aesthetic judgments, but it was based on the ability of the work to authentically reveal the self and one's feeling states. But it was a form of criticism which continued to develop and is different than criticism I've seen at other art schools since then. For example, Judy gave assignments having to do with emotional states, or feelings about mothers or about other women. Of course, one could also just do art art. There was no prescription against that. But we were very caught up in a burgeoning awareness of what it meant to be a woman. . . .

Those first consciousness-raising groups were incredibly intense. It was like uncovering, in a funny way, an entire new world, within your self. I remember seeing the movie, *The Bell Jar*, from the book by Sylvia Plath, and watching the scene where she's almost raped by her date, and thinking, my God; while I have never been raped, I had certainly had rather forceful experiences with dates. The kind of pressure that you wouldn't ever describe as attempted rape in the fifties and sixties. So our work together was like a continuing revelation. So performance developed. I did paintings, not much performance at that point. I did a lot of conceptual work, wrote, and I made sculptures. Things that looked like interior organic shapes. I did a lot of pencil and pastel drawings. And I guess one sculpture that sort of stands out in mind is a life-sized bride, which ended up looking like a cadaver, that was made with resin.

It looked like a macabre Kienholtz, with birth-control pills for her bridal bouquet and a gag over her mouth, and she was lying in a position like she was about to be raped. And she was, because of the material. . . . It was a papier mâché figure with about an inch of resin meticulously layered, and then this cloth wedding gown that was also layered in resin. So the whole thing had this rigid fifties look. And her eyes were popping out of their

sockets. For a cunt she had a plunger with a pink lightbulb in it. I didn't realize it at the time but it was an aggressive and frightening image of marriage as a trap. . . .

The consciousness-raising was interesting because it was also borrowed from—this was the late sixties, early seventies—from the intensity of the Gestalt therapy movement. People all over the country were sequestering themselves away in little rooms and screaming at each other in the service of changing their psyches. [chuckles]

That was not much different than what we did, and at times that aspect of the program made me nervous. I would back out of it. Part of it was my psychological training. I just felt that there was a kind of a group practice. . . . And I was always an outsider to the group. I was older; Faith and I were the oldest. I was educated very differently—in science and psychology. And I was very logical and conceptually oriented. Everybody else operated in a much more expressive emotional and intuitive mode. Some of it was quite good. People went through a lot of changes. Some of it I thought was a little destructive, though not any more so than any of the other encounter groups that I had participated in during that era. And I led many of them myself, including some sort of rebirthing experiments. . . .

I think that the women did some very good work. I think that they uncovered some important historical information in that program. Many of those women went on to be artists. Some dropped out later in the year, but by and large I think it was a tremendously affirming experience to be with all women, to have such a charismatic woman role model in Judy. We talked a lot about role models. I think it organized people's psyches in a different way, and allowed them to move forward with a lot more courage. We got to a point where we were doing exhibitions for the Fresno State Art Department, and all the faculty and students came. They were blown away by what they were seeing.

We took the show on the road a few times, and I remember one time (it was pretty funny) when somebody in the audience got up and slugged Faith. The presentations almost always ended in confrontation. There was a lot of antagonism men had to what we were saying.

We were really gutsy. I mean, we were really presenting a very tough female image—to the world through our art and our panels. Because of Judy's connections, we were able to make presentations in Los Angeles, the art world, and at schools. There was one weekend when Larry Bell came, and Miriam Schapiro, and Sheila de Bretteville. . . . Vicki Hall did a performance there. She was a terrific performance artist who moved to Fresno to study with Judy. A lot of people from CalArts came down, and we would have these big powwows, art showings, slumber parties. They were very exciting and intense times. That's when I met Sheila, who decided, prompted by Miriam and Judy, to do a Feminist Design Program at CalArts.

MOIRA ROTH: Did you also witness the beginning of Miriam and Judy talking with one another?

SUZANNE LACY: Yes, that was during that time. They began to meet each other and talk together, and indeed we were. . . . Witness is a good way to put it, because particularly Faith and I, who were older, were privy to conversations with Judy, who is very open about her process. Judy's a very, very fine teacher. She's incredibly demanding, and she knows how to push through to the tenderest parts of your psyche, and she goes right for the jugular in her criticism, which I think is good. Not in a humiliating manner, as it is in some art schools, but in a very direct and compassionate way. Why talk about the form and shape of something to the exclusion of what somebody is trying to express about themselves? She's also brilliant about historical context. The woman reads incessantly. Whenever she wants to know about something, she sits down and plows through scores of books. She's also tremendously supportive of her students. I remember many times over the years when I had trouble with money, she'd just quietly hand me twenty-five dollars. And I would never have to pay her back. . . .

 The feminist programs at CalArts were several. Miriam and Judy did the Feminist Art Program. Sheila did the Feminist Design Program. Deena Metzger did Women in Literature and Women's Writing. In the social sciences program—I think it's called humanities at CalArts—there was also a group of women working on women in sociology. At this point in time there was a massive amount of feminist consciousness and activity there, which CalArts has still not recovered from.

MOIRA ROTH: Did you also have contact with people outside CalArts?

SUZANNE LACY: [W]e did in fact have contact with national feminist artists, because we had the West-East Coast Bag Conference at CalArts. A woman was raped on campus, and so that became a focus point; we had a panel discussion with the feminist Z Budapest. Judy kept us connected with the Los Angeles, even national, feminist art scene. Like the Los Angeles County exhibition by Linda Nochlin and Ann Southerland Harris, that came about as a result of protests by artists like Joyce Kozloff and Bruria. *Womanhouse* was the production of the art program. I was in the design program, so I did not participate directly in *Womanhouse*. Judy did a performance workshop, and I took that, along with other classes she taught.

MOIRA ROTH: What kind of assignments did she give?

SUZANNE LACY: One that I remember with fondness was "Route 126." We had to drive along this two-hour stretch of road between CalArts and the coast and at some point stop the caravan of cars and get out and do a performance that had to somehow be identifiable as done by a woman. That was the only guideline. So we stopped at a telephone pole, and Judy and Shawnee Wollenman tacked Kotex on the pole. We have pictures of them being chased away by the highway patrol, who made us take them down.

Nancy Youdelman did this lovely piece at the beach where she draped herself in flowing scarves like Isadora Duncan and walked into the water until she disappeared. Somebody else (I think it was Shawnee) did something with eggs. This old, abandoned jalopy in a wash had fascinated me, and I stopped the caravan there for my piece. I gave everybody pink paint, red velvet, and a big stuffed heart, and we transformed this old jalopy into a woman-renovated car, and then we left it. After years there, it was subsequently hauled away in a week. [both chuckle] So, that was one assignment. I remember two other pieces that we did, both of them about breasts. We were involved with things like menstruation, breasts, ovaries, all the female anatomy parts. [chuckling]

I did one with Laurel Klick and Susan Mogul on mastectomy. We developed an image that we used later in a piece on mothers. We had a woman ace-bandaged around the chest, and somebody came in and cut her nipple off and blood came out. (We were into blood and guts.) But it was a long work about breasts and social attitudes toward breasts and breast cancer. In a second piece that Nancy Youdelman, Jan Lester, Dori [Atlantis], and I did, we took Nancy, who was flat-chested, and we pooled our money and sent away to several breast-development advertisements. This piece was called *I Tried Everything*. [chuckles] And we documented her for a month trying all these breast-enhancement devices. Every day we measured her, and we took photographs of her and we displayed them in the library, along with the various artifacts.

Another thing we thought about was mothers. Susan Mogul and Laurel Klick and I did a piece on mothers at Womanspace Gallery. It was a very interesting piece. Very body-oriented, organic, pre-verbal.

MOIRA ROTH: Could you talk about *Ablutions*? Because that was where you appeared fully formed as a performance artist.

SUZANNE LACY: That was in '72, so I believe it was in the same semester I was graduating. Judy never let us rest in terms of reaching audiences. In fact we didn't show at CalArts itself. We showed in classes to prepare the work, and then we were out there some place in L.A., some school or a gallery. She wanted us to put it out. For some reason, I was always very conscious of violence—I believe it has to do with my relationship to being in a body and with understanding sexual violence as an invasion of the body as a sacred space. At Fresno I said to Judy, "Wouldn't it be interesting if we tape-recorded stories of women talking about having been raped?" I imagined the audience would sit in a dark room and we would play the stories for them. That's not particularly interesting now, but you have to remember that in 1970 you could not find stories of women who were raped. They wouldn't tell you. So Judy said, "That's a very interesting idea. Why don't we start collecting stories." So Judy and I spent the next year tape recording. We'd hear rumors about a woman who was raped, and we'd find her friend, and

we'd. . . . You know, it was literally having to go down dark streets and end up in strange places in the middle of the night, tape recording these stories. Some women had never told anyone. We used seven women's stories.

Out of the performance workshop came many beautiful images. Sandra Orgel came in one day and showed us pictures of taking a bath in eggs. The slides showed the parts of her body—her breasts and her vagina—covered with these eggs with menstrual blood kind of running through them. It was a very beautiful image.

So we took these images, and the tape recordings and we put them together in a piece that was a linear narrative. The soundtrack was exclusively the women talking; really straightforward, like, "I was walking down the street. I was pushing my child in a stroller. . . ." Just telling in great detail the whole story of the rape. We had three galvanized metal tubs and piles of kidneys and piles of rope, and Jan Lester and I in white T-shirts and Levis and white gloves came out and methodically pounded these beef kidneys, in a row, starting from one side of the room to the other. In the meantime a nude woman came out and took a bath, first in eggs, then in blood, then in clay. She got out, was wrapped in white, laid down on the ground, and then another woman did it. I think two women went through the ablutions. Two other women did some imagery where they were twinning. They were adorning each other's hair with chains. This was very methodical and throughout women were talking about being raped on a sound system. At the end, Jan and I, like giant spiders, tied everything to everything: the beef kidneys to the people, to the trays. . . . And then we left the scene.

MOIRA ROTH: This is when the two women who'd been nude were bound.

SUZANNE LACY: They weren't bound really; they were wrapped in white and laid down, and then they were tied to everything. We went over the set, tying it together. And the last words on the soundtrack were, "I felt so helpless. All I could do was just lie there. All I could do was just lie there," and the tape stuck on that ending. The audience was stunned. They were really stunned. It was in Laddie Dill's studio, and so there was a fairly heavy-duty Venice art audience there. Apparently, several people just sort of gagged and ran for the door at the end of it. They had never been exposed—not only with that information at that level of detail, but to women's perspective on it. And the rage and the intensity of victimization that was in the piece. In fact, a couple of the women who were in the piece, one of them—I think it was Jan Oxenberg—had an emotional reaction to allowing herself to participate from the vantage point of the victim. She was one who took the baths. It was a very evocative work of art. We did it just before we graduated from CalArts. In the meantime Womanspace Gallery in Los Angeles had been developed. So we were starting, even as young students, to relate to it.

MOIRA ROTH: Which was an exhibition space.

SUZANNE LACY: Um hmm, run by women. And Judy had done *Womanhouse*, which I think was a tremendous accomplishment.

Ablutions was a kind of exit performance for us. It was moving from CalArts to Los Angeles. It was moving from graduate school into the professional community, so that our relationships then would be closer to Womanspace, as opposed to the school. The year before I graduated I had an important encounter with Judy. She had done *Womanhouse*, we had the performance program, and it was the last day of school, just before summer vacation. I had shown some sculptures in the crit class. I had taken some mannequins and put wax all over their faces, and then melted it, so that they looked like women whose faces were falling off. During the class, Judy said, "Suzanne, this has got real potential, this body of work. If you don't stop splitting yourself between design and literature and this and that and the other and make a commitment to art, I'm not going to work with you anymore." When I left class I ran around shaking and grabbed my friend Jill Soderholm and mumbled incoherently and ran off and grabbed somebody else. And then I just made this switch inside. I went out and caught Judy in the parking lot, and said, "Okay. I'll be an artist." I didn't actually feel pressured; I didn't feel like she was going to abandon me or anything. It had nothing to do with that. I knew that she was challenging me, which she had tried to do earlier, to acknowledge that I was an artist, not six million other things. And Judy knows about commitment, and I think that's what the issue is, and she knows how to push you up against the wall, those of us who are more nervous about making commitments.

Judy was all content. I mean, obviously Judy is herself a strong visual formalist, but her teaching was for expression, expression, expression.

5

THE FIRST FEMINIST ART PROGRAM

A View from the 1980s

Paula Harper

In October 1971, at the California Institute of the Arts in Valencia, California, twenty-one young women who wanted to become professional artists entered the radically new Feminist Art Program (FAP) organized as a community of women by its designers, Judy Chicago and Miriam Schapiro. While the experiment had a short life—faltering in its second year and ending in its third—this vanguard community made itself a memorable place in the history of both feminism and art.

Several values underlay its formation. Both Chicago and Schapiro held that women in our culture have not been able to express their creativity through the fine arts in the same way or to the same degree as men have: their potential has not been given the same interest or their achievements the same recognition. With the right kind of encouragement and supportive environment, Chicago and Schapiro believed, women's creativity could flower. Chicago, who had experimented with some radical educational techniques in her courses for women at Fresno State in 1970–71, was the chief architect of the program; Schapiro, impressed by what Chicago had done with the Fresno group, committed her considerable experience, energy, and professional skills to the collaboration.

Looking back on her own education, Chicago felt a growing conviction that she had been thwarted by her male teachers, who had not understood the images she had tried to make and had imposed their own forms, artistic language, and subject matter on her. One of her motivations was to "redo" her own education while providing other women with the extra support they needed to develop the strong sense of self necessary for an artist.

Building strong egos in the young women took a high priority in the educational program because a firm sense of self is indispensable to an artist, the center and source from which personal and therefore original expression flows.

Since women are conditioned to please and defer to men, the presence of men would interfere with women students' self-development and expressiveness. Chicago decided that men would have to be excluded. She wanted the young women to compare themselves only with each other and establish their identities in this nonthreatening ambience.

Schapiro was farther away from her own formal education (she was forty-eight years old to Chicago's thirty-two) and had enjoyed considerably more success as an artist. To her the most important condition of the community was not the exclusion of men, but she agreed that the women needed to work together as a separate group. As she has said, looking back on the experience, "We knew we had to take a hard look at who we were—and when we're in the society of men, we're generally prohibited from doing that. We're permitted to see ourselves as men want us to see ourselves but not as we really are." And practically speaking, "Men are not interested in encouraging any challenge to the patriarchy. They just want to keep order, according to their habits."[1]

Schapiro knew that it was very difficult to break habits—especially in art making. To her, the basic drama of the FAP was in "making something happen against the grain. We felt we were just as important to ourselves and to the world— now this is going to sound very pretentious—as all the scientists gathered together at Los Alamos felt when they were making the atom bomb. We felt that way. We saw ourselves as instruments of history."[2]

Both Schapiro and Chicago, and many of the former students of the FAP, have a keen sense of its historical mission. They see it in the context of the late 1960s in California—a time of social and psychological experimentation, of the self-development movements in which women participated, and of the burgeoning of feminism. California Institute of the Arts, or CalArts, is a professional art school that prides itself on commitment to the avant-garde and that sought out and encouraged innovators and visionaries. And the head of the School of Visual Arts at CalArts happened to be Schapiro's husband, Paul Brach. So a combination of circumstances, both general and specific, created a favorable historical moment for the program.

At CalArts, the students of the FAP were separated from the institution both physically and psychologically. They had their own communal space, the large "Feminist Studio." During group meetings and consciousness-raising sessions the door was sometimes locked from the inside to guarantee privacy. The students also had separate studio spaces of their own, and the school provided tools and equipment as well as money for projects and needed materials. Their teachers were all women: Schapiro taught drawing and painting; Chicago focused on performance art; Faith Wilding, the teaching assistant, led a consciousness-raising group and a journal writing class; I taught a seminar in the history of women artists. It was the "first time that a school of art was addressing itself specifically to the needs of its female students by incorporating an educational program designed and run by women."[3]

A question that often arises when discussion turns on women's cultural significance is, how can women's contribution to a culture be recognized and described? Thinking about this question in connection with the FAP, I concluded that in the visual arts the necessary first step is to be able to see women's work as work by women. That means setting it apart from visual art by men. One of the values in the separatism of the FAP, as I thought, was that it created a situation in which the art of the young women could be seen as different. But I had overlooked a practical reality. "The biggest difficulty," said Schapiro, "was in making the art different."[4] Helping the young women escape their own previous education was the first problem to be met. Chicago's goal, as she stated it then, was not to teach the students to make art but to help them restructure their personalities into those of art makers. In 1971 she wrote, "There are so few women artists because the personality structure of a woman, as dictated by the society in which we live, is inconsistent with the personality structure that is necessary to make art": active, aggressive, self-expressive, self-valuing, with a secure sexual, artistic, and historical identity. "Most women artists," she wrote in *Everywoman*, "are caught somewhere between male identity and female identity, between adapting male values and struggling to find their own values." In a moving conclusion to her statement, Chicago revealed her goal for her students and herself:

> In an attempt to compensate for the often uncomprehending responses, the woman artist tries to prove that she's as good as a man. . . . She chooses those areas of subject matter that most closely approximate the experiences of the male and she avoids those images that would reveal her to be a woman. She resists being identified with women because to be female is to be an object of contempt. And the brutal fact is that in the process of fighting for her life, she loses herself. For instead of deriving strength, power and creative energy from her femaleness, she flees it and in fleeing it, profoundly diminishes herself. She must turn and claim what is uniquely her own, her female identity. But to do that is the most difficult of tasks, it is to embrace the untouchable and to love what is despised.[5]

A statement of Schapiro's made at the same time—before the FAP actually began the following autumn—expressed simpler and more practical goals. She anticipated working with Judy and the students

> all day, every day, so that we merge together and form a collaborative working relationship of twenty women artists. . . . This means that I can finally break away from the standard student-teacher syndrome and that my range of teaching can be broadened to include friendship, mentorship, and sisterhood. . . . Neither Judy Chicago nor I believe that the simple goal of an art education is to reach sophisticated art making. . . . The most important thing you can do is be responsible for the level of humanity in

your classes so that when the art "emerges" it can be authenticated on the basis that it is true to the internal feelings of the artist. The women . . . will be able to open themselves up. . . . The ego strength they will need in order to survive as artists in our society will develop in the greenhouse of our program.[6]

Schapiro's "greenhouse" image, a tranquil metaphor for natural nurturing, contrasts with Chicago's dramatic image of desperate flight, struggle, and surrender. But despite their differences, they both agreed, at the beginning of the program, that a high priority was to be placed on developing strong female egos in the students.

One method of implementing this psychological goal led to what was perhaps the most important achievement of the FAP in creating new kinds of art. The students were encouraged to accept their own life experience and preoccupations—no matter how "trivial" they had been conditioned to think they were—as worthy subjects for their art. In the FAP, makeup and shoes were subjects as viable as machine forms and mathematical systems. For example, if a student was interested in lipstick, this subject was not dismissed as artistically trivial, as it might have been by a male teacher. Instead, she was encouraged to examine her own experience of lipstick, to expand it by considering the long tradition of face makeup, and to analyze the physical nature of lipstick—its color, texture, and sensuousness as well as techniques for its application. She could explore the psychological effects of applying and wearing makeup: enhancing and masking experiences, the emphasis that wearing makeup puts on the face as the communicator of self. The sociological implications of makeup also needed investigation through questions about who wears the makeup in different societies, when they wear it, and what it conveys about social relationships. In short, the student's interest in lipstick was shown to be not trivial or merely personal but linked with a long and complex tradition of human experience into which women, as the makeup-wearing sex in contemporary society, have a particular insight. Schapiro later recalled, "The real substance of the feminist contribution to the art of the seventies was that, for the first time in the history of art, woman's life became the content of her art. It was done spontaneously and without access to any previous model, and it coincided with a powerful political revolution, namely the feminist revolution—which was doomed, as all feminist revolutions are doomed in a patriarchy. So now what we're experiencing is the slow covering up of all the accomplishments and achievements."[7]

The methods that Chicago and Schapiro used to elicit new subject matter and build strong "female egos" were unconventional in an art school, although more familiar to psychologists who had developed a range of new group therapy and "encounter" techniques in the 1960s. Central to the program was the consciousness-raising so important to the feminist movement. Also, the students of the FAP were almost immediately plunged into a communal project that tested

the workability of these new methods of feminist art education. From November 1971 to January 1972, the creation of *Womanhouse* engaged the group in an intense collaboration.

Through a special lease agreement, the program took over an abandoned, seventeen-room house in downtown Los Angeles, forty miles from CalArts itself. The intention was to transform it into an environment that expressed women's experiences within their traditional domain. The students spent a month of eight-hour days as a work crew repairing and painting the dilapidated mansion—learning to operate power tools, plastering walls, replacing broken windows, building partitions. Many resented the physical work, unfamiliar to most, which seemed to have little to do with art, but Chicago in particular felt that this labor in common was indispensable to the building of a strong community. "A community," she later said, "requires bonding and identification. At CalArts the group was bonded by shared work. A model based on work and professional learning can transcend the personal, which is where many women's groups get bogged down."[8] She felt the students were learning discipline, perseverance, and cooperation in an ambitious, long-range project. They were being pushed beyond familiar limits, both physical and emotional.

When the house had been prepared, the art making began. Some students worked alone with one room; some students collaborated. Two students teamed up, for instance, on *Lea's Room*, a bedroom decorated according to the description given by Colette in her novel about an aging courtesan, Cheri. When *Womanhouse* was opened to the public, one of the students sat throughout the day at an elaborate dressing table in that room, examining her face in the mirror as she applied and removed layers of makeup as slowly and deliberately as a sleepwalker. Another student installed a female mannequin in the linen closet, her torso sliced horizontally by the shelves, trapped within the piles of sheets and towels. (See Plate 6.) The dining room—the only room in the house that celebrated the positive contributions of women in the role of homemaker—was a collaborative project. A feast made of painted bread-dough sculpture was set out on a table, a sewn vinyl chandelier swung overhead, and on the wall was a painted mural based on an eighteenth-century still life of fruit by Anna Peale. Next to the dining room was the *Nurturant Kitchen*, in which everything—walls, floor, cupboards, utensils—was painted a fleshy pink. The ceiling was covered with plastic poached-egg shapes that gradually changed into breasts as they moved down the walls, reminding us that the kitchen is the place where nurturing goes on for a woman's whole life. Chicago herself did a *Menstruation Bathroom*, a glaring white room seen through a white scrim stretched over the door-way. In it a wastebasket overflowed with bloody Kotex below a shelf filled with commercial products for deodorizing and sanitizing women's cyclical flow.

Recalling the intense experience of creating *Womanhouse*, Faith Wilding said, "When we were working . . . it was all day every day and usually in the evening, too. We were supposed to get there at 8 a.m., work until lunch, then a meeting

or CR (consciousness-raising)—or a big fight—over lunch, then work again until everybody had to go home. Often we got together at night to work on the performances or to sew pillows for the performance space or to work on bread dough for the dining room food piece. I was never home for three months— that was *Womanhouse*."[9]

Open to the public from January 30 to February 28, 1972, *Womanhouse* declared itself to be an art exhibition—a bold assertion at a time when abstract painting and sculpture dominated the upper reaches of the gallery and museum world. On weekend evenings students who had worked with Chicago on the techniques of psychodrama gave performance pieces that complemented the visual images of the transformed building. The "message" of the house, the entrapping and deadening nature of housewifery, was probably shaped largely by Chicago and Schapiro. The young students did not have much personal experience of traditional marriage and the homemaking roles of women. Nonetheless, the ideas of all were influenced by the general aim of feminists in the late 1960s to revise women's position in society by bringing attention to their oppression, and this ideology clearly shared by the many individuals involved gave *Womanhouse* its impact.

Art with feminist sources had been exhibited before, but in scattered fashion. *Womanhouse*, which made feminist art within a number of modes visible as an entity, proved that women's art could publicly express ideas and feelings special to women's private experience. In style, the exhibition was part happening, part environmental art, and part California funk. The materials used were not the traditional ones of fine art but the ordinary substances that women habitually work within their private lives—fabrics, makeup, furniture, food, threads, and yarns. Thus *Womanhouse* was, in a way, outside the ongoing professional dialogue of the art world and was not, as some have suggested, a reaction against minimalism.[10] With its use of women's traditions in craft and art, it came from outside the mainstream. This difference in its sources accounts for its freshness and for the wealth of new ideas and aesthetic possibilities it provided for the following decade.

By no means all its viewers have considered *Womanhouse* so positive an achievement, however. Some critics maintain that the kind of feminist art it represents seriously undermined aesthetic standards in the 1970s.[11] Feminists reply that the standards in question are male, not universal. They are produced simply through habits of seeing, not by natural laws, and can, therefore, be modified to accommodate women's habits as well. *Womanhouse* has also been criticized on the grounds that it was not art but therapy. (Such criticism indicates that it truly challenged the *definition* of art—a function of the avant-garde.) This essentially hostile response shows awareness at least of the implications of *Womanhouse*. An even greater, though perhaps unconscious, defensiveness lies behind the impulse of some critics to soften the impact of *Womanhouse* by assimilating it offhandedly into preconceived notions of conventional femininity. The *Los Angeles Times*, for example, called *Womanhouse* "cheerful and disarming as a pack of laughing schoolgirls under a porcelain sky . . . pervaded with the spirit of comfort and

magic that women bring to living, their endless inventiveness, bottomless energy and gentle persuasive humor."[12]

In fact, the techniques and processes that generated the form and content of *Womanhouse* constitute one of the most valuable contributions of the FAP to art education. The *Nurturant Kitchen*, for example, provides an illustration of how consciousness-raising generated subject matter for art. The three students working together on the kitchen were bogged down in indecision over what images to use. Schapiro suggested a CR session with the whole group on the topic of kitchens. As the women talked in turn, it became clear that the nature of the family relationship often revealed itself in the kitchen. Who gave and who took food, what kind of food was cooked by whom, and when it could be eaten was remembered by many as the basis of power struggles between mothers and fathers and between parents and children. In those struggles all family members, including women, came to tie women's identity to the giving of food. This realization led to the idea of a kitchen in which a decorative motif of poached eggs (humorous but not inappropriate) undergoes metamorphosis into breast forms: the essential symbol of women's power to nurture and the demands on her to do so. The kitchen of *Womanhouse* became a surrealist environment; the sickly pink color that suffused everything and the uncomfortable mutation of the somewhat nasty sculptural forms on the ceiling and walls demanded that viewers share the potentially draining effect of life in that room.

Consciousness-raising on a topic first elicited feelings and memories from the group. If a shared attitude, idea, or experience emerged, a symbol or image that expressed it was sought out by "going around the circle." The final and crucial step, of course, was actual use of the symbol or image in a work of art. This was the most difficult part of the process for the students—many of whom lacked skills in drawing, painting, and sculpture. Performance art proved to be a more direct outlet for expression. Faith Wilding recalled:

> Judy and Mimi ran an experiment for about a month in the spring [of 1972] where we all met regularly in the big studio to explore new subject matter. The subject was "mother" once, and in Judy's exercises we paired up— one played the mother and one played the daughter. I remember one day we were all lying on the floor groaning and giving birth and crying for our mothers. . . . Mimi led a drawing exercise where we wrote out the word "mother" and embellished it in different ways—a kind of automatic writing exercise. Later, there was a sharper separation: Judy led the performance group by herself and Mimi the drawing and painting group. Mimi began teaching skills. She brought in a model for life drawing, had a painting class where she taught us techniques, and she did a lot of crits.[13]

In the initial excitement of working on *Womanhouse*, with its emphasis on environment and performance, the students' lack of traditional art-making skills

was not as apparent as it would have been in a formal studio. And in fact the nonprofessional character of the student's art making was seen as a positive value. Part of the ideology of the FAP was a belief that a woman's art community could break down the traditional hierarchy of the art world—the distinctions between amateur and professional, between fine arts and crafts, between high art and popular art—in order to rebuild a new art from a more "democratic" base. Theoretically, the program was to be run democratically, with an emphasis on consensus, sharing, and a leveling of the traditional teacher-student relationship. The FAP was to be a paradigm of the proposed "female" social order, based on cooperation rather than competition and on the elimination of traditional hierarchies of authority. In practice, however, the strong personalities and leadership of Chicago and Schapiro guided the program. Many of the former students now perceive Chicago, in particular, as having been an authoritarian figure who imposed, or projected, her goals on the group.

At the time, the FAP took on a mythic quality for women in the Southern California art world because the group was thought to be making art through a democratic process. Women of the idealistic political left were especially drawn to a project in which "art was not the exclusive domain of the Artist [but] simply the place where you deal with visual materials," as Moira Roth, an art historian and frequent writer about performance art, recalled. "These were people just beginning art, not trained artists. Somehow, because of their passion, politics, anger, they made very good art. Their experience in life made it possible for them to make interesting art—for a short while. After a short while, then inventiveness and skill became more necessary." Roth is also perceptive about the distance between theory and practice: "At CalArts, it was not an equal CR circle; there were teachers and students. It was a microcosm of one aspect of feminism, of the contradictions between democratic theory and the reality of leaders and followers in practice."[14]

As the art historian for the FAP during its first year, my responsibility was to help discover and construct a tradition of women's art. My methods were themselves fairly traditional; I directed a research seminar on women artists of the past and began to assemble a library of material in what was then an archival vacuum. Since I was new to feminism, cautious by nature, and inexperienced as a teacher (I was still a doctoral candidate at Stanford), I clung to a more conventional role as protection against the thunderous turmoil of innovation around me, which I sometimes imagined as the noise of the Bacchantes pulling down the Parthenon. But in hindsight, it appears that my goal for myself and for the students was in the vanguard of scholarly revisionism.

It was surprising and moving to realize how much inspiration and nourishment the young women artists drew from the discovery of their predecessors. The elucidation of a continuous tradition within which they could see their own lives and work was so valuable to them, on a profoundly personal level, that it changed my idea of the real value of history. I realized what it had probably always meant

to men, whose tradition it so clearly and thoroughly traced, and what it could mean to me and to other women. My own professors, although excellent, viewed art works and art history from a male perspective only. Other women art historians, I have since discovered, had similarly one-sided training. When I interviewed Roth, for instance, she and I quickly realized a common base in our experience:

PH: Remember all those afternoons when we sat in darkened rooms looking at slides like, say, Rubens's *Rape of the Daughters of Leucippus* . . .?

MR: . . . which we wrote down carefully, mainly to memorize the spelling of "Leucippus" and the date—as opposed to the word "rape."

PH: I remember the lecturer talking about the form and color and the vigor of Rubens's "touch," and feeling—vaguely—that I and my feelings as a woman had been left out.[15]

Recognition of the problem of this "cognitive dissonance" between art history and women art historians made it comparatively easy to devise a remedy, one still in use, though refined and improved: for art historians as for artists, it was to go back and "redo" our education. In that process, the most helpful study was not only the history of women artists but also the general history of art from a newly critical viewpoint. We turned our raised consciousness toward the painted relationship between the sexes in the past and confirmed that our feelings as women had indeed, for the most part, been left out. This admission allowed us to discover that Rubens's *Rape of the Daughters of Leucippus* reveals much about masculine erotic fantasy, the requirements of Rubens's patrons, and the way art, mythology, and history were put to the service of these needs in the seventeenth century. My experience with the FAP was crucial to this rethinking. Introducing an art history session at the College Art Association in 1973, I defined the goal it had helped me to formulate: "The reevaluation of patriarchal scholarship and the challenge to its approved standards is a liberating activity not only for women art historians who must, in the effort, constantly check their own lived experiences, personal and collective, against received opinions—but for the discipline of art history itself, which can be energized by this criticism from a new source."[16] While the young artists of the FAP were not as much interested in this project as in discovering women artists of the past, who provided direct models of inspiration for them, the mutually supportive and stimulating environment of a women's community encouraged me as an art historian in this new and fruitful direction.

★ ★ ★

What happened to the original members of that community? Those with whom I have spoken felt that their teaching techniques and goals had been strongly influenced by the FAP experience. In their teaching, they strive to connect art

to the lived experiences of their students, male and female, and encourage them to value their own interests and perceptions. About half the students have gone on to careers as artists and art teachers. Suzanne Lacy is nationally known for her performance art, Mira Schor shows her work in a Soho gallery, Nancy Youdelman and Robin Mitchell in Los Angeles. Faith Wilding has written a history of the women's movement in Southern California.[17]

The later careers of the program's founders have diverged rather widely. Schapiro has successfully reentered the wider art world and shows her work—a synthesis of her strong formal gifts and her fabric collage techniques of the early 1970s—in good "genderless" galleries. Chicago has gone in her own characteristic direction with her cooperative project *The Dinner Party*. Her Through the Flower Corporation is "dedicated to social change through art."[18] In her new *Birth Project*, she creates graphic images of the process of birth as needlework designs that are executed by women in all parts of the country. Chicago increasingly bypasses the small, special audience interested in "high art." She is making what is essentially "popular art" and directing it to the general public. Schapiro had, and still has, a strong commitment to the importance of individual excellence, aesthetic quality, and the traditional categories of art. Chicago had, and still has, a strong commitment to art as an educational medium, to performance art, collaborative projects, and art by non-professionals. Their personal split embodies and illustrates a schism in feminist art in the later 1970s, one that was foreshadowed by the ideological and artistic differences of opinion between the two leaders that plagued the FAP during its second year.

In discussing the advantages and disadvantages of the FAP with a number of its former students, I found general agreement on the nature of the advantages. The program provided a psychological environment that gave them the confidence to trust their own instincts and judgment, even if their judgment was to leave or rebel against the FAP. It released their creativity. It was stimulating, demanding. It created a strong feeling of community and a conviction that the group was engaged in an experiment that was making history. Mira Schor described it as the "boot camp of feminism," implying an affectionate nostalgia for the hardships of its members' initiation. That feeling is one that bonds former students, no matter how severe their criticisms. Most of them acknowledge that for better or for worse the FAP changed their lives. When they assessed the program's disadvantages, the former students showed more variety in their viewpoints. Some criticisms recurred, particularly that both Schapiro and Chicago had, in carrying out their ideas, been psychologically manipulative; that Chicago's psychodrama exercises created more emotional disturbance than her training could manage and therefore were potentially dangerous; that the students were encouraged to express anger toward men that not all may have felt; and that Chicago, especially, projected her own goals on the students and tried to dictate the content of their art. On the last point, Robin Mitchell noted, "The students were not supposed to make abstract art. Making images like mainstream art was

a terrible no-no. Judy was so doctrinaire about what art was: it had a hole in the middle. That was okay for her but not for me."[19] These pressures to conform to the ideology of the community were resisted in varying degrees by many of the students, but Chicago felt them to be necessary: "Since women have so much trouble bonding, it was very important in the early seventies to build an artificial environment which supported bonding."[20] A former student's response was, "It couldn't last too long. It was a forced situation, too artificial. At one time I thought I would throw up if I saw another drawing of a split pear."[21]

The most troublesome aspect of the FAP, the one that generated the most serious and searching criticism from those involved, was its separatism. The students acknowledged that the sense of community was strongest when as a totally female group they were working on *Womanhouse* in close, daily association away from the CalArts building. When the separatism was most complete, the program was most successful. But a number of the former students are now bitter over what they see as the program's hostility to men. Students who were in relationships with men were often criticized; some were encouraged to repudiate their boyfriends or husbands. The emphasis was on the building of careers and the development of a professional life. They now question the sacrifices that were made for the goals of the feminist community and accept the goals themselves only as they can be modified as part of a larger social framework that includes men. Was the separatism of the FAP worth the difficulties it caused? Wilding's response is, "That's a hard question. . . . I guess I'd have to say it was worth it, but it cost a lot. I'm only now beginning to realize how much it cost. But we wouldn't have made the gains without that drastic, radical dislocation of the status quo. Once you've done that you can't go back. You can go somewhere else but you can't go back."[22]

Chicago's assessment of this issue is that failure to solve the problem of interaction between the community and the dominant male culture weakened the program. "Since most of the women, including me, lived with men, when we left our group it was very easy to move back into our identification with men. One of the things that destroyed the FAP is that the students used to have to leave the safety of the program and reenter their bonds with men, and they were continually, every day, every hour, confronting where their loyalty and primary identification lay. There was continual pressure on them."[23]

A few lesbian members of the FAP did not experience this problem of conflicting loyalties, but their solution could not work for the majority of the women because of their own sexual preferences and social conditioning. Schapiro's statement on why she ultimately had to forsake a separatist women's community reflects these concerns. "I am married to a painter, I have raised a son, I have parents who are part of my family. I could not adhere to a woman's community and keep one foot in a traditional nuclear family, so I was bound to go the way I did. One of the disadvantages with such a program is that you fall so in love with the community that you don't realize that in order to survive in

the real world you have to play a different kind of role where you hop on one foot and then the other foot and that your manipulative resources have to be strengthened."[24]

The FAP, although short-lived, demonstrated that a community of women could deliberately effect change in their own creativity and direct it toward specific goals. The art that resulted from the interaction of the group was of a different kind from that concurrently being made by any individual male or group of males working traditionally or as part of a conscious vanguard. (It had, however, some precedents in the work of California artists Edward Kienholz and Bruce Connor.) This achievement stimulated the debate, already begun by Chicago and Schapiro, on the question of whether a specifically female art exists and, if so, what its nature had been in the past and could be in the future.

The debate itself, with the attendant critical writing, probably encouraged the creation of the kind of art defined as "female." In the 1970s, the quantity of art by women that dealt overtly with female experience increased—or at least more of it was seen in national magazines and in exhibitions. When representational, this art dealt with sexual, domestic, and social experiences and situations. When abstract, it tended to use materials associated with women's experience and with the tradition of women's crafts as well as forms with a biological connotation. By the early 1980s, however, some women artists perceived that their creations of the 1970s had been adapted—sometimes expropriated—by male artists to different purposes. Schapiro, for example, began making collages in the early 1970s that incorporated pieces of pattern-printed and embroidered fabrics—tablecloths, curtains, and aprons. She called these "femmages" to make their source in women's tradition clear. Schapiro took a leading role in the subsequent development of "pattern and decoration." This movement includes both men and women and provides an example of the way the experimentation carried on by women in the early 1970s has been accepted by men and absorbed into mainstream art. A difference remains in the way men and women use pattern and decoration, but it is not one readily apparent. A pattern painting by an artist like Robert Zakanitch, for example, deals with color, form, and modes of stylization—it is about the formal aspects of decoration. A similar painting by Schapiro is about the tradition of women's involvement in the decorative arts. Although the two kinds of work may appear very similar, there is a crucial difference in their intention. This difference, however, is often of little interest to the dealer or critic, and so women's special contribution to the movement can easily be overlooked. Schapiro feels that "the real substance of the feminist contribution to the art of the seventies has never been acknowledged."[25]

Feminist art—embodied for a short time in the FAP—has had a strong influence on broader developments in the 1970s. By the end of the decade the cool abstractions, deadpan Pop images, and conceptual art of the 1960s had to a great extent been replaced by an interest in pattern and decoration, in the figure, in images that express emotional states, in the autobiographical statement, in new

syntheses of arts and crafts, and in the use of non-traditional materials. The women's art of the early 1970s opened up the possibility of a wider range of subject matter for artists in general and, after decades of formalist abstraction, seems to have stimulated an interest in content. But since the kind of imagery and attitudes that were engendered, recognized, and described in the early 1970s have been, to some extent, subsumed into the mainstream, women's art seems less visible now than it did ten years ago.

In the climate of feminist thought in 1985, a separatist experiment such as the FAP would probably not have much appeal. Now the challenge, as articulated by several former students, is to return with feminist goals to a social dialogue that includes men. Yet the problematic nature of the relationship between a community of women and the prevailing male culture remains. Some students felt that the FAP had failed to prepare them for the shock of the world of men in which they would have to compete; others said the experience of being in a women's community "strengthened" them. Clear answers have not yet emerged on the most effective ways to strengthen women's consciousness of their own constellation of interests, activities, and powers; effectively communicate this to the general culture; and achieve and maintain public recognition of the equal value of women's contribution. Recent events suggest that some degree of separatism is desirable, even if only to maintain a position from which a visibly female contribution can be made.

The differing directions taken by Chicago and Schapiro serve as illustration of the dilemma. While Chicago feels that an experiment such as the FAP could not be carried out now in a period of reaction and retrenchment, with institutions alert to potential disruption, she is still devoted to the idea of women's community—although not one tied to a specific place. The women whose needlework completes her designs for her *Birth Project* live all over the country. They consult with her by mail and telephone; she visits them in their homes, and they assemble periodically at her studio in Benicia, California. A regular newsletter documents progress. The sense of community necessary to women artists, she feels, comes from working together toward a shared goal, not from being together in the same place.

> The *Birth Project* is a decentralized community. It's about building a sense of community in people who are separated geographically. . . . It's still very frustrating for me to watch women refuse to accept the evidence of history which is that women do not achieve in isolation. They achieve in a context of support, and it's what's required and it's what's usually not there and that's why women go mad. The old communities of women huddled together for a sense of identification and survival. At some stage in their development women need to go through this. But huddling together is hardly a strategy for the future. The strategy for the future is to move into a new sense of the planet and a world community. This is where I feel I'm working.[26]

Schapiro has returned to the world she successfully inhabited before the FAP. Her combinations of collage and painting are formally excellent and can be situated in an aesthetic continuity with other twentieth-century developments. But to gain acceptance, she has had to compromise her feminist challenge to some extent. She is working within the system, and her art has necessarily been assimilated to it. Since she believes that "all feminist revolutions are doomed in a patriarchy," it would be foolish for her to take a revolutionary stance. From her current position she can make gains and offer younger women a solid model of a successful woman artist whose work has been nurtured by feminist ideas.

Women in the academic community face a similar situation. We exist within institutions that are dominated by male interests, preferences, and traditions. We are accustomed to working within the system, making the necessary compromises, "hopping on one foot and then the other," as Schapiro put it. This is a practical path, one resigned to small gains. While requiring tenacity and endurance over the long haul, it lacks the purity, drama, and possibility of creative leaps that a women's community can provide.

Notes

1 Miriam Schapiro, interview with author, New York City, June 1982.
2 Ibid.
3 Judy Chicago, *Through the Flower* (New York: Doubleday & Co, 1975), p. 103.
4 Interview with Schapiro.
5 "Special Issue: Miss Chicago and the California Girls," *Everywoman* (May 7, 1971), pp. 24–25, 30.
6 Ibid., p. 3.
7 Interview with Schapiro.
8 Judy Chicago, interview with author, Benicia, California, August 1982.
9 Faith Wilding, interview with author, Pasadena, California, July 1982.
10 See Grace Glueck, "Women Artists '80," *Art News* (October 1980), p. 68.
11 Ibid.
12 William Wilson (February 21, 1971), quoted in Faith Wilding, *By Our Own Hands* (Los Angeles: Double X Press, 1976), p. 27.
13 Interview with Wilding. "Crits" are critiques of each student's work in an open class situation.
14 Moira Roth, interview with author, Los Angeles, California, July 1982.
15 Ibid.
16 Opening statement for "Women in Art and Art History, Past, Present, Future," College Art Association conference, New York City, January 27, 1973.
17 Wilding, *By Our Own Hands.*
18 Logo, Through the Flower Corp.
19 Robin Mitchell, interview with author, Los Angeles, California, July 1982.
20 Interview with Chicago.
21 Mira Schor, telephone conversation with author, June 1982.
22 Interview with Wilding.
23 Interview with Chicago.
24 Interview with Schapiro.
25 Ibid.
26 Interview with Chicago.

6

FEMINIST ART EDUCATION

Made in California

Judy Chicago

I've often stated that it would have been impossible to conceive of, much less implement, the 1970/71 Fresno Feminist Art Program anywhere but California. One reason for this became evident in the 2000 Los Angeles County Museum of Art exhibit on one hundred years of art in California, whose title I borrowed for this chapter. The *Made in California* show demonstrated some of the unique qualities of California culture, notably, an openness to new ideas that is less prominently found in the East, where the white, male, Eurocentric tradition has a longer legacy and thus casts a stronger shadow.

Not that California has been exempt from some of the discriminatory aspects of that tradition. For example, to say that the Los Angeles community of the 1960s was macho would be an understatement. Women artists were simply not taken seriously. As a young artist, I was determined to overcome this prejudice. However, doing so took many years and the excision from my art of any form or content that could be labeled feminine. After a decade of struggle, I rebelled, asking myself what was the point of being an artist if I could not represent my experiences as a woman?

As I wrote in my first autobiographical book, *Through the Flower, My Struggle as a Woman Artist*, I started the Feminist Art Program in Fresno because, as a result of my own struggle, I suspected that the reason women had trouble realizing themselves as artists was related to their conditioning as women. I had found that society's definition of me as a woman was in conflict with my own sense of personhood (and, after all, it is a *person* who makes art).

I thought that if my situation was similar to that of other women, then perhaps my struggle might serve as a model for the struggle out of gendered conditioning that a woman would have to make if she were to realize herself artistically. I was sure that this process would take some time. Therefore, I set up the Fresno program

with the idea that I would work intensely with the fifteen women I chose as students.

It's important to take a moment to comment on the climate for women at that time. There were no Women's Studies courses, nor any understanding that women had their own history. In fact, attitudes might be best understood through the story of a class in European Intellectual History I had taken in the early 1960s, while I was an undergraduate at UCLA. At the first class meeting, the professor said he would talk about women's contributions at the end of the semester. I looked forward the whole semester to what he had to say. At the last class session, the professor came in, strode up to the front of the room, and said, "Women's contributions? They made none."

When I came to Fresno, in part it was with the idea of discovering whether my professor's assessments were true. At that time, while working in my studio and teaching, I began a self-guided research program into women's art, women's literature, and women's history, which I shared with my students. The way in which I structured the class was something I came to intuitively, in order to help my students find their own individual subject matter. I soon discovered that performance could be a valuable tool in this process. Most importantly, informal performance seemed to provide the students with a way of reaching subject matter for art-making. Ultimately, the most powerful work of the first year of the program was performance art.

My important discoveries about the positive effects of feminist performance for female art students led me to the conclusion that one of the reasons so few women succeed(ed) in art schools is that many of the techniques for establishing a focus for art-making rise primarily out of the conventional cultural education of men. In many sculpture classes, male students "got going" by completing presumably simple problems with materials and techniques assigned by their instructors. Many female students, like those with whom I have worked, often could not relate to these assignments because for them, the materials and techniques with which they were most familiar were often quite different. My students in Fresno were more comfortable with sewing than with hammering, for example. But within a supportive environment that acknowledged the challenges they faced, hammer they did, as I saw it as an essential part of their education to physically construct the off-campus studio we rented.

When it came to art-making, I encouraged my students to approach art with the materials with which they were most comfortable, and to bring their personal issues into the art-making process. This meant that both the form and content of their projects reflected their lives as women. The educational process I initiated in Fresno helped my students to confront those aspects of their socialization as women that prevented them from taking themselves seriously and setting ambitious goals. This was and continues to be a significant problem for women students.

In terms of performance, we started by "playing around." Our experiments grew out of our ability as women to put out direct feeling. We cried, roared,

screamed, and made animal noises, always trying to focus on a feeling and connect with it and with each other. Performances were based upon personal experience and also analysis of the female role, as we called it then; now it is referred to as the "construction of femininity."

The *Cock and Cunt Play*, a send-up performance piece I wrote which was first performed in Fresno in 1971, was a way of helping women deal with their more assertive sides. In the play, two performers take turns playing male and female roles. This piece was also performed at *Womanhouse*, one of the first openly female-centered exhibitions. Created in Los Angeles in 1972 by students of the Feminist Art Program at the California Institute of the Arts (guided by me and Miriam Schapiro, with whom I was team-teaching), *Womanhouse* was a group of installations created in each room of an old house about to be torn down. The living room was turned into a performance space, and performances for the space were created in the performance workshop that I ran, which was an outgrowth of what I had done in Fresno.

Some of the most influential pieces that came out of the workshop were what came to be known as duration performances. Women performed a series of domestic chores like ironing clothes or washing the floor. The audience simply had to sit there for the duration of the time these activities required. A number of art critics have noted that these initial duration performances had a considerable influence on later performance artists, notably California artist Mike Kelly.

Another work, both an installation and a performance at *Womanhouse*, was based upon *Cheri*, a novel by the French writer Colette. This performance, which dealt with female narcissism, was created by Nancy Youdelman and Karen LeCocq, both of whom went on to successful careers as artists. The two young women took turns making up while incessantly staring at themselves in the mirror of a room that recreated the ambience of the bedroom described by Colette in her book.

The mirror would figure prominently in the work of many later women artists, probably because, as the art historian Whitney Chadwick noted in the introduction to the catalog, *Mirror Images: Women, Surrealism, and Self-Representation* (1998): "For women artists, the problematics of self-representation have remained inextricably bound up with the woman's internalization of the images of her 'otherness'."

Some people have referred to the education process involved in Feminist art education as "consciousness-raising." This term has been overlaid on what I do, probably because CR groups were prevalent during the 1970s women's movement. But Feminist art education is actually something different, a distinction I hope will be better understood by the end of this chapter. I view Feminist art education as "empowerment education" because it begins with the process of helping students to become *empowered* to do what is important to them in their art. I accomplish this by "going around the circle," a basic structure and technique of the class. Each person speaks, beginning by telling the class about

themselves, then moving on to discuss interests and goals. *Everyone speaks and everyone listens.*

No one dominates the class, including me. My role in class is that of *facilitator.* As I wrote in my second autobiographical book, *Beyond the Flower*, the teaching methods I brought to Fresno evolved out of the part-time teaching I had done in the 1960s in Los Angeles. Even then my definition of a teacher had always been more akin to that of a facilitator, by which I mean one who facilitates the growth and empowerment of her students. This requires making a *real* connection with students, which I accomplish by encouraging my students to reveal *where they are* intellectually, aesthetically, and personally. Making this type of connection requires the shedding of the traditional teacher role in favor of a more humanized interaction that dissolves the distance conventionally maintained between teacher and student.

It has always been extremely important to me that all of my students actively participate, be it by asking questions or engaging in discussion. In my earlier classes I had noticed a tendency of some students (usually, but not always, the men) to dominate the classroom while others (often, but not exclusively, the women) remained silent. To counteract this, I developed the technique of going around the room, asking everyone to speak about the subject at hand. (One fascinating result was my discovery that the quietest people are sometimes the most interesting!) This was well before the days of consciousness-raising, with which this process has a lot in common, though with one important exception. Because I was the teacher, I could interject comments in order to make appropriate observations and suggestions.

The strategies of "going around the circle" and interpreting the teacher's role as a facilitator proved to be an effective way of combining education and empowerment, which I see as the most desirable goal for teaching. One without the other seems to lead to only partial growth for students, i.e. either the amassing of information without the ability to apply it in any meaningful way, or self-development at the expense of learning specific skills. One reason for my staunch and abiding commitment to feminism is that its principles provide valuable tools for empowerment, and not only for women. In my view, feminist values are rooted in an alternative to the prevailing view of relations of power, which involves *power over others.* In contrast, feminism promotes *personal empowerment*, something that, when connected with education, becomes a potent tool for individual and social change.

At the end of the first year of the Fresno program, we held an exhibition. Remarkably, several hundred people came, including many who drove up from LA to see what I had been up to in Fresno. Among the visitors were artist Miriam Schapiro and her husband, Paul Brach, who was the dean of a new art school, the California Institute of the Arts (CalArts). The campus now in Valencia wasn't built yet, and classes were being held in a convent in Burbank. I had invited Miriam (Mimi) to Fresno earlier in the year; I was desperate for someone with

whom I could discuss what I was doing, because the Fresno program had no precedent and therefore was somewhat frightening to me. After all, I was still a young artist myself.

Paul and Mimi invited me to bring my program and some of the more accomplished students to CalArts with the idea that Mimi and I would team teach and expand the program. Sometime during the summer, a number of the "Fresno Girls," as I called them, formed a caravan down California's Highway 5. Students, significant others, a variety of pets, motley furnishings, and an array of vehicles all made their way down to Los Angeles.

When school began in the fall of 1971, the new CalArts buildings were not yet complete, so we began to meet informally in various living rooms. In addition to a promised space and funding, CalArts provided the program with a feminist art historian, Paula Harper, who had recently earned her PhD at Stanford. In Fresno, we had begun assembling slides of work by women artists. This was critical because there were no such collections anywhere. My students and I would search through books, finding small black and white reproductions, which we photographed. I also brought slides back from my trips around the country or elsewhere. For example, I discovered Canadian artist Emily Carr on a visit to Vancouver and excitedly brought back slides for our developing archive.

It was Paula Harper who suggested the idea of doing some kind of project about a house. We rented an old house on Mariposa Street in Hollywood, a fitting location as "mariposa" means "butterfly" in Spanish. For a while we were all in the larval state, and then there was this incredible immersion in the first sort of openly female work. We started the *Womanhouse* project as we had in Fresno, by actually constructing the space.

People sometimes ask me if the "process" isn't as important as the "product" in Feminist art education. I always answer "NO" because the purpose of Feminist art education as I conceived it is to prepare students for a life of art-making. In other words, the goal of the methods involved in Feminist art education is *art practice*.

In terms of *Womanhouse*, this process resulted in many performances as well as many compelling installations, including the *Bridal Staircase*, for which a bride's veil flowed down the staircase from the landing at the top of the stairs, where viewers could see the back of the bride disappearing into oblivion. And like many of the other works in *Womanhouse*, *Lipstick Bathroom* was a precursor of a considerable amount of later Feminist art. The *Nurturant Kitchen* featured a series of fried eggs on the ceiling, which cascaded down the walls, the eggs slowly transforming into breast forms. The whole kitchen was just pink, pink, pink because in the days before we had more racial consciousness, we just assumed that flesh color meant pink, just like the Crayola Crayons used to be. (Similarly, when I was a young art student, almost all the models were Caucasian. And one of the things that happens when you're being formed as an artist is that in such art classes, everyone comes to assume that the norm is Caucasian, which is of course very destructive.)

My own contribution to *Womanhouse, Menstruation Bathroom*, was one of the first images of menstruation in Western art. I want to emphasize the fact that such openly female-centered art was only possible to create because of the context of support the Feminist Art Programs provided, not only for the students, but also for me. As I mentioned, I was still a young artist in my early thirties when I went to Fresno. It was certainly my intention to help younger women who desired to become artists and I wanted to do this in a way that did not require them to move away from their own experiences and content, as I had been forced to do in my own initial quest to be taken seriously. However, in addition to wanting to be of service, I also wanted to develop a context in which I could create a Feminist art practice, something that did not yet exist. Nor was there any precedent for the term Feminist art.

One of the students at CalArts, Mira Schor, went on to become a prominent painter and feminist theorist. Among her writings is the influential essay, "Patrilineage," in which she argues for the importance of a "matrilineage" in terms of our understanding of art history. What I believe she means is that generally artists, including women artists, are placed into an art historical narrative that is male-centered. Consequently, in terms of our understanding of women's art, we are deprived of seeing it in the context of women's long, historic struggle for creative freedom and artistic equity. With the development of Feminist art history and feminist theory, there has been some change—but not enough, particularly in the mainstream art world.

Although there are numerous women artists who had successful careers before *Womanhouse*, this revolutionary project definitely opened the way for a more explicit female imagery. One might say that both the Fresno Feminist Art Program and *Womanhouse* marked the moment when the construction of a true aesthetic matrilineage became possible, if only because of our conscious attention to issues of female identity and the expression of those issues in identifiable visual form.

Unfortunately, this perspective has not been incorporated into the mainstream art world, which insists upon viewing the Feminist art movement as an isolated phenomenon of the 1970s. In actuality, that period instigated a worldwide movement that is still going on, as attested to by the fact that women artists all over the world are working in ways that would have been impossible before the advent of the Feminist Art Program.

The *Womanhouse* exhibition was enormously successful. It was on display for a month during which thousands of people visited it. There was also an immense amount of media coverage, including an article in *Time* magazine. And a marvelous documentary film about the project (of the same name) made by Johanna Demetrakas, which subsequently brought images from *Womanhouse* to thousands of people all over the world.

By the time the exhibition closed, the new buildings at CalArts had opened and we had moved in. Within a very short time, even though I had a two-year

contract and was only half way through my first year, I became unhappy. At that time, I thought my dissatisfactions arose because we were operating within a male-dominated institution and I didn't like how that felt. Also, I didn't like the fact that, in the new buildings, there were all these unattractive corridors where different classrooms were identified by doors with different colors. To me, it was too much like a factory and I hated it.

On top of this, there began to be considerable friction between Mimi and me in terms of our respective teaching styles and philosophy. By the end of the first year, I tendered my resignation, working out the rest of my contract in a basement room far from the spacious quarters of the Feminist Art Program, where Mimi continued to work with many of my students. And when I left, I left everything—my program, my students, and all the art history slides we had compiled, even the slides of *Womanhouse*.

But even before my tenure at CalArts ended, I had begun making plans to establish an independent Feminist art program with Sheila De Bretteville, a designer who also taught at CalArts (and who is now at Yale), and the late Arlene Raven, an art historian who had come to Los Angeles to work with me and who also worked at CalArts. (She later moved to New York where she had a successful career as an art critic.) In the fall of 1973, the Feminist Studio Workshop began, filled with students from around the country who had moved to Los Angeles to be part of this new school. At first, we had no space of our own, so we again met in an assortment of living rooms.

Although Arlene, Sheila, and I specialized in different professional disciplines, we seemed to approach teaching in similar ways. This compatibility reinforced an equitable educational process for the students that was quite different from the traditional authoritarian model, which seemed to be the norm. One of the things I didn't like at CalArts was that this traditional model prevailed. Consequently, there was a lot of backbiting and undermining of the Feminist Art Program when it was at CalArts and, after it was over, the institution basically banished even its memory.

At CalArts, inside the Feminist Art Program, we tried to promote cooperative, egalitarian values. But when our students left our space to take other classes, they had to navigate in an art school with quite different values. CalArts was geared toward preparing students to "make it" in the art world, but without acknowledging that the art world was (and is) racist, sexist, homophobic, and class-ist.

I found this contradiction entirely untenable, which was one reason I had to leave. I cannot even imagine how difficult it must have been for the students I brought there. At the time I left, there were feminist programs across the disciplines at CalArts, an outgrowth of the impact of the Feminist Art Program. But as I said, within several years CalArts had erased the entire history of this period. In the 1990s, a group of women students who were struggling with the school's lack of support for female voices, unearthed the history of the Feminist

Art Program. As a result, they held a symposium and mounted an exhibition. But whether they accomplished any real change, I have not heard.

CalArts had evolved from Chouinard, an art school that Walt Disney had attended. Because he had become so successful, he decided to repay Chouinard, which had supported him when he had no money. Therefore, he created a new, presumably better school of the arts, CalArts. As a result, the old Chouinard building in downtown Los Angeles came up for rent and Sheila, Arlene, and I decided it was the perfect place for the Feminist Studio Workshop. We made affiliations with a number of other feminist organizations and brought a coalition of groups into the building, which we named the Woman's Building, modeled after an exhibition hall at the 1893 Chicago World's Fair.

The opening of the Woman's Building in 1973 was a delirious affair with thousands of people thronging the halls to visit the various exhibitions, performances, and activities that were going on. I held an exhibition of the *Great Ladies*, a series of paintings that reflected my growing interest in women's history. Most of the images were abstract portraits of women whose lives and work I had found inspiring.

One day, about a year into the Feminist Studio Workshop, one of the women from the "Board of Lady Managers" that ran the Woman's Building (another structure we borrowed from the 1893 Woman's Building) chastised me for not going along with some rule or other. Well, I had never easily abided rules throughout my life. I replied, "What do you mean? This is my institution. I created it. Why do I have to go along with the rules?"

During the ensuing argument, it dawned on me that bureaucracy was not just a male chauvinist invention (how I was able to be so naïve for so long is a mystery, even to me), but something that seemed to accompany institutionalization. The Woman's Building was becoming an institution, and that was not good news for me because I realized that I didn't feel comfortable with institutions of any kind, even those run by women.

Moreover, by 1974, I was becoming restless. I had found my way back to my own voice as an artist, something that I had lost as a consequence of professionalizing in the LA art scene, where I had been repeatedly told that I couldn't "be a woman and an artist, too." I went to Fresno to figure out how to be myself as a woman artist, which required *creating a context for myself and other women*, something the Woman's Building provided and continued to provide for nearly twenty years.

As important as the Woman's Building was, however, I couldn't be there anymore. I am sure this disappointed and upset Sheila and Arlene, not to mention the students who had moved cross-country to work with me. But I was extremely driven; I needed to stop teaching and devote myself entirely to my studio work. I was ready to begin working on a project that five years later would be known as *The Dinner Party*.

At first, I worked alone on what I had decided would become a symbolic history of women in Western civilization. But slowly I began to realize that this

undertaking would require help. Eventually, four hundred people contributed to the execution of my vision, a vision that allowed equitable collaboration within the larger structure of my imagery, something which later, many people would have trouble understanding. In *The Dinner Party* studio, I combined the methods of the Feminist art education I had developed at Fresno State, CalArts and in the Feminist Studio Workshop with my own art-making, bringing my level of professionalism to bear, thereby modeling the methods of art practice I had taught in the Feminist Art Programs.

In March 1979, *The Dinner Party* premiered at the San Francisco Museum of Modern Art, where it was an instant success. Five thousand people attended the opening and the show attracted record crowds. The museum bookstore made so much money that they bought a computerized cash register they named Judy. I was ecstatic, believing that the success of the exhibition would bring me opportunities, commissions, and sufficient support to begin research into a porcelain room in which *The Dinner Party* could be permanently housed. I even moved my studio and one of the studio ceramicists to northern California to begin setting up a ceramics facility.

Inexplicably (to me), the museums scheduled to exhibit *The Dinner Party* canceled and when the show closed, the work went into storage and I went into shock. All my plans for the future came to a screeching halt as I tried to make sense of what had happened and figure out how to continue making art. All of my assistants had scattered, as devastated as I was about what had occurred. I was deeply in debt as a result of having to borrow money in order to finish the piece. At that point, I had to start all over again.

Amazingly, there was so much interest in *The Dinner Party*—fueled by widespread media coverage and *Right Out of History*, Johanna Demetrakas' film about the making of the piece—that, slowly, a grassroots movement developed, first in the United States and then all around the world, to get *The Dinner Party* shown. Incredibly, people actually organized to bring *The Dinner Party* to their cities for an exhibition.

The first place this happened was in Houston in early 1980, less than a year after the San Francisco Museum of Art exhibition closed. By that time, I'd been getting considerable criticism from people who asked, "Why didn't you include this woman?" and "Why didn't you include that woman?" I responded each time, "Why don't you make a triangular quilt for somebody you think should be honored?" So, people started doing that. Every time *The Dinner Party* was exhibited, more and more of these quilts arrived, and now there are over seven hundred of them in the possession of Through the Flower, the small, non-profit arts organization that I started in order to finish the piece. (It went on to become the touring agency for what would be an international tour.)

In 1987, as a result of intense grassroots organizing in Germany, there was an exhibition of *The Dinner Party* at the contemporary museum in Frankfurt. A year before, to celebrate the success of their effort, the organizers of this grassroots

campaign held "The Festival of a Thousand Women" at the refurbished Frankfurt Opera House. Hundreds of women from all over Europe gathered together, all dressed as the women on the table and the floor. Many of the participants became so inspired that they began doing their own research into women's history, some even making made pilgrimages to ancient Amazon sites.

At one point during the festival, there was an evening performance of a little-known work by Fannie Mendelssohn. Publicly performed for the first time by an all-female orchestra, the conductor was dressed as the composer, which was very touching. Another poignant moment came when thirty-nine women dressed as the various women on *The Dinner Party* table assembled as a triangle in the room. One of the figures, Petronilla De Meath, was missing, so I stepped in for her. It was really amazing how the spirit of *The Dinner Party* came alive as we enacted *The Dinner Party* table.

Sadly, Dagmar van Garnier, the organizer of the festival, and I almost came to blows because she was using an authoritarian model of organization rather than a model of equality and cooperation, which I believe to be a fundamental principle of feminism. I was very upset about her understanding the form, but not the content, of my work and vision.

I continued to make art using these same principles, developed first in my educational programs, then applied in *The Dinner Party* studio. Between 1980 and 1985, I created the *Birth Project*, which was initiated at the San Francisco Museum of Modern Art after a book signing for my second book on *The Dinner Party* (*Embroidering Our Heritage: The Dinner Party Needlework*). In conjunction with its publication, I gave a lecture at the museum. Afterwards, I passed out flyers announcing that I was going to do another project on the subject of birth that involved needlework. About thirty stitchers responded.

Eventually, almost 150 needleworkers from around the country worked on the *Birth Project*, which resulted in eighty-five exhibition units (a needlework and its documentation) that were exhibited in over one hundred venues. I used the same methods I had employed in my teaching and in *The Dinner Party* studio, an inclusive process which generates both a group bond and considerable energy. And it's out of this base that my projects get done, whether it's a student's own work developing his or her own ideas, or working on one of my major collaborative projects.

However, the *Birth Project* was not executed in my studio as *The Dinner Party* was. Instead, it was done in a decentralized network, with people working in their own homes all over the country. One woman was even as far away as New Zealand. The glue of the project was something I called "the review process," where we would get together, either one-on-one, in small groups, or in larger groups to look at the work. At the reviews, I used the same principles I've been describing which produce a group dynamic as the group gets to know each other, and people begin to make connections. Out of this particular group dynamic, future projects of mine evolved, notably, the touring exhibition *Resolutions: A*

Stitch in Time. Many of the needleworkers who worked with me on *Resolutions* go back to the *Birth Project*. After that project was over, a number of them maintained a network among themselves throughout the years, as some of the "Fresno Girls" also did.

In all of my educational programs and collaborative projects, I try to create equitable relationships and equitable collaborations. One might say that my feminism—that is, my commitment to egalitarian relationships (be they between husband and wife, teacher and student, or artist and artisan)—has been central to my entire life. It has certainly informed my relationship with a woman named Audrey Cowan, with whom I've worked since *The Dinner Party*. One could say that we have a Feminist art partnership, although she works on my images. She says she can't paint and I can't weave, but together we do both and we jointly own all the work that we have created together.

This is also true of *Resolutions*, in that the stitchers and I own the work jointly. It's important to understand that such an arrangement is a very different scenario from conventional artist/artisan relationships. For example, in traditional Aubusson Tapestry weaving, which is the type of weaving that Audrey practices (though in a modified version), the weavers work from a design usually supplied by an artist. In fact, they weave with numbers around their necks that correspond to the colors chosen by the artist. Also, they weave from the back of the tapestry, which means that they cannot see the image except by running around and looking at small sections with a mirror.

This type of relationship is very different from Audrey's and mine. We redesigned the loom so that Audrey weaves from the front. This allows her to have input as she brings my image to life in thread. We discuss the color choices and the image and she translates my painted design into thread, a significant departure from traditional Aubusson weaving. It's the reason that Audrey would only work with me; she did not want to go back to the kind of robotic relationship between artist and artisan that is traditional.

I would now like to discuss Through the Flower, which began its formal life in the Santa Monica studio in the late 1970s, and then took up residence in a large building in Benicia, California, that was the headquarters for the *Birth Project*. As I mentioned, Through the Flower is a small non-profit organization that came into existence quite by accident in order to provide a fiscal structure to fund the exhibition and storage of *The Dinner Party*, allowing people to make tax-deductible contributions. At the time, I never dreamt how important the organization was to become in terms of my ongoing art-making and, now, the preservation of my art.

By the early 1990s, I was living in Santa Fe, New Mexico, and had moved Through the Flower there as well. We started an intern program, probably after I gave a lecture somewhere and some young woman asked if she could come and work with me, and I said "Sure." Young women, and some young men as well, began to work in the offices of Through the Flower. They reported that

they were not learning about women artists in their art history classes and that they knew very little about the Feminist art movement. This really upset me. So, we started holding public programs that began with the showing of the film by Johanna Demetrakas, *Right Out of History: The Making of Judy Chicago's Dinner Party*.

I was just astonished by the response and the hunger for knowledge about both women's art history and Feminist art practices. Even twenty years later, it seemed as intense as it had been in the 1970s. By that time, I had been deeply absorbed in my studio work for many years and had just assumed that things had changed. But in 1991, when we organized a summer art-making workshop in Santa Fe, I discovered that the needs and issues of young women artists seemed very much like those of my students in the 1970s. The art produced in the ten-day workshop indicated that even though post-modern theory posits the notion that gender is a changing construct, for many women it has not changed much in recent decades. Consequently, the issues and images of numerous women I've worked with are remarkably similar to that of 1970s Feminist art.

As to my art-making life, I continue to work both alone and collaboratively. In the *Holocaust Project: From Darkness into Light*, I collaborated with my husband, photographer Donald Woodman. In the mid-1990s, after eight years of difficult work on *Holocaust Project*, I began my fourth (and last) major collaborative project, *Resolutions: A Stitch in Time*, which, like many of my major projects, was a traveling exhibition. As I mentioned earlier, most of the women who worked on this project had worked with me previously and hence, as they said, they were already empowered. This made our collaboration the most successful in terms of the ease of working together.

This poem that I wrote when I was working on *The Dinner Party*—which has been incorporated into various liturgies—might be said to describe the philosophical underpinnings of my vision, a vision which, when I was young, scared me. Even though some people might find it overly idealistic, I believe in "choosing hope." It was with a newfound comfort with my own vision that in 1999, I began teaching again, one semester a year at different institutions. The "Merger Poem" expresses the fundamental beliefs that underlie both my teaching and my art-making.

> And then all that has divided us will merge.
> And then compassion will be whetted to power
> And then softness will come to a world that is harsh and unkind.
> And then both men and women will be gentle.
> And then both women and men will be strong.
> And then no person will be subject to another's will.
> And then all will be rich and free and varied.
> And then the greed of some will give way to the needs of many.
> And then all will share equally in the earth's abundance.

And then all will care for the sick and the weak and the old.
And then all will nourish the young.
And then all will cherish life's creatures.
And then all will live in harmony with each other and the earth.
And then everywhere will be called Eden once again.

Mellowed as I am by maturity, I no longer believe that we'll ever attain Eden. However, I do believe that we could do a far better job of living in harmony with each other and the earth. The principles of cooperation that are embodied in both feminism and Feminist art education could be a great contribution to improving our world.

As mentioned, in the fall of 1999, I went back to formally teaching again, in part because I saw that there had been this tremendous backsliding. Also, I received many letters from people around the country wishing for more access to my teaching methods. I decided to start teaching one semester per year at various institutions around the country. The first year, I taught at Indiana University in Bloomington. I was invited there to do a project class. The participants had their own studio, as they had at Fresno and CalArts. My thought was to do a project aimed at the gap between school and art practice, a gap that's particularly troublesome for women. Too many of them come out of art school and, after a short time, stop making art.

I worked with a number of students from around the state of Indiana. Unlike the original class in Fresno, it was open to men, but no men applied. The class was made up of women between the ages of twenty-six and sixty. At the end of semester, they held an exhibition which they decided to call *Sin/Sation*, a humorous play on the title of the show *Sensation* which was being held at the same time at the Brooklyn Museum in New York. The project attracted a little hubbub of media attention, even though I was staying out of the public limelight, just teaching, working in my studio and keeping to myself, much as I had done in Fresno. The show was held at the IU museum, an IM Pei Building that was an excellent venue. Doing a museum level installation presented a really good professional challenge for the students.

The exhibition demonstrated that when women are encouraged to work on their own subject matter, they tend to make art that is quite different from the mainstream. One large installation involved a series of digital photographs of the artist's vagina, which were overlaid with various crude words for that organ, printed on transparent vellum. Another piece involved a parody of De Kooning's misogynist *Woman* images. The artist, a feminist philosopher named Peg Brand who had been driven out of art school by the misogynist environment, took the head out, and then took pictures of people sticking their heads through the head hole—very funny!

AT IU, I also team taught an art history seminar class with Peg and Jean Roberts, an art historian. The topic was Feminist Art and Philosophy: History

and Context. There were a number of men in that class. One of them was a graduate student in theater who wanted to do a performance section in the exhibition. He got a number of theater students together to restage the *Cock and Cunt* play and other early pieces, plus perform some original pieces dealing with the students' own issues.

Several of these involved the pernicious myth about women being able to "have it all." The most effective work involved two performers. A young woman dressed in a black leotard sat on the stage to the sound of circus music. Then, a performer with a clown hat came on stage and dropped two balloons in the seated woman's lap. The first woman blew them up. One was marked "education" and the other "family." She playfully juggled the two balloons as the circus music kept playing. The clown came back out and dropped a third balloon marked "friends," with which the other performer had no trouble, happily juggling the three balloons. The clown then returned and dropped a fourth balloon, designated "career." The young woman was just beginning to have trouble juggling all these balloons when the clown came out again and dropped a fifth balloon labeled "relationship." At this point, the young woman really began struggling with the five balloons, whereupon the clown came back out and dropped yet another balloon, marked "baby." The poor woman just couldn't juggle them all, a metaphor for the situation that many young women seem to be confronting.

In the fall of 2000, I taught at Duke under very different circumstances. At that time, Duke—though an incredibly good university—had a very poor undergraduate art department and no graduate studio program at all. I taught a class there called "From Theory to Practice," which met twice a week for an hour and a quarter each time. The students were given a choice to do either text-based projects or art-making projects and surprisingly (given the lousy studio situation), a lot of them wanted to make art.

I structured the course so that the first three weeks were devoted to the type of personal empowerment work I have described earlier, along with very intensive readings. Then, the class was broken up into three segments and the students worked on different subjects that I had worked on: women's history, birth and the Holocaust. At the end of the semester, the students wanted to hold an exhibition in order to share what they had done with the campus community. The show was such a success and the administration so impressed, that—even though the show was only supposed to be up for a weekend—the university reopened it after the semester break for a month so that numerous classes could view it together.

One of the pieces in the Duke exhibit involved a series of photos in which a young woman re-enacted suicides committed by various important women of the past. Another work was a "history house," which had small inserts about different women in history. In the section on birth, there was a series of sculptures that were very funny, little mother-goddess sculptures that the young woman jokingly called "The Spice Girls" because they emanated various pungent spices.

There was also a modern take on the conception of Jesus. A series of cartoons depicted God calling Mary on the telephone to tell her that she was chosen to have an immaculate conception. Mary replies, "What do you mean; I'm not gonna have an orgasm?" Now, that was definitely a 1990s point of view. It was hilarious, especially in the South.

The section on the Holocaust included a poignant double-image done collaboratively by a man and a woman. Another work involved a closed cabinet which—when opened—told the story of a child victim. In a performance piece, a young woman took the part of three different women: one a survivor, the other a child of a survivor, and then herself. From three different viewpoints, she recounted her own reactions to the Holocaust education she had received when she was young.

Then, in 2002, I team-taught with my husband, photographer Donald Woodman, at Western Kentucky University in Bowling Green. We did a project with twenty-five participants, about one-third men, of various ages, who were students, local artists, or faculty. Donald and I helped the students explore the subject of the house thirty years after *Womanhouse*. It was interesting to see what differences in perspective existed and where nothing had changed, particularly in relation to the younger women. Many of them evidenced considerable confusion about their identities as women and the social expectations that still seem to be placed upon them. As to the men, my pedagogy seemed as effective for them as it had proven to be for women.

Although I continued to teach for a few more years, I was disheartened by what I observed, as I had hoped for more significant changes, both culturally and in terms of education, and was singularly disappointed that feminist education was still being marginalized. To my mind, Feminist art education offers profound possibilities for a new type of empowerment for both women and men. But in order for our art institutions to take advantage of such an educational approach, there will have to be a real commitment to altering the male-centered pedagogy that now exists.

It is not enough for Women's Studies or Women in Art courses to exist as an adjunct—or antidote, as it were—to male-centered art and art history curricula. There must be a recognition that in terms of art education, we need to rethink what is being taught, what is most important to learn in order to become an effective artist, and the purposes for which our present art curriculum is geared. Feminist art education begins with each person's individual voice and builds both individual and collaborative art-making out of those issues expressed by many different voices. Such an education can lead to a truly diverse art community and a more equitable world, which is what I still hope to see happen—and in my lifetime.

SECTION II

Re-Centering: Theory and Practice

7

ABUNDANT EVIDENCE

Black Women Artists of the 1960s and 1970s

Valerie Smith

The 1960s and 1970s saw dramatic changes not only in American social and political culture, but in the art world as well. As racial and gender relations were transfigured in the public sphere, increasing numbers of artists from communities that had historically been underrepresented in galleries and museums began to emerge. The heightened visibility of white women artists and artists of color during this period led to new strategies for reaching mass audiences, challenges to conventional distinctions between high and low art, and critiques of traditional exclusionary practices of exhibition.

Numerous artists, writers, activists, and scholars have noted that on both the political and artistic scenes, black women found themselves in a problematic ideological position.[1] On the political front, black women held positions of prominence and responsibility in the Civil Rights and Black Nationalist movements. In the Civil Rights movement, for example, women such as Ella Baker, Septima Clark, Fannie Lou Hamer, Diane Nash, Ruby Doris Smith Robinson, and Jo Ann Gibson Robinson did the essential but often unacknowledged work of training and organizing activists and creating and maintaining networks of communication. Yet for the most part, their male counterparts prioritized the eradication of racial inequalities and failed to acknowledge either sexist practices within their ranks or the inextricable relationship between patriarchy and racism.

Likewise, figures such as Elaine Brown, Kathleen Cleaver, Angela Davis, and Assata Shakur led Black Nationalist organizations; nevertheless, numerous accounts indicate that in this movement as well, black women in general were relegated to the roles of childbearing and nation-building. Both the Civil Rights and Black Nationalist movements privileged the powerful presence and voices of charismatic male leaders. Even as black women in both movements proved their commitment to the struggle against white supremacy and for social justice, they were expected

to capitulate to male authority, ignore misogyny within the organizations, and defer their concern with "women's issues."

Black feminists had long been among the first theorists and activists to recognize that gender and race are mutually constitutive and interlocking modes of experience and social construction. Thus they rejected the notion that a concern for gender discrimination would detract from the anti-racism struggle. While some continued to work within the Black Nationalist movement in the hopes that a true revolution would radically alter relations of class, race, and gender, others affiliated themselves with the women's movement, hoping to find common cause with white feminists. Their accounts regularly reflect their sense of marginalization in the feminist organizations as well, however, as they confronted white feminist claims that issues of race were diversions from the goals of the women's movement. Black feminists in the women's movement were expected to ignore white feminists' racism and assertions of the class privilege and countenance an agenda that ignored the connections between gender, class, and racial oppression. Not surprisingly, in response some black feminists formed their own organizations or, as Kimberly Springer has observed, "found their activism institutionalized in social services, governmental bodies, higher education institutions, and other organizations they could attempt to influence with antiracist and anti-sexist ideology."[2]

Black feminist analyses and the black feminist movement emerged as a way of theorizing the inextricability of various modalities of experience, such as race, gender, sexuality, and socio-economic status. While considerable attention has been focused on black women writers who came to prominence during this period, such as Toni Cade Bambara, Toni Morrison, Ntozake Shange, Alice Walker, and Michele Wallace (to name only a few), comparatively less attention has been given to their visual-art counterparts.[3] During the 1960s and 1970s, black feminist visual artists working in a range of media and styles—film, performance art, collage installation, painting, and photography—also broke into a world that historically had been dominated by white men.

Organized in 1971, "Where We At" Black Women Artists (WWA) provided an opportunity for black women, marginalized by both the predominantly male Black Arts Movement (the cultural and aesthetic counterpart of the Black Power Movement) and the largely white feminist (and feminist art) organizations, to share concerns and resources. Although they made art, many of WWA's members did not consider themselves professional artists. As Kay Brown, a painter, printmaker, and collagist, explained in a 1984 panel discussion held at the Hatch-Billops Collection in New York City: "They were conditioned to think that they could not really achieve the status of a professional artist."[4] By providing these women with a space in which they could engage in meaningful substantive conversation and exchange work and ideas, WWA helped them gain confidence and inspired them to continue.

Early in the history of WWA, the artists in the organization focused on the difficulties they faced in trying to exhibit their work. Most gallery owners

doubted that either blacks or women could legitimately claim to be artists, so black women artists were doubly challenged. Moreover, few of the WWA artists had sufficiently large bodies of work to warrant solo exhibitions. Through the efforts of Dindga McCannon—a painter, printmaker, and muralist who had been exhibiting her work at Pat and Nigel Jackson's Acts of Art Gallery in New York—Brown and others arranged the group show "Where We At: Black Women Artists 1971," which led to the organization of the WWA. McCannon's description captures the excitement of that first exhibition:

> We produced our own catalogue. We had pictures [of the artists], because this was the first time in history that black women had come together and had an exhibition. So we produced a flyer, which had everybody's picture and a statement by each woman about her art. We had a unique opening— we introduced [serving] food—and it became a media event. The press came; everybody wanted to interview us. All of a sudden, the [black] women artists were discovered![5]

While the original group comprised painters and photographers who worked in a figurative style that romanticized black subjects, over time it expanded to include a wider range of artists and genres. As McCannon observed: "Now, we have a cross-section of everything from minimalism to realism, we have craftspeople, we have a musician, a writer, poets, sculptors."[6] Moreover, the group shifted its focus from seeking opportunities to exhibit in galleries to finding ways to show the work to wider communities. For instance, a grant from the National Endowment for the Arts allowed several of the artists to show their work in hospitals. An America the Beautiful grant enabled them to work with the elderly at Cumberland Hospital in Brooklyn and inmates in the prison ward at Bellevue Hospital, New York. WWA also organized traveling exhibitions and workshops for children in Brooklyn and for prisoners at locations in New York State such as the Bedford Hills Correctional Facility for Women and the Arthur Kill Correctional Facility for Men. By 1984, the group was large enough to consider purchasing a building where its members could have housing, exhibition and studio space, and a school, but regrettably, the idea never came to fruition.[7]

In a 1998 article, Brown described the range of ideological perspectives that black feminist artists brought to the group:

> The women's liberation movement, generally headed by liberal white women, also emerged during the 1970s. Some people link the gains made by black women artists to the influence of the feminist artists. I don't believe this is an accurate assessment. Although WWA members and other black women artists agreed that women should empower themselves to gain economic and artistic equity, we generally viewed ourselves as integral to the black arts movement. Our struggle was primarily against racial

discrimination—not singularly against sexism. We were not prepared to alienate ourselves from our artist brothers. Nonetheless, it is important to note that some of the artists (a few quite well established ones) chose to align themselves with the militant feminists.[8]

In her recollections of this period in the history of the organization, Brown described two collaborative exhibitions that dramatized the complicated position of black feminism from the 1960s onwards. In the first, held in 1972, WWA artists exhibited with the feminist organization National Conference of Women in Visual Arts at a range of venues in Greenwich Village, SoHo, the East Village, and midtown Manhattan. Brown noted that the two groups displayed strikingly different work. While the white feminist artists addressed issues of sexism directly, the black women artists "explored the unity of the black family, the ideal of the black male-female relation, and other themes relating to social conditions and African traditions."[9]

In 1986, WWA artists collaborated on an exhibition at the Muse Community Museum in Brooklyn with selected black male artists. For "Joining Forces: 1 + 1 = 3," WWA invited men and women artists to work in pairs in order to display in a visual medium "the means through which male/female had come together to create something that 'went beyond the normal vocabulary to make an entity of a third thing.'" As Brown described it, this exhibition was "one of the crowning achievements in WWA's history."[10]

One of the co-founders of WWA, Faith Ringgold has long been recognized as one of the leading black feminist artists. The media in which she works, her subject matter, her collaborations, and her political activism on behalf of women artists and artists of color all bespeak her commitment to an ethics and a practice of empowerment for the disenfranchised. Perhaps her best known work, Ringgold's story quilts confound distinctions between fine and folk art, focusing viewers' attention on the artistic potential of a medium so fully associated with women's work. For decades she has been drawn to women as subjects and made numerous projects with her mother, the Harlem fashion designer Willi Posey, and her daughter, the feminist writer and critic Michele Wallace. During the 1960s and 1970s, whether independently or in her capacity as a founding member of such organizations as the United Black Artists' Committee; WWA; Women, Students, and Artists for Black Art Liberation; and the Ad Hoc Women Artists' Group, she denounced the exclusionary curatorial and exhibition practices of major New York museums, including the Whitney Museum of American Art and the Guggenheim Museum.

Born in 1930, Ringgold was raised in a lower-middle-class Harlem family. Her mother cultivated her interest in art during her childhood. Although she studied art as an undergraduate at City College in New York, she was only able to pursue a degree in art through the School of Education, as university regulations prevented women from declaring a major in the School of Liberal Arts. After

graduating in 1955 with degrees in fine art and education, she taught art in New York City public schools for many years. From 1970 until 1985, she also taught at various colleges and universities in Brooklyn, Manhattan, and Staten Island. In 1985, she was appointed a full professor in the visual arts department at the University of California, San Diego.

Ringgold began her American People Series—what she described as her earliest mature body of work—with *Between Friends* in the summer of 1963. She completed the series in 1967 with the three largest works: *The Flag Is Bleeding*, *U.S. Postage Stamp Commemorating the Advent of Black Power*, and *Die*. Painted in what was for her a new style she called "super realism," these works responded to the political climate of the Civil Rights movement and expressed the ambivalence she and many of her contemporaries felt during this period of dramatic social upheaval.

The ninth painting, *The American Dream* (1964), captures something of the complicated legacy of integration in the depiction of an ostensibly wealthy woman whose body is half dark and half white.[11] On the side of the face that is white, shadows are conveyed in blue, a technique that highlights the paleness of the face, the neck, and the breast. On the dark side, the woman has raised her hand and bent it at the wrist to reveal a large diamond ring and long, manicured red nails. Forming a downward arch from left to right over the woman's head is a blood-red arrow that matches her nail color; the right hand is positioned almost as if the color from the nails is dripping into the tip of the arrow.

An expensively dressed woman who is both black and white appearing in a painting suffused with red, white, and blue might be read as a symbol of the achievement of the dream of integration and equality of access to opportunity. Both races seem to co-exist in a figure bearing symbols of wealth and the colors of the flag. But the prominence of red, the downward pointing arrow, and the garish conspicuousness of the ring provide a less sanguine interpretation of the promise of integration. The painting thus evokes a fear that integration may lead to the fortification of capitalism instead of a means to profound social and political transformation.

Like many artists and activists of the 1960s and 1970s, Ringgold protested against racism, sexism, militarism, and other forms of oppression by confronting the iconic image of the American flag. The use of red, white, and blue in *The American Dream* manifests more explicitly in works such as *The Flag Is Bleeding*. In this painting, three figures stand behind a semi-transparent American flag, its red stripes seeming to drip with blood. A black man stands on the left, a white man stands on the right, and a white woman stands in the middle, a link between the two men. The placement of the figures correlates to the social and political power they possess: the white man is the tallest and most visible; the white woman is the most diminutive; and the black man fades into the background, his face partly obscured by the blue area on which forty-eight stars were placed.[12] While the white man's hands rest authoritatively on his hips, the black man holds a knife

in his left hand while his right hand is placed ambiguously over his heart, simultaneously stanching a bleeding wound and pledging allegiance. The images suggest the incommensurate access to civil rights and socio-economic privilege enjoyed by whites and blacks—and men and women—within American society. Smaller than the white man but more visible than the black, the white woman occupies an intermediate status, privileged on the basis of race but disenfranchised because of her gender. The black man, gripping a knife and holding back his own blood even as he pledges allegiance, has had to risk his life to claim his identity as an American.[13]

In the American People series, Ringgold's works comment on contemporary race politics in American culture. Beginning in the late 1960s, she began to seek a visual language that would express on canvas an emergent, more radical political agenda. She began the Black Light series, a group of twelve paintings she produced from 1967 until 1969, that work with a darker palette as "experiments in toning the light to the blacks, browns, and grays that cover my skin and hair; and the shades of blues, greens, and reds that create my forms and textures."[14]

The tenth painting in the Black Light series, *Flag for the Moon: Die Nigger* (1969), responds to the famous image of the Apollo 11 moon landing on 20 July 1969, when Neil Armstrong planted an American flag on the surface of the moon. In this painting of the flag, the word "die," in black letters, is barely visible in the blue area containing the stars. The word "nigger," printed in horizontally elongated gray-brown letters against a red background, is almost illegible, occupying the place where one would ordinarily expect to see white stripes. Through her use of color and form, Ringgold deliberately manipulated positive and negative space, the visible and the invisible, to allegorize the role of race hatred and violence in the construction and assertion of American identity and to call attention to the fact that "too many American people go to bed hungry, while the government spent billions to place their flag on the moon."[15]

One of Ringgold's earliest, most explicit pieces of black feminist art is her poster *Woman Freedom Now* (1971). During this period of heightened radical activity, many artists and activists used posters to convey information and disseminate art to the wider public. On red, black, and green interlocking triangles, the words "woman," "freedom," and "now" appear backward, forward, and upside down. *Woman Freedom Now* unites a feminist message with the colors of black liberation and Kuba design, creating a dialogue between feminist and black liberation politics.

Ringgold often uses Kuba design techniques to organize space and "combine several ideas in one composition."[16] As she described it, the design, which works with configurations of eight triangular spaces, is "an ancient one often seen on African textiles and attributed to the Kuba tribe of the Congo region of Central Africa. At this time I was trying to use these Kuba triangular spaces and words to form a kind of rhythmic repetition similar to the polyrhythms used in African drumming."[17] Kuba design is evident in other posters Ringgold produced during

this period, including *The People's Flag Show* (1970) and those for Angela Davis: *Angela Free Women Free Angela* and *America Free Angela Free America* (both 1971).

In 1971, Ringgold received a grant from the Creative Arts Public Service Program, which enabled her to produce a mural titled *For the Women's House* for the Women's House of Detention on Riker's Island in New York. Before she began the piece, she met with some of the inmates to learn what sorts of images they would like to see in the mural. She was inspired by suggestions such as "a long road leading out of there" and "women of all races holding hands and having a better life."[18] Also incorporating Kuba design, *For the Women's House* (permanently installed in 1972) depicts women in a range of roles, each of its panels representing a politically emancipatory position.

Just as Ringgold's palette and choice of media is inextricably linked to the message of the art she produces, Betye Saar's selection of found materials taps into the historical memories and narratives embedded within objects (see Plate 7). As Peter Clothier has written, "Things have a curious life of their own. They come to us and leave us in mysterious ways, somewhere between chance and destiny. A part of Saar's art has been to arrest them in these paths and attract them into an orbit in her own intuited constellation, while yet allowing them their curious independent life."[19]

Born in Los Angeles in 1926, Saar grew up in a middle-class family in Pasadena, California, and often spent time with her grandmother in Watts. She attended Pasadena City College and the University of California, Los Angeles, where she studied design. After graduating in 1949, she worked as a social worker and made enamel jewelry and home accessories for a business she shared with the artist and fabric designer Curtis Tann. In the mid-1950s, after she had married and begun to have children, she enrolled at Long Beach State (now California State University, Long Beach) to pursue her teaching credentials and to study printmaking and etching, earning a master's degree in graphic design and etching in 1960. At the age of thirty-four, realizing that she was an artist, not a designer, she began to make images using occult symbols. This shift gave way in the 1960s to an abiding interest in the representation of African-Americans:

> After the black movement began I found my work changing because of my strong feelings. I started collecting my derogatory black images. By that I mean Aunt Jemima, pickaninnies and Black Sambos—and by using that black imagery my work changed and became a revolutionary art. For example in *The Liberation of Aunt Jemima*, I take the figure that classifies all black women and make her into one of the leaders of the revolution—although she is a pretty strong character anyway. But there was a time, even during the revolution, when blacks put other blacks down as "Uncle Toms" and "Aunt Jemimas." It is only recently that we realize that we are here because of the particular role that they played—the subservient role that protected the youth so that they could grow up and get an education.[20]

Saar's *The Liberation of Aunt Jemima* (1972) is one of a number of works produced during the 1960s and 1970s that takes on the persistent stereotype of the abject and loyal black domestic servant.[21] *Liberation* is a mixed-media assemblage in a shadow-box format. Michael D. Harris has observed that this format recalls Joseph Cornell's allegorical medicine cabinets of the 1940s and 1950s: "Here in Saar's cabinet we find powerful antidotes and remedies for the mammy headache."[22] The box contains three versions of Aunt Jemima—reproductions from Aunt Jemima pancake boxes and syrup bottles, a kitchen memo-pad holder in the form of an Aunt Jemima figure, and a small painting—superimposed on one another. The multiplicity of these figures reminds us of their ubiquity and persistence. Confined within the small box, they would seem to underscore the ways in which the lives, experiences, and representations of black women have been constrained in aesthetic discourses as well as in social and political space. But these images are disrupted in a variety of ways. For example, the memo-pad figure holds a broom and a pistol in her right hand and a rifle in her left, while the figure in the painting wears a knowing grin instead of a vacuous smile. Although she stands behind a white picket fence, this Jemima is anything but a comforting domesticated servant—the white baby she holds on her left hip is crying and looks terrified. Emerging from the bottom of the frame in front of her (from the mist-like cotton at the bottom of the box) is a dark brown raised fist, the familiar symbol of black power. Visually echoing the rifle to the right, the fist announces the power of black aesthetic and political power to put an end to racial and gender oppression. *Liberation* thus represents the ability of black power to emancipate black people from the tyranny of a repressive history.

While Saar's representational constructions may appear more content-driven to some, Howardena Pindell's work reveals that the form-content dichotomy is inherently problematic. In the 1998 documentary *Howardena Pindell: Atomizing Art*, Lowery Stokes Sims observed that critics typically separate artists into those concerned with formalist issues and those concerned with content; however, Pindell confounds that distinction. Whether exploring the nuances of color in early work such as *Untitled #6* (1975), *Untitled #43* (1974), and *Untitled #73* (1975); conveying the incalculable impact of the slave trade; satirizing racist attitudes through grainy video; or detailing the "demographics of exhibitions at New York museums and commercial galleries"[23] in essay form, she is interested in what is revealed when forms and experiences are broken down into their constituent components.

Pindell was born in 1943 and raised in Philadelphia, the only child of middle-class parents. She began to take art lessons in the third grade, studying ceramics, drawing, fashion design, and advertising. She encountered overt racism at the girls' high school she attended and later at Boston University, where she received a bachelor's degree in fine arts in 1965. In 1967, she graduated from the School of Art and Architecture at Yale University with a master's of fine arts and, after a few months, was hired by what was then the international and national

circulating exhibitions department at the Museum of Modern Art, New York. She spent twelve years there, first as a curatorial assistant and then as associate curator in the department of prints and illustrated books, before becoming a professor in the art department at the State University of New York at Stony Brook.

Early in her career, Pindell produced figurative work, but by the late-1960s her fascination with color had drawn her to more abstract projects. She produced a series of untitled works by cutting strips of canvas or oak tag, or using a hole-puncher to make innumerable paper circles, then arranging and gluing the strips or paper dots on board. The works shimmer with a brilliant palette, their composition organized around the opposing forces of positive and negative space; they are a testament to the meditative power of repetition.[24] At the time they were produced, however, they met with some disapprobation. In an interview with Kettle Jones, Pindell described the way in which the Studio Museum in Harlem responded to her early abstract work:

> I didn't really get involved in the women's movement until the early seventies. That was really a direct response to taking my work to the Studio Museum. I was told by the director at the time (late sixties) that I was not doing black art because I was not using didactic images. I was not dealing with information that would be helpful to the black community. I also felt that there was bad feeling because I was a woman. I wasn't one of the boys.[25]

This rejection led her to become active in the feminist art movement, but there she found that racism was treated as an afterthought and women of color were marginalized. Her 1980 video *Free, White and 21* provided her with the opportunity both to speak out about her own experiences of racism in schools, places of employment, and social settings and to satirize the condescension and hostility she encountered from many white women in the feminist movement. Indeed, the video begins with an account of a racist episode her mother endured as a child.

Pindell plays two roles in *Free, White and 21*. While wrapping and then unwrapping her head in a gauze bandage, she recounts stories of racist abuse both she and her mother experienced. She also performs the role of a white feminist who denies the veracity of the stories Pindell tells, referring to her as ungrateful and paranoid. For this role, she donned a blond wig, white stage makeup, lipstick, and dark glasses. At the end of the piece, this character pulls a white stocking over her head to draw a visual comparison between the feminist's dismissiveness and a robbery:

> I did that because . . . you know, in bank robberies people who want to disguise and hide themselves do that. In a way I think I was trying to make

a political statement about how in this culture, a dominant culture which represents a tiny percent of the globe, is in a sense robbing us blind. As she is pulling this thing over her head she says, "You really must be paranoid but after all I am free, white and 21."[26]

Like Pindell, Lorraine O'Grady has used performance art to make powerful interventions. In *Mlle Bourgeoise Noire* (1980–82), her earliest piece, she invaded select New York art openings as the eponymous invented character. Wearing a rhinestone-and-seed-pearl tiara and a sash celebrating the Silver Jubilee of her coronation as "Mlle Bourgeoise Noire (Internationale) 1955," she disrupted the events with a performance of polemical poems about art and race. Flagellating herself with a whip, she castigated black artists for failing to assert themselves politically and for capitulating to the conservative standards of the art establishment: "That's enough! No more boot-licking . . . No more ass-kissing . . . No more buttering-up . . . No more posturing of super assimilates . . . Black art must take more risks!"[27]

As Mlle Bourgeoise Noire, O'Grady spoke to complex issues of race, gender, and class. She wore a gown and cape made of 180 pairs of previously worn white gloves that she had stitched together—an outfit that, as Andrea Miller-Keller has remarked, "carried the unknown histories of the women who had worn them," histories of both propriety and repression.[28] The tension produced between this costume and her performance of aggressive and confrontational poems spoke to the complicated position of African-Americans who, she felt, simultaneously resisted the hegemony of white power while being complicit in their own victimization.

The daughter of Jamaican immigrants who came to the United States in the 1920s and settled in Boston, O'Grady as a young woman found herself negotiating diverse pressures: her family's "tropical middle- and upper-class British colonial values . . . the cooler style to which they vainly aspired of Boston's black Brahmins . . . the odd marriage of Yankee and Irish ethics taught at the girls' prep school . . . and the vital urgency of the neighboring black working-class culture."[29] These formative experiences of hybridity and diaspora have been central to her life and work. She received a bachelor's degree in economics from Wellesley College in 1961 and a master's degree in fiction from the University of Iowa in 1967. In 1970, she moved to New York, where she worked as a journalist for *Rolling Stone* and *The Village Voice*. By 1980, she had begun her career as a Conceptual artist, using photography, drawings, text, and sound to address the complexity of cultural politics and black female subjectivity. In one of her best-known performances, *Nefertiti/Devonia Evangeline* (1980), she combined a one-woman play with projected photographs in order to memorialize the ancient Egyptian queen and her sister, who died unexpectedly at the age of thirty-eight.

Ringgold, Saar, Pindell, and O'Grady have all produced work in a variety of styles and genres for close to forty years; they represent a range of political

perspectives and have found diverse ways to express their feminist and anti-racist convictions. They, along with contemporaries such as Camille Billops, Adrian Piper, and the women in Where We At, either emerged or achieved greater visibility during the 1970s. But of course African-American women's visual culture did not originate with them; since the nineteenth century, black women

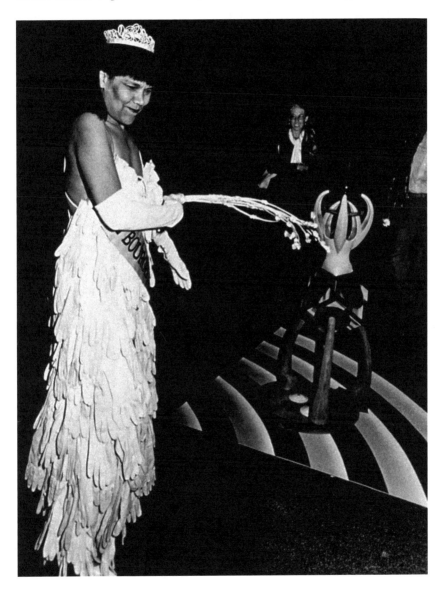

FIGURE 7.1 Lorraine O'Grady, *Mlle Bourgeoise Noire, Whip-That-Made-Plantations-Move* (1980). Silver gelatin print. Courtesy Alexander Gray Associates, New York, NY.

sculptors and painters had been producing images in opposition to demeaning representations of black female bodies. Indeed, by the 1960s and 1970s, artists including Elizabeth Catlett and Emma Amos had developed national and international reputations. Moreover, by the late 1970s black women artists such as Varnette Honeywood, Synthia Saint James, and Brenda Joysmith had begun to lay the groundwork for the popular acclaim they and other "Black Romantic" artists have received for figurative work that represents and celebrates the rituals of everyday African-American life.[30] The successes of a younger generation of artists including Renee Cox, Ellen Gallagher, Renée Green, Alison Saar, Kara Walker, and Carrie Mae Weems—as well as filmmakers Julie Dash, Zeinabu Davis, Cheryl Dunye, Kasi Lemmons, Michelle Parkerson, and Yvonne Welbon— provide abundant evidence of the enduring and variegated legacy of black feminists in visual culture.

Notes

1 For early black feminist critiques of anti-racism and women's movements, cultural representations, and public policy, see Toni Cade, ed. *The Black Woman: An Anthology* (New York: New American Library, 1970); Gloria T. Hull, Patricia Bell Scott, and Barbara Smith, ed. *All the Women Are White, All the Blacks Are Men, But Some of Us Are Brave: Black Women's Studies* (New York: The Feminist Press, 1982); and Smith, ed., *Home Girls: A Black Feminist Anthology* (New York: Kitchen Table—Women of Color Press, 1983). For a detailed discussion of black women in the Civil Rights and Black Nationalist movements and a history of black feminist organizations of the 1960s and 70s, see Kimberly Springer, *Living for the Revolution: Black Feminist Organizations, 1968–1980* (Durham, North Carolina: Duke University Press, 2005).
2 Springer, *Living for the Revolution*, 9–10.
3 Many important studies of black women artists do exist, however, and include two valuable books: Lisa Gail Collins, *The Art of History: African American Women Artists Engage the Past* (New Brunswick, New Jersey: Rutgers University Press, 2002); and Lisa E. Farrington, *Creating Their Own Image: The History of African-American Women Artists* (Oxford, England: Oxford University Press, 2005).
4 Dindga McCannon, in "When That Time Came Rolling Down: Panel II," *Artist and Influence* (1985): 194.
5 Ibid., 190.
6 Ibid., 191.
7 Ibid., 195.
8 Brown, "The Emergence of Black Women Artists: The 1970s, New York," *The International Review of African American Art* 15, no. 1 (1998): 47.
9 Ibid.
10 Ibid., 48–49.
11 Although Faith Ringgold described this figure as "half white, half black," Farrington read her as a white woman. See Ringgold, *We Flew Over the Bridge: The Memoirs of Faith Ringgold* (Boston: Little, Brown, 1995), 148; and Farrington, *Art on Fire: The Politics of Race and Sex in the Paintings of Faith Ringgold* (New York: Millennium Fine Arts Publishing, 1999), 27–28.
12 Ringgold wrote that although the flag actually had fifty stars in 1967, she chose to paint only forty-eight because she "liked the regularity of the position of the forty-eight stars." Ringgold, *We Flew Over the Bridge*, 158.

13 Of the absence of a black woman, Ringgold wrote: "Let us just say that in 1967 she was reluctantly standing behind her man. The white woman was too, but somebody had to get between these two men, and since she was the daughter of the white power structure, she had inherited the role of peacemaker." Ibid.

14 Ibid., 162.

15 Ibid., 187.

16 Ibid., 190.

17 Ibid., 189.

18 Ibid., 190.

19 Peter Clothier, "The Other Side of the Past," in *Betye Saar*, exh. cat. (Los Angeles: The Museum of Contemporary Art, 1984), 16.

20 Saar, in Cindy Nemser, "Conversation with Betye Saar," *The Feminist Art Journal* 4, no. 4 (Winter 1975–76): 20.

21 For a discussion of other works of the period by African-American artists such as Murry DePillars, Jeff Donaldson, Jon Lockard, and Joe Overstreet that take on this figure, see Michael D. Harris, *Colored Pictures: Race and Visual Representation* (Chapel Hill, North Carolina: University of North Carolina Press, 2003). See also Bridget R. Cooks's insightful analysis of *The Liberation of Aunt Jemima* in relation to other examples of contemporary artwork that confront racist and misogynist images in "See Me Now," *Camera Obscura* 36 (September 1995): 67–83.

22 Harris, *Colored Pictures*, 117.

23 Howardena Pindell, "Art World Racism: A Documentation, 1980—1988," in *The Art of the Question: The Writings and Paintings of Howardena Pindell* (New York: Midmarch Arts Press, 1997), 7.

24 See observations by Corinne Jennings, Lowery Stokes Sims, and Farrington in *Howardena Pindell: Atomizing Art* (dir. David Irving, 1998).

25 Pindell, interview with Kettle Jones, April 2, 1989, *Artist and Influence* 9 (1990): 118.

26 Ibid., 121

27 Lines quoted from *Creating Their Own Image*, 221.

28 Andrea Miller-Keller, "Lorraine O'Grady: The Space Between," in *Lorraine O'Grady/MATRIX* 127, exh. brochure (Hartford, Connecticut: Wadsworth Atheneum, 1995), 3.

29 O'Grady, "The Space Between," in *Lorraine O'Grady*, 8.

30 See Michelle Wilkinson, ed. *Black Romantic: The Figurative Impulse in Contemporary African-American Art*, exh. cat. (New York: Studio Museum in Harlem, 2002).

8

"TEACHING TO TRANSGRESS"

Rita Yokoi and the Fresno Feminist Art Program

Jennie Klein

To educate as the practice of freedom is a way of teaching that anyone can learn. That learning process comes easiest to those of us who teach who also believe that there is an aspect of our vocation that is sacred; who believe that our work is not merely to share information but to share in the intellectual and spiritual growth of our students. To teach in a manner that respects and cares for the souls of our students is essential if we are to provide the necessary conditions where learning can most deeply and intimately begin.

—bell hooks, *Teaching to Transgress*, 13

In 1970, Judy Chicago set up a unique program for women students at Fresno State College. Called the Feminist Art Program (FAP), Chicago ran it for one year in Fresno, after which she—along with ten of her students—transferred to California Institute of the Arts. By the end of her year at CalArts, where she ran the program with Miriam Schapiro and Paula Harper, Chicago had decided that she could no longer work under the constraints of a male-dominated institution. She parted company with Schapiro (who remained at CalArts) and, together with art historian Arlene Raven and graphic designer Sheila De Bretteville, founded the Woman's Building, an institution devoted to feminist art and pedagogy, and the Feminist Studio Workshop, the first program of feminist art study that was offered outside of traditional, patriarchal institutions.[1]

Until recently, much of the literature devoted to this unprecedented moment of radical feminist pedagogy in the art world has been primarily concerned with Chicago. Yet there were other women who taught courses on feminist art and art history during the heady days of second wave feminism. One of those women, Rita Levine Yokoi Lovato (1938–2006), is the focus of this chapter.[2] Before Chicago left Fresno for CalArts in 1972, she asked Yokoi to take over

the Fresno program. Yokoi, a visiting professor like Chicago, ran the Fresno FAP for two years, after which she left to take a teaching position at UCLA. Joyce Aiken subsequently took over the program, which she ran until 1992, the year that she retired. The program was discontinued at that time. The history of feminism—and the feminist art movement—is full of people like Yokoi who continued the work that other, more prominent figures such as Chicago and Schapiro had begun. Much like the names inscribed on the ceramic tile floor of Chicago's *Dinner Party* (1989), these women are barely mentioned in historical accounts, even when those accounts are about transformative programs and events that would not have been possible without their work.[3]

Significant feminist art exhibitions have emphasized the larger context in which feminist art was made (*Sexual Politics*, 1996, and *WACK!: Art and the Feminist Revolution*, 2007) and the experience and work of students (*A Studio of Their Own: The Legacy of the Fresno Feminist Experiment*, 2009 and *Doin' It In Public: Feminism and Art at the Woman's Building*, Otis College Ben Maltz Gallery, 2011). Similarly, the British feminist art journal *n.paradoxa* devoted a 2010 issue to "Feminist Pedagogies" that includes first-person accounts, theoretical essays on pedagogy, and articles about experimental programs in feminist art education.[4] However, despite this expanded consideration of the feminist art movement, the many women who turned their backs on their traditional training to teach feminist art and art history, some of whom jeopardized their bids for tenure or tenure track positions, remain unacknowledged. Yokoi, for example, was able to take on the Feminist Art Program and step into Chicago's larger-than-life shoes in fall 1971 because of her visiting professor status.[5] Although there is very little published material on Yokoi as either a teacher or artist, what does exist suggests someone who was more measured and less confrontational than Chicago. Her account of this time and the recollections of her colleagues suggest that she modified the program to ensure its success. How did a very different kind of feminist and artist approach teaching? What were Yokoi's limitations, and in what ways did she go further than Chicago?

Rita Yokoi

Although quieter and less outgoing than either Chicago or Schapiro, Yokoi exhibited the same staunch commitment to feminism. Prior to taking over the program, Yokoi had attended the performance class run by Chicago (with the help of Schapiro) in the spring of 1971. She then returned to Berkeley where she organized several consciousness-raising (CR) groups and picketed the UC Berkeley Art Museum to protest its under-representation of women artists.[6] Unlike Chicago, Yokoi's work was humorous and playful rather than ideological. In the 1970s and 1980s she enjoyed a great deal of professional success, exhibiting her work nationally and internationally and getting reviewed in publications such as the *L.A. Times* and *Art Week*.[7] Her feminist politics were evident in her choices

of exhibition venues. Yokoi was included in group exhibitions at prestigious venues such as the Los Angeles Institute of Contemporary Arts, the De Young Museum in San Francisco, the Long Beach Museum of Art, and the Pasadena Art Museum, and also participated in exhibitions in feminist galleries such as Womanspace (before it moved to the Woman's Building) and the galleries associated with the Woman's Building. Yokoi was part of the vibrant west coast feminist art movement that produced artists such as Chicago, Schapiro, Suzanne Lacy, Barbara T. Smith, Eleanor Antin, Rachel Rosenthal, Faith Wilding, Judy Baca, Yolanda Lopez, Mónica Mayer, and Cheri Gaulke. During the 1970s, Yokoi's work was shown in exhibitions with these artists. But the renewed interest in second wave feminist art that began in the mid-1990s and gained momentum in the first decade of the twenty-first century did not result in any increased visibility for Yokoi, whose work was not included in any of the major feminist art exhibitions. One reason may be that though Yokoi facilitated and participated in student performances in Fresno, after she left for Los Angeles she moved away from performance and video, art forms that lent themselves to an engagement with social issues and practices—and visibility in subsequent critical writings on art from that time. Moreover, because Yokoi's career as an artist took place prior to the advent of the Internet, information about her career and reproductions of her work are difficult to find.[8] Most importantly, though, in the mid-1980s when she moved from Los Angeles to Colorado, Yokoi's life and focus shifted to promoting, exhibiting, and selling Native American jewelry.

Yokoi grew up as Rita Levine in Long Island. Her sister Bambe Levine recalled that she was an avid reader of poetry and philosophy.[9] After studying ceramics at Alfred University in upstate New York from 1956 to 1957 (and marrying her ceramics professor George Yokoi), Yokoi earned a BFA in ceramics from the San Francisco Art Institute in 1961; a Fulbright in 1962–1963 at the Tokyo University of Art; and an MA in sculpture from UC Berkeley in 1970. Yokoi's work included whimsical environments, sculptural installations, painting, and photography. Both Lillian Faderman and Joyce Aiken, who were colleagues at the time, remember Yokoi as a serious, intense person who was passionate about her art.[10] Although divorced from her first husband by the time she came to Fresno State, Yokoi, who had established a professional reputation by the early 1970s, continued to use her married name, in spite of being involved with a different man. Faderman recalled that Yokoi, an elegant, sophisticated woman at the time of her death, wasn't as concerned about her personal appearance in those heady days of second wave feminism. While teaching the feminist art class at Fresno State, Yokoi wore work overalls and her long blond hair in a bun just about every day. As was the case with many women involved in second wave feminism, Yokoi eschewed the traditional trappings of femininity in pursuit of her vision as an artist.

In 1985, Yokoi had a one-person exhibition at Cal State Long Beach as part of the Centric series which is still going on today.[11] After that, Yokoi turned her

attention to Native American arts and became an expert in heishi beads and Santo Domingo jewelry.[12] She married Martine Lovato, a highly regarded jewelry maker from the Santo Domingo Pueblo tribe. In the early 1980s, she founded Silver Hills, named after the Silver Hills of Colorado. She was living in Bayfield, Colorado and ultimately moved to Albuquerque, New Mexico where Silver Hills became known as a prominent distributor of Native American jewelry specializing in objects from the Santo Domingo Pueblo, Hopi, Zuni, and Navaho tribes.[13] Yokoi died in Albuquerque in May 2006 at the age of 67.

The FAP and Yokoi

When Yokoi took over the FAP, the definition of feminist art pedagogy was open-ended. It could entail a class or two devoted to the history of women artists and gender and representation, or an immersion program that fostered women students' questioning all aspects of their lives, including their approach to art making. The latter approach to feminist art education is most closely associated with the feminist art programs that developed in the 1970s. The FAP, as described by Chicago in her 1975 autobiography *Through the Flower*, began as a proposal by a young artist named Judy Gerowitz (Chicago had not yet legally changed her name) to teach a class instructing women how to become professional artists.[14] The FAP first took the form of a four-hour class; by spring of 1971 it had morphed into a full-fledged program, with the students able to sign up for fifteen hours and have their credits count toward various core requirements such as sculpture, painting, and art history. To keep the program cohesive, Chicago took the unprecedented step of interviewing the students before permitting them to register for the program.

In retrospect Chicago felt that the isolation of Fresno State made it possible for her to propose and implement such a radical and immersive educational program. As she wrote later, "because Fresno was outside of the sophisticated art world, there was little real comprehension of the implications of my plan."[15] Many of Chicago's students were from rural, working-class backgrounds and had little or no familiarity with the art world in Los Angeles. Before teaching her students how to make art, Chicago taught them how to be artists in practical terms. The first assignment was for the students to find studio space off-campus, negotiate a rent, and fix up the studio. Then, Chicago set about undoing the patriarchal brainwashing that she felt hindered these women from viewing themselves as working artists. Although unaware of feminist consciousness-raising per se, Chicago began using a modified version, asking her fifteen students to place their personal experiences within a larger context of gender inequity and ideologies about what constituted acceptable female behavior. Chicago encouraged her students to make work from their experience, with the result that content became more important. In this environment, the immediacy of performance art was incredibly appealing. In LA, performance art in the 1970s

was an anti-object, conceptually-based art form that had its roots in avant-garde art-making practices. Paul McCarthy's flinging and pushing of paint, for example, was based on his training as an abstract expressionist painter, while Barbara T. Smith's performance environments were influenced by Robert Irwin, her professor at University of California, Irvine. At the FAP, the performances, which were based on group responses, personal experience, and research into the history of women, took the form of skits in which narrative was privileged over the visual and conceptual impact of the piece. Chicago believed that these "informal" performances gave the students the raw material that they needed for art making.

At the end of the academic year (spring 1971), Chicago accepted Miriam Schapiro's invitation to move the program and many of her students to CalArts, and Yokoi took over the Fresno program. She described its purpose as "trying to validate or give value to the activities and experiences of women" through art.[16] Two years after her tenure as FAP director ended, Yokoi collaborated in a collection of women's studies syllabi organized by Athena Tacha Spear for the College Art Association.[17] Yokoi's contribution follows a brief description of the Feminist Art Program at CalArts by Chicago and Schapiro and precedes a description of Betsy Damon's Feminist Art Studio, which Damon offered at Cornell University. There were only a handful of studio art courses included in this collection, with Yokoi's the most detailed and the most thoughtful.[18] But in the fall of 1971, the program that Yokoi had taken over had shrunk back down to a class that met twice a week for three hours each meeting. Even this was difficult for Yokoi to negotiate; she had to settle for fewer credit hours than she felt were equitable. In spite of the reduced contact hours with the class, which meant that the students had other demands placed on them as well, Yokoi, like Chicago, insisted that the students find their own studio off-campus, which she characterized as "a practical experience in that they learned how to negotiate with realtors, determine what their needs were for work space, learn to make tables, and to build and paint walls."[19] As with the previous incarnation of the FAP, students were encouraged to make work based on content rather than materials and formal issues. Once again, the class—and Yokoi—were drawn to performance. "It seemed natural for the women to act out their feeling about themselves; their anger, their fantasies, their perception of themselves, their feminist issues. They were able to draw from their background in costume and cosmetics and to develop it into an art form. The work produced was powerful."[20]

Yokoi's pedagogical approach integrated her class—and their art work—into the Fresno community. Aiken recalled a performance, undertaken with the help of Sharon Shore, a Fresno State design professor, in which Yokoi and her class went to the local mall and performed a spoof on the iconic prom queen.[21] On campus, Yokoi and her students were instrumental in getting a women's studies advisory board formed that led to the creation of a women's studies program on campus. They organized a group show and a number of activities during March, which had been designated as women's history month. They put together several

group shows for the library, organized guest lectures by prominent women artists and art historians, and presented as a group at several conferences, including The West Coast Women Artist's Conference held in Los Angeles in 1972. The final class project, *The Wedding*, was structured to involve members of the community. An environmental installation/performance/exhibition, *The Wedding* was an exploration of the contradictions of (heterosexual) marriage. First, posters/invitations were mailed out to "guests." At the performance, an audio installation and slide installation explored "the double bind" facing women to be both "pure virgins and seductive whores" while two performers/brides—one red, one white—sat in a decorated environment meant to mimic a wedding chapel. Red punch and nipple cupcakes were served to the audience, who had been "invited to dress as members of the wedding." An exhibition of related work by the students was on view on the walls of the "chapel." The exhibition was very well received, drawing larger than expected crowds.[22]

Yokoi's program parted company with Chicago's in that it was based less on the intense and claustrophobic, but incredibly fertile, community that resulted when the women in Chicago's class opted to take all of their credit hours in the FAP. The pedagogical community constructed by Chicago was not to everyone's liking. The CR-style sessions that Chicago led sometimes caused hurt and bewilderment rather than enlightenment. Meyer has noted that:

> while Chicago's goal was presumably to create a safe environment in which all participants could identify and articulate their life challenges, fears, frustrations, and desires, and address them in their artwork, participants did not always feel safe or supported with the group. In retrospect, many of them remember feeling painfully aware that there was an "in group" that enjoyed Chicago's favor and an "out group" that did not.[23]

This assertion is echoed by Wilding in her essay "Gestations in a Studio of Our Own: The Feminist Art Program in Fresno, California 1970–71" and by Aiken, who recalled admitting a woman student to her program who had stopped making art as a result of her contact with Chicago. Chicago's view was that "in order to help the women establish stronger personal identities I had to become involved with them and their lives,"[24] and she pushed the women to "drastically alter their personality structures," as she put it in a 1971 interview.[25]

Chicago's pedagogical methods, while quite radical, nevertheless worked with most of her students, many of whom went on to have long careers as professional artists and educators. Yokoi, on the other hand, backed off from and finally discontinued the CR techniques that Chicago had instituted. As Yokoi explained:

> the students didn't want it, and I saw it to be less valuable and in some instances harmful. Some students felt intimidated and they also felt that they were so nervous about talking according to the consciousness

raising rules that they failed to listen . . . Further, some women revealed serious emotional problems, and the class and myself were not trained to deal with these problems productively.[26]

Yet, like Chicago, Yokoi was concerned by the limitations of a group of women who came from working-class backgrounds and had little familiarity with intellectual discussion. Yokoi was also similarly frustrated that though her students were willing to talk endlessly about how they had been oppressed, they were less willing to use those feelings to make art. In fact, an anti-intellectual climate prevailed, making it difficult to get the students to do assigned reading and research. Yokoi concluded in retrospect that the problem lay less with the subject of the class than it did with the fact that "I was teaching in Fresno where there is a lack of competition, stimulation of artists and art exhibits, and a high level of demand within the University."[27]

In response, Yokoi decided on a more structured approach to the class. The previous year, Chicago had required her students to read and discuss feminist writers such as Ti-Grace Atkinson, Simone de Beauvoir, and Roxanne Dunbar. Yokoi revised that list, adding new topics and some recent publications that were not available when Chicago taught in Fresno. Yokoi's assigned book list included Virginia Woolf, *A Room of One's Own*, Valerie Solanis, *SCUM Manifesto*, Shulamith Firestone, *The Dialectic of Sex*, and Anais Nin, *The Diary of Anais Nin*. Significantly, Yokoi added required readings that offered a more inclusive approach, such as Woman's Free Press, *Lesbians Speak Out*, and the 1971 issue of *Everywoman* devoted to lesbianism. She assigned articles by Lucy Lippard and Linda Nochlin published after Chicago left Fresno, and recommended Helen Diner's work on feminist spirituality. Class discussion and research were based on required books and articles rather than on the personal experiences of the women. However, Yokoi insisted that her class continue the research into the history of women artists begun during the first year of the FAP. To do so, Yokoi arranged for her class to conduct research at the Oakland Museum on the history of the many women artists in California. Students also interviewed contemporary women artists. Through these activities, Yokoi encouraged students to rethink what it meant to be an artist and a feminist in California's Central Valley. In 1972, Yokoi reported her students as a "cohesive group who are demanding of themselves and each other. They are learning to take responsibility for their own lives, taking themselves seriously and striving toward professional careers."[28]

Yokoi as an Artist

Yokoi left Fresno in 1973 to teach full time at UCLA and part-time at Otis. She never taught a feminist art-making class again, although she did teach a number of female students. Her subsequent art work is informed by feminism, though without necessarily being directly about feminist issues. Yokoi's assignment of

Helen Diner's *Mothers and Amazons* in 1971 pointed to what would become the primary preoccupation of her work for the rest of the 1970s and part of the 1980s: the suggestion of an alternative, non-patriarchal spiritual and intellectual path infused with a sly sense of humor through the creation of environments, sculpture, and painting. Yokoi's work drew upon her experience at Fresno making anti-patriarchal work. Bambe Levine recalls that in 1976 Yokoi made a sculptural work entitled *Cocksicles*, four replicas of "cocks" placed in ice cream cones that were balanced in a plastic cone holder similar to those used in ice cream stores. Yokoi's earlier work with performance translated into a desire to allow the viewer to "perform" the work by moving through the installation. Her background in ceramics as well as her year in Japan while a Fulbright Fellow also may have been sources of inspiration for this new direction. In reviewing Yokoi's work for *Artweek*, William Hemmerdinger suggested that:

> Yokoi's paintings, collages and constructions rely on viewers' interpretation of the artist's personal mythology—a brand of asceticism akin to a blending of eccentric Rinzai Zen, EST, American transcendentalism, Confucianism and a variant of Christian-era esthetics. Added to this complex broth is the practical studio philosophy of a ceramist turned sculptor.[29]

Several years later, Yokoi characterized her installation *Voyage in Search of your Soul* as "a place to sit and contemplate, or to wander around and communicate with the personal and universal self within each of us."[30] The installation, which included a canoe as a vessel of transformation, was meant to recall the shamanic rituals of the Salish Indians, who would undertake a ritual journey as a means of restoring balance to the community.

Yokoi's work never dealt directly with feminist politics. Nevertheless, she was included in several feminist art exhibitions. In 1972, Yokoi had a piece in *Invisible 21 Artists Visible*, a feminist exhibition curated by Dextra Frankel with the help of Judy Chicago for the Long Beach Museum of Art. Yokoi's *Untitled Wall Relief* (1966–1971) used materials traditionally associated with the male-dominated California Finish Fetish school—lucite, plastic, tubing, and ceramics. In Yokoi's treatment of these very modern, synthetic materials, the plastic tubing became long, hair-like strands attached to ceramic bone-forms mounted on lucite.[31] By the late 1970s, Yokoi was making environmental installations. For the Woman's Building exhibition *What is Feminist Art?* (1976) Yokoi created an installation of fake palm trees, pink flamingos, and a serpentine rubber hose that coiled around the fake "island." Yokoi's installation played on the kitschy elements of southern California culture which she again juxtaposed with industrial, finish-fetish materials in the form of the hose, which threatens to overwhelm everything else.

In 1977, which was designated the International Year of the Woman, Yokoi was invited to participate in *Female Fantasies*, a group exhibition curated by Melinda Wortz for the gallery at UC Irvine. This show was one of a number that year

featuring women artists at galleries and museums in Los Angeles to complement *Women Artists: 1550–1950*, curated by Linda Nochlin and Anne Sutherland Harris at the Los Angeles County Museum of Art. In conjunction with this unprecedented exhibition of women artists, Wortz curated a collection of contemporary feminist work that used fantasy to reference previous eras in the history of art. Yokoi's installation *Chuck's Pet Dinette* was a bit of a departure for Yokoi, who normally worked more abstractly. Composed of ready-made, found objects, *Chuck's Pet Dinette* took as its point of departure a business of the same name that was located across the street from Yokoi's studio. The real Chuck's Pet Dinette sold rubber toys for dogs that were facsimiles of people food. Yokoi's installation consisted of a counter with six place settings, each plate holding a "dish" from the original Chuck's. Below the place settings were six dog dishes, each with a fried egg chew toy that fit exactly into its contours. Above the place settings were five kitsch prints of dogs behaving like humans. Yokoi had previously made a series of prints of dogs wearing glasses and Groucho Marx mustaches for the Woman's Building Exhibition *Social Commentary* (1976). The installation built upon the print series and can be read as an ironic commentary on contemporary capitalist consumption. Adding to the irony was that these chew toys were no longer manufactured due to safety concerns. *Chuck's Pet Dinette* also recalls Edward Keinholz's *The Beanery* (1965), an assemblage recreation of a popular bar. Keinholz made the installation as a protest against the Vietnam War after observing people drinking at the actual bar in spite of a prominently placed newspaper with the headline "Children Kill Children in Viet Nam." Twelve years later, Yokoi picked up on the same incongruity, this time using the treatment of pets to highlight the hypocrisy of contemporary culture, but in a less didactic, more humorous manner. Unlike Keinholz, whose dripping, ramshackle assemblages were a scathing indictment of contemporary culture and politics, Yokoi's installation suggests an appreciation for the kitschy excesses of southern California culture. According to Bambe Levine, it was also homage to her time in Japan, where she had gained a real appreciation for the kitschy plastic toys that were sold there.

By the early 1980s Yokoi was working primarily with forms and color, using paint to transform a collection of disparate objects into a unified environment. It was this work, which even in photographic reproductions comes across as much more powerful and unified than the earlier assemblage pieces, that earned her a prestigious National Endowment for the Arts grant in 1981–1982. In the late 1970s and early 1980s Yokoi appears to have transitioned to paintings, albeit paintings with heavily built up surfaces that were partially sculptural. The exhibition that Hemmerdinger reviewed in 1980 was comprised primarily of paintings. These paintings were not particularly well-crafted, as though Yokoi had decided to eschew her background and evident skill in ceramic techniques. The deliberate disavowal of craft, which may be read as a rendering of the Japanese concepts of sabi/wabi (weathered antiquity), carried over into her environments. In 1982, Yokoi exhibited at 80 Langton Street in San Francisco with Valerie Reichert. Yokoi and

Reichert were the third pair of artists to exhibit their work in the program *Painting Installations*. For this exhibition, Yokoi had been required to submit a proposal—her work was selected from a national pool of applicants. Yokoi's unique design for the exhibition, *The Grounding Place, Number 1* (see Plate 8), was a visualization of the idea of equilibrium, defined as a person achieving oneness with universal time. Yokoi chose to paint everything red, a color that to her symbolized energy and regeneration, as well as heat and life. *The Grounding Place, Number 1* was a total sensory experience. A heating element was laid over the rocks in the installation while a tape of synthetic sounds embodying red energy composed by Steve Roach played continuously. According to Suzanne Foley, "the experience of the active aspect of a transcendent world of continuum was offered to the viewer, in a synthesis of physical and spiritual, through a multi-sensory experience in red."[32] Animals appeared in this installation as well, in the form of turtles—possibly Japanese toys painted red—that moved from the floor to the wall. According to Foley, Yokoi had planned a companion installation to *The Grounding Place, Number 1* in which the elements of red and blue were equally balanced. Whether or not Yokoi realized this piece remains a mystery. Yokoi did complete an installation for the Cal State Long Beach Gallery's Centric series *Voyage in Search of Your Soul* in 1985.

Conclusion: A Life Suffused by Art

Yokoi's interest in alternative spiritual paths apparently led her away from making art shortly after she exhibited at Cal State Long Beach in 1985. Yokoi's artist's statements suggest that the most important aspect of her life was her spiritual journey, with art objects simply being one manifestation of that path.[33] In 1977, in conjunction with an exhibition that she curated for Mount St. Mary's College Art Gallery entitled *Attitudes Towards Space: Environmental Art*, Yokoi wrote, "The environment includes the universe and universal consciousness as well as the environment of the personal perception of each artists [sic] and each viewers [sic] mind. There is no gap here in my opinion."[34] For the next ten years, Yokoi's work was increasingly tied up with expressing her own drive for universal consciousness and a spirituality that was not patriarchal in origin. In her 1985 statement that accompanied *Voyage*, she wrote that the premonition for the piece had come to her a year prior and had proved to be prescient, as she had made great changes in her personal life. In retrospect, it appears that Yokoi's path was leading away from art making. In her statement, Yokoi suggested that *Voyage* was intended as a teaching tool.

> Why did I do this piece? I wish to share and communicate through a visual language that is both individual and universal, to create a context, and to expand consciousness. I'm strong and very tough. I'm vulnerable and afraid. I'm with you and I'm alone. The canoe has two paddles. The work is feminine. You enter it. It is assertive and masculine too.[35]

In the passage from *Teaching to Transgress* that begins this chapter, bell hooks stressed the importance of teaching in a manner that cared for the souls of one's students. Clearly Yokoi was concerned with doing just that, whether it was as a young artist teaching even younger women in feminist art making, or as a more established artist and curator intent on sharing her vision with the people who came to the art gallery. Yokoi's résumé from 1998 indicates that she continued to teach people about the Native American jewelry that she loved, by giving lectures, supporting the artists, helping to found a museum, and then opening a gallery of her own.[36]

In 1974, the year that Tacha Spear assembled syllabi of feminist art studio classes, there were only five prototypes included. How many would be included in a similar book today? Have many of the ideas Yokoi taught infiltrated art programs at universities and colleges? Does the current generation of young women artists take for granted the rights and space that pioneers such as Chicago, Schapiro, Yokoi, and Aiken made possible? Is teaching about their struggles incorporated sufficiently into contemporary art curricula? It should be, and for that reason this chapter is written in the memory of Yokoi, a person that I never met, but who I wish that I had.

Notes

1 Laura Meyer, "The Woman's Building and Los Angeles' Leading Role in the Feminist Art Movement," in Sondra Hale and Terry Wolverton, eds., *From Site to Vision: The Woman's Building in Contemporary Culture* (Los Angeles: The Woman's Building, 2007), 71–102.

2 Although Rita Lovato was active professionally as an expert in Native American jewelry who founded a company, Silver Hills, that specialized in jewelry from the Santo Domingo Tribe, she taught at Cal State Fresno as Rita Yokoi and will be referred to by that name in this chapter.

3 Linda Nochlin first discussed this concept of teaching genius in her ground-breaking article "Why Have There Been No Great Women Artists," *ArtNews* (January 1971): 22–39, 67–71.

4 Laura Meyer and Faith Wilding, "Collaboration and Conflict in the Fresno Feminist Art Program: An Experiment in Feminist Pedagogy," *n.paradoxa* 26 (July 2010): 40–51.

5 When she left Fresno State, Yokoi asked Joyce Aiken, who was tenured, to take over the class because she feared that anyone else would be too vulnerable.

6 Eleanor Dickinson, "Report on the History of the Women's Caucus for Art," in Karen Frostig and Kathy A. Halamka, eds., *Blaze: Discourse on Art, Women and Feminism* (Newcastle, UK: Cambridge Scholars Publishing, 2007), 37–69. The article is available on the Woman's Caucus of the Art website as a PDF at www.nationalwca.org/wcadocs/TheHistory%20of%20the%20WCA.pdf, accessed 12/13/2010.

7 Yokoi's résumé through 1976 was published in Melinda Wortz, *Female Fantasies: Jo Anne Bourgault, Anna Gunter, Elatia Kopfli, Janice Lester, Rita Yokoi* (Irvine, CA: University of California Fine Arts Gallery, 1977), 15.

8 The only reproductions of her work online are pieces included in exhibitions at the Woman's Building and thus in that institution's archive: www.otis.edu/life_otis/library/collections_online/wbimages.html, accessed 12/16/2010. In an interview conducted with Joyce Aiken on 12/21/2010, Aiken mentioned that the Cardwell

Jimmerson Contemporary Art Gallery in Culver City was unable to obtain any of Yokoi's work for a January 2010 re-creation of "The Last Plastics Show," the inaugural exhibition at CalArts curated by Chicago, DeWain Valentine, and Doug Edge. For more information about this exhibition, see http://cardwelljimmerson1.xbuild.com/#/2010-last-plastics-show/4536766849, accessed 12/24/10.

9 Bambe Levine, "Interview with Jennie Klein," 2/5/11. Special thanks to Bambe Levine, younger sister of Rita Levine Yokoi Lovato, whose generosity with material on Yokoi's life added immensely to this chapter. See also http://obits.abqjournal.com/obits/search, accessed 1/28/11.

10 Lillian Faderman, "Interview with Jennie Klein," 12/18/10 and Joyce Aiken, "Interview with Jennie Klein," 12/21/2010.

11 Yokoi's installation was reviewed—unfavorably—by William Wilson for the *L.A. Times*. William Wilson, "Art Review: A Sizable Minority Breaks Out," *L.A. Times* (April 1, 1985). http://articles.latimes.com/1985–04–01/entertainment/ca-28382_1, accessed 12/25/10.

12 Elizabeth Ann James, "Art Column Archive 1999–2003," *Short North Gazette*, www.shortnorth.com/LizArchive1999–03.html, accessed 12/24/2010; William and Susanne Waites, "Winners and Loser at IACA Spring Market," *Tribal Artery* (July 20, 2006); and http://tribalartery.blogspot.com/2006_07_01_archive.html, accessed 12/24/10.

13 http://tribalartery.blogspot.com/2006_07_01_archive.html, accessed 12/24/10.

14 Judy Chicago, *Through the Flower: My Struggles as a Woman Artist*, Anais Nin, introduction (New York: Doubleday and Co., 1975, and Lincoln, NE: Author's Choice Books, 2006).

15 Ibid., 70.

16 Mary Gomes, "Art Gives Value to Women's Lives," *Fresno Bee* (December 15, 1972).

17 Athena Tacha Spear, ed., *Women's Studies in Art and Art History: Description of Current Courses with Other Related Information* (New York: The College Art Association, 1974). This was a photocopied book, complete with hand-written corrections and page numbering, that was distributed at the 1974 meeting of the College Art Association in Detroit, Michigan. Tacha Spear compiled a list of forty-five programs and instructors of studio and art history courses.

18 Chicago and Schapiro, who had had a falling out by this time, provided a one-paragraph description and directed readers to two articles that they had published: Judy Chicago and Miriam Shapiro [*sic*], "A Feminist Art Program," *Art Journal* 31, 1 (Fall 1971): 48–89 (this was an excerpt of the article originally published in *Everywoman*) and Miriam Shapiro [*sic*], "The Education of Women as Artists: Project Womanhouse," *Art Journal* 31, 3 (Spring 1972): 268–270.

19 Rita Yokoi, "Feminist Art," *Women's Studies in Art and Art History* 3 (1974).

20 Ibid.

21 Joyce Aiken, "Interview," December 21, 2010.

22 Yokoi, "Feminist Art," 5, 7.

23 Laura Meyer, "A Studio of Their Own," in Laura Meyer, ed., *A Studio of Their Own: The Legacy of the Fresno Feminist Movement* (Fresno: Cal State Fresno Press, 2009), 15.

24 Chicago, *Through the Flower*, 75.

25 Judy Chicago and Miriam Schapiro, "A Feminist Art Program," *Art Journal* 31, 1 (Fall 1971): 48.

26 Yokoi, "Feminist Art," 4.

27 Ibid., 6.

28 Gomes, "Art Gives Value to Women's Lives."

29 William Hemmerdinger, "Inquiries into Personal Mythology," *Artweek* 11 (June 21, 1980): 6.

30 Rita Yokoi, "Voyage in Search of the Soul," in *Centric 14: Rita Yokoi* (Long Beach, CA: California State University, 1985), 2.

31 Dextra Frankel with Judy Chicago, *Invisible 21 Artists Visible* (Long Beach, CA: Long Beach Museum of Art, 1972), 51.

32 Suzanne Foley, "Painting Installations," in *Painted Installations* (San Francisco: 80 Langton Street, 1982), 6.

33 There are no published interviews with Yokoi. Merle Schippenberg interviewed Yokoi in the 1970s and donated her audiotape of the interview to the Smithsonian Archive of American Art in Washington, DC. Unfortunately, despite several attempts, I was unable to access what is possibly an important source for Yokoi's ideas and thoughts.

34 Yokoi, "Introduction: December 22, 1976," in *Attitudes Towards Space: Environmental Art* (Los Angeles: Mount St. Mary's College, 1977), 1.

35 Yokoi, "Voyage in Search of the Soul," 2.

36 Rita Yokoi, *Curriculum Vitae*, 1998, Archive of Bambe Levine.

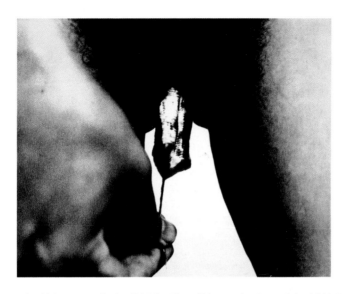

PLATE 1 Judy Chicago, *Red Flag* (1971). Photolithograph. Copyright 2010 Judy Chicago/Artists Rights Society (ARS), New York.

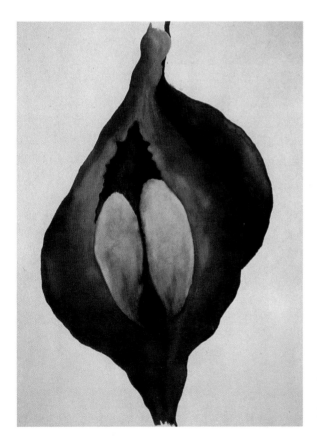

PLATE 2
Faith Wilding,
Womb (1971).
Watercolor on paper.
Reprinted with
permission of the
artist.

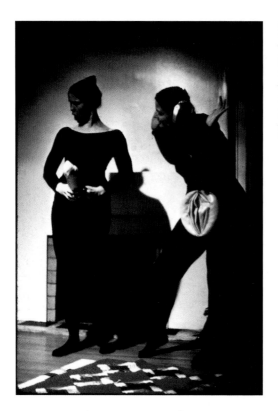

PLATE 3
Judy Chicago, *Cock and Cunt Play* (1970). Performance by Faith Wilding and Janice Lester at *Womanhouse*. Photograph by Lloyd Hamrol. Copyright 2010 Judy Chicago/Artists Rights Society (ARS), New York.

PLATE 4 Karen LeCocq, *Feather Cunt* (1971). Fabric, feathers, wood. Reprinted with permission of the artist.

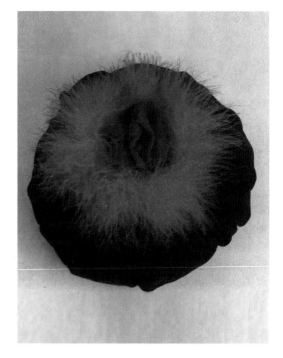

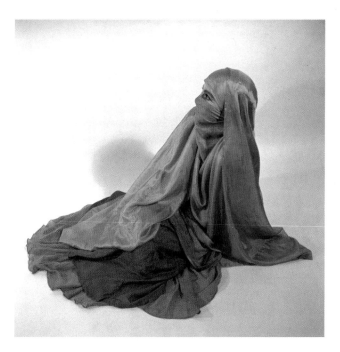

PLATE 5 *Veiled Woman* (1971). Photograph of Shawnee Wollenman by Dori Atlantis; costume by Nancy Youdelman. Reprinted with permission of Dori Atlantis and Nancy Youdelman.

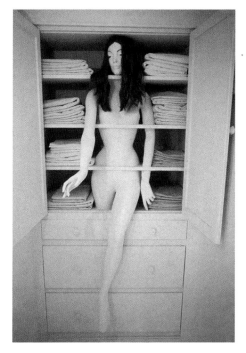

PLATE 6
Sandra Orgel Crooker, *Linen Closet* (*Womanhouse*, 1972). Mixed media installation. Reprinted with permission of the artist.

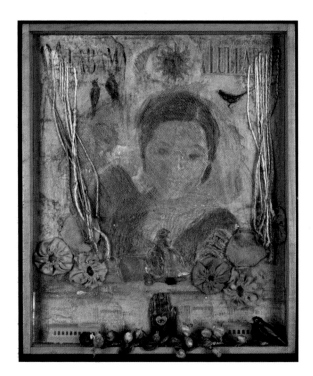

PLATE 7
Betye Saar (b. 1926),
*Victory of Gentleness
(For Rosa Parks)*
(1975). Mixed media
assemblage. Courtesy
of Michael Rosenfeld
Gallery, LLC, New
York, NY.

PLATE 8
Rita Yokoi, *The Grounding
Place, Number 1* (1982).
Reprinted with permission of
Bambe Levine.

PLATE 9
Geraldine Serpa, *36D* (1974).
Acrylic painting on canvas.
Serpa was Joyce Aiken's
student during her first two
years directing the Fresno
Feminist Art Program.
Reprinted with permission
of the artist.

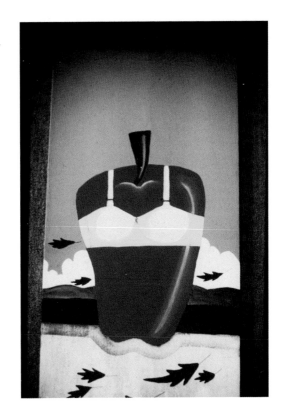

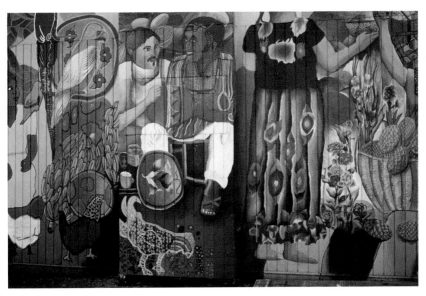

PLATE 10 Las Mujeres Muralistas, detail: *Para el Mercado* (South Van Ness and 24th
Streets, San Francisco) (1974). Acrylic on wood. Photograph by Patricia
Rodriguez reprinted with her permission.

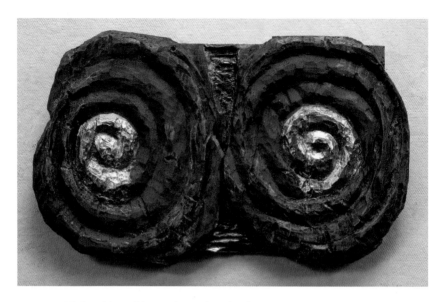

PLATE 11 Nancy Azara, *Two Red Spirals with Silver* (2009). Carved and painted wood with palladium leaf and encaustic. Reprinted with permission of the artist.

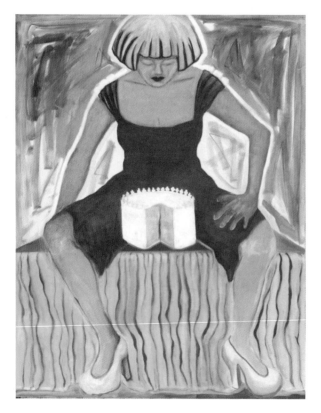

PLATE 12
Sylvia Savala,
Let Them Eat Cake
(2003). Oil painting
on canvas.
Reprinted with
permission of the
artist.

9

JOYCE AIKEN

Thirty Years of Feminist Art and Pedagogy in Fresno

Lillian Faderman

In the 1972–1973 academic year, I was acting dean of the School of Humanities at Fresno State College (as California State University, Fresno was then called). That spring, I asked my department chairs to submit to me their budget requests for the following year so I could prepare the School of Humanities budget, which I would then send to the vice president's office. All the departments met my deadline—except for Art. "Typical," I thought with frustration. By now I'd come to suspect the truth of the stereotype that artists were hopeless about doing practical things, yet such things had to be done to keep a college department running. When I received a phone call from the vice president's office telling me that my school's budget was overdue, I stormed over to the Art Department, furious that they were making me look bad. I confronted the Art Department chairman, who told me that he simply hadn't had a chance to prepare the budget himself and that a few days earlier he'd assigned the preparation to one of his faculty members. The chairman offered to introduce me to that person, so I could be reassured that the budget was indeed being prepared. He led me into a studio room where, perched on a tall stool at a drafting table, was a young woman who looked like Eva Marie Saint. She was working calmly but assiduously at lists of figures that could only be the long-awaited budget. She graciously promised that I would have the budget in hand before the day was over—and I did. What she submitted to me was a model of clarity and good sense.

The lovely and efficient woman was Joyce Aiken. In addition to lending a much needed hand to helping the Art Department run more smoothly and making her own art while teaching a full load, she was soon to take over the Feminist Art Program that had been started at Fresno State in 1970 by Judy Gerowitz (who later became Judy Chicago). Through the decades that followed, I learned that my first impression of Joyce Aiken was spot-on. She's an artist who can also deal

superbly with the vital but mundane demands of life and can teach other artists too how to deal with practicalities. She's a committed feminist who ceaselessly lends her talents to assure the smooth functioning of the important causes that desperately need her.

The beginning of the 1970s had been a heady time for feminists and for academic experimentation at Fresno State College. After campus unrest that reflected the upheavals on campuses all over the country, not only was an Experimental College formed to offer classes that had not gone through the usual channels for course approval, but various departments decided that they would be open to experiment. Judy Gerowitz had been hired by the Art Department in the spring of 1970 as a visiting instructor to replace Joyce Aiken who had gone on sabbatical. Judy stayed at Fresno State for the following academic year, and in the fall she was permitted—in an unprecedented arrangement—to limit her sculpture class to women only. In the English Department that semester, the poet Ingrid Wendt was teaching a course on women poets and I was teaching a course that I'd titled, in keeping with the times, Women's Liberation in Literature. In the spring of 1971, Judy convinced the chair of the Art Department, Heinz Kusel, that her entire load should be made up of a feminist art course, that the course should be open to women only, and that students should take nothing but that course, fifteen units worth, for the entire semester.

Judy hoped to teach her students to obliterate totally their conditioning as womanly women, to be bold, assertive, and confrontational. She helped the students develop in-your-face performance art, in which they would, for example, reclaim words that had been used to put women down, such as "cunt." In one of the most memorable bits of performance art, four of the Feminist Art Program students arrived at the Fresno Airport to greet a feminist luminary, Ti-Grace Atkinson, who had been invited to give a lecture on campus. The students were dressed as cheerleaders, with pink satin mini-skirts and matching pink panties. Each of the four had a single letter emblazoned on her shirt so that lined up in order they would spell C-U-N-T. There at the airport (to the chagrin of tamer types, and even of Ti-Grace Atkinson), they led cheers such as "Give me a C/Give me a U . . ." and "I don't stand on pretense when I pee/I kiss the earth and the earth kisses me."

As Joyce Aiken now theorizes, such "art radicalism" was possible in Fresno as early as 1971 precisely because it was not New York or Los Angeles or San Francisco. There was no strong art community in Fresno at the time to be vocal in its judgment about whether or not this was "art," nor was the general community sophisticated enough (or perhaps interested enough in art) to pose interfering questions. Joyce suggests that, paradoxically, it was Fresno's art-backwardness that made it a fertile place to start a revolutionary feminist art program.[1]

In any case, Judy—by now Judy Chicago—left at the end of the spring semester to work with Miriam Schapiro at the California Art Institute where they started

a second feminist art program. Judy was succeeded in the Fresno State Feminist Art Program by Rita Yokoi, whose teaching style, while less flamboyant than Judy's, was nevertheless intensely radical. When Rita was offered a job at UCLA that would begin in fall 1973, she encouraged Joyce Aiken, who was tenured, to take over the Feminist Art Program. The program had by then attracted enough controversy so that Rita feared that its short history would come to an end if there weren't a tenured professor to continue the classes and place the program safely in the curriculum.

Joyce Aiken recognized that her personal style was nothing like the flamboyance or overt aggressiveness of Judy or Rita, but because she had long harbored feminist sentiments she agreed to Rita's proposal. Near the end of the spring semester, Rita suggested that Joyce come to her last class session in order to meet the present crop of feminist art students. She was to encourage them to enroll in her feminist art course the following fall. Jackie Doumanian, who was Rita's student at the time, still has a vivid image of Joyce, sitting in front of the class, poised and gracious. "And I was thinking, 'Lady, you're never gonna be able to pull it off,'" Jackie recalls. "You don't fit the mold of someone who can teach feminist art because you don't have Judy's or Rita's hard edge. You're just not a tough enough cookie!"

But Joyce, her gentle demeanor aside, has been a "tough enough cookie" from the beginning. She remembers that growing up in Dinuba, in rural Central California, most of the clothes that she and her fraternal twin wore were sewn by her mother, who insisted on dressing the two girls in identical outfits before sending them off to school. Joyce, a quiet rebel even as a child, would invariably sneak back into the house and change into clothes that better expressed her individuality. In an era when girls were not supposed to, she excelled in math (which explains perhaps her impressive competence with the Art Department budget), and even worked as an accountant when accountancy was an occupation that was almost exclusively male. Her own early art work was primarily in drawing and painting, but in 1968 she began a provocative and hilarious project—a pioneering conceptual piece that started out as a protest over the high cost of funerals and the absurdity of funeral rituals. She designed and built her own fully-lined casket, in shocking red, loud orange and hot pink, with matching burial shroud and equally outrageous plastic flowers. Joyce sees the initial impulse behind that piece as being feminist because it was a strong statement in a woman's voice; but, she says, "We didn't yet have a vocabulary to describe feminist art. After Judy Chicago created that vocabulary, I understood the extent to which my own work really was feminist."

Once Joyce identified consciously as a feminist, she focused on seeking other ways to express that feminism in her art. Miriam Schapiro, Joyce recalls, was a major inspiration because she urged women artists to "take back" their traditional work in media such as fabrics, to understand that work as art. "It made me realize the art connection I had with my mother and grandmother through 'women's

work'—needlework, rug making, quilting." From there, Joyce was able to formulate a crucial and unexpected link between feminism and fabrics. She traveled the world—to Mexico, Guatemala, Japan, and China—to find beautiful fabrics that were hand-woven by women. Then, through techniques such as sewing, needlepoint, embroidering, and quilting, she brought together the female art that dated back centuries and the feminist art that was just being conceptualized. Joyce insisted on the historical point that women had usually been barred from the academy where men could go to study painting or sculpture, and so they had developed techniques (needlepoint, for example) to create their own kind of art.

She was determined too to make personal art by, to paraphrase Virginia Woolf, "thinking back through [the] mothers," to her own mother and grandmothers. As she wrote in "Women's Traditional Arts: The Politics of Aesthetics," a special issue of the feminist journal *Heresies*, she could remember her pleasure playing on the floor of the Methodist Church at the feet of the "sewing ladies" who were making quilts for missionaries during the Depression; visiting her maternal grandmother where she helped to make quilts with the women while the men were outside smoking and sitting under the umbrella tree; watching her mother and grandmother and the women in a group they formed crocheting and stitching; learning from her paternal grandmother how to make rugs—washing and preparing the rags, stretching and sewing the burlap to the frame, and hooking.[2]

She began to apply such skills to her feminist art and to give them symbolic commentary. A 1975 piece she did for the Woman's Building in Los Angeles, for example, consisted of pouches made of hand-woven fabrics. They looked like the drawstring purses she recalled her grandmother carrying, and they were filled with sand or water. Joyce's work during these early years often expressed the mother–daughter connection. For example, she was struck by a childhood memory which had helped awaken her consciousness about the social roles of women: Joyce's mother would wear floral-print house dresses all day long as she went about her housework—until it was time for Joyce's father to come home, and then her mother would "dress up." In one piece, Joyce silk-screened images of the houses in which her mother had lived, using the material of floral print housedresses to represent the houses.

Her work became, as artist Ellouise Schoettler describes it, "visual autobiography," and it proclaimed that women's lives were a worthy subject about which to make art. Joyce remembers that during those years,

> I was beginning to experiment with looking back on my history, seeing what I couldn't express before. Now I understood the importance of women developing their own voice and dealing with their personal experiences instead of trying to copy mainstream, academic art. Before feminism came to art, a woman wouldn't dare talk about her connection to family, for instance. It wasn't considered "high art." Since women weren't valued, why should their personal art be valued?

Ironically, because what wasn't valued also wasn't seen as posing a significant threat to the social status quo, Joyce's approach to feminist art at this time assured the longevity of the Feminist Art Program at Fresno State, which continued until she retired in 1992. She tells a story to illustrate the point: though in 1971 it had been possible to run a feminist art program that encouraged performance art such as cheering "C-U-N-T" at the Fresno Airport, by 1978 the political atmosphere and the university administration had gone through a sea-change. When Joyce applied for a sabbatical so that she might help the Feminist Art Institute start a program in New York, it was approved by her department and the liberal School of Humanities, but the academic vice president rejected her proposal. "He said he would refuse to approve anything that had to do with feminist art. He was thinking of Judy Chicago's confrontational art," Joyce remembers. "'That's not the kind of project I'd condone,' he said. Then I told him about women's artistic history and Miriam Schapiro's work with traditional arts like embroidery and quilting." Those who were hostile to feminism couldn't imagine how these kinds of women's arts could possibly be used for the purposes of social revolution. "'Oh, if you're talking about quilting,' Joyce recalls the vice president exclaiming, 'then I can approve it!' Well, I really needed that sabbatical so I could help the Feminist Art Institute," she says, "so . . . whatever worked."

In 1978–1979, Joyce not only lent her efforts to the Feminist Art Institute in New York, but she also became the president of a newly-formed national group, the Coalition of Women's Art Organizations, which was centered in Washington, DC. Ellouise Schoettler, who was the executive-director of the Coalition, recalls that Joyce was crucial to the viability of the organization because she knew how to give it the structure and direction that it badly needed in order to survive and be effective—from putting together by-laws, to gathering an influential board of directors, to raising money, to lobbying Congress on behalf of women artists. "She also understood marketing and how to get things done," Ellouise says. She and Joyce had tens of thousands of postcards made that were mailed to women artists all over the country—on one side a picture of Joyce and her executive director with the Capitol Building in the background; on the other side, statistics that showed the shocking neglect of women artists: for example, 50 percent of art students in America were women, but only about 10 percent of the contemporary artists whose work was exhibited in major museums and galleries were women.

Ellouise recalls, "We let it be known in Congress and elsewhere that the Coalition represented 150,000 American women artists," adding, "Maybe we did have all that active backing, or maybe we didn't, but the Coalition's lobbying produced some far-reaching effects." Working together with the Women's Caucus for Art, a group within the national College Art Association, Joyce and her executive-director convinced Congress that the judging for the National Endowment for the Arts grants must be blind: that is, NEA judges must award grants based only on their estimation of the quality of a proposal; they were no

longer permitted to know the name (and thus the gender) of the applying artist. As a result, male bias in the selection of NEA grant recipients was effectively eliminated. Another result of their lobbying was that in 1979 the White House, in an unprecedented move, recognized women artists by honoring five of them with special awards. "We could accomplish what we did in the Coalition," Ellouise says, "not only because of Joyce's wonderful organizational skills and her quiet power, but also because she would be bold and take some risks. She understood what had to be done, and she'd stay with it until she figured out how to do it." The following year, in 1980, *Ms.* magazine named Joyce Aiken among the "80 Women to Watch in the 1980s."[3]

During her tenure as president of the Coalition, Joyce traveled around the country lecturing, bringing feminist art as it was practiced in the west to audiences in the midwest, the south, and the east. Ellouise, who often lectured with her, recalls that Joyce "blew people away" when she talked about the feminist art she was making and teaching. "There was nothing like that in D.C. or Richmond, Virginia or Detroit or South Bend, Indiana—the work of her students, which she showed them, and also her own work, like the coffin project. It was pushing the envelope, and they loved it."

Joyce also garnered a national platform during these years through several books that she wrote with artist Jean Ray Laury, which promoted what Joyce valued in feminist art, such as *Handmade Rugs* (Doubleday, 1971) and *Creating Body Coverings* (Van Nostrand Reinhold, 1973). Some of these publications also demonstrate a quirky sense of humor and the risk-taking that Ellouise Schoettler describes—such as *The Pantyhose Craft Book* (1978), which, as Jean Ray Laury recalls, had the distinction of meriting prominent mention in a catalogue of "weird and bizarre books." *The Pantyhose Craft Book*, which gave instructions for turning discarded pantyhose into objects such as rugs, stocking-face dolls, and quilts, was also something of a pioneer among books on recycling.

Despite national recognition for her work as an artist, writer, and organizer, "basically," Joyce insists, "I've always been a teacher." As a feminist art teacher, she thought it vital for her students to learn what it meant to be a woman artist. In order to learn that, they had to understand the history of women artists and why that history was a short one. They had to learn to establish their own voice. And they had to learn to envision an "art future" for themselves. Each student in her feminist art class was obliged to produce a new body of work that was personal and came from the point of view of being a woman. For many of her students, particularly in the 1970s, such ideas were startling as well as freeing, since they had been working in male-dominated art departments where they had been taught to suppress their differences from men artists rather than to emphasize them (see Plate 9).

Joyce was conscious not only of conducting her classes in a manner very different from that of her predecessors, but also of giving a new emphasis to feminist art education. "What Judy started was important," she recalls. "It was a radical

first step. But it wasn't my style. It wasn't what I could best teach my students." Jackie Doumanian, who was in both Rita's and Joyce's classes, characterizes the difference in their approaches by saying that

> Rita Yokoi was focused on our expressing what kept us back, what might have stood in the way of our making art, like my father saying about me, 'She doesn't have to go to college. She'll get married and have kids.' That was very important to deal with, and Joyce Aiken worked with that too; but she also thought the class should teach us practical ways to be in the world.

In place of the extensive consciousness-raising which was central to Judy's approach, Joyce believed that what she could do best for her feminist art students was to make sure they had certain skills that were indispensable if they wished to find their place as artists. Class time was first devoted to discussing the concepts and content that were to go into the students' projects. After they produced a body of work, each student was obliged to learn all the requisite skills of exhibiting by giving a one-woman exhibition of her work in a venue off campus, such as a bank, library, furniture display room, or rented storefront. The student not only had to find an exhibition place, but also arrange her exhibit, figure out how to publicize it, design and send out invitations to her opening, plan a reception—in short, learn to do everything a professional artist has to do in order to survive. As Joyce wrote in a 1978 article for the *Washington Women's Art Center News*, "The women go through the same anxieties and fears that a practiced artist goes through before a show, but with the knowledge that they have an understanding support group there for help." Perhaps most importantly, each student had to learn to defend her work. Joyce brought a video camera to class. The student who was exhibiting sat in front of the camera while she was interviewed by the class, challenged about her art so that she might have practical experience in what it was like to "go public as an artist."

Joyce's own pedagogical technique was not confrontational unless a student was inhibited from doing an art piece because she believed a parent or a boyfriend would not approve or someone would be shocked by it. Then the student was urged to risk serious re-examination of her life in order to make art that probed more deeply. The feminist art class was clearly about a lot more than making art. It was about overcoming fears and taking chances. Joyce wished to create a classroom environment that was open to whatever the students wanted to explore and that made young women art students feel safe enough to try edgy things. If physical obstacles stood in the way of making art—such as the complications of transporting materials for large sculptures—Joyce guaranteed the students assistance.

Though angry confrontations with the sexist world were not specifically on the class agenda, the focus on developing their woman's voice sensitized Joyce's

students to whatever drowned out or diminished women's voices. They regularly challenged art professors whom they deemed insensitive to women's issues. In 1984, when a figure-drawing class and several male professors erected a huge mural that depicted clothed men and nude women, members of that semester's feminist art class were determined to paint over the work because, they said, "It treats women as sex objects." Joyce shared her students' annoyance, though she discouraged them from mutilating the mural. (As Jackie Doumanian characterizes it, "She always taught us how to make our point without getting arrested.") The irate students finally agreed that instead of demolishing the offensive drawings, they would carefully cover them with butcher paper. On huge rolls of pink paper they wrote statements such as "BAD PAINTING STILL WON'T COVER UP BLATANT SEXISM," and "NUDE WOMEN IN PAINTING HISTORICALLY HAVE BEEN ANTIQUE PORNO."

Joyce notified the television studios and the *Fresno Bee*, the city's major newspaper, knowing that the local media in those years were delighted to send out reporters to cover colorful feminist demonstrations. The butcher-paper protest made the evening news as well as the front page of the newspaper's regional section. Joyce still remembers that

> The male professors were outraged. They said I should have come to the faculty meeting and protested there instead of letting the students go public. I said, "Sure, and you wouldn't have done a thing about getting rid of that mural." The students got to make their point.[4]

The performance art of Joyce's feminist students was generally not as in-your-face-shocking as the Cunt cheerleaders at the Fresno Airport, but it sometimes made similar points about feminists' willingness to openly confront sex and sexual symbols that had long been used to intimidate or diminish women. When one class needed to raise money in order to pay a visiting artist, the students decided to do what women had always done to raise money. They would have a bake sale—though theirs would be somewhat different from the usual bake sale: some of the baked goods were to be sold at the campus art gallery; others were to be sold by feminist art students dressed as Renaissance wenches who would wander the campus, crying out their wares. The food they sold was both edible and inedible—each a piece of art they had made themselves. Their artistic creations included the McDonald Breast Burger (a hamburger with a nipple on top); vaginal cream puffs with whipped cream and cherry pie filling; warm breadsticks in the shape and size of tumescent penises, with which they offered customers softened butter; banana splits in which the penis-banana was accompanied by testicles made of two scoops of ice cream.

Other performance pieces by Joyce's students were more ingenuous, such as the "virginity ritual," in which the feminist art students staged an ancient rite of renewal during the early spring. Joyce recalls that they dressed in flowing white

robes with garlands in their hair and bowls of fresh flowers in their hands. They scattered flower petals on the ground as they followed a path that led to a large circular fountain at the center of campus. When this ritual was performed the first year that Joyce taught the class, the students discovered as they arrived at the fountain—which the day before had been full and flowing—that it was empty. The ritual required that a woman be submerged in the water of the fountain and that all the participants be anointed with water. The students were certain that the draining of the fountain had been part of a plot against them.

Joyce immediately marched to the office of the executive vice president, who assured her that there was no plot, that it was nothing more than coincidence that the fountain had been drained early that morning. He quickly sent the gardeners out with hoses to refill the fountain. The ritual continued. The students anointed one another and made vows to the goddess that they would renew themselves and start a new year clear and clean. Their feminist message of independence was not lost on the large crowd that this performance piece gathered. Women bystanders soon came forward to make their own vows of renewal, pledging to take charge of their lives starting at that moment.

Women who were in these early classes are now middle-aged, but many of them say they used the skills they learned under Joyce to make life-long careers in art, and they still see themselves as feminist artists. Joy Johnson, who has been a studio artist for more than thirty years, attributes much of her longevity in the profession to Joyce's tutelage and encouragement. Before going back to college in the 1970s, Joy had married, had two children, and worked as a nurse. She'd played with oil painting and ceramics, she says, but nothing about her art had exhibited a feminist awareness. Because she was interested in sculpting, she took a casting class her first semester and, she recalls, was horrified to hear one male student observing about her to another, "Well, she's got a cute butt, but can she really do anything?"

Joyce, she says, provided an antidote to such experiences. "When I'd tell her about things that the male students and professors were doing she'd laugh and laugh, and I could laugh with her. We made a joke of them, and that made it a lot better." Joyce Aiken was also a huge help, Joy says, because she understood the special problems of re-entering students who had to juggle family responsibilities with school; but—most important, she believes—"Joyce opened doors for me by helping me find ways to do sculpting that was feminist," such as a sculpture Joy made of welded steel armatures covered with layers of gauze that she painted decoratively, which, she says, "represents the strength of women: the very sturdy inside concealed by the feminine outside." She thinks her "life's work," as she calls her art, continues to be feminist through the approach she learned in Joyce Aiken's feminist art class: "the materials that I use, which traditionally have been identified with women—such as fabrics, strings, and beads—combined with materials that men traditionally used such as wood and steel. The two kinds of materials are balanced in my work."

Many of Joyce's former feminist art students with whom I spoke talked about how she changed their angle of vision, and how that change made it possible for them to consider themselves artists and find a life-long place in the art world. Jerrie Peters, who, like Joy Johnson, returned to school after marrying and having children, says that Joyce showed her students "how to jump from thinking of ourselves as 'doing crafts'—making quilts for our sons' bedrooms—to seeing ourselves as artists who exhibited, who got into galleries, who belonged in the mainstream of art."

That change in angle of vision was helped along by Joyce convincing her feminist art students of their entitlement to the resources that male artists had always claimed, such as space and tools. "Before, I used to think, 'well, I'll just work on the kitchen table when no one is around'," Jerrie Peters recalls. "Then I realized that serious work needs serious space. I learned how to make the whole garage into a studio. I started doing larger and larger pieces." Like Joy Johnson, Jerrie learned how to combine her skills in traditional women's arts with what had before been considered male arts, such as work in wood. Joyce, she says, gave her the courage to explore what was unfamiliar, and to do it by using what she'd once thought of as unfamiliar tools: "I work with the dremel saw a lot. I used to think that was just a tool for men artists. I work with band saws, and drill presses and sanding belts. I have three dremel saws now."

Cay Lang also traces the successes of her life-long career in art back to the early inspiration of Joyce Aiken. Cay exhibits internationally as a photographer and, from 1989 to 2005, she was the head of a school she founded for artists. She is the author of an art textbook which is widely used in art schools around the country. "If it weren't for Joyce I wouldn't be an artist," she insists. She became Joyce's student in the early 1970s, when she was twenty years old, feeling badly beaten up by experiences with another art instructor, and ready to give up on art. She says Joyce turned her around completely through "infinite compassion. She's a Buddha with a sense of humor." Cay explains that she was able to permit herself to come back to art because Joyce taught by "creating an atmosphere of absolute safety," which, Cay believes, is "essential if you're really trying to make art: You have to go to places in your mind that are scary, and you need a safe place in which to do that." Joyce's very practical assignment, that each student organize an off-campus exhibit of her work, was equally valuable to Cay. "That," she says, "changed everything for me. It made me feel I'd gone from being a student to being an artist." More than twenty years later, the exhibition requirement that she'd had to complete in Joyce Aiken's feminist art class became the inspiration for and basis of Cay Lang's textbook, *Taking the Leap: Becoming an Exhibiting Artist* (1996; revised ed. 2007).

Even artists who were not formally her students say they consider her their mentor and guru, and they look to her for practical guidance. As Trude McDermott, an artist who has known Joyce since the 1970s, observes:

She was this woman operating successfully in the field of art at a time when there didn't seem to be too many women role models. She's been an image for us of how a woman in the arts can be. We women artists were always so aware of her energy and her good sense.

Trude says that she herself has continued to profit from that good sense to this day. She tells a recent story that illustrates for her how Joyce shows women artists to stand up for themselves:

In October 2006, I had some work in a show, and this man said he'd like to buy a piece, but he kept wanting me to give him "a deal." Even though I'd thought the work was already reasonably priced, I did it—and then I was annoyed with myself. I talked to Joyce, who was president of the Fresno Arts Council, about it, and she said "The Fresno Arts Council needs to sponsor a 'Pricing and Selling' seminar." That was exactly what we artists needed. The room was packed.

The artists to whom I spoke say that what was most valuable to them in Joyce's tutelage wasn't simply that they learned how to take make art out of what had traditionally been seen as merely "crafts," or how to use the tools associated with women's creative work along with those tools that were long associated with the work of men, or how to become professional artists and how to stand up for themselves as professionals. Of course those aspects of her instruction have been indispensable. But even more important has been her ability to make them believe in themselves. Joy Johnson remembers:

I'd take on a project that was so hard, and I'd tell her, "It's too difficult. I can't do it. It makes me run around the house crying." She'd say, "That's okay, cry. But come back, and I know you will do it." She never let me doubt that I could do what I strove to do and do it well.

"It was okay for us to stumble all over ourselves," Jackie Doumanian says, "because of the safe space that Joyce created."

Out of the feminist art class requirement that each student arrange her own exhibition came a town-gown project that continues today: a cooperative art gallery. Jackie explains that "We started Gallery 25 because we'd learned that exhibiting was so empowering that we didn't want to give it up. We wanted to open up the possibility for other women." Gallery 25 began as a women-only exhibition space in 1974. The board pledged to show art that was personal, that was about being a woman and being a woman artist—art that would not be welcomed in most other venues. Fifteen years later, in 1989, Gallery 25 became open to male artists as well, though as Trude McDermott observes:

The feminist art movement roots, which Joyce and her students established for Gallery 25, are still there. You can see its influence even on the men who exhibit in the Gallery. It's work that doesn't abide by the formalist tradition, that's experimental and personal and that questions social and gender roles.

The agitations of feminist artists like those at Gallery 25 have made a huge change in the way men are doing art all over the country now, as well as in what has become acceptable in museums and galleries. "Thirty years ago," Joyce Aiken points out, "most museums would have no interest in showing personal art. Now it's everywhere"—though she laments that because feminist art programs have virtually disappeared from the academy, "maybe there's a lot of freedom now, and women artists are much more accepted now, but there's not much consciousness and not much understanding about where the freedom came from."

In addition to the work of the artists that emerged from the Feminist Art Program and that of other local women artists, with Joyce's help Gallery 25 exhibited the work of feminist artists of national renown. She was also instrumental in bringing nationally recognized women artists, as well as the work of their predecessors, to a larger Fresno venue. In 1985, the Fresno Art Museum, inspired by the Feminist Art Program, asked Joyce to aid in organizing a year-long exhibit of women artists. Joyce spearheaded an effort to raise thousands of dollars among community women for a matching grant that would fund the exhibit, which was to be in two parts: women artists who made their mark before 1967 (curated by Joyce) and "The New Wave." In 1986 this became the first full-year museum exhibit in America devoted exclusively to women artists.

Joyce believes that her own work too has evolved as a result of the years she spent teaching feminist art, which, she says, "made me see more things as art. Before feminist art, women weren't doing much that was experimental, but the movement pushed them and pushed me too." Her present work is very different from her older work, though it maintains the wry and macabre sense of humor that was apparent in the funeral project that she began in 1968. For example, she has been photographing gum wads on the streets of London and analyzing where the wads were least often deposited ("in front of art museums"), and most often deposited ("in front of betting shops"). Part of the project was to interview gum-chewers about their gum habits. "Only two admitted to throwing their chewed gum on the street, though there's lots of chewed gum out there." Some of her recent work has become even more personal than her earlier art. She says that in recent year she has felt very free to focus on new topics, quipping, "My age means I can do anything." One project involves a reliquary using the bones and ashes of her dead husband. Another uses love letters that she wrote. In still another, an addition to her on-going funeral project, she uses "obituary" notes that people wrote about their memories of her.

Not only has her "age [permitted her to] do anything," she also does *everything* to spread art and the appreciation of art in the community in which she finds herself—such as working full-time as the volunteer director of the Fresno Arts Council, which funds all manner of worthy art projects, and lending her accounting skills (shades of 1972, when I first met Joyce as she was preparing the overdue Art Department budget!) to the Fresno Film Works, an organization established to bring good movies to a city that sorely lacks films which don't involve car chases or buckets of blood. A recitation of Joyce's continued activities in the service of art would be endless. Cay Lang remembers that more than twenty years ago—when Cay was in her thirties and Joyce in her fifties—she and another young artist, Carrie, attended a national conference in New Orleans with Joyce. The three shared a room. They would spend days at the conference and nights running around the city. "By the time we got back to our room, Carrie and I would be totally exhausted," Cay says. "We'd sink onto our beds with our clothes on. But Joyce would sit up and read for three or four hours. Carrie said to me one night, 'I hope we have Joyce's energy when we're her age'." And I said, "Look, we don't have Joyce's energy now!"

In 2001, Joyce Aiken was given a Lifetime Achievement Award by the Women's Caucus for Art, the major still-existing organization for women professionally engaged in the visual arts. The Caucus eloquently summed up why she was selected for the award and why she is a central figure in the history of feminist art:

> for being a powerful and precise catalyst in the lives of women artists; for your rare ability as a teacher to know what lies in the hearts of your students and then to give them the tools to achieve their desires; for your clarity of vision that opens vistas for all who are willing to see . . . for your courage and selfless service in the endeavor to create equity and greater opportunities for women in the arts.

Notes

1 For their generous sharing of memories, Lillian Faderman would like to thank Jackie Doumanian, Cay Lang, Jean Ray Laury, Trude McDermott, Jerrie Peters, Ellouise Schoettler, and, of course, Joyce Aiken. The interviews were conducted in Spring 2009.
2 Joyce Aiken, "Reminiscences," *Heresies* 1:4 (Winter 1978), pp. 85–6.
3 Ellen Sweet *et al.*, "80 Women to Watch in the '80s," *Ms.* 8:7 (January 1980), p. 40.
4 "Mural Protest," *Fresno Bee* (December 14, 1984).

10

"YOUR VAGINA SMELLS FINE NOW NATURALLY"

Phranc

What is feminist art? In my opinion, it is art made by women who have the self-awareness and hold the responsibilities of being female in the very highest regard and with that in mind and heart, create their work with the consciousness that champions, exposes, and illustrates, in whatever medium, the woman's perspective. I did not go in search of feminist art—it found me. It became my world.

At seventeen I dropped out of high school to be a lesbian. It was the mid-1970s. I lied to my parents and told them that I was going to the library and rode my bicycle to a tiny ramshackle bungalow in Venice called the Women's Center where I encountered my very first lesbian feminist drop-in rap group. I sat on the floor in a circle surrounded by women who were maybe aged 25–30, and was encouraged to tell my story. I spoke of "chicks" and how I loved them. The women around me responded by making peeping sounds. "Peep, peep, peep," they said every time I used the word "chick." I didn't get it. Finally one of them said. "Women are not chicks!" Chicks go "peep peep peep." Ah! My first lesson in feminism. I moved out of my parents' house and out into the world as an often-homeless teenager, lovingly watched over by a protective lesbian community. I was schooled in the ways of feminism, lesbian liberation, and political correctness. I learned that "the personal is political" and "an army of lovers cannot fail!" I learned about "old gay" and overalls and Nature's Gate shampoo and incense and peppermints and Birkenstocks and the Fat Underground and . . . feminist art.

My first trip downtown to the Woman's Building was in 1975 when I attended a Women Only dance. Wow! What an event. And what a place! I marveled at this huge two-story building that was dedicated to women and women artists specifically. That night I was on the roof of the Woman's Building

hollering in delight at my discovery and throwing beer bottles off the roof in drunken enthusiasm. Soon I learned what the Woman's Building was all about. It was a place where women came to gather as a community. To make and discuss art. To create and design and print. To read and sing and perform. To educate and entertain each other. The building housed the Women's Graphic Center, Sisterhood Bookstore, and the Feminist Studio Workshop. On the first floor of the Woman's Building I found Dorothy Baker's coffee house, where one could perform at an open mic or have a cup of tea. I would beg a ride from Venice Beach to downtown and the stage at Dorothy Baker's where I could play my guitar and sing my songs.

At the Woman's Building I encountered a friendly lot of gals who welcomed my arrogant teenage junior dyke self with a smile and only a little apprehension. I fell in love with the Woman's Building and in 1976 I enrolled in the Feminist Studio Workshop (FSW), a two-year intensive study for women in the arts.

It was the most exciting time for women artists. Women came from all over the country to attend the FSW. The collective power and energy we felt creating and sharing was incomparable. Endless hours of CR (consciousness-raising) sharing our most inner selves, sitting cross-legged, curled in a ball, sprawled across a bean bag chair, or crouched over a piece of paper after a guided meditation. I once found a roll of round hot pink stickers at the Woman's Building imprinted with the phrase "YOUR VAGINA SMELLS FINE NOW NATURALLY," a leftover from a guerilla consciousness-raising exercise that entailed stickering the feminine hygiene section of supermarkets. You could say that was my introduction to feminist art.[1]

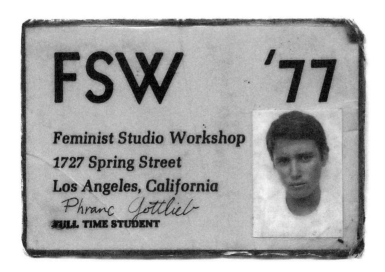

FIGURE 10.1 Feminist Studio Workshop ID Card. Reprinted with permission of Phranc.

At the Feminist Studio Workshop, every woman was on her own path. No right or wrong path, just her own path, and some shared terribly dark pasts and others did not. We explored all art forms. We claimed ourselves. We championed each other. We created graphic art, performance art, paintings, drawing, reading, and made sculpture. We danced and sang and laughed and cried. We sat through crits and CR groups. I grumbled and hated the "Process." And even though I was much more interested in getting high than I was interested in studying anything, I learned something. I learned that for the shared experience of women artists there is no substitute. I inhaled the air that has sustained me until now. That air fed me with antibodies that have made me immune to everyone that has ever dared to cross my path and question me as an artist. This collective produced strong individuals whose personal work to this day impacts the world we live in. I wish that the Woman's Building and the Feminist Studio Workshop were here today because there is no climate better in which to grow a strong woman artist who will take her strengths forth and share them with the world.

Note

1 Sheila Levrant de Bretteville explains, "When a deodorant product was launched—a 'feminine hygiene spray'—my response was to have these shocking pink stickers made. The Label House would not produce 100; you had to order 500. So I ordered 500. I was thirty years old and new to teaching. I asked my students at CalArts if they would help me by putting these stickers on the 'feminine hygiene spray' products in the markets in their neighborhood. This was a stealth action, and I should have known better, and cautioned my students that this was against the law. One of my students was apprehended, and released with only a reminder that stores and streets are private property and cannot be defaced." Email from Sheila Levrant de Bretteville, August 12, 2010. De Bretteville founded the first design program for women at CalArts in 1971, and was a co-founder of the Feminist Studio Workshop with Judy Chicago and Arlene Raven in 1973.

11

A COLLECTIVE HISTORY

Las Mujeres Muralistas

Terezita Romo

> Our intent as artists is to put art close to where it needs to be. Close to the
> children, close to the old people, close to everyone who has to walk or ride the
> buses to get places.
>
> —Las Mujeres Muralistas[1]

During the 1970s, the San Francisco Bay Area became one of the greatest centers
for mural production in the United States. In this period of intense idealism, civil
rights activism, and cultural nationalism, many artists left individual careers to
pursue collective artistic projects in service to their community. Murals painted
on neighborhood walls became the public art preferred by many community artists.
Though produced by artists from all racial groups and painted throughout various
neighborhoods and cities in the Bay Area, it was the murals of San Francisco's
heavily Latino Mission District that came to the forefront of media attention.

As was true of other art forms, at first mural production was almost entirely
the province of male artists. This was reflected in their murals' thematics:
"At the time, a lot of the images were of men. All the heroes were men and it
seemed like historical events only happened to men, not to families or com-
munities."[2] Las Mujeres Muralistas would change this. Formed in direct reaction
to the historical male exclusivity, the San Francisco based collective was begun
by Patricia Rodriguez and Graciela Carrillo with their first joint mural in 1973
and expanded later that year to include Consuelo Mendez and Irene Perez.
Although the group remained together for only six years, the impact both on
mural making and on other Chicana and Latina artists was significant.

The revival of mural painting in the United States in the mid-1960s was
markedly different from its social realist forerunner in Mexico and the United

States some forty years earlier. Rather than being government-sponsored and directed towards government buildings, the contemporary mural movement in the United States sprang from the people themselves and continues to thrive today, with murals appearing on community and campus-building walls. Perhaps the biggest difference, however, was the process. In the Mexico of the early twentieth century, murals resulted from the vision of individual artists. As a result of the civil rights movements in the United States, murals in barrios and ghettos were produced by artists with the input of local residents on design and creation. "This element of community participation, the placement of murals on exterior walls in the community itself, and the philosophy of community input, that is, the right of a community to decide on what kind of art it wants, characterized the new muralism."[3]

Community engagement was characteristic of the Chicano art movement as a whole, for Chicano art evolved from the same foundation as the Chicano civil rights movement of the mid-1960s. Known as *el movimiento*, it was a direct response to the needs of Mexican American people living in the United States, their fight for the right to adequate education, political empowerment, decent working conditions, and a call to end social discrimination. Artists joined other cultural workers in making political statements and played a key role in taking these statements to the public. According to noted scholar Tomás Ybarra-Frausto, "artists functioned as visual educators, with the important task of refining and transmitting through plastic expression the ideology of a community striving for self-determination."[4] Chicano activist-artists developed collectives and established *centro culturales* (cultural centers) that functioned as the propaganda arm of the Chicano sociopolitical movement. "Integrally related to the human concerns of their local neighborhoods, artists pursued the vital tasks of creating art forms that strengthened the will, fortified the cultural identity, and clarified the consciousness of the community."[5] However, while the movement's leaders called for ethnic and racial equality, the need for gender parity in the areas of leadership and decision making was often overlooked. Consequently, Las Mujeres Muralistas not only had to dedicate themselves to reclaiming an artistic legacy, but also to creating within the Chicano movement a new organizational structure along gender lines and a uniquely Latina aesthetic.

The Women

Patricia Rodriguez and Graciela Carrillo first met in 1969 at the University of California, Berkeley's Third World Student Strike. A native of south Texas, Rodriguez came to the Bay Area in 1966 to become an artist. In 1968, she enrolled at Merritt Junior College in Oakland where, a year later, her instructor was the noted muralist and poster artist Malaquias Montoya. Through Montoya, Rodriguez met Rene Yañez and Manuel Hernandez, all three members of the Mexican American Liberation Art Front (MALA-F). She credits them with introducing

her to the Chicano Movement. "There were a lot of things going on, lots of demonstrations, a lot of exciting moments . . . It was the ideal of trying to be liberated and trying to be feminist; of trying to work for something you could never achieve otherwise because society wouldn't let you."[6] In 1970, she was admitted to the San Francisco Art Institute's painting program on a fee-waiver scholarship.

Graciela Carrillo was born in Los Angeles and attended California State University in San Jose. In 1969, she moved to San Francisco to pursue an art career and soon enrolled at the San Francisco Art Institute, also on scholarship. Carrillo and Rodriguez became roommates, renting an apartment on Balmy Alley in San Francisco's Mission District, which became a focal point of the mural movement.

Consuelo Mendez, whom they met in 1972, was born in Caracas, Venezuela. Through her father, himself a painter as well as a doctor, she met César Rengifo, a poet, playwright, and painter who had a great interest in the Mexican mural movement and its leftist politics. Rengifo's art and his political ideology influenced her greatly. Initially a medical student at Rice University, in 1972, Mendez enrolled in the San Francisco Art Institute's printmaking program.[7]

The youngest of the muralists, Irene Perez came from a migrant farmworker family that had settled in East Oakland. She first studied commercial art at the San Francisco Academy of Art. Through Michael Rios, an accomplished artist and muralist, Perez met Yañez who facilitated her admission to the San Francisco Art Institute under the fee-waiver program. Perez's focus on printmaking, especially serigraphy, led her to La Raza Silkscreen Center where she met and worked with Mendez.[8] Unfortunately, the fee-waiver program was terminated before Perez could finish her degree.

The Beginning at Balmy Alley

The San Francisco Bay Area was an important epicenter for the various student movements of the late 1960s and early 1970s, including the Free Speech, anti-Vietnam War, and Third World Student movements. But, for the three Chicanas and the Venezuelan it was a very frustrating time. As the only Latinas at the Art Institute, they lacked a support structure and role models. Moreover, the splendid Diego Rivera mural that graced the school notwithstanding, the painting department showed a strong preference for abstraction. "I was having a bad time with trying to be more formal," recalled Rodriguez, "trying to express myself in the code of colors which didn't represent the real me, the emotional and spiritual aspects."[9] Thus, the four began to meet to talk about art and its role in their lives and in the Chicano Movement taking place outside the Art Institute walls. Perez recalled that Mendez was adamant about her support for Latino, versus only Chicano issues. This more inclusive perspective became one of the defining elements of the Mujeres' artistic philosophy and aesthetics.

Through their association with the artists Yañez and Rios, the four women were aware of the burgeoning mural movement in San Francisco, but they were

not invited to participate in the exclusively male projects. Meanwhile, Carrillo and Rodriquez saw murals being painted literally around them in Balmy Alley. The first one was painted in 1972 by Mia Galivez and children from the neighborhood community childcare center. Soon, other artists began to paint murals on all available walls, garage doors, and fences. In 1973, Rodriguez and Carrillo initiated their own project on a garage across from their apartment. According to Rodriguez,

> It was a total learning process. We had to experiment with what we had, since we were art students with no money. So we got the scaffolding from the Arts Commission. The outdoor paint was donated by neighbors who gave us a lot of half-filled cans. We didn't even know what the wall grid process was; we just eye-balled it.[10]

Rodriguez and Carrillo's design incorporated fantasy imagery full of tropical vegetation, animals, and a large globe containing a multitude of fish and parakeets. While the public's response was overwhelmingly positive, there were men, including Yañez, who urged them to quit, saying, "You're not going to finish. It's too much for you."[11] But they persevered and completed the mural.

That same year, Perez created her own mural, also on Balmy Alley. Situated over a garage door, it consisted of two figures sitting with their backs to each other playing flutes. Drawing on her personal experience, she wanted to make a statement against the overtly political imagery characteristic of the majority of the murals in the Mission District. "I felt a lot of murals were very political, disclosing injustices, which to me were very violent. True, it is part of our experience. But what about the other parts—the quiet, positive images of our experience?"[12] This belief in an expanded definition of "political art" that included aspects of nature, culture, and the family, came to characterize the work of Las Mujeres Muralistas. Although a point of contention with their male counterparts, their commitment to this ideology was such that it altered the history of mural practice. This is exemplified in the collective's first collaborative project, *Latinoamérica* (1973).

Latinoamérica

> Our people and culture are our images. Full of color, of life, and the strength to continue the struggle.
> —Consuelo Mendez[13]

In 1973, Rodriguez was commissioned to create a mural on two interior walls for the Jamestown Community Center on Fair Oaks Street in the Mission District. She approached Mendez to help her and to invite other artists. In order to

accommodate the expanded participation, they created a tree motif as the unifying structure for the whole. "It was after this, when the project was rolling that I contacted Rene [Yañez]. He brought in Rios and all the other artists."[14] For her section, Rodriguez revised her Balmy Alley globe imagery, with the addition of a central tree figure, a monkey, and various representations of plant life. However, while the Balmy Alley mural had been limited to the muted tones of the donated paint, the Jamestown mural was alive with reds, yellows, and greens. In a humorous playfulness, Rodriguez painted her fish swimming in the midst of tree branches and alongside ascending birds. This whimsical view of the natural world contrasted with Mendez's imagery across the hall.

Mendez also chose bright colors, but used them to create a pre-Conquest death god awaiting the death of a heroin addict. In its reference to a recognizable cultural image, Mendez claimed the Jamestown Center as a Latino space. However, her choice of an anti-drug message directed at the young clientele of the Center also addressed a serious community concern. The Jamestown mural is historically significant as one of the earliest murals created by a group of artists and set a precedent for subsequent collective projects.[15] It was also the beginning of the "aesthetics versus politics" discourse that would challenge the Mujeres' collective ideology.

Also in 1973, Mendez was commissioned to create a mural for the Mission Model Cities building on Mission Street near 25th. The 20 x 76 foot wall was much larger than her previous project, so she enlisted Rodriguez, Carrillo, and Perez to participate. They decided to work collectively and to approach the planning, designing, and painting collaboratively. For the first time they had a small budget but, more importantly, Perez noted, "we were going really big and outdoors."[16]

They agreed that the mural should be colorful and send a positive message about Latino culture, with a special focus on individual histories, families, and culture. Mendez explored imagery from Venezuela and chose to focus on the family. Rodriguez incorporated traditional images drawn from her travels to Bolivia and Peru. Carrillo researched the Aztec heritage of Chicanos and reworked its imagery in an innovative way so as not to repeat the prevalent pre-Conquest imagery of other murals. Perez's images of magueys and cornstalks were emblematic of her parent's birthplace in Mexico. Initially titled "Panamerica," the mural's name was later changed to "Latinoamérica."[17]

The group was also concerned with sharing the space effectively. They chose the images through consensus, utilizing Perez's graphic art skills to cut and paste them into a unified whole. In what is a remarkable procedure, the colors to be used were not chosen in the design stage. Rather, beginning with only a line drawing, they inserted color as they painted. According to Rodriguez, "Our greatest strength was our instinctive sense of color that we all shared."[18]

The mural was a stunning tribute to the cultural traditions, peoples, and landscapes of Latin America. Described as an "ode to life," it merged the natural, human, and spiritual dimensions of each country. Referencing the countries of Bolivia, Peru, Venezuela, Guatemala, and Mexico, the motifs were chosen for

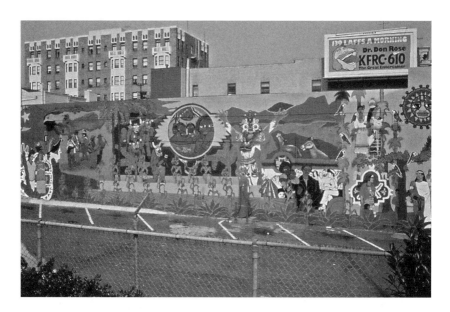

FIGURE 11.1 Las Mujeres Muralistas (Graciela Carrillo, Consuelo Mendez, Irene Perez, Patricia Rodriguez), *Latinoamérica* (Mission District, San Francisco, 1974). Paint on concrete. Photograph by Ralph Maradiaga and Patricia Rodriguez, reprinted with permission of Patricia Rodriguez.

their uniqueness and their special relationship to the residents of the Mission District. Images of banana palms, corn stalks, and magueys formed the foundation of the mural in direct reference to their key sustenance role for Latin American peoples. Other natural resources, such as the reed and alpaca from Peru, were also depicted. There was also a commitment to portraying everyday people, especially women and children. In fact, women in beautiful traditional costumes flanked both sides of the mural. Acknowledging its significance within Latino culture, the central image was a family encircled within a sun. Located on both sides of the central motif are the Venezuelan and Bolivian devil figures representing the spiritual and ceremonial aspects of culture, while at the same time symbolizing the merger of indigenous spirituality with the Catholic religion. There was also a conscious attempt to represent the ancient indigenous concept of duality with different symbols, such as the sun and the moon, day and night, and male and female. At the far right was a scene depicting the people of the Mission. Rendered in black and white to evoke newsreel footage, it included Latinos, Blacks, and Asians from different generations. Thus, even though the mural was a celebration of the Latino presence, it also recognized the reality of the Mission's present and future ethnic evolution.

Latinoamérica reflected sophisticated techniques, as well as aesthetics. Through the unorthodox process of assigning color at the site, the Mujeres achieved a distinctive palette. They were also very creative in their approach to architectural

challenges. For instance, Rodriguez incorporated an already existing gas pump into the mural design by painting a Bolivian devil emerging from it, thus making a statement on gas rationing then in force. The group was just as innovative in reworking Chicano images that were becoming cliché. For example, they included a pyramid leading up to the image of the family, but it is subtle and well hidden. "At that moment, it was a breakthrough. It was no longer the same repetitive symbols borrowed from (José Alfaro) Siqueiros or (Diego) Rivera, but an experiment done in the community for Latinos by Latinas."[19]

Though the core group designed the mural, other women assisted them, four of whom remained throughout the project: Ester Hernandez, Xochilt Nevel, Miriam Olivo, and Tuty Rodriguez. The Mujeres ensured that the apprentices contributed in a meaningful manner to the project and learned mural painting techniques in the process. Aside from the benefits to the project, this was a conscious attempt on behalf of the group to encourage female artists and open the door to other women interested in murals.[20] Some of these women later joined the group.

Even before it was completed, *Latinoamérica* received major community and media attention. People from the neighborhood not only came by to look, but many also provided the artists meals in appreciation. Everyone was shocked to learn that the muralists were women. "We received a lot of publicity and became well known. It helped us in our own community because, as women in the Chicano community, we were not taken seriously."[21] With the heightened media attention, the group felt the pressure to be identified collectively. According to Perez, Ralph Maradiaga, co-director of the Galería de la Raza, called them "Las Mujeres Muralistas," and the name stuck. The women adopted it because it was short, reflected their role as women muralists, and was in Spanish, which helped their community relate to them.[22]

With *Latinoamérica*, the group gained prominence, a name and more members, but ironically it would be the first and last time that the core members Carrillo, Mendez, Perez, and Rodriguez would work together on a mural. Subsequent murals painted under the name of Las Mujeres Muralistas were designed and directed by only one or two of these artists. Their other obligations—particularly the need to support themselves financially and to pursue individual artistic endeavors—meant they had less time to devote to mural projects. But the group's greatest challenge was the maintenance of their collective structure in the face of increased requests from other women to join. They settled on a structure in which whomever from the original core was available would spearhead the mural project, with assistance from other artists.[23]

Para el Mercado

> My community, the people on this block, they may never leave the Mission. So whatever you can do around here is going to be the most effective.
> —Graciela Carrillo[24]

In 1974, Mendez and Carrillo painted the mural *Para el Mercado* (To the Market), with the help of Susan Cervantes and Miriam Olivo.[25] It was commissioned by a tacqueria owner in response to the opening of a McDonald's down the street. Continuing the Latin American theme, *Mercado* was a vibrant montage of people and animals set against landscapes that ranged from lush tropics through clear streams to arid ground. The vibrant colors of the natural world were accentuated by those of parrots, fish, and women's traditional woven garments. There were scenes of men and women preparing food, including fishing, harvesting, and kneading dough. Interspersed were people from ancient through modern times at the market, buying and selling food items. The people in *Mercado* reflected the various racial groups of Latin America, including the Indigenous, mestizos and Afro-mestizos. Though some community members thought the people portrayed were "too dark," the media response was laudatory. The neighborhood paper, *El Tecolote*, proclaimed that "The ideas and images of the cultures they blend are bold achievements in the move toward unity. South America and the barrios of Aztlan have taken a stand and we stand together."[26] However, male muralists continued to criticize their lack of overtly political imagery. About this, Rodriguez countered, "There are other things that one can say, especially as an artist . . . I never believed that you had to be so dogmatic, in fact, I resented it"[27] (see Plate 10).

Various configurations of the original core group, assisted by other artists, continued to paint murals as the Las Mujeres Muralistas. In 1975, Carrillo, Perez, and Rodriguez painted a mural on a two-story wall in the 24th Street Minipark. Their last project under the collective name was the "Rhomboidal Parallelogram," also undertaken in 1975. At this point, Mendez, who had always grappled with the issue, decided the murals were no longer sufficiently political and left the group.[28] In 1976, she returned to Venezuela where she pursued her political graphic art. By 1979, the individual artistic pursuits and frustrations stemming from the collective ideal being stretched too far brought an end to Las Mujeres Muralistas. Rodriguez took a teaching position at the University of California at Berkeley and turned to creating box assemblages. Carrillo married and moved to Arizona. Perez took a job at a community clinic in Oakland and returned to printmaking.

The Legacy

> The beauty and pride we all feel for our culture is expressed through artists, who act as our hands to make the praises of our culture visible and tangible.
> —Las Mujeres Muralistas[29]

Las Mujeres Muralistas hold a very unique and significant place in Chicano art history. They developed a reputation for their distinct artistic style and collective techniques. Their unique iconography, with its emphasis on Latin American

cultural traditions and landscapes, formed a new vocabulary of images that extended and redefined the political nature of muralism. As the first all-woman collective, they shattered the long tradition of male muralists and became role models for other Chicana artists. Other groups followed in their footsteps: Celia Rodriguez, Rosalinda Palacios, and Antonia Mendoza in Sacramento painted a mural celebrating women on a pillar in San Diego's Chicano Park in 1975; Yolanda Lopez and a team of young women from San Diego also painted a pillar at Chicano Park; and Las Mujeres Muralistas del Valle, a group of fifteen women, created murals in the mid-1970s in their hometown of Fresno.[30] Women continued to make murals throughout the 1980s and 1990s, culminating in the San Francisco Women's Building murals completed in 1994. The legacy of Las Mujeres Muralistas had come full circle.

Notes

1 Victoria Quintero, "A Mural is a Painting on a Wall Done by Human Hands," *El Tecolote*, 5:1 (September 13, 1974): 6.
2 Ibid.
3 Eva Cockcroft and Holly Barnet-Sanchez, editors, *Signs From the Heart: California Chicano Murals* (Venice: Social and Public Resource Center, 1990), 9–10.
4 Tomás Ybarra-Frausto, "The Chicano Movement/The Movement of Chicano Art," *Exhibiting Cultures: The Poetics and Politics of Museum Display*, ed. Ivan Karp and Steven D. Lavine (Washington, D.C.: Smithsonian Institution Press, 1991), 140.
5 Cockcroft and Barnet-Sanchez, *Signs from the Heart*, 67.
6 Interview with Patricia Rodriguez in "*Califas*: Chicano Art and Culture in California." Taped October 30, 1982, San Francisco, transcript p. 4.
7 Shifra Goldman, "Querida Consuelo," *La Opinion*, n.d., 8–9.
8 Author interview with Irene Perez, December 11, 1999.
9 Author interview with Patricia Rodriguez, December 11, 1999.
10 Ibid.
11 Taped interview with Patricia Rodriguez, October 30, 1982, p. 5.
12 Author interview with Irene Perez, December 11, 1999.
13 Goldman, "Querida Consuelo," 8–9.
14 Author interview with Patricia Rodriguez, December 11, 1999.
15 Ibid.
16 Author interview with Irene Perez, December 11, 1999.
17 Author interview with Patricia Rodriguez, December 11, 1999.
18 Ibid.
19 Taped interview with Patricia Rodriguez, October 30, 1982, p. 9.
20 Author interview with Patricia Rodriguez, December 11, 1999.
21 Theresa Harlan, "My Indigena Self: A Talk with Irene Perez," exhibition brochure for *Irene Perez: Cruzando la Linea* (Sacramento: La Raza/Galeria Posada, 1996), n.p.
22 Author interview with Irene Perez, December 11, 1999.
23 Ibid.
24 Interview for WKQX-TV5, produced by Huascar Castillo, San Francisco, 1975.
25 Timothy W. Drescher, *San Francisco Murals: Community Creates Its Muse, 1914–1994* (San Francisco: Pogo Press, 1994), 23.
26 Quintero, "A Mural is a Painting on a Wall," 6–7.
27 Cockcroft and Barnet-Sanchez, *Signs from the Heart*, 75.

28 Alan W. Barnett, *Community Murals: The People's Art* (Philadelphia: The Art Alliance Press, 1984), 138.

29 Quintero, "A Mural is a Painting on a Wall," 6.

30 Shifra M. Goldman, *Dimensions of the Americas: Art and Social Change in Latin America and the United States* (Chicago: The University of Chicago Press, 1994), 214.

12

THE WOMEN ARTISTS' COOPERATIVE SPACE AS A SITE FOR SOCIAL CHANGE

Artemisia Gallery, Chicago (1973–1979)

Joanna Gardner-Huggett

This article explores a series of programming and exhibitions implemented by Artemisia Gallery in Chicago from 1973 to 1979, which prepared women artists to enter the professional workforce equipped with feminist pedagogy to promote social justice for women in the art world.[1] Each event was sponsored by the Artemisia Fund, which was founded after the gallery was incorporated in 1973, to foster a national educational dialogue regarding the history of women artists, as well as the social, economic, and political concerns they faced (Poe, 1979). The Fund identified the problems that barred women from attaining a professional identity, used a separatist space as a site to tackle those issues, and employed strategies to reach beyond the immediate audience of its membership.[2] To investigate the impact of the Artemisia Fund, four programs will be examined: "Economic Structures of the Art World," "Feminist Art Workers," "Feminist Education: Method and Techniques," and the exhibition "Both Sides Now."

Founding and Philosophy of Artemisia Gallery and the Artemisia Fund

Artemisia was founded in summer 1973 after two large meetings of women artists.[3] Stimulated by the work of the West-East Bag (W.E.B.)—a group formed to create an international network of women artists that included the first slide registry for women artists in the United States—women in Chicago realized that they needed greater exposure. Joy Poe (cited in Pieszak and MacLeod, 1973: 3), a founding member of Artemisia, notes that at the First Annual Midwest Conference of Women Artists, the artist Harmony Hammond showed a video about A.I.R. (Artists in Residence), a women's cooperative in New York City that formed a

year earlier. Then a graduate student at the School of the Art Institute of Chicago, Poe visited A.I.R. that May and concluded that the same could be done in Chicago (Poe, 1979). After the initial summer meetings, a subsequent meeting of forty women selected five core members (Joy Poe, Barbara Grad, Margaret Harper Wharton, Emily Pinkowski, and Phyllis MacDonald) and they later chose fifteen more members. Taking their name from the 17th-century Italian Baroque painter Artemisia Gentileschi (1597 to c. 1651), "whose best work had been credited to her father," these women were determined to make their own names known to the art world of Chicago and beyond (Holbert, 1983). Like many feminist organizations of the early 1970s, they rejected the hierarchical structure of patriarchal governance and distributed authority among all the members, implemented a rotating leadership, made all decisions a participatory process, conceptualized power as empowerment, rather than domination, and argued that the process was as valuable as the outcome (Bordt, 1997: 11).

Attitudes toward feminism among Artemisia's members varied. Joy Poe explained, "Some of us, like myself, are ardent feminists. Many are not. But we all wanted to avoid the isolation that women artists in Chicago have faced" (in Koch, 1974: 22). To counter their invisibility, they accepted a mode of cultural feminism defined by Linda Alcoff (1988: 408) as an "ideology of a female nature or female essence reappropriated by feminists in an effort to revalidate undervalued female attributes," in this case in women's art. Alcoff added that this position necessitates "maintaining a healthy environment—free of masculinist values . . . for the female principle" (Ibid.). The benefits of instituting a separatist space, as noted by Cottingham (2000: 31) and by Alcoff (1988: 421), were community and self-affirmation, but it would always pose a dilemma as well. Because Artemisia's philosophy, and women artists' cooperatives more generally, were influenced by the construct of universal woman, in the eyes of its feminist critics a separatist gallery marginalized other elements of oppression, such as race, class, ethnicity, religion, and sexuality.

Although the essentialist ideology embraced by Artemisia Gallery posed problems, operating under the umbrella of "women's interests" permitted the Fund to develop a wide range of educational programming that was not available in mainstream art institutions. As Joy Poe wrote in 1977, "every program touched on a different phase of the woman artist's role—how we are perceived in our past and present society as women and as artists." The Artemisia Fund began by inviting visiting artists, critics, and curators, and in its second year expanded its mission to national and international concerns, particularly emphasizing the history of women in non-European cultures through a series of lectures. Whitney Halstead and Marilyn Houlberg, art historians from the School of the Art Institute, for example, spoke on Navajo and Pueblo women artists and African body art. The Fund augmented their educational resources in 1975 by establishing a video library, and their slide library had grown to over 800 images that included the works of contemporary and historical women artists. A speaker's bureau was

also formed, offering lectures such as "How to Form a Cooperative Gallery." By 1977 the Fund grew so successful that it applied for grants to establish The Artemisia School of Art and aimed to develop a three-year accredited art degree (Poe, 1977). Its seven-member board (Ester Benjamin, Suzanne Craig, Sandra Eisenberg, Barbara Hodes, Susan Michod, Jane O'Connor, and Joy Poe) was very astute in answering the needs of their community. Ultimately, the school never opened.

Economic Structures of the Art World

Many of the events offered by the Artemisia Fund tackled practical concerns of women artists. A critical component of any artist's identity is visibility, and in the early 1970s feminists recognized that the financial systems of the art market were instrumental in women's erasure. Historically, men's art has commanded higher prices and the work of many women artists disappeared for centuries whenever a dealer sold the work under a male name, including that of Artemisia Gentileschi, whose paintings were sold under her father's name, Orazio. The Artemisia Fund sponsored a session entitled "Economic Structures of the Art World" in February of 1976 to make transparent the commercial gallery system, the role of private collectors, and the museum. The workshop was co-taught by Ellen Lanyon and Johnnie Johnson and was held at Lanyon's home in Chicago. Particularly committed to this education, Lanyon was a founder of the W.E.B. and a critically acclaimed painter, while Johnson was a printmaker, painter, photographer, and founding member of the women artists' cooperative Artists, Residents Chicago (A.R.C.) and the Midwest branch of W.E.B. In an article on Chicago's women artists' cooperatives, Johnson (in Koch, 1974: 20) noted: "I'm not going to wait until I'm old or dead to be discovered. . . . You have to know how to sell your work; it's taken me five years to learn how to hustle. I keep a detailed inventory of my work, and I always expect more of myself than the individual I'm showing it to expects." She also made women artists aware of how gender affects an artist's economic value and observed, "sometimes I feel guilty about using the name Johnnie Johnson. That name sold a lot of prints because people didn't know they were done by a woman. But it's a question of survival. If that's how this culture is, I'm smart enough to out-trick unfair cultural-sociological limitations with a pen name" (in *Ms.* Forum, 1975: 63).

This program addressed concerns shared by women artists attending the May 1973 First Annual Midwest Conference of Women Artists (sponsored by the W.E.B. and the Women's Art Coalition of the School of the Art Institute of Chicago), a number of whom became members of Artemisia. Participants in a session called "Tactics—Galleries, Grants and Commissions" felt that women artists' cooperatives were a good solution for enhancing the visibility of women artists, but they were unhappy that these organizations did not do more to address the practical issues of being an artist, such as understanding legal procedures, tax issues,

and how to obtain outside funding. Johnnie Johnson gave a talk with Janet Harold, a New York artist, entitled "Business and Sales," which examined the financial aspects of being an artist. Only an hour in duration, a longer and more thorough session was needed (Duchon and Hardenburgh, 1976: 387). Statistics from this period support this assertion and make clear the necessity of such education. The median income for women artists in 1970 was $3,400 per year, in contrast to the $9,500 figure for men (Dickinson, 1999: 5). Additionally, in 1972 100% of artists' grants sponsored by the National Endowment for the Arts went to men, and although the number of grants awarded to women increased to 27% in 1973, the percentage of women's awards remained at that rate for a number of years (Ibid.: 6). Therefore, the teaching of these strategies remained essential and Johnnie Johnson continued to offer the seminar; in 1979, she repeated another version of the course at Artemisia entitled "Money and the Woman Artist." In 1977, the Artemisia Fund also implemented a pilot program that included career counseling for high school and college students interested in pursuing a career in art, since members learned from their own experiences that students, whether male or female, needed this education well before entering art school (Artemisia Fund, 1977). Making the program open to the public enabled the Fund to reach women artists beyond Artemisia's twenty members and to participate in an activist goal of disseminating this power.

Feminist Art Education and Methodology

Teaching feminist theory and methodology also became important to the Artemisia Fund in the early 1970s since artists interested in feminist art and art history found few resources in academia. In Chicago, many of the members of Artemisia were graduates of the School of the Art Institute of Chicago, where art history played a fundamental role in their art education, but where few examples of women artists or feminist issues were addressed in the classroom or in the accompanying museum collection. Celia Mariott, an art historian teaching at the School and the Museum of the Art Institute during the early 1970s, commented in *Ms.* Forum in May 1975 that when she decided to teach a course, "Women in Art," she could only find fifty slides by women artists in the Institute's collection of thousands, which encouraged her to write directly to contemporary women artists and ask them for slides so that the course was possible (p. 63). This example points to the important role taken by women artists' cooperative spaces to offer feminist art education and methodology, not only to its membership, but also to the wider community. In a grant application for the Artemisia Fund in 1977, Joy Poe (1977) commented: "No college or university in the Chicago area presently offers a program in Women's Studies." Like Mariott, Artemisia addressed the historical absence of women artists by developing its own slide library, but it also offered panel discussions and seminars that situated feminist practice historically and philosophically. "Feminist Art Workers" and "Feminist Education:

Method and Techniques," both taught in 1976, were more activist in nature; they encouraged self-development for the individual artist as well as collaboration and wide diffusion of their practices.

"Feminist Art Workers" was an intensive, one-day workshop offered by Candace Compton, Nancy Angelo, Laurel Klick, and Cheri Gaulke, who shared an affiliation with the Woman's Building and the Women's Video Center in Los Angeles. The L.A. Woman's Building, founded in 1973 by Judy Chicago, Sheila de Bretteville, and Arlene Raven, was intended to create a site where women's history was preserved, taught, and created through programs such as the Feminist Studio Workshop and the women artists' cooperative Womanspace founded in 1972. Laurel Klick (in Artemisia Fund, 1976a) best symbolized the aim of the workshop: "I am constantly questioning the relationship between my politics, work, and art. What is my time worth? How does my job relate to my art? . . . How can I make my values a reality in these situations?" Describing themselves as artist-educators, they approached the workshop from three perspectives. They first used history in presentations on Grandma Prisbrey's Bottle Village (1956–1981), located in Simi Valley, California. At the age of sixty, Tressa "Grandma" Prisbrey took her one-third acre lot and created a series of life-size constructions, primarily made from bottle caps and other found objects that were set in mortar, which were created to house her 17,000-piece pencil collection; also included were a Doll's Head shrine, bird baths, and the Leaning Tower of Bottle Village. Produced by a woman, this type of installation also questioned the modernist paradigm of art, whereby the heroic white male artist painting in mural scale continued to dominate art criticism and the market. Prisbrey's work suggested that the individual artist, as well as the educator, should expand the borders and challenge the language of art history.

A second workshop theme sought to expand the view of contemporary women artists in the United States to include those not generally covered in mainstream art journals, such as female performance artists in Southern California and examples of works from the Los Angeles Women's Video Center. Like the Bottle Village, performance art disrupted the term "art" and encouraged experimentation from the participants. Performance had proven to be a particularly powerful mode of art for women, as it was difficult to commodify and could operate outside the traditional art market. Additionally, it allowed women to tackle the personal as political in a manner that was not possible in the reigning mode of minimalist art. Further, these sessions provided students with the necessary tools to transform their art practice and take back to their studios, organizations, and classrooms, such as collaborative art, working on public projects, and using consciousness-raising and journal writing as a means of exploration and giving one's ideas perspective. Lastly, "Feminist Art Workers" reminded participants that they also needed to be vigilant about women's representation outside the art world by giving instruction on how the media disseminates violent images of women (Artemisia Fund, 1976a).

"Feminist Art Workers" used the term "worker" very broadly: the individual artist, the collaborator, and the feminist activist. "Feminist Education: Method and Techniques," in contrast, was specifically geared toward the "artist-educator," who was already employed by, or would eventually teach in, an art school or university. Taught by two L.A. Woman's Building instructors, Arlene Raven and Ruth Iskin, it offered practical, historical, and theoretical material. For instance, one of the subjects raised was how female faculty can cope in male-dominated institutions; for women artists making their living through teaching, this was a crucial issue. Statistically, women held little security or power in the academy during the 1970s. Although women comprised 75% of art students in the United States in 1971, there were very few female role models (Dickinson, 1999: 4). In 1975, only 33% of studio art faculty were women, and in Master of Fine Art programs the number dropped significantly, with only 12% serving as faculty (Ibid.: 12). Certainly, this limited the possibility of mentorship for women artists, a role that Artemisia stepped in to fill. Additionally, many of these female faculty were not tenured or tenure-track, so they were put in vulnerable positions and were less able to challenge the status quo.

The ten-day seminar began by outlining the history of feminist education and then addressed how women are socially and culturally conditioned; it also covered problems that arise from this experience in society. Iskin and Raven then turned to actual approaches in the classroom. In the first half, they broached the issue of the separatist classroom versus a coeducational one. Many key figures of the feminist art movement, including Iskin and Raven, advocated and worked within separatist institutions, but the reality of spreading feminist ideology beyond the scope of alternative spaces necessitated the discussion in mainstream situations as well. The second part of the workshop focused solely on this question, offering advice to female faculty in male-dominated institutions and methods of integrating feminist methodology into well-established programs in colleges and universities (Artemisia Fund, 1976b).

With a registration fee of $250, "Feminist Education" was probably considered expensive by many, but a shortened version—a two-day workshop—was offered the following September at $10 for non-Artemisia members and $5 for members. "Feminist Art Workers" and "Feminist Education: Method and Techniques" were instrumental in introducing the historical framework for feminist art and strategies of teaching and skills that could be used to infiltrate the academy. More important, they created means for women to find solidarity and community that were not available previously in a public institutional setting. Further, these workshops created a tradition of passing down the skills to others who could expand the circle of knowledge. For instance, Joy Poe later took the strategies learned at Iskin and Raven's seminar and developed her own course, "Creative Awareness," which was offered in 1978 and 1979. Poe geared the six-day class toward visual artists, writers, and educators and utilized a few of the key methodologies described above. Each student was guided in journal writing, created a group project, and engaged

in a discussion of "feeling to form that examined internalized images and focused on how to incorporate them into one's own work" (Poe, 1978). It also considered how parental and other relationships affected individual art production, as well as the importance of developing one's "self-image." Lastly, it explored the relationship between women artists past and present, and the subject of female imagery or a female aesthetic—a critical debate among feminist artists of the 1970s.[4] Workshops such as "Feminist Art Workers" and "Feminist Education: Method and Techniques" were offered at other women artists' cooperatives across the country; these classes contributed to the wider dissemination of feminist art theory and practice.[5]

Both Sides Now, 1979

Exhibitions were the primary mode of programming in women's cooperative spaces, since they were dedicated to creating visibility for the membership and emerging artists. The Artemisia Fund, however, used visiting curators to expand the perspective on women in the arts and feminism beyond the membership and local debates. Artists featured in these exhibitions were generally not members of Artemisia and frequently not from Chicago. The Artemisia Fund invited feminist art critic Lucy Lippard as the guest curator for an exhibition entitled "Both Sides Now: An International Exhibition Integrating Feminism and Leftist Politics."

Lippard (1989: 266) described *Both Sides Now* as "a show I organized . . . to reconcile cultural and socialist feminisms." Included in the exhibition were: Donna Henes, Betsy Damon, Leslie Labowitz, Suzanne Lacy, Alexis Hunter, Mary Kelly, Margaret Harrison, Marie Yates, Adrian Piper, and Martha Rosler. Now considered a list of canonical feminist artists, they offered a wide range of voices within feminism that would stimulate a critical debate in Chicago's art community in 1979 through artworks not readily available in the city's museum collections or commercial galleries. Co-sponsored by the School of the Art Institute, Illinois Arts Council, and the National Endowment for the Arts, the show also demonstrated a significant shift in economic support. As noted, the NEA had awarded no individual artist grants to women in 1972, but by the end of the decade women artists' cooperatives like Artemisia would find recognition and financial support with these agencies, undoubtedly due to the dedication of second-wave feminist campaigns for equality.

A catalogue for *Both Sides Now* was not published, but a reconstruction of the exhibition is possible through photographic documentation and reviews.[6] Examples of works that derived from a cultural feminist point of view were site-specific installations by Betsy Damon and Donna Henes. Damon produced *Shrine for Every Woman*, which emphasized ritual and magic, as well as woman's connection to nature. Visitors moved through an entryway created by two big banner sticks that were covered in tiny earth-toned bags. Each person was invited to "bring a memory (object or written) to put in a bag and throw in the shrine"

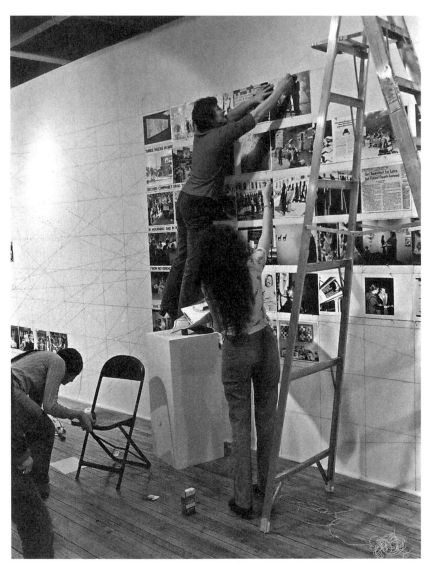

FIGURE 12.1 Diane Simpson (Artemisia member), Lucy Lippard (curator), and Joy Poe (Artemisia member) installing *Both Sides Now: An International Exhibition Integrating Feminism and Leftist Politics* at Artemisia Gallery (1979). Copyright photographer Terry Seaman. Reprinted with permission of Ryerson and Burnham Archives, The Art Institute of Chicago; Diane Simpson; Lucy Lippard; Joy Poe; Suzanne Lacy; and Terry Seaman. Included in the exhibition were Donna Henes, Betsy Damon, Leslie Labowitz, Suzanne Lacy, Alexis Hunter, Mary Kelly, Margaret Harrison, Marie Yates, Adrian Piper, and Martha Rosler.

and then was asked "to devote three weeks to remembering female history" (Litten, 1979: 14). After passing through the banners, visitors then encountered a circle of dirt surrounded by four more banners. Henes created *Great Lakes Great Circle Continuous Ritual Transformation Cycle*. In a review of the show, Laura Litten (ibid.) noted that when Henes traveled, she would search for "high energy stones" at each site she visited and would look for forms that alluded to symbolic stages in the lunar cycle. By building a stone circle, Henes permitted visitors to connect with these sacred sites, encouraging audience participation and contemplation in a manner similar to Damon. For both artists, the model of nature and matriarchal culture, which is suggested by their landscapes, allowed these artists to "reimagine what it might have been like to be female, and to experience one's body, mind, spirit, and soul free of all the fetters imposed upon women by Western patriarchal religions" (Orenstein, 1994: 176).

In contrast, Margaret Harrison, Mary Kelly, Suzanne Lacy, Leslie Labowitz, and Adrian Piper represented the position of "socialist feminism." These feminist artists believe that "the very category of 'woman' is a cultural construct" (Wolff 1992: 150), necessitating an analysis of oppression where gender intersects with issues of class, race, ethnicity, and religion. Photographic documentation of Suzanne Lacy and Leslie Labowitz's large-scale performance, *In Mourning and Rage* (1977), was included in the exhibition. It was originally produced as a multimedia work to challenge newspaper and television coverage of the Hillside Strangler Case in Los Angeles, as well as to offer strategies of education and to attempt to assist people affected by violent sexual crime. The event began with a motorcade of fifty women draped in black and one woman in red who addressed media representatives, local politicians, and community activists on the steps of City Hall in Los Angeles (Lopez and Roth, 1994: 149). *In Mourning and Rage* was a key example of how feminists could challenge the problematic representations of women in the media, as taught in the Feminist Art Workers program, and provoke a renewed and powerful discussion of sexual violence against women.[7]

Adrian Piper contributed *Political Self-Portrait #2 (race)*, one of three self-portraits she created between 1978 and 1980 to examine how her childhood experiences established three important aspects of her identity in terms of race, class, and sex (Phillpot, 1987: 9). A critical work for *Both Sides Now*, it was one of the few to tackle how feminism interconnects with questions of racial identity. It also exposed how little race was addressed in Artemisia's exhibitions and the Fund's programming. As women artists' cooperatives moved toward their ten-year anniversaries, the lack of racial diversity would become a major site of critique in the 1980s and was already raised at the Midwest Women Artists' Conference in 1973, where participants noted that the limited and selective memberships of cooperatives, comprising primarily white women, as well as the financial obligations, potentially excluded nonwhite artists (Duchon and Hardenburgh, 1976: 388). Not surprisingly, women of color in groups such as Where We At: Black Women Artists, established in 1971 in New York City, and Mujeres

Muralistas, founded in 1973 in the San Francisco Bay Area, had already embraced the separatist model of a cooperative. They shared with Artemisia Gallery a commitment to creating visibility, in this case for African-American and Chicana women artists; more important, they directly involved their own communities in their art, which was not collected or highlighted in public art institutions.[8]

Piper's self-portrait functions as a powerful political work of art, since one can interact with it on various levels. The viewer is first greeted by a smiling self-portrait of Piper that is split into two parts. On the right side, her pale skin and black hair are shown. On the left, reminiscent of a photographic negative, her face is black and hair white—pointing to the fact she was constantly answering to both blacks and whites about what her race actually was. Inscribed on the bottom edge in block capital letters is "PALE FACE." Viewers willing to look further can read typescript in the background that reveals a series of experiences Piper had growing up in black Harlem while attending a private white preparatory school in New York City. Each anecdote forces the viewer to consider how these events contributed to Piper's identity and points to the limiting construct of race as a binary of black and white.

Giving particular emphasis to class oppression and women, Margaret Harrison, a British artist, exhibited *Homeworkers: Woman's Work* (1978). This series of photographs, accompanied by written material, reveals the lives of a community of underpaid workers, most of whom were women bound to home for one reason or another, especially childcare. *Homeworkers* presents a key example of how capitalist economies perpetuate women's oppression by relying on their inability to get away from the home, ultimately preventing them from unionizing and demanding fair wages and benefits (Litten, 1979: 14). Mary Kelly was also committed to questions of labor and previously collaborated with Margaret Harrison and Kay Hunt on *Women and Work* (1973–1975) in London. In *Both Sides Now*, a selection of Mary Kelly's six-part installation, *Post-Partum Document* (1973–1979), was displayed. She summarized it as an "analysis and visualization of the mother-child relationship" (Kelly, 1996: 10).

In *Both Sides Now*, Lippard emphasized sites of overlap between cultural and socialist feminisms: "Both presuppose a collective approach and support system, non-hierarchical leadership, joint responsibility for all aspects of the world. Because everything is a woman's issue—not just equal pay and reproductive rights" (Lippard, 1979: 7). Lippard and the Artemisia Fund's goals were realized as visitors to the show were presented with a range of points of view that were contemporary, sometimes in conflict, and controversial. What the Artemisia Fund, Artemisia Gallery, and Lippard could not avoid, however, was that 1979 was a turning point in feminist art debates. By that moment, cultural feminism was under attack, as was separatism, and the educational programming that first took place under the sponsorship of the Artemisia Fund and other organizations was moving into the academy.

Entering the decade of the 1980s, Artemisia had to contend with shifting ideological discourses in feminism. Now gender was to be construed as only one

element of oppression—one that should not be privileged and should be understood in conjunction with issues of ability, class, ethnicity, race, religion, and sexuality. These ruptures were reflected in the changing membership of the space as well. Barbara Ciurej (1988), who joined Artemisia in 1979 and later became treasurer and president, recalled that at that date, "there were still a lot of women who were founding members of the gallery [that] were still around and then there was this new crowd coming in who didn't really know what they had accomplished." Ciurej's comment revealed that the new members of Artemisia were removed from the experiences of founding members for two reasons. First, many had not participated in the grassroots organizing and protests of the early 1970s; second, they had not been subjected to the same prejudices in the academy. Jackie Brookner (1991: 12) observed that this gap between second-wave feminist art activists and succeeding generations of female art students in the 1980s and early 1990s would continue to widen because these young women "have not yet experienced much overt sexism and much of what they do experience they have already been socialized not to notice." In addition to a generational clash among members, the political climate of the United States grew more conservative when Ronald Reagan was elected the following year. This change in the country's political philosophy and federal administration eventually reduced the federal and state resources that could support Artemisia's programming and led to the failure of enough states to ratify the Equal Rights Amendment. Second-wave feminist campaigns organized under the notion of "woman" demanded a period of reassessment. The Artemisia Fund continued its innovative programming until the gallery closed in 2003, but the activist orientation that drove its agenda from 1973 to 1979 became less visible.

Nevertheless, the four programs organized by the Artemisia Fund from 1973 to 1979 clearly satisfy the key characteristics of cultural activism as outlined by T.V. Reed (2005: 299): to encourage, empower, harmonize, inform internally and externally, historicize, provide transforming tactics, critique movement ideology, and make room for pleasure. It is nearly impossible to trace the specific impact on each individual who participated in these events, but it is important to historicize because it challenges the assumption that women artists' cooperatives were isolated sites that had little interaction with the wider public. Because it was a separatist space operating on the margins of the art market, it held a distinct advantage by providing a safe environment for women artists to form a sense of community. Moreover, they could engage with feminist pedagogy, learn practical skills to create greater visibility for their art, gain financial control, and be introduced to experimental modes of feminist art.

Notes

1 This article derives from the author's project that catalogued the Feminist Archive of Artemisia Gallery, Chicago, Illinois (1973–2003) and was supported by a Faculty Summer Research Grant from DePaul University. This archive includes exhibition files,

financial documents, video documentation of panels, performances and workshops, slides of artists' work, press clippings and releases, and interviews with individual members of Artemisia. The author is indebted and grateful to Ellie Wallace, a former co-president of Artemisia, and Joy Poe, a founding member of Artemisia Gallery and the Artemisia Fund, for making these resources available, and to my undergraduate research assistants, Melissa Campos and Haley Kerman.

2 For a discussion of the problem of collaborative and activist art being negated in art criticism due to modernism's emphasis on the individual artist genius, see Amy Mullin (2003).

3 After these two meetings, two factions developed. One developed into Artemisia Gallery and the other became the women artists' cooperative, Artists, Residents Chicago (A.R.C.). The two galleries would be housed next to each other and frequently collaborated on programming and exhibitions. See Devonna Pieszak and Bonnie MacLeod (1973).

4 For a detailed discussion, see *Ms.* Forum (1975) on the debate that took place between artists and art historians in New York, Chicago, and Los Angeles. Poe participated in the Chicago discussion.

5 Both "Feminist Art Workers" and "Feminist Education: Method and Techniques" were considered extension programs of the L.A. Woman's Building and were offered across the country. See promotional material, Joy Poe Papers, Feminist Archive, Artemisia Gallery, Ryerson and Burnham Libraries, Art Institute of Chicago.

6 The works included in *Both Sides Now* were derived from Terry Seaman's photographic documentation of the exhibition, now in the Joy Poe Papers (see note 5), and from the invitation for the show, which lists its participants. Laura Litten's (1979) review also provides a detailed description of many objects in the show. Correspondence between Lucy Lippard and the artists included in *Both Sides Now* is held in the Lucy Lippard Papers, Archives of American Art, Smithsonian Institution, Washington, DC.

7 Seeking to disseminate these strategies to other artists, in 1985 Labowitz and Lacy published "Feminist Media Strategies for Political Performance," which was based on their experiences executing *In Mourning and Rage*. Reprinted in Jones (2003: 302–313).

8 For further discussion, see Kay Brown (1972) and Maria Ochoa (2003).

References

Alcoff, Linda 1988 "Cultural Feminism versus Post-Structuralism: The Identity Crisis in Feminist Theory." *Signs* 13 (Spring): 405–436.

Artemisia Fund 1976a "Feminist Art Workers." Pamphlet. Feminist Archive, Artemisia Gallery, Chicago, Illinois.

—— 1976b "Feminist Education: Method and Techniques." Pamphlet. Feminist Archive, Artemisia Gallery, Chicago, Illinois.

—— 1977 "Artemisia Fund's Public Education Program." Pamphlet. Joy Poe Papers, Artemisia Gallery, Chicago, Illinois.

Bordt, Rebecca 1997 *The Structure of Women's Non-Profit Organizations.* Bloomington, IN: Indiana University Press.

Brookner, Jackie 1991 "Feminism and Students of the '80s and '90s: The Lady and the Raging Bitch; Or, How Feminism Got a Bad Name." *Art Journal* 50 (Summer): 11–13.

Broude, Norma and Mary Garrard (eds.) 1994 *The Power of Feminist Art.* New York: Harry N. Abrams.

Brown, Kay 1972 "Where We At: Black Women Artists." *Feminist Art Journal* 1 (April).

Ciurej, Barbara 1988 Interview with artist. Feminist Archive, Artemisia Gallery, Chicago, Illinois.

Cottingham, Laura 2000 *Seeing Through the Seventies: Essays on Feminism and Art*. Amsterdam: G&B Arts International.

Dickinson, Eleanor 1999 *Discrimination in the Art Field*. Pamphlet, San Francisco, CA; See http://eleanordickinson.wordpress.com/gender-statistics.

Duchon, Susan and Linn Hardenburgh 1976 "In Retrospect—The Midwest Women Artists' Conference." *Art Journal* 35 (Summer): 386–388.

Holbert, Virginia 1983 *Artemisia X: Ten Years*. Chicago: Artemisia Gallery.

Jones, Amelia (ed.) 2003 *The Feminism and Visual Culture Reader*. London: Routledge.

—— 1999 "Contemporary Feminism: Art, Practice, Theory and Activism—An Intergenerational Perspective." *Art Journal* 58 (Winter): 17–18.

Kelly, Mary 1996 *Imaging Desire*. Cambridge, MA: MIT Press.

Koch, Joanne 1974 "The New Professionals." *Chicago Tribune Magazine* (September 8): 20–22.

Lippard, Lucy 1989 "Both Sides Now." In *The Pink Glass Swan, Selected Feminist Essays on Art*. New York: W.W. Norton and Company.

—— 1980 "Sweeping Exchanges: The Contributions of Feminism to the Art of the 1970s." *Art Journal* 40 (Autumn–Winter): 362–365.

—— 1979 "New York Times IV." In *A Day in the Life, 24 Hours in the Life of a Creative Woman*. Chicago: A.R.C. Gallery. Exhibition catalogue.

Litten, Laura 1979 "Both Sides Now." Exhibition review. *New Art Examiner* 6 (April): 13–14.

Lopez, Yolanda and Moira Roth 1994 "Social Protest: Racism and Sexism." Norma Broude and Mary Garrard (eds.), *The Power of Feminist Art*. New York: Harry N. Abrams: 140–157.

Ms. Forum 1975 "What Is Female Imagery?" *Ms*. Forum, *Ms*. Magazine 111 (May): 62–65; 80–83.

Mullin, Amy 2003 "Feminist Art and the Political Imagination." *Hypatia* 18 (Fall–Winter): 189–213.

Ochoa, Maria 2003 *Creative Collectives: Chicana Painters Working in Community*. Albuquerque: University of New Mexico Press.

Orenstein, Gloria Feman 1994 "Recovering Her Story: Feminist Artists Reclaim the Great Goddess." Norma Broude and Mary Garrard (eds.), *The Power of Feminist Art*. New York: Harry N. Abrams: 174–189.

Phillpot, Clive 1987 "Adrian Piper: Talking to Us." In *Adrian Piper Reflections 1967–1987*. New York: Alternative Museum, Exhibition Catalogue: 7–14.

Pieszak, Devonna and Bonnie MacLeod 1973 "Consciousness Raising on Ontario St.? Chicago Women's Galleries and the Women's Movement." *New Art Examiner* 1 (November): 3.

Poe, Joy 1979 "Artemisia Gallery." Joy Poe Papers, Feminist Archive, Artemisia Gallery, Chicago, Illinois.

—— 1978 "Creative Awareness Workshop." Pamphlet. Joy Poe Papers, Feminist Archive, Artemisia Gallery, Chicago, Illinois.

—— 1977 "Artemisia—Past, Present, Future." Joy Poe Papers, Feminist Archive, Artemisia Gallery, Chicago, Illinois.

Reed, T.V. 2005 *The Art of Protest, Culture and Activism from the Civil Rights Movement to the Streets of Seattle*. Minneapolis: University of Minnesota Press.

Withers, Josephine 1994 "Feminist Performance Art: Performing, Discovering, Transforming Ourselves." Norma Broude and Mary Garrard (eds.), *The Power of Feminist Art*. New York: Harry N. Abrams: 158–173.

Wolff, Janet 1992 *The Social Production of Art*. Second edition. New York: New York University Press.

13

SALON WOMEN OF THE SECOND WAVE

Honoring the Great Matrilineage of Creators of Culture

Gloria Feman Orenstein

As I time-travel through my own life back to the early 1970s I find myself with a Doctorate in Comparative Literature, having written a dissertation on Surrealism and Contemporary Theatre, a divorced mother of two daughters, aged eleven and thirteen, and a feminist with dreams that the Surrealists had expressed in their manifestos as the goal of transforming the world. Unfortunately, lofty as these ideas and accomplishments were, and dedicated as I was to my chosen work and to raising my daughters with hope and a vision of survival and success, I had not found any security in my part-time university job teaching Women's Studies at Douglass College on a one-year contract. Moreover, after the divorce, my personal and social lives seemed to have been permanently extinguished. I felt that I had very little hope for future fulfillment in my chosen career, and much less hope for an exciting social life. In a state of panic over my survival, I took an Ira Progoff Journal Weekend Workshop, where one is taught to overcome the blocks in one's life by dialoguing with various parts of the self, with others, and with circumstances.[1]

I remember clearly that I had decided to dialogue with Work, and my question was: "If I have no job next year, what is my work?" It did not seem possible that I could come up with a satisfying answer, but I was ready to give this process a try, since many of my friends had recommended it.

The journal pushes you to the extreme limits of your imagination—and no sooner had I begun to dialogue with work than one part of myself asked another: "If you were to have all the money you needed available to you, what kind of work would you choose to do during your life?" My answer was immediate. "Unfortunately I was born in the wrong century to do my ideal form of work, for since I love literature and am committed to the women's movement, I think I would have liked to be an eighteenth-century Salon Woman in France." The

journal responded. "OK. You are living the twentieth century in the U.S., and you have no money. How will you start your salon?" I began to see how this process worked, for suddenly I had to come up with what then seemed to me to be an absurd answer. I began by saying to the journal: "You win. That was merely a foolish fantasy for a woman in my situation to entertain." But the journal seemed to have developed a nagging personality of its own, and it wouldn't stop hounding me until it succeeded in forcing me to figure my way out of this dilemma. "OK, OK then, I guess I'd have to pool resources with many people, and start a salon in a collective manner." "Fine," the journal replied. "Tell me exactly, step by step, how you would proceed." And so I dreamed of a salon on a houseboat that sailed up and down the East River, like a showboat, giving literary readings in every port. The journal had more of a practical personality, and made me realize that I was fantasizing again, but that I could, actually create a salon in the twentieth century if only I set my mind to it. Naturally, I did not leave the workshop with concrete plans for inaugurating a salon, but I left it with the dream of a dazzling literary life for women writers of the feminist movement in New York in the 1970s.

Two years were to go by before I attended a reading by women writers in New York during which the proverbial bell rang in my head. "Oh. I see!! *This actually is a woman's salon! Only no one knows it yet!!!*" At the conclusion of the reading I stood up, and asked those present if they were interested in forming a Woman's Salon, and I was taken aback by the intensity and immediacy of the positive reaction I received, for, as it turned out, each woman writer present told her story of coming to live in New York from a different part of the country in search of the literary life of legendary salon women. Five of us got together the next week to plan the first event of what was soon to become a passionate creative commitment to the Woman's Salon for Literature in New York.

Since I was the only one of those women who had a job at the time, I volunteered to contribute $60 to funding the first event, a slide-lecture on "The Women of Surrealism" held at my apartment. In November of 1975 I was joined by my co-creators, Erika Duncan, Karen Malpede, Marilyn Coffey, and Carole Rosenthal, in welcoming literally hundreds of women who came bearing gifts and offerings, food and writings, flowers and wine to my apartment. We could not fit them into my tiny living room. We had pooled our five mailing lists, and sent our invitations, thinking that perhaps some fifteen people might show up, but there were more than a hundred, and they overflowed into the night, down the hall and up the street. In that first lecture I discussed the magical and esoteric imagery in the works of such women Surrealists as Léonor Fini, Leonora Carrington, Remedios Varo, Meret Oppenheim, and Toyen.[2]

We knew that we had to continue, and that we would find the support necessary to go on, since this was the realization of a dream that I actually shared with vast numbers of women of my generation. Of course we knew that we had to find a larger space, and so we began to migrate our salon events from artists'

lofts in Soho to various other spaces, eventually to settle in the art studio/
apartment of Erika Duncan at Westbeth, an artist's residence in New York. Her
space was dramatic—painted in magenta, pinks, reds, and purples, and sculpted
by her then sculptor husband into various levels, so that we felt we were in a
theatrical space. We read from a magenta balcony overlooking the throng of salon
women sitting on the floor on their/our magic carpet, which seemed to transport
us into worlds that were to me, then, what the dream worlds of the Surrealists
must have been to them at the beginning of the century.

After settling into Westbeth, because we could no longer transport our books,
flyers, posters, and other feminist cargo from loft to loft, we printed a salon flyer
stating our aspirations and our programs, and we created a form of membership
so that salon frequenters could attend events for free by showing their card, while
others had to pay three dollars to enter. Membership simply consisted of a tax-
exempt $10 donation.

Reading back over our brochure, I find that some of our early salon members
included Dorothy Dinnerstein, Rachel Blau Du Plessis, Arlene Raven, Sara
Ruddick, Deena Metzger, Ann Snitow, Alicia Ostriker, Arlene Raven, Miriam
Schapiro, June Blum, Claudia Weill, Josephine Withers, Louise Bernikow, Audre
Lorde, Cynthia Mailman, Robin Morgan, Judith Stein, Stephanie Golden, June
Arnold, Suzy Charnas, Barbara Gates, Lynne Fernie, Susan Schwalb, and Batya
Weinbaum. We had many visual artists and art critics who attended our salon
along with the writers. The intermingling of artists and writers had been my goal;
the Surrealist Movement served as a model for my creation of a salon in which
artists from all media would share their feminist artistic visions.

Because many of us were mothers of young children, our daughters often
attended the salon. Since it took place at Erika Duncan's apartment, her three
daughters were constantly present, helping us organize the book table and our
food offerings. Erika's daughter, Gwynne Duncan, today an artist in her own
right, recalls:

> My mother, Erika Duncan, was one of the founding members of a
> writer's group called The Woman's Salon, which took place in my home
> at Westbeth. I was seven or eight at the time, so most of my memories are
> not of what they were reading, but what went on surrounding that. My
> childhood growing up with artists has influenced me to become a painter,
> and the salon influenced me to become a curator, and bring a community
> of artists together.
>
> My two sisters and I would always put on nice seventies hand-me-down
> dresses. Our job was to work at the door, collecting a dollar admission
> from the women lined up at the front door. Our apartment was a duplex,
> and the Salon took place upstairs. My father, a sculptor and carpenter, had
> transformed our open loft into a magical space of different balconies
> and levels painted pink and purple. The dining room became the stage, and

my mother would ring this ancient bell that hung from the rafters when the reading was about to begin.

I remember my mother making her famous spaghetti sauce in a giant soup pot, and heaps and heaps of spaghetti for the guests. They also served wine in big gallon jars. I remember one special dish they prepared from the Alice B. Toklas cookbook—a large baking dish filled with mashed potatoes dyed red with wine, and then string bean lettering on top. That was my favorite dish. I remember prominent black and American Indian writers coming to read, and an air of excitement and importance. As a child I would get bored and wander downstairs to play with the heaps of dollar bills, our biggest thrill.

Although the rhetoric of our salon publications—brochures, literary criticism, and articles may sound a bit flowery, 1960s-ish, and much too essentialist (as if all feminists shared one single vision) to our contemporary de-constructed, re-constructed, hard-wired, multi-cultural, eco and technoselves of the new millennium, I had consciously been seeking to connect our salon to those of the salon tradition in France from the seventeenth and eighteenth centuries—and particularly to the salons of Gertrude Stein and Natalie Clifford Barney of the early twentieth century.

From our Salon Brochure, written at the end of our first year of salons, in 1976:

> The woman's Salon is a forum for criticism and theory as well as for fiction, poetry and plays. The Salon was founded by five women writers in the fall of 1975. While we make no exclusive esthetic judgments, the major com-mitment of our Salon is to work that seeks through its poetic and imagistic intensity and its structural innovation to alter individual consciousness and to change the social world. The Woman's Salon supports, encourages and provides an intelligent and receptive audience for writing that generates the personal and communal transformations which are the essence of the feminist world vision. We are committed to the writing we believe in regardless of its acceptance by the contemporary literary establishment or its distribution under the current system of economic censorship. We believe the Woman's Salon can influence literary history.
>
> We believe in the power of the written word to define the evolving nonviolent human relationships that are the most profound discovery of the feminist movement. We believe in the power of the imagination to create a world in which women and men can contact and deepen our joyous connection to the life force. We believe carefully crafted feminist writing increases our capacity to relate to one another without bondage and that as the capacity to love freely increases, fear and violence are transcended.[3]

If I were to analyze the origin of these ideas, I would say that the expressions of passion and intensity came directly from Erika, the political vision of non-violence came from Karen, and my contributions were the idea of writing a kind of manifesto inspired by the Surrealist rhetoric of Rimbaud and Breton on transforming the world, and my knowledge of what literary salons had accomplished historically. I knew that our salon would be more easily understood if we rooted ourselves in the history of salon women, and so I went off to the library, and began to do research on literary salons. In a summary of this research that I published widely and gave at many public gatherings, I wrote:

> The traditional salon was a creation predominantly of and by women . . .
> Salon women had their own culture, and transmitted it to each other
> through apprenticeships. Many were educated in convents—all female
> communities. These women became each other's protégées. These mentor
> relationships between women were fostered by the salon spirit. The salon
> was a place where women reigned in the positive aspects of their most
> traditional locus of power, the home. The salon was the *foyer* par excellence
> —the hearth and home of many an itinerant intellectual, artist, or writer.
> . . . It was the seventeenth century that witnessed the official creation of
> the literary salon as we have come to know it today. Mme. De Rambouillet,
> known as "La Divine Arthénice" (an anagram of her name, Catherine,
> composed by the poet, Malherbe), held her salon in the Blue Chamber of
> the Hotel de Rambouillet. She is credited with having originated the
> intellectual tradition of the salon. It is sobering to note that Mme. De
> Rambouillet was married at the age of 12, and that she had seven children.
>
> By the eighteenth century, salons had become a full-blown tradition
> with the most brilliant women in Europe. The power of salon women to
> positively affect the lives of those attending their salons can be seen in the
> examples of eighteenth-century salon hosts, Mme. De Geoffrin, Mme. De
> Tencin, Mme. Du Deffand, and Mme. De Lambert. They exerted an
> important influence upon the literary and artistic styles of their times, and
> helped mold the opinions held by the leading intellectuals of their day.
>
> Across the channel, eighteenth century salon life in England was taken
> up by the Bluestocking women, and later in the early twentieth century,
> Lady Ottoline became the patron of the Bloomsbury Group at her home
> in Garsington, where she received D.H. Lawrence, Bertrand Russell,
> Santayana, Katherine Mansfield, Vanessa and Clive Bell, Virginia Woolf,
> Lytton Strachey, Aldous Huxley, and T.S. Eliot. In the United States, the
> Bluestocking tradition was carried out in Philadelphia in the second
> half of the eighteenth century. Then, as seminaries in upstate New York
> began to offer better educational opportunities for women, those women
> who received a seminary education and were trained in the fine art of
> conversation began to open salons in the East.

When we reflect upon the literary life of the twentieth century in France the great salon of Gertrude Stein immediately comes to mind. Stein's salon hosted Picasso, Matisse, Cocteau, Hemingway, T.S. Eliot, Sherwood Anderson, F. Scott Fitzgerald, Edith Sitwell, and Dos Passos. Another American expatriate in Paris, Natalie Clifford Barney, held a salon that lasted for almost seventy years. Known as "The Amazon of Paris Lesbos," the salon events that she sponsored were frequently restricted to women only. Those who frequented her salon included Colette, Valery, Ezra Pound, Edna St. Vincent Millay, Radclyffe Hall, Rilke, Romaine Brooks, Dolly Wilde, Gertrude Stein, Alice B. Toklas, Janet Flanner, and many others.

Salons held in France also developed for the visual arts. Their history reveals the importance of the Salon as a haven for experimental and vanguard tendencies in the art world. The annual official Salons were eventually opposed by the Salons of those whose work had been refused; they became known as the Salon des Refusés. In 1884 the Salon des Indépendents was created, dispensing with all prizes and juries and open to all artists.

The New York Woman's Salon was inspired both by the traditional aspects of the literary salon and by the radical aspects of the artistic salon. On the one hand it took from the literary salon a desire to partake in a traditionally female intellectual culture with a historical record of over 300 years, while on the other, it took from the artistic salon a desire to create an alternate space for the presentation and reception of works born of a new consciousness and thus not easily accepted in the official artistic venues.[4]

Over our salon's ten years of existence, we held one salon each month for a woman writer, who would be introduced by a critic, another writer, or a friend. Some of our salons included presentations by Barbara Deming, Adrienne Rich, Catharine Stimpson, Robin Morgan, Kate Millett, Dorothy Dinnerstein, Phyllis Chesler, Marge Piercy, E.M. Broner, Valerie Miner, Susan Griffin, Alix Kates Shulman, Susan and Nina Yankowitz, Olga Broumas, Helen Yglesias, Paula Gunn Allen and Linda Hogan, Mae Swenson, Anaïs Nin (who was ill in California) with participation by Alice Walker, Frances Steloff, Nona Balakian, Daisy Aldan, Sharon Spencer, and my daughter Claudia Orenstein. We had special salons featuring the works of writers in the Toronto women's collective Fireweed with Lynne Fernie, women writers in prison, black women writers, and Latin American women writers. Each New Year's Day we held an Open Reading that went on all day. It was accompanied by a potluck feast, and on special occasions we made dishes from the recipes of Alice B. Toklas.

Special salons that created a relationship with the visual artists were the Surprise Art Salon of March 1977 held at the AIR Gallery. This was my brave attempt to include presentations by visual artists in the program of the Woman's

Salon. Although it was very well attended, and the visual artists enjoyed it immensely, the writers were unimpressed. Why? Well, the salon had featured artists who used words in their art. Thus, we had some words on video screens that were accompanied by a reading of words by an artist who used words as concrete artistic or visual elements. My writer friends said to me: "Gloria, this is *not literature*. We want fully developed texts." A similar reaction from the other perspective came about on the day that the women artists from the Women's Caucus for Art made a bus tour of the art spaces in Manhattan. We put our salon on the list, and they had to stop by for a reading. They came in, walked around, and started to leave. We told them we had not even begun yet. They were amazed. They said: "Well, we've seen it. You know. We came in and checked out the walls." We begged them to stay, and began the reading. Many left in tears saying: "Oh my, we had forgotten all about the power of words!"

Our most successful art event was the salon we held for Judy Chicago on Saturday, September 24, 1977. Judy presented a slide-show of *The Dinner Party* in the making before it opened. She was accompanied by Susan Hill and other workers from the project, and news of her salon spread rapidly through the women's art community. All day long we received phone calls about the salon.

Some of the women were angry with Judy for various reasons such as not paying a salary to the women who worked on the project. However, today, as

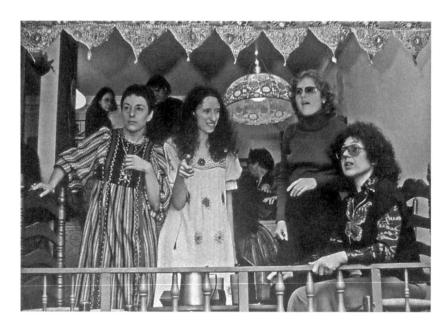

FIGURE 13.1 *Salon for Judy Chicago* (1977). Pictured on left are Gloria Orenstein and Erika Duncan; Judy Chicago is on right. Reprinted with permission of Gloria Orenstein.

I reflect upon what took place surrounding that salon, I see it all as a part of salon history, which both in the arts and in literature is simply replete with agitation, rebellion, confrontation, and debates. It was exciting, and became even more so when over two hundred women showed up to attend the slide-lecture. Many could not fit into the loft space at Erika's, and we thought of holding two salons for her—but I think that ultimately we did manage to fit most of the women in. Everyone was on edge, and tempers flew around the room, as one woman had to leave early, which definitely upset Judy. So Arlene Raven cheered her on from high up on a balcony: "Come on Judy. Do it for the West Coast." And Kate Millett cheered her on from another perch: "Come on Judy, do it for the East Coast," and so she did it for both coasts, and we marveled at what we had in store for us when *The Dinner Party* would open. I remember that night, not so much as one of tension and upset, as one of high voltage . . . a coast to coast high wire act that we had all collaborated on to pull off successfully.

Another inter-arts salon that I remember fondly was a salon we gave for Jovette Marchessault, a Québecoise writer on September 22, 1979. Pol Pelletier, the creator of Le Théâtre Expérimental des Femmes in Montreal gave a performance of Jovette's visionary text, *Les Vaches des Nuit* (*Night Cows*).[5] Jovette was also a visual artist, so in this salon we brought together literature, theatre, and art on an international scale. Her text is about a female cow who is a beast of burden in the daytime, but who, at night, puts on her speckled robe, and journeys with her mother cow to the great Sabbath of animals in the sky, where a kind of ecofeminist, interspecies consciousness-raising celebration takes place in which the roof of heaven shakes very hard until the cows have to hurry back to their oppressive existences in daytime reality. Jovette's *Telluric Women, Women of Hope and Resurrection* are totemic sculptures of primeval women, women sprung directly from the Earth, who embody the forces of womanpower and the primordial energies that revive the lost worlds we communed with in ancient times.[6]

Yet another fascinating inter-arts salon that we created was held at Bargemusic, Olga Bloom's music-barge salon at the Fulton Ferry landing in Brooklyn, in April of 1980. There, overlooking the East River with the lights of the many boats shining in the harbor, we presented the works of composer Roberta Kosse, who wrote the oratorio *The Return of the Great Mother*. The concert included vocal and chamber works, as well as a talk about women writing contemporary music whose hopes and dreams resonated deeply with those of feminist composers in the other arts. So, although each of the arts was living in a world apart, I tried to bring them together, always inspired by the model of the Surrealist Movement.

Meanwhile, by 1977 the Houston International Women's Year (IWY) National Women's Conference was being organized, and our own Salon Woman, artist Susan Schwalb, was selected as the Arts Representative. Our salon immediately organized a program of readings, which was presented at the Seneca Falls South venue for the arts at the Houston conference. Erika and I brought with us Kate Millett, Olga Broumas, and Valerie Miner. We spoke about salon

history and our aspirations, and then each of the writers read an excerpt from her work. Our archives sport a lovely letter of thanks from Bella Abzug for our presentation.

Every Saturday I would go down to Soho with my artist friends and visit AIR and Soho 20, the women's cooperative galleries, so that I could keep abreast of the developments in the women's art movement. I had also been offering a Women's Studies course at Douglass College, and I often invited artists whose work I saw in Soho to speak in my class. One day on a class field trip to Soho we discovered that Hélène de Beauvoir, Simone de Beauvoir's sister, was included in a gallery exhibit. I left a message for her, and she invited me to tea. When she asked me to tell her about my life, I did not want to go into it. At that time, my job security was at rock bottom, and my marriage had ended. I was fairly despondent, actually quite anxious, and frantic. Yet she was thrilled, absolutely ecstatic to hear what I had said: "That's just wonderful, Gloria," she exclaimed with enthusiasm. "Now you can freely invent the rest of your life. You have chosen your freedom, and now you are at liberty to create your true self." I immediately recognized the Existentialist message that de Beauvoir championed. I knew she was right, and that is partly what gave me the courage to invent the salon for women writers in New York. She literally gave me the "go ahead" to do it.

By 1978–1979 I was directing the Rutgers Junior Year in France. As much as I would miss my salon life in New York, I was very excited about taking the news of the Woman's Salon to the feminists in Paris, and I hoped to inspire some salon thinking over there as well. Of course I imagined I would find a salon already in existence in Paris. I was wrong. There were none. But with my New York experience behind me, I knew that I had to present the idea of creating a salon to my French feminist friends. Our Rutgers Junior Year in France program was housed in Tours, in the Loire Valley, but every weekend I would take the train to Paris and meet with feminists in literature and the arts. As soon as I mentioned my salon, the French feminist energies were galvanized. Yolaine Simha, known as Ygrecque, an author who published with Les Editions des Femmes, and who had created a Salon de Thé at 171 Rue St. Jacques, Paris V, near the Panthéon, was eager to use her own dramatic salon space for literary and art events on weekend evenings.

There was a noted feminist art critic in Yolaine's entourage—Aline Dallier. There were also women active in the arts and letters in our group. Françoise Pasquier was the creator of Editions Tierce, a feminist publisher, and Michèle LeDoeuff, a feminist philosopher, frequented our salon. Writer Renate Stendhal, psychoanalyst Françoise Eliet, artist Françoise Janicot, Monique Plaza, and many other feminists in the arts and letters attended our salon events.

The salon was known as Le Lieu Dit, which means "the appointed place." The art space opened in November 1978 with a show that included works by Françoise Eliet, Irene Laksine, Gunvor Berquist, Françoise Janicot, and Marion Settekorn. In the summer a photographic exhibition "Hysterics from the 19th

Century" was mounted. It presented original photos and engravings of women who were diagnosed as "hysterics" and confined in the Salpetrière Clinic in the late 1800s. The feminist analysis spoke of how these women had been posed by photographers for hours, and how they sought to be photographed so that they could escape for a while from the brutal treatment they received in the clinic. Hysteria seems to have been encouraged: it met men's needs, but these women used it as a means of liberation from the oppression they underwent in the clinic.

During the summer I gave a slide-presentation on "The Re-emergence of the Great Goddess in Art by Contemporary Women," which included works by Ana Mendieta, Mary Beth Edelson, Betsy Damon, Donna Byars, Miriam Sharon, Mimi Lobell, Carolee Schneemann, Judy Chicago, Donna Henes, and others. I also presented on the Woman's Salon for Literature in New York and a program in French on Quebécoise feminist writing for International Women's Day. Writers who read at Le Lieu Dit literary salon included Charlotte Crozet from England, author of *Voie Privée*; Florence Dupont, author of *Adieux à Marguerite Yourcenar*, and Luce D'Eramo from Italy, author of *Le Détour*. Encounters in other arts focused on women in architecture and women in music.

On one of my previous trips to Paris, I walked over to 20 Rue Jacob, and rung the doorbell of Berthe Cleyrergue, who ran Natalie Barney's salon with her. It was Berthe who made the little sandwiches and pastries, and who was her devoted woman in service. My interview with her was later published in *Signs*.[7] As I was seeking out other salon women, I happened to be introduced to Mme. Tezenas, who had held a salon in Paris as recently as the 1970s. The story of our interview illuminates the contrast between the cultural texture of the Parisian salons and that of our New York salon.

Our New York salon had as one of its social goals the creation of a network of women artists, writers, critics, journalists, publishers, literary agents, gallery owners, and dealers. Networking was important to our empowerment in those days. I actually considered our salon as a form of Work—and that came directly out of my dialogue with WORK at the Ira Progoff journal workshop. Thus, you can imagine how surprised I was when I asked Mme. Tezenas what the social goal of her salon was, and she replied: "Why, my dear, *we had no social goal. I don't even know what you are talking about.*" I did not understand her either. So I explained how important networking was, how we hoped to further women's contacts toward publishing their books etc. She replied:

> Good Lord, I certainly hope that nothing practical ever came out of our salon! My dear, we were simply interested in good conversation with good friends, in good food, good music, good wine, and . . . well you know . . . all "les agréments de la vie" [the pleasures of life].

Then she went on to talk about the sheer joy and delight of gathering together with intelligent friends and sharing those pleasures. At that moment I

burst into tears. Like the women artists who had forgotten about words, and the writers who had forgotten about images, I had completely forgotten about pleasure. I was convinced that I could only have pleasure if I reframed it as work, and so the salon had become an extension of my movement work and my women's studies work and my academic work on women in the arts. I was determined to come to terms with what would constitute an "agrément de la vie" for me, and to bring that back to the New York salon.

That summer, before I returned to New York, my friend, artist Susan Schwalb, came to visit me in Paris. There we were on a panel with Miriam Schapiro and Judith Stein at Le Centre Culturel Américain, and there Susan Schwalb conceived of creating the First International Festival of Women Artists for the IWY Mid-Decade Conference on Women to be held in Copenhagen, Denmark, in the summer of 1980. She was sent on a mission to Copenhagen to meet with women artists to organize the project, and when she and I met in New York in the fall, we went to work applying for funding to create what was to become a major festival of international feminist artists, writers, filmmakers, performers, and critics at the Ny Carlsberg Glyptotek in Copenhagen. In some sense our festival was like a salon on an international scale, and because it somehow realized the dream I had long held onto—the creation of an inter-arts, international festival—I see it as an outgrowth of our salon activities.

Susan Schwalb wrote me about what belonging to our literary salon meant to a visual artist:

> For me, joining the Women Artist's movement in the early 1970s was as much about political action as it was about discovering the work of women artists, writers, and composers. I met Gloria Orenstein when I invited her and the Woman's Salon to be part of the arts celebration in 1977 at the International Women's Year (IWY) conference in Houston, TX where I was the arts delegate from New York City. The Woman's Salon was a special place for a visual artist, like myself, to learn about the work of writers such as Kate Millett, Alix Kates Shulman, and Helen Yglesias, and to hear them read from their newest books and works in progress. The room, a brightly colored sculptural environment packed with women on many levels, had a warmth that encouraged and nourished creativity. I gained a community for my work and a freedom to explore the "personal as political" in my art.

Susan Schwalb, Marcia Miller, and I left for Copenhagen in July to attend the conference that took place July 14–30, 1980. While most of the NGO sessions took place at the Amager University Forum, Susan had insisted that the festival take place at the Ny Carlsberg Glyptotek, because she was thinking of how prestigious it would be for the artists to present their work at that museum rather than at a university forum. Buses were used to transport women back and forth

from the forum to the museum. The central feature of the permanent exhibit at the museum was *The Shrine* created by Betsy Damon, who came as part of the group of artists and writers that we funded from the United States. I coordinated the literary programs, and I invited Audre Lorde to represent our group. She gave several readings and met with women from international feminist publishing houses. Susan Schwalb worked with Anneliese Hansen from Copenhagen, so that all went smoothly when we arrived.

Betsy Damon's shrine was composed of five hundred pounds of earth paved with a circular slate pathway, bordered with banners from which pouches were strung and into which women would place offerings at the rituals that were held there. Women who attended the political events at the NGO forum often felt depleted at the end of the day, and they would gather for rituals of healing and communion at the shrine. Artists and writers who attended the Copenhagen conference came from over thirty nations. They participated in panels, art exhibits, performances, rituals, encounters, and a film festival in addition to the political activities of the NGO forum. Viveca Lindfors brought her *I Am A Woman* show and Emmatroupe, and Italy's Theatro Viola and Teatro Madelena presented performances along with the Edith Stephen Dance Connection and Folk Dance presentations. Because a juried exhibition of paintings or larger works coming from the United States would have been almost impossible to transport and fund, we decided to invite women to contribute art postcards to *The Postcard Show*, which would travel to many international venues. The only requirement for submission was that the work be the size of a postcard. The conference sponsored an important colloquium of international feminist publishers and I organized a series of international readings by authors from Japan, Indian, Scandinavia, France, Germany, and the United States. Audre Lorde, Robin Morgan, and E.M. Broner were all participants in these readings and literary events. Art critic Eleanor Tufts came as a part of our art delegation, along with Betye Saar and Cynthia Navaretta. Eleanor Tufts wrote an article about the First International Festival of Women Artists for *Arts* magazine in the fall of 1980. California performance artist Anne Mavor created a ritual at the Little Mermaid statue in Copenhagen that she called *Gathering of the Mermaids*, Barbara Hammer talked about rituals, Lorranie Garcia spoke about California muralists, and Muriel Magenta and Alida Walsh coordinated the Film Festival. An important exhibition of women's art from developing countries was held at the Nicolaj Church, which featured weavings from Botswana, tapestries from Chile, and paintings from Indonesia.

As I look back to that conference, I think of it as a true international multi-arts women's salon. Thus, it is no surprise that when I returned to the United States from the Copenhagen conference, I was determined to co-create a second salon, a salon in the multi-arts. I decided to do this with Marcia Miller, who had been with me in Copenhagen, and was eager to collaborate with me on this project.

From our joint (unpublished) text about the history of Cerridwen Salon:

> Our first idea was to bring a bit of "the Copenhagen experience" back to
> the States with us. Because some of our most moving experiences in
> Copenhagen took place in the shrine created by Betsy Damon in the
> Glyptotek Museum, where rituals were held commemorating women's lives
> from many nations, we wanted to begin our first salon with a ritual.
>
> We were fortunate that Hallie Iglehart and Romilly Grauer, two ritualists
> who had worked with Betsy in Copenhagen, were coming to New York
> from California. We thus planned our first event celebrating women's myth
> and ritual and with their presence in mind. Hally and Romilly's ritual created
> a special atmosphere for the inauguration of the Cerridwen Salon because,
> by a special alchemy, they managed to fuse 130 women, most of whom
> did not know each other, into a participating, organic whole. One of the
> main differences between the Cerridwen Salon and the Woman's Salon
> was the involvement and active participation of the women present. They
> joined hands in singing, weaving slow dances, and in invoking the powers
> of the Celtic Goddess, Cerridwen, who presided over the sacred cauldron
> of wisdom and inspiration. Hallie and Romilly brought with them artist
> Mary Curtis Ratcliffe's wind sculpture, which had also been in Copenhagen
> with us, and which hung directly over the center of the circle. Romilly
> played the guitar and chanted shamanic prayers, while Hallie invited us to
> bless the powers of the directions with corn, seeds, candles, incense, shells,
> and volcanic ash from Mt. St. Helens.
>
> Eleanor Johnson, co-director of the feminist experimental theatre
> Emmatroupe, graciously invited us to use her loft for our first event. Eleanor
> Johnson's statement read: "Emmatroupe's understanding of political theatre
> requires that we go back in time to reclaim our lost legacy, a history denied
> to women, in order to form the broad base of analysis and understanding
> necessary to expose, challenge and change the social-sexual-political
> view of women which has defined them in a man-made world. New
> research into history continues to reveal the erasures, exclusions, and
> misrepresentations of women's lives."

Susan Schwalb presented a slide-show which traced the evolution of her
art. Following Susan's presentation, Karen Malpede, co-founder and Resident
Playwright of the New Cycle Theatre, and who was also one of the original co-
founders of the Woman's Salon for Literature, presented a scene from her play,
A Monster Has Stolen the Sun. Our last artist of the evening was Merlin Stone,
author of *When God Was a Woman* and *Ancient Mirrors of Womanhood*, who read
from her chapter on Cerridwen. The enthusiasm and exaltation of the 130 women
present was indescribable. It was only because of fire laws that we had to turn
forty others away.

In planning our second Cerridwen Salon in the multi-arts we decided to continue our commitment to a thematic event. Our choice of a theme for the next salon was inspired by a reading given by Meridel LeSueur at the New York Marxist Society. Speaking about aging, she said, "Women do not age, they ripen." A poet, novelist, and political activist, Meridel was then eighty-two years old and a committed socialist who was arrested many times, beginning at the age of sixteen. She was passionate and vital, and her dynamic presence made one realize that maturity can be a blooming and a gathering together. Her inspired verses were a high point of our evening.

We then invited Betsy Damon to create a new Ripening Ritual in honor of our second salon. She brought banners, posts, and bags—a Tree of Lives—and spoke of connecting us to our 6,000-year-old history. Once again, women present participated in the ritual, by approaching the Tree of Lives and putting an offering of a thought, vision, or object which they had nourished for a long time into a bag on the tree.

The literary feature of this salon was Virginia Scott, a well-known poet, teacher, and founder of Sunbury Press, who read several poems by Meridel as well as some of her own works.

As a highlight of the evening, Alida Walsh, filmmaker and performance artist, gave a moving slide-presentation of autobiographical encounters with her aging mother through the simultaneous use of tapes and family album photographs. She and her mother reviewed the past and shared memories and images of their lives together and apart.

Finally, Susan Kleckner, filmmaker and photographer, showed her film *Bag Lady*, which described the evolution of a middle-class prima donna into an ancient bag lady. The showing of this film was followed by an enthusiastic open discussion about her aims and perceptions of this phenomenon, as several women in the audience were currently researching homeless women.

Our last salon of the season, on the theme of Women and Earth Ecology, began with a concert given by the Crescent Quartet, composed of women musicians Alicia Edelberg (violin), Nancy Diggs (violin), Jill B. Jaffe (viola), and Maxine Neuman (cello). They played the American premiere performance of *String Quartet # 3* in four movements composed by Lucie Vellere (1896–1966), and Sara Aderholdt's *String Quartet* (1955–).[8]

Then, Phyllis Birkby, a feminist architect, showed slides of women's drawings of their ideal shelters and abodes, as well as some already constructed habitations in trees, caves, box-cars, and remote country settings.

To round off the evening, Diane Churchill, painter, and Sarah Lechner, poet, collaborated on an artistic presentation of their work bearing on the ecology of the Pine Barrens in New Jersey. They handed out to everyone small samples of rich earth from the Pine Barrens, a region now endangered by commercial development. Alternately reading poetry and showing slides evoking the natural wonders of this precious area of New Jersey, they created a necessary

consciousness-raising which naturally led to an animated discussion, and closed our program for the year.

★ ★ ★ ★ ★ ★

In September of 1980 the English Department of Douglass College voted not to grant me tenure. I had never obtained a doctorate in English, and Douglass College did not have a comparative literature department. Thus, I was forced to seek work elsewhere, and fortunately I was hired by USC in Comparative Literature and Gender Studies as an Associate Professor. Naturally, I had to leave my New York salons behind, take my daughter Claudia with me, and leave Nadine at Barnard College. USC was excited by the idea of my teaching a course on women's salons, and having met many of the feminists in the California art world at various national and international conferences, I moved to California, for my survival, with the knowledge that my salon life could become a bicoastal phenomenon. I decided that I would propose to organize a series of salons at the Woman's Building on Spring Street, with which I soon found myself affiliated and a Board Member. My move to Los Angeles in September 1982 would then permit me to continue to create salons for women in the arts.

In 1985 we inaugurated the West Coast Women's Salon, which was held on the first Thursday of each month at 8 p.m. In March I presented a talk on "Salons as Strategies for Survival," and in September I showed slides from the IWY United Nations Decade for Women Conference that was held in Nairobi in 1985, which I attended, and where I presented a slide-show on women artists' works worldwide to the accompaniment of poetry read by contemporary writers. For International Women's Day Renée Coté, author of a book in French on the origins of International Women's Day, spoke about her book, and about the socialist origins of this holiday. Other political organizers such as Jan Stewart of the Ribbon Project spoke about the Peace Ribbon, the wrapping of the Pentagon on August 6, 1985, and Nancy Berlin of the Women's Coalition to Stop US Intervention in Central America spoke on her visit to the Mothers of the Disappeared and Murdered in El Salvador in 1984. Maggi Feigen told of her experiences organizing around the bombing of women's clinics, and Emily Stewart of Women United spoke about women's civil disobedience against Wincon, a military weapons conference, and her six days in jail. The evening concluded with a concert of women's songs by Joanna Cazden.

The Woman's Building salons had more of a focus on political activism. The Second West Coast Women's Salon was on "The Role of Culture in the New Nicaragua," and featured a slide-lecture by Carol Wells. The Third West Coast Women's Salon was "Sharing the Chicana Experience" and, in addition to poetry and songs, included a performance of Flamenco dancing. The Fourth West Coast Women's Salon was on "Women's Spirituality," and featured Joan Iten Sutherland, founder of the Amargi Institute, which was involved in creating

and preserving rituals and workshops devoted to women's spiritualities and matristic cultures. Later, women from a diversity of spiritual traditions, including Nancy Jones from the Metis Sweet Medicine Sundance Religion, Debra Manley of the New Church of the Followers of the Great Mother, and other representatives of Feminist Liberation Theology and The Black Community, spoke about women and spirituality in their traditions

For many years, I was without a woman's salon, and I deeply felt the absence of the excitement of those heady, celebratory evenings of feminist art, culture, and politics in my life. Although I teach in a Gender Studies program at USC, these worlds have very little in common. I miss the social life of the literary and the art world, when they are linked through feminist visions. However, over the years I have lived in Los Angeles, I also created several salon events at Sisterhood Bookstore, and I have remained a friend of its creator, Simone Wallace. In 2001, as I was feeling bereft of a salon circle, I approached Simone about founding yet another mini salon, and, as she was missing the social world of Sisterhood Bookstore which was closed after thirty years of existence, she agreed that we should invite a few women over, and talk about founding something new along the lines of a salon that would meet our current needs.

In 2001 our mini salon had its first meeting. Each of us present talked about our contributions to women's culture, and somehow we came up with a name for our salon—Living Treasures. We had first said it as a joke, as if we were living dinosaurs, but we soon realized that we actually were repositories of a specific *herstory*. We held monthly events, and went as a group to various functions in the arts, including the 2001 opening of Judy Chicago's show at Skirball Museum in Los Angeles.

It does not surprise me that we women who have created salons would feel the need to create a new salon and to pass the tradition on to others, for that is precisely what older salon women have always done. Typically, salons that existed for twenty or thirty years were often interrupted by events such as wars, but salon women took up their salon work after the war had ended. In their second salon creation phase, they were often living as single women in convents— their husbands had often died, and in those centuries they were safer living alone in apartments within the confines of a convent. Nevertheless, they held salons in their convent quarters, and trained younger salon women in the ways of running a salon.

We need salons because their unique essence is that they meet on a regular basis for many years and are composed of "salon frequenters." The salon forms a community of creators of culture, who over the years come to know each other creatively, in some cases for thirty to fifty years. These are the kinds of friendships that Natalie Barney celebrated in her Temple à L'Amitié that she had built in the yard behind her Parisian home. For Barney, friendship was a sacred relationship.

Reflecting on how the salons I co-created contributed to the writing of feminist art history, as I went over my archives I saw that these salons often had spin-offs

in which frequenters wrote articles on various women artists or writers, but actually, what these salons contributed to was more the elaboration of the texture of an interconnected life of art and letters that would create the framework for the possibility of a chapter about the interconnection of literature and the arts in a future feminist cultural history of the twentieth century. And that history has yet to be written, for the salon frequenters of the Woman's Salon, Cerridwen, Le Lieu Dit, and the West Coast Women's Salon are still at the apogee of their creative lives.

When we five women writers created the Woman's Salon in 1974, we wanted to prevent the suicides and madness of contemporary women writers—such as those we had tragically encountered in the examples of Virginia Woolf, Sylvia Plath, and Anne Sexton. We wanted to provide a support community so that women would not create in isolation—ever again. Today I wonder how many women of the twenty-first century, who have benefited from the second wave of the women's movement—the changes in society and in the curriculum that feminists fought for—how many women coming of age today through e-relationships, who are alone with their computers, may be driven to repeat the patterns of Plath and Woolf for lack of the support system whose living fiber is composed of the energies and bonds fostered by the intimate, face-to-face, long-term friendships provided by a society in which salons exist in such quantity that a creator can attend at least one a day—the way it was in the eighteenth century.

I know that my life would not have been as fulfilled as it is today if we had not created the Woman's Salon, and if I had not gone on to participate in the creation of the other salons in New York, Paris, and Los Angeles.

Notes

1 Gloria Feman Orenstein, *The Theatre of the Marvelous: Surrealism and the Contemporary Stage* (New York: NYU Press, 1975)
2 Gloria Orenstein, "The Women of Surrealism," *Feminist Art* (Spring 1973). This article was the first on women of surrealism, a field that has now grown astronomically. Although Surrealism was a movement of both visual art and writing, neither the American academy nor the art world of the 1970s presented the visual arts along with a study of the literature. Thus, as a scholar of Surrealist literature, I did not know that Leonora Carrington was also a painter. I was in correspondence with her, at that time, because I was interested in her plays for my dissertation on surrealist theatre. Then, noting that I was unaware of her artistic oeuvre (as it had largely been omitted from important books on Surrealism), Leonora began to send me reproductions of her art works from various magazines. I was galvanized by the discovery of her work into imagining research on all the other women of the Surrealist movement, and when I spent a year in Paris (1971–1972), I sought out those other women. Thus, I met Léonor Fini, Meret Oppenheim, Jane Graverol, Lise de Harme, and Bona de Mandiargues. However, since I had written about the iconography in the works of the Women of Surrealism as depicting images of women as Alchemists, Guides, Visionaries, and ultimately images of the Great Mother, I was soon contacted by Mary Beth Edelson and the *Heresies* collective, and asked to write a piece on women artists reclaiming the Great Mother Goddess in their art for their journal. It was through the Woman's Salon

and the *Feminist Art* journal that women artists heard about me, and they asked me to write an article for the *Heresies* Great Goddess issue and ultimately my piece in *The Power of Feminist Art*: Gloria Orenstein, "The Re-Emergence of the Archetype of The Great Goddess in Art by Contemporary Women," *Heresies* 5 (1978); Gloria Orenstein, "Recovering Her Story: Feminist Artists Reclaim The Great Goddess," in Norma Broude and Mary D. Garrard, eds., *The Power of Feminist Art* (New York: Harry N. Abrams, 1994). This research also contributed to the chapters on the visual arts in my book, *The Reflowering of the Goddess* (Pergamon Press, Athene Series, 1990; later with Columbia Univ. Teachers College Press, NY). Because of this research, I also published a review of feminist art historical articles: Gloria Orenstein, "Art History: Review Essay," in *Signs: Journal of Women in Culture and Society* 5:2 (Winter 1975).

3 The Woman's Salon brochure. Written in 1976. Unpublished.

4 Gloria Orenstein, "The Woman's Salon," *Womanart* (Fall 1976).

5 Jovette Marchessault, "Night Cows," in *Lesbian Triptych*. Translated from the French by Yvonne M. Klein (Toronto: The Women's Press, 1985).

6 These sculptures were part of an eight-woman show of Montreal Artists held at the Soho 320 Gallery in New York from January 26 to February 20, 1980. I did not know, when I wrote those words then, that quite literally, in 1987, a Shaman from Samiland, Lapland, northern Norway, would appear in my life, telling me: "Gloria, the Great Spirit has called YOU," and that I would engage in a vision quest at the North Pole that would constitute an initiation into the meaning behind all the visionary vocabulary I had been using in my writing until then, and that I would embark on a long spiritual journey that is still ongoing today.

7 Gloria Feman Orenstein, "The Salon of Natalie Clifford Barney: An Interview with Berthe Cleyreque," *Signs* 4:3 (Spring 1979), 484–486.

8 Other participants included Penelope Schott, a poet and professor of English who is inspired by earth geography and land formations, who read selections from her poetry written during a trip to Iceland and poems from her more feminist works; Roberta Gould, poet; and Ruth Ann Apelhof, professor of humanities at SUNY Auburn.

14

THE NEW YORK FEMINIST ART INSTITUTE, 1979–1990

Katie Cercone

An oral history of the New York Feminist Art Institute (NYFAI) based on interviews with founders, faculty, and members is currently being compiled as a donation to the Rutgers University Library which houses the NYFAI's documentary archive. This is a project funded through a generous grant by the daughters of deceased NYFAI member Helen Stockton in honor of their mother. This short history of the NYFAI uses some of this material to demonstrate how the teaching curriculum contributed to this unique institution.

On a spring day in March 1979, hundreds gathered to celebrate the installation of Louise Nevelson's commissioned wall sculpture in the lobby of the World Trade Center in New York. An important force within contemporary sculpture, Nevelson's accomplishment acted as a symbolic monument to the potential for all women artists to be recognized as the equals of men. A benefit held in the same space also marked the beginnings of the New York Feminist Art Institute, a new feminist art institution, organized with the help of then *Ms.* magazine editor Harriet Lyons and the *Ms.* staff.

The NYFAI was founded by a small collective of women artists: Nancy Azara, Lucille Lessane, Irene Peslikis, Miriam Schapiro, Carol Stronghilos, and Selena Whitefeather. The feminist process of consciousness-raising which they had undertaken in the preceding decade had helped them to recognize the need for an art school on the East Coast that approached the visual arts from a feminist perspective and used consciousness-raising as a primary technique in developing women's experiences into artistic ideas. As Nancy Azara recalls, "It was in 1970 in my consciousness-raising group that I first used the word *I* in conversation with a sense of my own power and the first time that I called myself a woman." Through consciousness-raising the women who founded the NYFAI became critical of cultural artistic myths about gender, race, and sexuality. They were

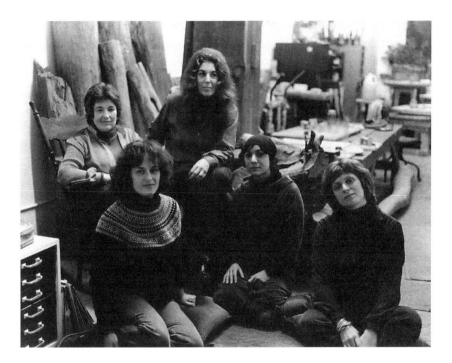

FIGURE 14.1 Feminist Art Institute Founders (1978), L–R top row: Miriam
Schapiro, Carol Stonghilos. Bottom row: Nancy Azara, Irene Peslikis,
Lucille Lessane. (Selena Whitefeather not present.) Reprinted with
permission of Nancy Azara.

keen to open up a space, into which they could enter and make art for and about
their experience as women.

The institute opened its classroom doors on July 9, 1979 with the ambitious
vision of giving students both an increasing self-awareness and the skills necessary
for the visual translation of a personal point of view shaped by an historical and
political consciousness. The first members of the NYFAI utilized consciousness-
raising techniques, particularly the circle-format meeting group in which all
spoke in a way that put emphasis on the word "I," and encouraged each woman
to articulate and reflect on her life experience. Consciousness-raising circles
emphasized the importance of each woman's experience because at the time
many women spoke in terms of "we" rather than the more assertive and self-
affirming "I."

Irene Peslikis suggests the context of the institute was important because "new
feminist ideas need an environment in which to be developed and nourished, as
well as the power of an institution to make them known." The NYFAI was the
only school on the East Coast at that time to combine both art and feminism
and, as a holistic educational institution, the NYFAI entered an art world in which

nurturing the artist as a person, particularly as a woman, was absent from most other creative study programs. As Alix Kates Shulman noted in the introduction for the catalog of the NYFAI's first full-time program in September 1979:

> An art institute which has the daring and vision to undertake the education of the whole artist—not only the eye and the hand, but the mind, feelings, sensibility and deep sources of vision—has the possibility of creating art we have not imagined before. For too long women had been discouraged from acquiring the full range of artistic skills, cut off from full expression of feeling arising from women's wide achievement, and relegated to the periphery of the public world of artistic creation. The brilliantly conceived holistic program of the New York Feminist Art Institute seems designed, not only to remedy the scandalous exclusions and injuries women have traditionally suffered as artists, but to encourage the discovery of untapped powers of insight and expression.

In the United States prior to the 1970s women artists were rare amongst art faculty or as instructors in higher education; those who did succeed were often praised for having the capacity to "paint like a man." As a completely female-run community, the NYFAI offered women an alternative to the competition-based paradigm of the New York art scene. In addition to placing women in positions of power as instructors, board members and students of the NYFAI, the new feminist art school scarcely resembled the typical educational facility where hierarchy and education was structured around master/pupil relationships. Moreover, the NYFAI kept to a feminist collaborative model of decision-making in all of its social, educational, and financial affairs. Whether one sat in during Arlene Raven's Feminist Art History, Darla Bjork's Separation Loss, and Anxiety, Sandra Langer's Gyn/Aesthetics, or Judy Chicago's *Birth Project*, traditional teacher–student hierarchies seldom applied to the institute's collaborative learning models. In fact, faculty and board members were often interchangeable with students. Joan Arbeiter sums up this attitude when she recalls, "We scrubbed floors together at the same time we broke bread together at the same time we paid bills together."

The NYFAI was about cooperation, and about striking a balance between introspection and healthy, supportive networking. Collaboration was a chief leitmotif in much of the creative work of the NYFAI's students and faculty. Particularly through performance, women learned to use models of collaborative expression. Juxtaposed to the isolation of traditionally female and domestic roles in 1950s and 1960s America, this non-hierarchical educational model engendered a new synthesis between a female community and the woman artist as individual, begetting the unraveling of the myth of artistic creativity defined by the genius white male artist who worked alone.

The continued challenge of the NYFAI was to remain open. For the NYFAI as with many alternative not-for-profit structures, it was the institute's alterity,

coupled with the backlash against feminist gender politics that emerged in the early 1990s and declared feminism the new *f-word*, that led to its financial difficulties and eventual closure.

The organization's infrastructure and philosophy discouraged major endowments or grants because they were not in sync with dominant art world norms. NYFAI alumna Melissa Meyer compares the NYFAI's financial hardships with those of the *Heresies* Collective, a small collective that produced a regular publication on feminist art and politics from 1976 to 1995. The collective took the position that purchasing their office on Franklin St. in Soho (then $5,000) was engaging in capitalism, but their refusal to do so left them vulnerable to skyrocketing New York City rents. When the Ford Foundation withdrew promised grant money in the 1980s, one of the things the company objected to was the fact that the NYFAI board members were also faculty and working members. The lack of a typical hierarchy between management and workforce challenged the Ford Foundation's sense of an educational model based upon stratified power that constructed difference, separation, and privilege, those very elements of patriarchal culture that feminism attempted to dismantle. These new ways of operating pushed the NYFAI and its members to the fringes of capitalist patriarchal culture.

What the women of the NYFAI came to learn was that breaking away from oppressive cultural patterns can be a long, complicated process of unlearning. This process of (un)learning and of (re)conceptualizing visual and cultural narratives rose to the surface in the work produced by the NYFAI students. Although the NYFAI focused on the lived experience of its members, its rhetoric of empowerment and the school's mere existence buttressed the demand for alternative educational, political, and social models everywhere. Compared to most art school campuses, the NYFAI opened its doors to students of a much wider range by offering both full- and part-time study as well as a seminar program for art educators, special community events and a Women's Resource Center. Intermittently, the art institute organized project exhibitions in which professional women artists were teamed up with emerging women artists, an unusually inclusionary practice in the United States of the 1980s. The NYFAI frequently invited the most prominent, successful female artists of the period as guests of honor; these included among others Elaine DeKooning, who led a collage workshop, May Stevens, who led a political activism workshop, and Louise Bourgeois, who frequently submitted work to the NYFAI's salon exhibitions.

Students of the NYFAI came from all over, and ranged in age from sixteen to sixty-five. Some were married, some were in college, and some were college graduates already successful in the work world. Judith Chiti remembers her very first meeting candidly, "I walked in and there were forty women sitting on the floor. But none of them were talking about their children or their husbands. This was such a profound relief that I was very impressed and very interested." Chiti continued later in her interview discussing how, despite the financial hardship she experienced working and raising a small child alone during her time with

NYFAI, "It was probably the best time of my life," if only because "I believed we could change certain things, and I was part of it."

Joan Arbeiter remarks that prior to taking classes and uncovering her artistic sense at the NYFAI, her husband used to comment on the strange arrangement of peas, carrots, and potatoes Joan would make on the dinner plates of their New Jersey home. Joan later realized, "I was making compositions," and eventually expanded the idea into a series of paintings. Joan reflects that prior to the NYFAI she was "still very involved in what I now would call the 1950's handbook," that caused her to espouse certain "notions, preconceptions and long-held and, frankly, half-baked, sexist ideas and theories." Today she says of the NYFAI and the important changes it set in motion in her domestic and professional life, "It was a revolution." Her initial puzzlement at a 1972 sculpture by Nancy Azara drew her to the NYFAI to study:

> I recall being both totally puzzled and blown away because it was sculpture—but it didn't have any of the qualities I had associated with sculpture. It was a good size, over life-size, and it took up a lot of floor space, but it wasn't one solid, tall, monolithic anything. It was lots of little pieces, different colors, pegged together with wooden pins. She later told me it was a self-portrait and a metaphor for the female condition, struggling to get up off the floor, struggling to put things together to make a bigger thing. In 1972, I hadn't yet read the "new feminist handbook" to know that it was okay to do that, but I couldn't articulate this at that time. However, I could see and feel that it worked.

At the NYFAI, many women developed their feminist consciousnesses as they began to sift through former values and adopt more enabling priorities. Judith Chiti articulates this process of unlearning culture in the curatorial statement for the *Transformations* art exhibition the NYFAI organized in 1981, saying, "the feminist movement of the past altered more than the artist's consciousness; it altered her unconsciousness, her process of receiving and selecting the significant." This show, held in the New York City Coliseum exhibition space, featured the work of thirty-nine women artists from the institute and included paintings, prints, performance, sculpture, and drawings that all embodied this sense of a new personal feminist perspective. As a composite, the *Transformations* exhibition generated a visual narrative timeline. Pieces were separated into what were at the time three broad periods: early 1970s, mid-1970s, and late 1970s/early 1980s. The first group used methods and materials such as fabrics, fibers, glitter, and hair traditionally associated with women's work that were refashioned as personal and historical metaphor. Early 1970s feminist artistic intentions embraced matriarchs, goddesses, queens, and oracles, and moved from linear and rational to circular, anthropomorphic, and natural concepts and values. Later works featured in the show began to question the existence of an intrinsic feminine or feminist art practice and moved

toward an expanded, less certain, but nonetheless empowering conception of womanhood, one which continued to depolarize the personal/political and enabled female artists to conceive of themselves as artists and individuals with a shared collective history.

In her piece, *Dialectic Triangulation: A Visual Philosophy* (1970), Agnes Denes reflected on the passage of time through her own symbolic system featuring precise, map-like technical designs. In her presentation *Streams of Consciousness*, urban shaman Donna Henes used ultraviolet light and fluorescent ribbon to circumvent conventional western medical models and revisit alternative forms of healing such as ritual, dance, and chanting. For the wall hanging piece *Wedding Portraits* (1977), Pat Lasch used photo compositions surrounded with cake-icing-like paint squeezed from a pastry pouch, a technique she learned from her family's bakery business. The show also included work by Ana Mendieta, who spoke as a NYFAI panelist on the intersections of art and spirituality, as well as some of Hannah Wilke's original late 1960s vaginal imagery. Wilke was involved with the NYFAI through speaking on panels, and taking on an apprentice from the Institute for a period. The *Transformations* show became a hallmark of what was truly a transformation in the educational processes that the school had started to introduce in so far as each piece acted as a forceful catalyst.

Establishing a healthy working rhythm between the NYFAI member's personal and professional aspirations for producing art collaboratively sometimes proved to be a delicate affair. Dena Muller, who conducted a portion of the NYFAI interviews and formerly served as director of A.I.R. Gallery in New York, a women-centered artist cooperative gallery established around the same time as the NYFAI, spoke to this matter during her interview with Melissa Meyer, "[T]he art world is structured around the individual artist being recognized for their individual talent, so collaborating in a group context can be especially complicated." Although the largely positive reflections of former NYFAI members have proven the NYFAI was a much needed source of inspiration for many, the conflicts the women spoke of demonstrate how feminist community is never an idyllic, conflict-free utopia.

Over the course of the interviews a number of women discussed some of the conflicts that arose between the NYFAI's members, some left unresolved. Elke Solomon spoke to the power struggle which developed between Nancy Azara and Miriam Schapiro, an instance she felt was "deleterious to everybody" and "deleterious to the school as well." Solomon also lamented her cohort's cursory deletion of abstract painting from the feminist visual economy: "Abstraction was seen as male. It's yet another dogmatic way of thinking or not thinking about something." In Joan Arbeiter's interview, both she and Dena Muller touch on the drawbacks of consensus-oriented feminist models of administration, Joan remarking, "It was too laborious," and Dena, "That circle business doesn't work, somebody has to be in charge." According to the Irene Peslikis Papers, held at the Special Collections Library at Duke University, Irene Peslikis, now deceased,

was voted off the institute's board of directors due to a conflict regarding the issue of racial integration, a decision which prompted the resignation of others. Phyllis Rosser, who worked for *Ms.* magazine at the time, recalls when a number of the younger women didn't want to have women of a certain age, including the institute's oldest student Helen Stockton, showing in the Ceres Gallery. She recognizes that it was co-founder Rhonda Schaller who said, "No, this is going to be for women of all ages," and remembers how subsequently, "All the young art students left." Currently, Rhonda Schaller owns and directs The Rhonda Schaller Studio, an art gallery, studio, and mentoring space in Manhattan's Chelsea district where she continues to curate feminist exhibitions for women of all ages.

Despite its flaws, the NYFAI seldom failed to provide a unique environment in which students, faculty and teachers might cultivate new methods of conflict resolution through a consensus-based model. NYFAI alumna Sandra Lara, a blue-collar worker and telephone supervisor, speaks to the way in which NYFAI "softened" her feminism and her way of approaching cooperative situations, "Working in a craft position with all men, in order to be seen and heard, [you had to] definitely elbow in . . . make yourself room, make yourself heard. They're not going to hear a gentle voice."

In "Our Journey to NYFAI" from *From Our Voices: Art Educators and Artists Speak Out About Lesbian, Gay, Bisexual and Transgendered Issues*, partners Nancy Azara and Darla Bjork affirm their experience at NYFAI as a critical period in terms of defining and accepting their sexual identity. For lesbians, NYFAI became an environment of emotional safety, a place where a homosexual female artist could, in the words of Darla Bjork, "feel comfortable for the first time." What resulted was an open dialogue between lesbian and straight women, each learning to listen and respect each other's differences, and channel these new awarenesses into their art. "We listened, we drew, we learned, we made art, and we healed," remembers Nancy.

Even so, another member Barbara Hammer felt that the NYFAI didn't explicitly make a focus of lesbian sexuality. Within a 1980s context Hammer's concern was somewhat radical, and in hindsight she observed very critically the absence of "classes about lesbian art-making, lesbian dreams, lesbian sexuality in art . . . all those things that are crucial . . . The lesbian part of me didn't feel celebrated in any form." She was also the only woman interviewed to bring up issues of class, saying, "We weren't aware of class the way we are today. Even if the board was diversified towards the end of the NYFAI experience, all of us were racist and classist, it's institutionalized in us." Although NYFAI members may have overlooked their own social and political privileges as largely white, middle-class, American women, what 1970s feminist art did do was plant seeds that created a larger platform for addressing various forms of oppression and how they are interrelated. Feminist identity politics in the United States have become a useful vocabulary for many individuals and groups.

The curriculum over the course of the NYFAI's ten-year lifespan involved a number of workshops and around eight to a dozen classes per semester, some held in industrial locations such as the old Port Authority bus terminal in Manhattan. Students were offered courses as diverse and special as Visual Diaries, Map Making, Life Patterns, and The Architecture of the Self: Models of Home, in addition to more conventional media-based courses on painting, sculpture, and art history. At the NYFAI, students focused on their whole selves, the goal was rarely painting the perfect image but rather reclaiming a particular sense of agency and ability in a culture which was critiqued for its masculine privilege. Miriam Schapiro expressed this in the interview she gave regarding her own experiences at the NYFAI:

> Feminism is when you know who you are and who you want to be, and you know how to speak and you know that you can speak well, people can understand what you are saying, and you know that you want to talk.

Helen Stockton, the institute's oldest student at the age of sixty-five in 1979, remarked that the NYFAI kept her from censoring herself, "Why make art unless making art for myself?" and she reflected that NYFAI gave her a much freeing "permission to be mediocre." Nancy Azara recalls the growth she saw many women go through in her popular visual diaries course, remembering how as the students opened up and explored core emotional issues in their visual diaries, often they would "begin to become more assertive in their personal life." At the NYFAI women refined their own sense of feminism through the development of a personal visual vocabulary and a new way of relating and operating in the world on their own terms. For many women who walked through its doors, the NYFAI was in this sense thoroughly therapeutic.

And yet as a holistic feminist training program the NYFAI offered much more than emotional catharsis. NYFAI students were hardly off the hook in terms of producing exceptional, quality work. Elke Solomon, who taught painting at the NYFAI, remarks of her teaching ethics:

> It became a very safe atmosphere, and a very permissive atmosphere, not-with-standing what a bitch I was. I'm really very tough. I don't like frou-frou. I don't believe in non-critical stuff, and I don't believe in people saying, "it's beautiful."

The NYFAI was further distinguished by the way it synthesized a West Coast approach to feminist art/processes, which made it comparable to feminist programs established a decade earlier at California State University, Fresno and California Institute of the Arts, but combined this with an East Coast approach to getting women into galleries. At the NYFAI, scant attention was paid to the importance of grades, credits, and similar gauges of academic success at an accredited

university; instead energy was redirected to assist women to show their work successfully in the public sphere. With the help of artist collective galleries such as A.I.R., Soho20 and Ceres Gallery, a non-profit gallery founded in 1984 by NYFAI members Darla Bjork, Rhonda Schaller, and Polly Lai that was housed right in the school's building, the NYFAI began to realize its vision of showcasing women's art to the public in legitimate gallery settings. "The very labeling of themselves and the exhibiting of their work—as women—was the beginning of a new feminist iconoclasm," remarks Judith Chiti in her statement for the *Transformations* catalog.

NYFAI had a two-way vision, on the one hand it connected its members back to their creativity and on the other it connected their creativity back to the public. Elke Solomon, who worked as an art historian and curator before coming to the NYFAI, remarked that, "NYFAI had to do with permission in making art." Women under NYFAI's roof felt free to do work that was not shaped by the expectations of male faculty, male students, or the suffocating presence of a purportedly *universal* artistic canon that had marginalized the contribution of women to art and culture. They were free of what Judith Chiti identified as "the sexist tradition of expectation, sensibility and scholarship" upheld by the art world and culture at large. Barbara Hammer adds that the real strength of the NYFAI was that, "It was where [the women] could feel that they were artists, and they could get validation for their art, rather than having to compete in the larger system which is male dominated." At the NYFAI, women developed a new relationship to their work in which they came to understand their creative expression as women as deeply meaningful.

Today, through gains achieved by renegade women artists in the 1970s, many women feel free to work alone and/or collaboratively with men and women, and they are able to earn greater recognition and in larger numbers than ever before. After the institute's disbanding, many of its members continued on in their art careers toward successful ends.

A considerable number of faculty, students, and affiliates of NYFAI, by now most well into their sixties and sometimes facing ageism, continue to make art, publish, and teach from a feminist perspective. Former NYFAI faculty member Louise Fishman shows her abstract oil paintings in New York City at the Cheim & Reid Gallery. Leila Daw, who was the only female faculty member in the fine arts department of Southern Illinois University in the 1970s, retired in 1990 and currently installs public sculpture in Massachusetts and Connecticut. Melissa Meyer, who shows at Elizabeth Harris in New York City, has been on the faculty of the School of Visual Arts in New York since 1993. Harmony Hammond, who in addition to serving as a faculty member of the NYFAI was a cofounder of *Heresies*, teaches at the University of Arizona and published *Lesbian Art in America: A Contemporary History* in 2002, a text that attempts to curtail the erasure of homosexual identity in the arts by exploring what it is to "see" and represent as a gendered, lesbian subject. Julia Cameron, whose spiritually based philosophy

for artists has gained extensive notoriety in *The Artist's Way* (1997), a book she co-authored, contributed to the NYFAI through a workshop on journaling, one of the foundational components of her creative philosophy.

Former faculty member Jewell Gomez, widely known for her novel *The Gilda Stories*, won the Lambda Book Award for Lesbian Fiction and Lesbian Science Fiction in 1992 and continues to write novels, poetry, and plays from her home in San Francisco. Faith Ringgold, who led a mask-making workshop at NYFAI and through her activist work played an instrumental role exposing art institutions that neglected the work of women and people of color in the 1960s and 1970s, shows her paintings and quilt-based works at ACA Gallery and has written and illustrated eleven children's books to date. Her most popular, *Tar Beach*, was the recipient of numerous awards including a Caldecott Honor. Elke Solomon currently teaches in the fine arts department of Parsons New School in New York and had her first Manhattan solo exhibition, *Body Talk*, at the A.I.R. Gallery in 1995. Agnes Denes, shortly after being featured in the NYFAI's *Transformations* exhibition, made a bold gesture in environmental art when she planted "Wheatfield," a two-acre field of wheat in a vacant lot in downtown Manhattan. The project, for which Denes aimed to comment on "human values and misplaced priorities," yielded 1,000 lbs. of wheat which would travel to twenty-eight cities worldwide. She has subsequently published four books, shown at the Museum of Modern Art, the Metropolitan Museum of Art, and the Whitney Museum in New York, and participated in three Venice Biennales. Founder Nancy Azara continues to sculpt, lecture, and give workshops and classes on using guided meditations in art, an issue she expands upon in *Spirit Taking Form: Making a Spiritual Practice of Making Art*, published in 2002.

Barbara Hammer, who taught a course on "Visualization of Personal Imagery with Videotape" at the NYFAI, is an internationally recognized herald of experimental lesbian-feminist cinema, most notably for her trilogy of documentary film essays on lesbian and gay history—*Nitrate Kisses* (1992), *Tender Fictions* (1995), and *History Lessons* (2000). She has participated in three Whitney Biennials and her films are part of the permanent film collections at the Museum of Modern Art in New York City, the Centre Georges Pompidou in Paris, the National Film Archives in Brussels, and the Donnell Library in New York City. Her video work remains firmly rooted in a bold feminist politic:

> I choose film and video as a medium to make the invisible, visible. Anyone can be left out of history. I am compelled to reveal and celebrate marginalized peoples whose stories have not been told. I want people to leave the theater with fresh perceptions and emboldened to take active and political stances for social change in a global environment.

Barbara Hammer's words here embody what is so deeply meaningful about the feminist legacy which was set in motion when the NYFAI was born during

such a crucial point in the history of women's art. The institute directed critical attention to hierarchical matrices of power through the nurturing of what these forces reduce, delete, and entrap in women artists.

At the NYFAI, women worked in a controlled, female-only safe space, unhindered by restrictive cultural forces as they freely contributed to American feminism's oeuvre. Two decades after the NYFAI closed its doors, we must address the task of recording the history of such a foundational institution. How might we utilize the teaching principles of an organization which, in its heyday, chose through strategic philosophical alliances to marginalize itself? What precautions must we take to ensure that the features of a 1970s feminist art curriculum won't be erased by the cultural record? This is a story about the education of women and a story about access. Considering the widespread achievement of NYFAI founding members, teachers, and students, surely the contemporary interest in feminist art is indebted to this prior group of transgressors. What we might choose to do is look at 1970s American feminism as both a movement and a critical point of germination in a much larger, still evolving global *feminist* polemic, one which surely has the power to endure.

15

OUR JOURNEY TO THE NEW YORK FEMINIST ART INSTITUTE

Nancy Azara and Darla Bjork

> What are our social conditions, our qualities of being female, and how do they influence our vision? How do our perceptions change the world and how does the world change our vision? Our challenge is to investigate our qualities of being woman and being human and affirm our investigations, through art, so that our voices might be heard and shared.
>
> —Adrienne Rich, *NYFAI Catalog*, 1979

The following is the co-authored memoir of Nancy Azara and Darla Bjork, both pioneering members of the feminist art movement in New York City in the 1970s. They relate what they, with a small group of like-minded women, set out to accomplish in building the first feminist art school on the East Coast. Through their own fond recollections they recount the evolution of the collectively-run New York Feminist Art Institute (NYFAI) amidst the spirited climate of women's consciousness-raising in the late 1960s and 1970s, as well as the personal breakthroughs, ideological shifts, and financial struggles they encountered along the way. An essential addition to the historical record of feminist art, their candid narrative provides inspiration and practical advice to all women who are interested in alternative art education or who dare to make political art.

Nancy

I come from a middle-class, southern Italian family in Bay Ridge, Brooklyn where I learned very early that anyone who deviated from the strict family structure was either labeled *nervous* and often kept hidden and isolated within the family, or "put away" in an institution rarely to be seen again. In my community it was essential to fit in and to adhere to the rules.

In this Italian-American community women were openly affectionate with each other but the idea of women being together to set up a household or to become partners was inconceivable. Women in that era were predestined to become housewives. That a girl might grow up to be a professional artist was never even considered. Being creative was encouraged, but only within the restrictions of home. Now, looking back, I can see that my mother had been conflicted over being a housewife and longed for a strong, independent life. I remember her talking to me from time to time about women who were different, "peculiar," she would say, a little "boyish" or "odd," referring to their wardrobe of men's jackets, and sometimes, trousers. Yet my mother herself often wore what she called "man-tailored" suits, like the ones she so admired in her beloved Joan Crawford movies of the 1940s. She never revealed how much she wanted to be as powerful and in control as the business executive that Crawford portrayed in those films.

In the late 1960s I began to attend art school at the Art Students League in New York City. I studied painting and sculpture. My sculpture instructor was extremely demeaning toward the women students, holding a special class just for the "ladies," where he would give demonstrations on how to make shapes and forms from donuts, hamburgers, and various culinary objects. Then he would go for lunch with the male students. I was horrified that we women were being limited to the domestic sphere.

Darla

I was born and raised in southern Minnesota in the 1940s and 1950s, where the word *lesbian* was never used openly, only whispered. The only references to homosexuality were words like queer or fag that were used in derogatory ways. I began to realize that somehow I was different from other girls in junior high school but attributed this difference to the fact that I was a tomboy, was left-handed and/or studied too hard. In my hometown there were no acknowledged gay or lesbian people when I was growing up and there may not be any even today.

I had decided to become a physician when I was a teenager but had no idea as to why I did this. Years later, in my own psychotherapy I realized that as a physician I might be able to understand why I was the way I was. Looking back, I now see that I chose to become a psychiatrist for the same unconscious reason.

In medical school during the 1960s there was a 10 percent quota for the number of women allowed in each class. The discrimination toward women was very strong, and I tried to survive by emulating the men. I felt isolated and knew no other lesbians. During medical school I began having anxiety attacks in part as a result of forbidden crushes. I went into therapy with a kindly male psychiatrist who assured me that I was not a homosexual—much to my relief! Up until the 1970s, homosexuality was considered a mental illness by the psychiatric

establishment. However, in spite of that psychiatrist's opinion, I continued to prefer to be with other women.

In 1965 I moved to New York City for my residency training and started having lesbian relationships in spite of the fact that the concept of *homosexual* as abnormal was reinforced even more by the conservative Freudian program that I was in. I entered psychoanalysis (four sessions a week for four years) in order to be cured. Of course that was impossible. Despite the efforts of my heterosexual male analyst, I continued to be conflicted over my identity. I still had no openly lesbian women as role models.

Gradually, attitudes in the psychiatric community became less rigid and moralistic. The stigma lessened further when the American Psychiatric Association voted to remove homosexuality as a diagnostic category in 1974. Homosexuality was no longer considered to be an illness, but the prejudice against my sexual "deviancy" remained in a more disguised manner as gays and lesbians continued to be treated as abnormal by most therapists.

Nancy

During the late 1960s, a close friend of mine was active in founding Redstockings, one of the first feminist consciousness-raising groups in America. She gave me regular progress reports, and her excitement was electrifying. She described consciousness-raising (CR),[1] a technique used to examine our status as women in the world. I became very curious, and when she invited me to participate in 1969, I joined one of the first CR groups. Meeting once a week to examine our lives in detail, our group was made up of eight women from different backgrounds and ages, all heterosexual except for one. When we discussed issues around the nature of gender, we gingerly touched upon the topic of women loving women, except for this very militant lesbian in the group, who quickly grew impatient with the rest of us. Meanwhile, this particular woman was fighting the National Organization of Women's (NOW) attempted purge of lesbians, whom they labeled the "lavender menace." NOW thought that being associated with lesbians would diminish the credibility of the organization in the eyes of the public. As our lesbian colleague shared her struggle, the rest of us began to learn about another level of discrimination, one of which we were largely unaware. It was the first time I had heard a lesbian talk so candidly about her life. I was moved by her struggle and was indignant about the discrimination she had suffered. She began to pique my curiosity as to exactly what kind of lifestyle this could be.

Redstockings was one of the major CR groups; there were three or four others. As a collective it began to train other women in the art of consciousness-raising. This led to more consciousness-raising groups, one important way the movement was branching out. We began to disrupt things. We did an action at the studio for the television show *Sesame Street*. Women would do sit-ins in the offices of television and print editors. One woman became a stockholder of the *NY Times*

and went and disrupted stockholders' meetings. We challenged the fact that we had to be "Miss" and "Mrs.," that a woman was always identified relative to her relationship with a man. Women like Arlene Raven started going to junk shops and looking for books on women's issues and lost or underrepresented female artists.

It was in this CR group that I first used the word *I* in conversation with a sense of my own power and the first time that I called myself a "woman." I was thirty years old. My change of attitude brought permission to be myself in a way that I had never known before. I examined the restrictions society had placed upon me because of my gender and the way that I had internalized them. I became in touch with my desire to be recognized, to achieve a place in the world, to give myself the permission to be who I wanted to be, to make and exhibit my art, to live in a loft with a wood-carving studio in it and to make the kind of home that I had always envisioned.

It was a very exciting time. Everything was being discussed, discovered, examined; from the very essence of our birth, to childhood, to the forms, colors, and shapes that we put on paper. We asked ourselves: what was male, what was female? Were there particularly relevant female images? At the time, most of us were convinced there was truly a women's aesthetic, and that we were going to discover this. A search for a unique female aesthetic was a philosophy shared among many women artists of the feminist movement. It was at that time that I began to examine my personal forms in the same way. I knew art was a language, but didn't truly know my personal forms because I had learned to erase them in art school. In the 1970s we were redefining the very essence of who we were; examining women's traditional ways of working, like quilts, and braided rugs. We discussed how those were important works just as paintings and sculptures were. "The Personal is Political," was a favorite mantra. We understood "personal" to mean the private, traditionally female domestic sphere, which was thereby undervalued and often belittled by male patriarchal culture. We began to give value to and acknowledge the relevance of our daily activities, and their relationship with our artwork.

I was married at the time so I had a lot of dialogue with my husband, a Mexican-American man. He and some of the other men from our group (husbands and boyfriends) started a men's group. My husband pointed out that the men in his group would challenge each other a lot. We women rarely did this . . . and if we did it was really heart wrenching. In those brief, lucid moments my husband and I could begin to talk about equality. He would talk about the male sense of entitlement, the unabashed listing of accomplishments. I began to understand personal power in a way that I didn't quite see or appreciate before. Some of the women were more comfortable than I with this idea of personal power. At the same time, in general, most women were so constrained by social factors—not having their own studios, forced to work in the bedroom or the

kitchen. If they were married to a male artist they had a corner of his studio. This affected both the quality of their work and their ability to value their own creative production.

In a subsequent CR group, one that was predominately composed of artists and art related professionals, it came to me to try to draw while others were speaking, eventually making what I called "visual diaries"—a record or journal of what we were saying in a visual format. I made book after book, trying to capture what was said each evening. It was an unsuccessful project in that I discovered what I was trying to record could not be translated. As I made these drawings, original forms belonging only to me would surface. In fact I noticed that these same forms, such as scratchy marks, repeated ovals, and long angles, kept returning again and again even after I had erased them as not "good enough." Eventually I came to treasure them, realizing they had emotional import, an expression in shapes and colors of the internal dialogue that was occurring. Eventually, I accepted this process as natural and normal. It became so normal that I began to think of ways to share it with others, not only so that they could adapt it to their process, but also because I was interested in whether it would be as natural for them as it was for me.

Darla

Because I had been so immersed in medical school and my psychiatric studies, I was unaware of many world events until the mid-1970s. By talking with friends who introduced me to feminist books, I slowly became aware of the emerging women's movement. As a result, I finally saw the problem with the use of the universal *he*. As I began to use *she*, I stopped seeing myself as different from other women and began affirming that all women have the potential for equal status in this world. I was now able to view women with respect and appreciation, not in the least my mother, whose intelligence rose rapidly in my mind as I gained insight as to why her life choices had been so limited and narrow. My mother loved art in high school but never even considered going on to college or art school.

A major transition for me came in 1977 when I finally realized that there could be something in my life besides medicine. I had always thought about making art but never allowed myself this "luxury." A friend at the hospital where I was working encouraged me to take an art course at the Brooklyn Museum School. The course description only listed the faculty by last name, so I assumed that the sculpture course I signed up for was going to be with a Japanese man (Azara was close to Azuma in my Midwestern mind and I was still in the "all professionals are men" mode). My whole life changed when I walked into that classroom and met Nancy in her pink work overalls and wild 1970s hairdo. It was love at first sight but it took me two very long years to convince Nancy that we could be more than just friends.

Nancy

I was recently separated with a young daughter after a ten-year marriage when I met Darla Bjork in a sculpture workshop at the Brooklyn Museum School. That was 1977. We easily became friends and as Darla shared her background with me, I slowly became aware of how different our lives had been. In truth I had been comfortable and secure in my life as a heterosexual woman; my disappointment in my marriage was the result of that particular relationship, not a sexual-identity issue. It was a big leap for me to understand the isolation and loneliness Darla had experienced in her life as a lesbian in the 1950s and 1960s.

During that time in the mid-1970s, I had become a member of a small collective of women artists who felt the need for an art school on the East Coast that approached the visual arts from a feminist perspective. By the time Darla and I met, I had been working on founding and organizing NYFAI for about a year. Our group needed much help to realize such an immense project as a feminist art school, and I recruited Darla, who was Chief of Service at a state psychiatric hospital. She helped me understand some of the dynamics of the faculty and student interactions and became an active member on the board. As we worked on the development of NYFAI, our friendship deepened. Together we took workshops, explored spiritual issues, and studied Tibetan Buddhism and shamanism. While I recognized her romantic interest in me, I had every expectation that our connection would remain conventional. I just didn't want to spoil a good relationship by having a lesbian "fling." Darla, however, disagreed.

I was completely immersed in making the school a reality. I remember roping Darla into driving me around as I plastered posters for the Institute all over New York City. Darla would get hysterical because she was a practicing physician, but fortunately she was a psychiatrist so I would say to her, "just tell them I'm your patient." We'd take huge stacks of fliers to 420 W. Broadway, a building which at the time housed most of the major galleries. We'd set up a table outside and hand fliers to everybody that walked by. One of the major problems of doing an alternative organization is obviously issues with funding, and without money you can't advertise. Women would often say, "Where have you been? This is what I've been looking for, for years." We didn't have enough money to advertise on the radio and I think if we had, the school would have struggled much less.

Our group expanded, and in 1979 NYFAI opened with a benefit in honor of sculptor Louise Nevelson. Harriet Lyons, who worked at *Ms.* magazine, was hugely helpful in obtaining the support of Louise and many other important figures she was connected to through the magazine. She was also able to get NYFAI a free ad in *Ms.*, which ran for a number of years.

Our brochure invited women to expand their awareness, connect, learn, and create. Participants were encouraged to find their own unique voice in a supportive, non-judgmental atmosphere, consider the idea of a women's aesthetic

and explore the concept "The Personal is Political." Our school offered classes, workshops, and special events, including painting, drawing, papermaking, art history and criticism, and later poetry and filmmaking. I was elated to see my inner dreams manifested in the school, and I felt like I had come home.

Darla

When Nancy recruited me to help with NYFAI, I naturally agreed to do all kinds of things that I had never dreamed of doing, such as driving around putting up posters surreptitiously to advertise the school or sitting at a table in Soho handing out brochures. Since there was very little funding available for a school like NYFAI, many volunteers were needed to do these kinds of tasks, and I became one of them. After being an administrator in a hospital, some of the policies of NYFAI felt very foreign and, at times, tedious. Coming from a hospital with a very traditional bureaucratic hierarchy, when I walked into NYFAI I thought, what are these women trying to do? I have to acknowledge that working as a physician I had adapted to the male role very successfully, meanwhile cutting off the aspects of myself that were inherently feminine. NYFAI helped me create more of a balance, and yet I felt that the consensus-based decision model and non-hierarchical administration were ultimately ineffective. Huge lapses of time were lost in staff meetings as women couldn't come to a total agreement and preferred to discuss esoteric philosophy, meanwhile, somebody had to see that the school and its many students, teachers, and year-round programming functioned.

At the same time, for many years I had longed to be in an environment with openly lesbian students and instructors and found that studying painting with teachers such as Harmony Hammond and Louise Fishman provided me with a stimulating environment—one where I felt comfortable as a lesbian in public for the first time. At NYFAI, I no longer had to worry about how others would judge me for being a lesbian. I was able to focus all of my energy on becoming an artist. Louise was a wonderful teacher, very meticulous and obsessive. She started with a very basic set: how to stretch canvas. For several classes I felt like I was just mixing mud until one day I did this abstract thing. Suddenly in the corner of the canvas a landscape emerged. It was then that I saw one could do something magical with paint, and I was hooked.

At the Institute I was exposed to a faculty of women artists who were showing their work in New York City galleries. They took me seriously and helped me realize that I too could become a "real" artist. Without their support I would have floundered for much longer, or only seen myself as just an amateur painter, one who might paint on Sundays, or once in a while. NYFAI really helped me to feel the seriousness of my art. This is exactly why the feminist aspect of it was so very critical. It helped us as women to finally value what we did; to see what we produced as meaningful.

Nancy

The creation of the Institute was the fulfillment of many years of searching for a way to work in a community with other like-minded women, a way to dissolve the barriers that forced women to make art in a vacuum. It wasn't easy though. Other than the general camaraderie we shared as women artists with a unified goal, very few of us had prior school administrative experience, and our naïveté often left us overworked and disappointed in one another. Amongst Darla and my other colleagues, we have since evolved beyond the consensus-based decision model, and many groups structure their progressive organizations in much the same way that men run their corporations.

I know that when Miriam Schapiro and Judy Chicago visited New York City in the early 1970s, they were very disappointed because the women in New York weren't into collaboration as much as they had hoped. We met at Marcia Tucker's place, where we had much dialogue. They told us about the exciting things they were doing in California. As the feminist art movement grew we developed a network that spanned two coasts. Later, Darla and I were very involved with other feminist art projects happening in and outside of New York City. I attended a few of Gloria Orenstein's New York salons, and both Darla and I went to those of Erica Duncan when Gloria moved to California. Various other women's art groups became involved with NYFAI, including the three feminist collective galleries at the time, A.I.R., Soho20, and our own Ceres. Several women who were involved with the magazine *Heresies*, including Joan Snyder, Louise Fishman, Elke Solomon, and Lucy Lippard, contributed to NYFAI in some way. We attended Guerilla Girl events and honored the group at one of NYFAI's many open houses. When I was later teaching in Big Sur, Darla and I stayed at the home of Susan King, then the director of the Los Angeles Woman's Building, with whom we had much important dialogue.

Prior to the network created by feminist art, women artists faced a heightened sense of isolation because they did not have access to the exclusionary interchange of male artists that usually took place in bars, an environment in which females were sexualized or excluded. Women couldn't really go make chit chat at bars about their art like the men, and we dearly needed a place to congregate. NYFAI gave us a place of our own where we could share each phase of the art making process.

Because of the media's association of feminism and lesbianism, many women who enrolled often thought that the school was a lesbian school, even though only 30 percent of the students and 50 percent of faculty were lesbians. Straight women later told us they felt frightened of the school before they arrived, and they thought they would be intimidated by so many gay women. The gay women tended to enroll more easily but said that they were cautious because they were used to being judged and disparaged for their lifestyle.

Issues of race also surfaced as a point of contention, as women of color pointed out that the women's art movement generally focused on the needs of female artists who were white and privileged. As an organization we addressed this issue by getting a number of women of color to serve on our board. We were able to do workshops with women of color teaching and attending, and honored a number of women of color at our open houses.

Nancy on the Visual Diaries

The Institute gave me a chance to bring the visual diaries that I had been making to other women in a workshop format. The group ranged from twelve to fifteen students. We talked about the meaning of talent, our personal goals and expectations for ourselves, our relationships with our mothers and siblings, our childhood and school experiences, our lack of role models, and the trauma women experienced at traditional art schools. Each woman kept a visual diary of her personal vision and inner life and would draw in her book while other women spoke. It was a fairly standard process—the same one that we had been using in our women's groups—and the participants' drawings confirmed what I had found myself. One of the rules of the class was that each participant was to treat her drawings as if they were a written diary. They were not for publication or display, but her own personal visions, a very personal diary of her inner life.

It was thrilling to be a part of my students' discovery. I could literally watch people change in their process, many returning to art after years of being stuck, others shifting gears and making images which came more truly from themselves. We drew and made collages, built up pages in our books and made substantial and powerful diaries. We showed only sections of them if we chose to in exhibitions at NYFAI, tying off the other pages with ribbon, or clipping them together, to keep private what was not ready to be revealed.

The visual diaries workshop gave the straight and gay women an opportunity to be together and make art from their experience as they shared. We listened, we drew, we learned, we made art, and we healed. Some women took appointment books and drew on the days and weeks, putting the mundane part of their lives into a broader context. Others made scrolls the length and width of their bodies, creating imprints of their hands and feet adorned with writing. Some used everyday objects such as cardboard boxes or candy wrappers to make collages. Women wrote with words in patterns, circles, and squares or made book quilts with fabric and yarn. It was thrilling to see their connections between language—the evening's topic of discussion–and the imagery it ignited for them.

Darla

Some things still felt challenging and new, for instance I will never forget Judy Chicago's workshop at NYFAI in which she gathered information for her

Birthing Project. It garnered various mixed reviews from its participants. I had not encountered any consciousness-raising groups until I enrolled at the Institute and participated in the visual diaries workshops. I liked the group dynamic of the visual diaries course as well as the psychological interplay that occurred between those involved. Coming from a background in psychiatry, it was nice for me to participate on a peer level, as just another painter, another art student. I found that if I drew while other women were talking about their lives, I was able to shift my focus away from what I was drawing and myself. As a result I discovered a marvelous connection between color, image, and mood. This profoundly affected my art making and also my work with patients.

In time I developed some of my own workshops, each with its own psychological slant. Seeing the way that the non-threatening and healing atmosphere of Nancy's visual diaries course allowed women to discuss openly their secret and often painful core issues led me to develop a couple of Saturday discussion workshops, including *Menopause, Truth or Myth? Women's Self-Esteem and Sanity* and *Separation, Loss and Anxiety*. I wanted to try to address some of the problematic practices I perceived working in the medical profession, for instance the way women who were depressed in the 1960s could easily get misdiagnosed and institutionalized.

In 1984 the school moved from the Port Authority building on Spring St. to a new building on Franklin St. that a small group of us were able to purchase. This was of great significance financially to the school at the time because our rent went from a couple of thousand dollars a month to zero. Shortly thereafter Nancy, myself, Rhonda Schaller, and Polly Lai came up with the idea to use the first floor of the Franklin St. building for a collective gallery, which we called Ceres. We renovated the place ourselves. Helen Stockton, our oldest participant at age 65, and I took up sledgehammers and knocked down an old plaster wall, which took us forever. The rent that Ceres Gallery paid helped offset the financial burden I had in buying the building. We had some major group shows, and some unjuried shows that were open to all the students of the school. One show included a piece by Louise Bourgeois; it was for sale for five hundred dollars. Some of the more established women artists like Louise we knew wouldn't have wasted their time in just any gallery but they valued what we were doing and were there to support us.

Nancy

The Institute changed my artwork. My sculpture in particular evolved. I began to think about the idea of a female god and develop a new language in my work. I completed *About the Goddess Kali* (1979), *Goddess Wall* (1991), and *Great Coat* (1996)—works that at their core were about "women-identified women." As I found direction and voice from the female within, these ideas became the wellspring for my art. I have gone on to create *Passages* (1999), *Heart Wall* (2000),

Changes (2006), and *Two Red Spirals with Silver* (2009). Each work consists of carved and painted wood (see Plate 11)

Nancy and Darla

The Institute was open for ten years but closed in 1990 after a long struggle with funding. Here and there we received some help, including a grant from the Ford Foundation, and much appreciated support from Tony Korner, the publisher of *Artforum.* Tony sponsored and helped fund a benefit we had at Cooper Union. He did things like get us free champagne and throw a pre-benefit party at his house. He was one of the few men who worked closely with us to make NYFAI a reality.

In general, funding was hard to come by because the school was either too political for foundations interested in supporting the arts or not political enough for foundations interested in supporting political organizations. When it got to the point that we could barely pay instructors, we even tried changing our name to "NYFAI/Women's Center for Learning," thinking that maybe if the "feminist" part were less obvious we might attract more conservative money. Needless to say, we fell between the cracks. That same year we were audited by the Internal Revenue Service in such a punitive manner that it interfered with the rudimentary operations of the school. The IRS consultant spent weeks in our small office scrutinizing our books and interrogating our employees, which drained our meager resources and affected the performance of our staff so much so that we were unable to withstand this onslaught.

We still miss the NYFAI community but of necessity we shifted our focus and immersed ourselves in our work in new ways. Nancy returned to making the assembled, wood-carved large sculptures that she had been making in the 1970s. Darla started to experiment with painting on glass and began some larger paintings dealing with the pain of the people she worked with in mental hospitals.

We were deeply saddened by the closing of the school but reflect on its success and mission.[2] Looking back, I think most of us thought at the time that we would break through, the way feminist art has done halfway now. We really thought feminism had the power to make a major change in the world and that the art world would shift, or at least stand up and take notice, which didn't exactly happen. It's complicated, because on the one hand you want to be recognized, but on the other hand if you're recognized for work that's not important or valuable to you personally, what's the point? You always have to compromise something in life, but you compromise too much when you make "acceptable" work, which even so is much easier said than done. The Institute gave many women the opportunity to find themselves as artists, to become more confident in their work and to examine their art in a new way. Lesbian artists in particular developed the ability to be open about their visions that had for so long been silenced. Even if the art world didn't move to meet us, the shifts we experienced as women working

together collaboratively, creatively, empowering each other and evolving together—were well worth our efforts.

Making a Visual Diary by Nancy Azara

You can make a visual diary in a similar manner to the one that I use. Try to make a habit out of it so that it becomes a part of your daily life. This way you and your art have an ongoing relationship with each other.

Keeping a Visual Diary

Buy a bound blank book.
Keep a book with you.
Keep it open at home with your crayons and pencils next to it.
Bring it with you when you are not at home or have a separate one in your pocket or purse to take with you.

Try not to write in your book at first, so that you can train yourself to use a visual format rather than falling back into the verbal.
Store it as you would any personal diary. If you think of it that way, you will be able to give yourself more freedom.

Bound books are best because you are less likely to tear out the pages. Don't erase what you make. If you don't like it, turn the page and make a new one.

Just begin to work on the page and see where it takes you.
Try not to think about it or judge what you are making.

Begin to keep a record of your activities for a day and then the next and so on, but be gentle with yourself.
Draw your life day to day.
If you miss a day (or a week) just continue when you are able.

Draw, collage, or paint in it when you are so inclined to.
Be free and open. Be spontaneous.
Make marks in it.
Paint masks in it.
Draw cubes and squares in it.
Make a special code for yourself in it.
Or a secret language in it.

Express onto the page whatever comes up.

Do it as automatically as you can, without thinking or planning.

Especially try to record your experiences, keeping in mind that the translation of visual information is not the same as words.

Draw what you feel, what you think, what you see.

Draw what you would like to know.

Draw your friends, family, not just what they look like, but perhaps symbols of what they feel like.

Improvise.

Draw the things that you don't like.

Collect different things.

Put a leaf in your book.
Draw a bird wing in your book.
Trace your hand in your book.
Trace your feet.
Draw everything.

Make a page that is a special gift to yourself.
Make believe you are a child and that you are excited about describing to your adult self your day,
or your party
or your time alone or with a friend.
You could ask yourself, "How would you divide your life up into what chapters and sections. What would you describe? Looking at your life as an overview, what would you include? What would you want to say about yourself in this book? What would you like to portray? What would you like to describe? How would you use color and shape for this?" Describe an ordinary day in your life.

You can also start a group and you can get together and talk about your life, even do CR if you like, and draw in your books.
If you meet once a week, take one meeting-time a month and discuss your visual diary with the rest of the group.

Remember you are not taking photographs. Try to describe the sense or essence of the experience, be it by using color, or pencil, or magazine photos.

Notes

Katie Cercone's editorial expertise was very much appreciated.

1 Consciousness-raising is a method of discussion used by women in the 1970s to understand how their lives were shaped. We would sit in a circle and talk about a particular topic, always using ourselves as the subject to describe it. We honored the use of the word I. Before this wave of feminism, women in particular used *we* or *one* to discuss themselves and others. Using *I* was considered impolite and self-important, which we were never to permit ourselves to be. This was the first time in my life that I remember saying, "I did this. I felt this. I thought this," and others would listen to me. We listened to each other without interrupting or fixing, just listening.
2 Art affects our imagination, presents us with new ideas, projects the individual into the world, and as a social force so challenges one-dimensionality and uniformity. NYFAI Catalog 1979.

SECTION III
Picturing: Transformation

16

HOW I BECAME A CHICANA FEMINIST ARTIST

Sylvia Savala

In 1970, Judy Chicago spearheaded an art program at Fresno State. It was a pilot program of sorts, but a paradigm shift in the making. And like many monumental changes, it began as an idea. In this case, courageous women were incorporating aspects of their daily lives, their politics, and their sexuality into an art form. They portrayed their angst, anger, heartbreak, joy, and creative sexual juices with paints, textiles, embroidery, quilting, and other traditional women's *past times* in shocking new ways. Why? Because many times they were *painting* their breasts, buttocks, and vaginas into art. But it wasn't just their body parts they celebrated; it was also about commemorating their womanly passages and in some cases, their wounds, and their dark secrets that had kept them in bondage since childhood.

Although they experienced and represented in their art emotions that many women shared, these women artists showed that creative self-expression was vital and healing and the vehicle upon which *voice* rides. Art is a potent outlet, a release, a steam valve for those who have suffered and experienced oppression, suppression, or "all of the above." Art does this for me.

The flood gates had opened to a new kind of warrior—the *feminist artist*.

When the Feminist Art Program began, I was a student at Fresno State. I had no idea that this movement was in the making. Instead, I was involved in on-campus demonstrations, sit-ins, and picketing for students' rights, Chicano rights, and La Huelga. I believe that for many Chicanas and African American women, fighting racism took precedence over feminism. But for many women of color, this community dynamic would serve as an impetus for future self-discovery and productivity. Mine would one day involve the visual arts, and later writing and poetry.

Childhood

In grammar school, I would find myself drawing figures during math and in science, and I particularly loved painting with watercolors during art period.

But art wasn't something that was encouraged at home. Dad, who had grown up poor during the Depression and who knew nothing of the arts, discouraged the idea of becoming an artist simply because "there's no money in it, you damn fool."

My women role models were not women who were in the arts; I had never heard of a woman artist, much less a Chicana artist. My role models were women who had initially worked in the fields picking cotton and grapes or cutting peaches and apricots to help support the family. It was when Mom married Dad that she became a stay-at-home mom. Nana ran a mom-and-pop store, and two of my aunts would later be first-generation college graduates who would teach at grammar schools.

I hadn't even been allowed to decide what I wanted to be when I grew up. When I was ten years old, Dad walked into the house, announcing he had a present for me. I thought it was a doll or maybe dishes. The blue and white china doll dishes were my favorite, and I always welcomed another set. But when I walked into the dining room, he pointed to a typewriter on the table and to the chair. I stood there and looked at it and obediently sat down in front of it when he commanded, "*Sientate.* Sylvia, you're to learn the keys on this typewriter within three months, and you had better know them, too, because someday you're going to be a legal secretary." I hadn't thought about what I wanted to be when I grew up, but it certainly wasn't a legal secretary.

I sat down in front of the typewriter. *But there are so many keys,* I thought. The key area of the Remington dipped low. The stems of the keys swooped up toward me like legs of a praying mantis coming out from an opening in a cave, and the keys looked like little feet at the edge of a trench. I looked down at the keys with letters, dots, numbers, and squiggly lines that meant nothing to me. I pressed hard to make one of the keys go down, taking all the cooperative effort of one hand to push down the "A" with my baby finger. My little finger sunk down low, only to begin the process all over again with another finger. I began to *peck myself away.*

My future had been determined. My family's Latino culture and values mandated that I obey, and I did. This was the 1950s, a far stretch from the 1970s that would someday foster women's liberation.

Adolescence

When I was fifteen, we moved from the little barrio of Pinedale to a prosperous suburb three or so miles south and two blocks from Bullard High School where I was one of six Chicanos and where maybe two African Americans were enrolled. I missed my friends and worst of all, I didn't fit in. It was clique after clique of bourgeois white people. Although it was painful, I was determined to muster up the courage to make friends and penetrate social barriers. This skill would later serve me to make the breakthroughs needed in the art world.

Dad's brother was in law school when I was in still in high school. He would remind me from time to time that I had a sure-job with my uncle and after all, I was going to be his soon-to-be-lawyer brother's secretary. It sounded OK, but it somehow felt that a lot of that had nothing to do with me. After high school, I enrolled at Fresno City College, even though I had expressed the desire to attend a school in the Bay Area. Nonetheless, I signed up for business classes.

While attending school in the late 1960s, I worked part-time for my uncle. I was a lousy legal secretary, maybe because I didn't like it. Perhaps it was because the job lacked creativity, or because it was a job of servitude. But at that time, nothing better came to mind.

I began looking at the books of students who were transferring to Fresno State. I was stunned when I realized that I was well capable of reading and digesting the texts. I now wanted a B.A.

When Dad came home from work, I announced that I was no longer going to work as a legal secretary and that I was transferring to Fresno State. He cussed me out and said that I was to continue working as a legal secretary. Although we had always lived prosperously because of his thriving plastering contractor's business, the country was in an economic recession, and he needed my help. I saw red I got so angry. I was the oldest child of four and felt I had already spent most of my life helping my parents with their kids. I was done. I didn't say anything in response, but I had made up mind. No one was going to stop me from getting my B.A.

My parents had already prevented me from attending a community college in the Bay Area. When I first told Mama about leaving to go away to school, she literally threw herself on the carpet and wailed, "*Ninguna hija mia va dejar la casa sin casarse in vestido y velo blanco en la iglesia Catolica! No quiero putas!*" Then she told Dad when he got home, and I heard about being a *puta* again if I left home before being married in the Catholic Church and in a white dress and veil.

"Ok, Ma," was all I said. Mama made it clear: I'd be a whore if I didn't marry as a virginal bride. But I had to have their blessings; I needed their approval, and it was important that I be a good role model to my younger two sisters. Tradition was important: tamales at Christmas, handmade tortillas at every meal, and a well-kept house where a woman stood by her man's side, and served his sexual whims whenever he demanded. I knew; the walls were thin.

Marriage

I met a nice young man at Fresno City College. We dated for a year, sans the sex, and a year later he left for Mexico City to study Spanish for a semester. I began sowing my wild oats, dancing, and having fun. When he returned, he asked me to marry him and asked my parents for my hand the old-fashioned way. Sadly I was over the relationship, but I didn't want to break his heart. I now felt obligated and married anyway. It was my only way out of the house.

And so I married in a white dress and veil in the Catholic Church—and as a virgin. That's what was expected of me; it was how I had been raised. Besides, I was willing to do just about anything my parents wanted just so that I could get the hell out of the house where Mama's booze permeated the walls, Mama and Dad fought over his infidelities, and my brother acted out his as yet undiagnosed schizophrenia.

Now I was off the hook, but I had gone from leaving one master to being with another. The marriage lasted two years. I walked away, but with a lot of guilt.

I was in my last semester at Fresno State and three units from graduating with a B.A. in Spanish when I dropped out of school. I rebelled. I was going to do things my way. I had only majored in Spanish because my counselor who chaired the Spanish Department talked me into it. It was just as well, I thought. I still didn't know what I wanted to do or be. I did some student teaching, but being in a classroom, teaching a subject for which I had no passion, sounded as boring and dry as being a legal secretary. And, because I had forgotten how to speak Spanish, I felt pretty dumb, especially since I was involved in so many Chicano activities. I already felt guilty not having had to pick grapes or live in poverty like so many of the Chicano students.

Bail Bondswoman and Bounty Hunter

In 1971, I was a divorcee and a college dropout. I was hired at Albert's Bail Bonds, initially as a bookkeeper. After working there for about a year, Albert, the owner and bail bondsman, asked if I wanted to work as a bail agent. I went for it.

The bail bonds world was colorful all in itself. On weekends, I wore a beeper and took bail calls late into the nights and early mornings. Many of the people I bailed out were the dregs of society; moreover, those dregs were pimps.

I thought about the girls I bailed out and felt compassion for them. How was it that these women could work late hours into the night only to give their money to a man? But, now that I look back, I worked on weekends bailing people out of jail in the wee hours of the night while my boss kicked back and made the big bucks.

I was also the investigator's sidekick, looking for people that had jumped bail. On one occasion, Grady and I went to hunt down a prostitute who had jumped a $10,000 bond. We flew to Alaska to get her.

I think I originally liked being a bail bondswoman because it was rare in those days for a woman to assume that role. It empowered me knowing that I was doing a man's job and that it paid more than a secretarial or bookkeeping position. But the glamour and liberation I experienced as a bail bondswoman was slowly dissipating. When I turned twenty-six years old, I began thinking of big girl stuff like retirement and returning to school.

Four years had passed, maybe five, since I had *bailed* from school. It was time to finish things and, besides, I wasn't feeling all that civilized as a bail bondswoman.

I worked all hours of the night, going in and out of the jail bailing out the rebellious segment of society, doing a job that didn't offer security or benefits. I had also come to realize that rebellion without a noble purpose paid few dividends, if any, in the real world.

Although at twenty-six years old, I had purchased a duplex in downtown Fresno a few blocks away from the office on my own, I still felt insecure and lacked self-confidence. There was no one whom I could depend on to help or take care of me. I needed a better job.

Garage

I worked with about five people at Albert's Bail Bonds. One day I overheard a co-worker tell one of the secretaries that his wife was studying oil painting. My ears perked up. I began thinking about art again and how much joy it gave me. I visualized myself wearing a big hat and painting at an easel by the lakeside. The idea of it was romantic and gratifying. I asked my co-worker where his wife was taking art lessons. He said that she was taking instruction from an artist who taught classes in her garage. The thought of attending an art class in an academic atmosphere terrified me. But because it was at someone's *home*, I felt safe and grounded. I knew I could manage *garage*.

The idea of drawing or painting in front of people was scary, too, but I made myself go to class. The instructor had us copy a photo of a vase and flowers. She'd paint stroke by stroke, and we'd imitate her. By the end of the first lesson, I had created a painting.

When I arrived home, I showed it to my roommate. She said, "You didn't paint that. You're lying." I assured her that I had. I went to my room and looked at my first painting in amazement. I didn't blame my roommate for doubting me. I could hardly believe it myself.

I took painting classes for over a year. I tired of the same subject matter, always painting mountains, seascapes, landscapes, and flowers from photographs. I disliked my paintings more and more. They reminded me of the paintings that I had seen in the cheap motels where the prostitutes stayed.

About that time, I began dating a young man from San Francisco who worked at the De Young Museum and who was very much involved in the Chicano mural projects and the art scene. He looked at my paintings and said, "You paint very well, and I admire your technique, but your subject matter has little meaningful content."

"Oh," I said, as I stared at my work, literally with my mouth open. But I understood his point. I was painting landscapes, seascapes, mountains, and flowers. I began to lose my zest for the paintings. They were lifeless; they communicated nothing, and they were boring. I was painting what had already been done; I was copying God's work. I wanted license.

I gained more self-confidence and enrolled in a figure drawing class at an adult school. This was a step up from *garage*. I loved people, and why not learn to draw people since I found them so fascinating and engaging? I fell in love with it. The idea of recreating the likeness of the human figure was magical. I had no idea, however, how challenging it would be. My figures were stick-like; they lacked proportion and movement. I'd leave class asking myself, will I ever be able to do this? And then I'd cry all the way home.

The Lawyer's Wife

As I approached thirty years of age, I began to think about children and marriage. I tired of the party scene, the flaky, player-boyfriends I dated, and the suffering that resulted from the volatile combination of my immaturity, vulnerability, loneliness, and naïveté.

One day while posting a bail bond at the courthouse, I met a law student who worked at the public defender's office. He resonated with the salt of the earth. Two years later, we married, and I became part of his Armenian-American family. My mother-in-law was overbearing and controlling, and embarrassed that her son was marrying a Mexican. When she made disparaging comments to me, I said nothing. I feared her and at times I even feared my husband. The marriage mirrored many of the dynamics with which I had grown up. I found myself retreating inward with each day, but I was determined to stay married.

During our marriage, my husband's law practice prospered. I spent my time in the home caring for my children, being involved with the Fresno Art Museum, and taking art lessons. Fifteen years and two children later, I found myself in another divorce and with a settlement that would give me the freedom to be a full-time artist.

Artist/Divorcee

When I was thirty-two, I joined the Friday Life Drawing Group held at the Fresno Art Museum. I also drew with many of the members of the Tuesday Watercolor Group who painted figures as well as traditional landscapes.

In 1986, an artist friend of mine who attended the Friday Group told me of an opening at an art gallery where she would be exhibiting. The name of the gallery was Gallery 25. Many of the artists who had studied under Judy Chicago and Joyce Aiken were members. I attended the reception and was impressed by the women's subject matter. I longed to be one of them, but I didn't feel I was good enough (on many levels) nor did I yet have anything to say.

While hanging out at the Fresno Art Museum in 1989, I read an announcement about a call for artists for an exhibition of *women's* art. I felt my chances of getting accepted were good since it was limited to women only. I asked a couple of artists who were at the art museum what I needed to do in order to submit

my work for an exhibition. I needed an artist's statement, bio, slides, and history of exhibitions. Well, I could take slides of my work and write a brief bio, but what would I say in my artist's statement? And, I certainly hadn't exhibited anywhere.

I, hopefully and naïvely, submitted slides of my work. My work was rejected. I soon learned that it was a feminist art exhibit; Judy Chicago and her students were displaying their work. This was the first time I had heard of feminist art work and my first visual introduction to feminist art *and content*.

Soon after, an acquaintance told me of a woman artist by the name of Frida Kahlo. She showed me the book with Frida's self-portrait on the cover. The only female artists I had studied and admired were white or Jewish: Georgia O'Keefe, Berthe Morisot, Jennifer Bartlett, Louise Nevelson, and Helen Frankenthaller to name a few. Frida Kahlo's father was a German-Jew and her mother was Mexican. I immediately zeroed in on the *Mexican*. I couldn't get to the bookstore fast enough.

Frida's blatant and graphic outpouring of emotions and expression of the love and heartbreak that she experienced with her philandering husband Diego Rivera were there for the world to see—on canvas. Frida spoke loud and clear to me— paint what you feel. I became mesmerized and empowered by her courageous spirit. The damned-up reservoir of festering emotions within me had at last found a passageway.

A Chicana Artist

In my forties, I felt my hormones surging. A lifetime of repressed sexuality surfaced. With therapy sessions and a desire for self-expression, I began to paint boldly. I painted nude women on the beach, sitting, praying, and reclining. One painting was of a woman lying on her back in brush strokes of cobalt and cerulean blue with intermittent strokes of red and orange swirling throughout on a white background. I named it *La Feminina Sensual* (1992). That was also the name of my solo exhibit which was held on the westside of Fresno at Centro Belles Arts in 1992. I was breaking the bonds of sexual suppression. My artist statement spoke of the importance of being comfortable with your own body and sexuality. I had found my voice.

From then on, I began doing works on feminine subject matter. The etching, *Our Lady of the Pots and Pans* (1993), evolved from my recognition of the time and energy sacrificed by women who maintain the family home.

This image of a woman on the cross, with pots and pans dangling where her arms are tied, and a mop leaning on the cross, clearly expressed my sentiments toward house cleaning. I was the eldest of my siblings. I was the one that helped Mama; I was the one that had sacrificed my childhood, cleaning and babysitting.

I began painting about things that were particular to women that I found perplexing and/or conflicting. For example, women wear high-heeled shoes to

look sexy and because the fashion industry dictates it. But the reality is that they hurt. So, why do we do wear them? From this thought process evolved my painting *Zapatos*. It's of a woman holding a pair of high heels. In the background is a foot with a bandaid and words saying, "Hay estos zapatos!" and "ouch!" High-heeled shoes became a metaphor for women's bondage to the fashion world. Over time, I discovered that I had the *cajones* to express the nitty-gritty of my life, which was at times darn right embarrassing. But I had to *paint it out of myself; it helped me move forward.*

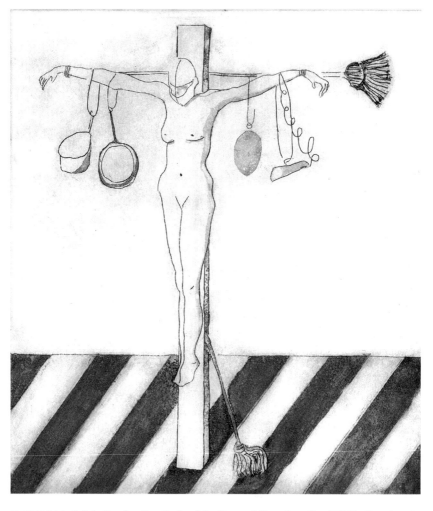

FIGURE 16.1 Sylvia Savala, *Our Lady of the Pots and Pans*, intaglio (1993). Reprinted with permission of the artist.

The Censored Artist

In 1996, I exhibited at Fresno City Hall. About three o'clock on the first day of the show's hanging and the day of the reception, the curator announced that people were complaining to the City Manager about the nudity in my paintings. They would have to come down, she said. I was enraged. *Our Lady of the Pots and Pans* was one of the etchings singled out. A pastel of two nude women would also have to be removed. I decided to call a friend of mine at the *Fresno Bee* and told her that my work was being censored and that they wanted to take several pieces down. A reporter came to talk to me and so did several television reporters who later came to my studio and interviewed me.

Then a panel was formed at City Hall to discuss censorship, and I was asked to talk about my art. Who would have ever thought that people would be reacting to the *content* of my work? I was flying high.

A Chicana Feminist Artist

In 1999, I served as a board member of Arte Americas, a Latino cultural arts center in Fresno founded in 1987. Part of their mission was to have artists on the board to review all applicants who desired to exhibit. For many years, I had volunteered my time at the Fresno Art Museum, whose staff and membership were predominantly if not all white. So, I was thrilled to know that I would now be contributing my time and talents to an organization that was focused on the Chicano community.

One afternoon two years later, I happened to stop by when the director asked if I could attend a meeting in her place. All the directors of the museums and galleries in town would be attending, and it was being held at Jackie Doumanian's house, who I was acquainted with and who I was to learn had been one of Joyce Aiken's first students.

I was delighted to discover that the meeting's purpose was to organize feminist art exhibits at various venues in Fresno and hold seminars at CSU Fresno in March, celebrating the thirtieth anniversary of the Feminist Art Program begun by Judy Chicago in Fresno. Some of the members of Gallery 25, which had been started by some of the *firsts*, were also in attendance. Needless to say, this meeting became the auspicious event where I would merge with my sister artists who were on the same path.

The committee decided that Judy Chicago would exhibit at the Phebe Conley Gallery at CSU Fresno, her students at the Fresno Art Museum, and the students of those students would exhibit at Gallery 25. I sat there thinking, I don't fit anywhere here. I want to be a part of this, but how and where? Think, I thought. Think of something! Then I blurted out, "How about having an exhibit of the feminist art of the new millennium? I'm sure Arte Americas would love to have the exhibit there." The group thought it was a great idea—I was in. And because I was hooked up at Arte Americas, I became curator *and* artist.

The day arrived when Judy Chicago came to Arte Americas to look at the exhibit. She was quite pleased. When she stood before my painting, *Birth Day* (1996), which had the heads of two infants coming out of a mother's vagina, she said, "I like your work. You should really paint large." It might as well have been God speaking to me.

Gallery 25

I admired my artist friend Phyllis's work. It was raw, primitive, and strong. She gallantly announced to me one day that she was going to apply for membership at Gallery 25. I was impressed by her bravery. I wanted so much to be part of the gallery. But I didn't have a degree in art, and what made me think that just because I was painting feminist art that they would include me?

When I saw Phyllis a week later, she was angry and despondent. They had rejected her work. They told her that her work was similar to that of student's work in a beginning figure drawing class. I didn't understand; Phyllis was the real thing. She drew her figures with varied strokes of charcoal that gave them strength and depth. They were powerful. I asked her how she had presented her work. "They were charcoals on newsprint," she said. And, she had not framed any of it. Couldn't the members have looked past the presentation? Couldn't they see her talent? Nonetheless, Phyllis was devastated.

When I saw her months later, she said that after she was rejected from Gallery 25, she felt she no longer had it in her to do her art. I was flabbergasted. If the gallery's rejection had impacted her to such a degree that she was abandoning her work, there would be no way in hell that I was going to apply for membership. I dared not put my art and my ego at risk, and I was not going to subject myself to that trauma and rejection. The stakes were too high.

A Piece of Cake

Around 2002, there was an article in *Vanity Fair* magazine about a group of high scale professional women in New York whose gatherings became labeled as *cake parties*, cake serving as a metaphor for the vagina. The Chippendale Dancers performed while they partied and socialized. The news of these parties became so widespread that they required larger venues. Women from all over wanted to attend. The Cake Club membership became international.

Even before I set the magazine down, an image came to mind of a woman sitting with her legs apart and a cake between her legs with a slice missing. In 2003, I painted that image and named it *Let Them Eat Cake*. The woman in the painting became the little girl within me, spreading her legs apart in rebellion from having to keep her knees touching while she sat (see Plate 12).

President of Gallery 25

In 2005, Gallery 25 expanded and needed more members. I received a phone call from member Nanette Maka Dearson asking me if I wanted to join Gallery 25. I still had to submit my work. But the painting *Let Them Eat Cake* gave me all the confidence in the world. The day arrived when I was voted in; I was so excited. My dream had come true; as a member, I was officially exhibiting with my sister artists in a feminist gallery.

A year later, I was voted in as president.

I was very impressed with the gallery. Many of the original members like Joy Johnson and Nancy Youdelman were still attending or would drop in at the meetings to make sure things were going well. I worked hard as president and made sure that the meetings ran smoothly and that everyone who worked on committees was acknowledged. When my term ended, I was pleasantly surprised with the compliments I received. To date, I have exhibited in several states throughout the United States, in Florence, Italy, and in Armenia in a Gallery 25 group exhibition where one of my paintings sold.

The Feminist Artist vs. the Woman Artist

Within the domain of art created by and involving the female, there lies a distinction between the woman artist and the feminist artist. The woman artist may explore the panorama of her emotions, focusing on the individual. But *what* makes a feminist artist and what is it at the bottom of the cauldron that fires up a woman to finally speak? The oppression and suppression that manifested in the passages of my life ignited a deep desire to find my voice. I believe this was also the case for other feminist artists. Yet for the feminist artist, there is also a pervasive sense of duty to express the desires and hardships of all women experiencing life as controlled by patriarchy. The feminist artist owes an obligation not solely to herself, but to her gender and, more importantly, future generations.

I define myself as a woman artist transformed into a feminist artist by the conditions of my life. As evidenced by my earlier work, I began by painting simple landscapes and drawing figures. Later, I used oils, acrylics, pastels, mixed media, printmaking, and intaglio to blatantly exhibit the hardships of a woman's ostensibly immutable disposition, making malleable that which was unrelenting and rigid.

A transmutation such as mine can be achieved through various methods and is not limited by education, social distinction, background, race, or color. The woman artist has strengths and suffers similar obstacles as the feminist artist, but expresses her plight in order to reach a different end. This statement is made without derision, but as a necessary distinction between two classes of artists. I, my sisters in arms, and those who follow in our footsteps dare to take the road less traveled by which I believe we will continue to make a difference.

A New Frontier

I continue to paint and look forward to exhibiting in New York at some point, but I now write, too. A new challenge has arisen. In 1990, I began to write poetry and essays, and perform Spoken Word at various venues in Fresno. I graduated with a Masters of Fine Art in Creative Writing at Fresno State (2007), and I'm embarking on a couple of book projects. One is an art book of my work, and another is a book project about the little town of Pinedale, a small community that lies on the outskirts of Fresno, California, and is the little barrio in which I grew up. When I think about these projects, they become immense in size, like Half Dome in Yosemite. It scares me to death—but I think I can do this.

17

SEARCHING FOR CATALYST AND EMPOWERMENT

The Asian American Women Artists Association, 1989–Present

Lydia Nakashima Degarrod

Chinita!! (Little China girl!!) *Hablas español Chinita?* (Do you speak Spanish little China girl?). As a child I often was asked this by strangers in the streets of Santiago who were oblivious to the fact that I was a native born Chilean like they were, that I was fluent in Spanish, and that I was of Japanese, not Chinese descent. I was a Nikkei Chirijin[1] in a country where Asians were rare. On the other hand, Japanese people in Chile treated me with either impatience for my lack of fluency in Japanese and lack of understanding of Japanese customs, or with a certain condescending attitude and pity for being of mixed blood, for not being wholly Japanese. Several decades later I was flooded with these memories and others related to the cultural dislocation that I experienced growing up while I worked on a project of the Asian American Women Artists Association, *A Place of Her Own.*[2] This project required each artist to create an installation answering the question: if you had a place of your own, what would it be? My place contained all the pathways inscribed at different times by the journeys of my grandparents, my father, and myself, and the historical events that caused us to move from faraway places and to become strangers in new lands. Working on this project surrounded by ten other Asian American artists at the San Francisco's De Young Museum of Art studio allowed me to reflect on my multiple identities, and specifically on being an Asian American woman artist.

In this chapter, I address the making of the evolving concept of the Asian American woman artist by examining how the Asian American Women Artists Association (AAWAA) contributes to its formation through programs and exhibits. Specifically, I examine two programs in which the artist members created artworks answering specific questions geared to make the artists reflect on their identities and their place in society and in art. I argue that these reflections become important in the creation of a shared Asian American female heritage and in the

building of a group identity because, like the Asian American population at large, AAWAA is composed of cultural groups whose main denominator is racial.

I will start with one of the many journeys that transformed me into becoming an Asian American, the one I experienced by moving from Chile to the United States and the identity labeling that ensued. This is followed by a history of the concept of Asian American and the problems associated with the use of this concept in the arts. Then I present the history of AAWAA and the group's ideological background, and examine the programs sponsored by AAWAA as tools to create spaces for the reflection and creation of images that form part of a pan-Asian American women's art consciousness. I also consider the images of Asian American women and art, based upon interviews I conducted with twelve members of the organization.[3] I conclude with a reflection on my own consciousness as an Asian American artist.

My Beginning

My journey starts in Chile long before I acquired a pan-Asian American women's consciousness. I was born and raised in Chile as the child of a mixed race family of Japanese and European Chilean lineage. I grew up with two confusing and at times conflicting identities. I was labeled a foreigner, an Asian (commonly a Chinese) by most Chileans, and labeled by the few Japanese living in Chile as being of a dubious category because of my mixed race. The ignorance displayed toward my ethnicity was in great part due to the almost complete lack of Asians in Chile. During my childhood, Chile was largely racially homogenous, the majority of the inhabitants being mestizos, a mixture of Indian and Spanish. The rest of the country consisted of two minorities: white Europeans and Mapuche Indians, located at opposite ends of the scale of wealth and social status. White Europeans were the wealthiest and were at the top of society. The Mapuche were the poorest and at the bottom in the social strata. My family belonged to the professional class, and thus I grew up and went to school with European looking children.[4] Asians—especially racially mixed Asians—were a complete oddity in Chile during my childhood and adolescence. The few Japanese residents in Chile were either members of the Japanese embassy or executives of a few Japanese companies. In either case, their stay in the country was time limited.[5]

The misunderstandings I regularly encountered created a desire to stress my individuality and I corrected people about their ignorance as often as I could. "No, I am not Chinese, I am of Japanese descent," I used to tell people. I didn't have any negative feelings towards Chinese people, but I was irritated by the error. "Yes, I speak Spanish," I would say when my sister and I were surrounded by a group of curious people in the street. "They are so cute!" was another typical comment. I remember clutching my sister's hand and wanting to escape this attention. My mother would politely bow to them and grab our hands to sidestep the crowd. Among Chileans, the emphasis was on our Asian looks and our

perceived foreignness. At the Japanese embassy where my mother would take us to cultural events, the emphasis was on our non-Japanese characteristics. "How come you don't you speak the Japanese language?" I would be asked by a kimono-clad lady serving beautiful Japanese candies to me. "I am only half Japanese," I would mumble as I ate the sweets.

My disoriented sense of cultural identity changed when I came to the United States as a young person. While in Chile, I lacked a cultural group with which I could identify. Coming to the United States meant facing an ascribed membership in two different ethnic groups: Asian American and Latin American or Hispano American. Being ascribed memberships in ethnic groups is the normal fate of people who do not fit culturally and racially with the dominant sector of the country.[6] While each ethnic category comprises a large number of countries, cultures, and languages, the Hispanic category appears more homogeneous in comparison to the Asian category in that the former is united by a common dominant language whereas the latter has been created by uniting members whose only shared characteristic is race. As an Asian American I have been ascribed a category that unites me with people of countries and cultures of which I have little knowledge or which historically have been the enemies of my Japanese ancestors. How does one create solidarity and establish a common identity with people from such a diverse background? Similarly, is the concept of Asian American art adequate for examining the art created by people in America of Asian descent? I have become more acutely aware of these questions since joining the AAWAA organization eight years ago.[7] I will address these questions by examining the evolution of the concept of Asian American and the problems that scholars and activists face when using the term to understand Asian American art and/or to mobilize Asian Americans.

History of the Asian American Concept and Pan-Asian Consciousness

The concept of Asian American identity and its implication of an Asian American consciousness are problematic primarily due to the migration patterns of Asians to the United States, and the relatively recent history of the concept. The migratory pattern of Asians to the United States has created, from the early 1970s to the present, a changing population of immigrants who are separated by languages and cultures, and by their length of stay in the United States. Since the late nineteenth century through the mid-twentieth century, the majority of immigrants to the United States were from Japan, China, and the Philippines, with their numbers controlled by the strict immigration rules enacted specifically to apply to Asians. This changed dramatically in 1965 when the quota limits were lifted. Not only did the numbers of immigrants increase, but the scope of the countries of emigration broadened. Hence after 1965, the Asian American population changed from being primarily formed by Japanese, Chinese, and

Filipinos to its present composition of twenty unrelated cultural and linguistic groups from different Asian countries. The largest number of Asian Americans is from China, followed in decreasing order by the Philippines, India, Vietnam, Korea, Japan, Cambodia, Pakistan, Laos, Thailand, Indonesia, and Malaysia. Furthermore, the rate of migration has increased exponentially since 1965, producing a high ratio of recent immigrants relative to those born in the United States.[8] Yen Le Espiritu, a sociologist who has studied the creation of pan-ethnicity among Asian Americans, finds that the heterogeneity and the changing nature of the Asian American population defies sociological interpretations and generalizations.[9] Other scholars and activists who agree with Espiritu go further and state that the lack of a common culture with its identifiable symbols of ethnicity among Asian Americans is not conducive for the creation of a common Asian consciousness.[10]

The history of the concept Asian American is rather recent. While Asians in America have experienced over a century of prejudice and discrimination based on race, a pan-Asian consciousness was only created in the late 1960s and early 1970s by young Asian American activists as part of the political activities opposing the Vietnam War and racism in the United States. This activism was modeled after the Black, Chicano/a, and Native American Movements, and mobilized Asian Americans around the notion of a common race and a shared experience of the racial prejudices they endured. Asian American activists used the term "Asian American" as a reaction against the terms then ordinarily used, "Oriental" and "Mongoloid," with their racist and European colonialist associations, and the racist policies and discrimination that identified them as one racial group without regard to the diversity of their histories and cultures. Prior to the 1960s, Asians in the United States had only united on a few occasions; within the labor movement, for example in Hawaii in the 1930s, Japanese Americans and Filipino Americans united in a strike. Their unity was primarily motivated by class issues rather than race. As explained by Yen Le Espiritu, Asians saw themselves as belonging to their own cultural groups and at times acted against each other. For example, Japanese opposed Chinese during the period of the anti-Chinese laws in the early part of the twentieth century, and Chinese and Koreans opposed the Japanese during World War II. Since the 1960s, Asian Americans joined together at times when violence was committed against members of their group. For example, in 1982 when Chinese American Vincent Chin was murdered because his assailants thought he was Japanese, Asian Americans expressed their outrage and demanded justice. However, though the Asian American concept has become institutionalized by professionals, community groups, and government agencies, pan-Asian consciousness has been questioned.[11]

What has been the role of Asian American women in the rise of pan-Asian consciousness? Asian American women were involved from the beginning in the creation of the Asian American movement, but grew frustrated by the sexism

exhibited by their male partners. Influenced by the progressive ideology of the women's movement of the late 1960s, they formed separate groups to discuss their feminist concerns. They felt alienated from the early white women's organizations because of their lack of concern with race and class issues, so they often aligned with other Third World feminists.[12]

The framework established by the politics of the 1960s and 1970s about Asian Americans continues to influence Asian American artists and their art. A legacy for art practitioners, curators, and art historians has been the use of the category of race to exhibit, write about, and to examine the artistic practice of Asian American artists.[13] In this practice, race is the prime category followed by ethnicity and then gender.

Art historians have found that using the category of race in defining Asian American art is limiting and problematic. Elaine Kim finds the term Asian American art inadequate in that it groups artists in terms only of their racialized ethnicity. Curators therefore see only racial issues, and miss the complexity of other issues addressed by Asian American artists. Karen Higa makes the strongest critique of the term "Asian American woman artist" saying that it is both too specific and too broad, thus making it ambiguous.[14] A category such as Asian American woman artist, which relies on context for its meaning, could be used equally to affirm or to marginalize differences.[15] Valerie Matsumoto agrees with Higa in that the category glosses over the individual biographies of the artists, and doesn't take into account two major areas of difference among Asian American women artists: class and generation number in the United States. In addition there is the problem of differing political perspectives, and a differing sense of cultural heritage and identity.

Though the term Asian American in itself has limited the discourse about and exhibition of Asian American women's art, groups like the Asian American Women Artists Association actively work to correct this concept by creating a pan-Asian American women's consciousness, and by mobilizing Asian American women artists to end their invisibility in the contemporary art world. By examining the ways AAWAA has created this reflection on identity among Asian American women artists, I analyze the term not as static, but as it changes according to the individual circumstances of the artist. In other words, through the programs that AAWAA members participate in, different images of the Asian American woman artist emerge that create a pan-Asian American women artists' identity.

The making of a pan-Asian ethnicity involves the creation of a common Asian American heritage. Part of the Asian American heritage is a shared history of exploitation, oppression, and discrimination. Espiritu points out that people establish a group identity only when they become aware of the treatment they share. For Asian American women artists, a shared identity was created as Asian American artists became aware of their invisibility in the art world, an invisibility that has been noted by art historians and that continues today.[16]

History of AAWAA

AAWAA was started in 1989 by California-based artists Flo Oy Wong and Betty Kano. Ideologically the movement benefited from the rise of Asian American consciousness and the women's liberation movement, which influenced both women. As Flo Oy Wong said, "I had been looking for women artists that looked like me."[17]

Wong and Kano created AAWAA as a political gesture to make Asian American women artists and their work visible in the US art world. Both of these artists became acutely aware of the invisibility of Asian American women artists when they attended the 1989 National Women's Caucus for the Arts held in San Francisco, and noticed the absence of Asian American women. "There weren't any Asian American women in any of the panels presented at the conference. A troubling fact since the conference was held in San Francisco, a city with a 30% Asian American population," recalled Betty Kano.[18]

The Asian American Women Artists Association is a non-profit national organization of women artists of Asian and Pacific Islands descent who were born or immigrated to the United States. Its ethnic composition resembles the contemporary Asian American population of the country in that the largest group is of Chinese descent, followed by Japanese, Filipino, Indian, and Vietnamese. The ages of the members range from fourteen to eighty-five, but the majority are between forty and sixty. One-third of the members are Asian born with the rest US born. More than two-thirds of the members are visual artists; the rest are writers and a small group of performance artists. The organization operates primarily in the San Francisco Bay Area, though its scope is national.

AAWAA's main mission is to ensure the visibility and documentation of Asian American women in the visual and literary arts by sponsoring and promoting exhibitions, publications, and educational programs. Through these projects, AAWAA aims at offering thought-provoking perspectives that challenge societal assumptions and promote dialogue about Asian American women's art.

The first project that was organized by Flo Oy Wong and Betty Kano and served as a starting and unifying point for the organization of AAWAA was the creation of a set of slides of the work of Asian American women artists. The gathering and cataloguing of these slides was part of a larger project initiated in 1989 by Moira Roth of the National Caucus of the Arts to remedy the lack of representation of artists of color by creating a national archive of slides that would include the artwork of women of color in the United States. While this goal was not fully achieved due to a lack of funding, the strengthening of Asian American women's representation was accomplished. The artists met for discussions of art and potluck meals at their studios and homes. Flo Oy Wong recalls the early meetings as energizing. "It was the first time that I was surrounded by women artists who looked like me, who had so much in common, and we were all very hungry to talk about art and common problems."[19] Flo had felt isolated prior to

these meetings. In fact, she had unsuccessfully been searching for organizations or galleries dedicated to Asian American artists.

The first meeting was held at Betty Kano's house in Berkeley, California, in March 1989. Flo recalls that at the first meeting nobody wanted to go home because of the high energy that emerged among the artists. "I had found the missing link in my life. . . . There was an instant camaraderie among the women who some of them met for the first time," recalls Flo.[20]

Both artists agree that their effort in creating the organization was a political act because of the invisibility of Asian Americans women in the arts as well as within the male dominated Asian American organizations. Asian American women artists felt excluded from these organizations as well as from the feminist art movement, which was primarily white.[21]

AAWAA was born at a fruitful time for the national discourse on multiculturalism. The creation of AAWAA was slightly ahead of the national discussion among minorities in the United States, according to Kano. As the national dialogues among minority artists grew in a synergetic atmosphere, the recently organized AAWAA benefited from the new ideas circulating. According to Kano, an important realization emerging from this national discussion which influenced the early years of AAWAA was that in order to be successful in an art world dominated by white males, people of color needed to control the whole apparatus of art production. This meant including, in addition to the artists, journalists, art critics, and historians. It became imperative for people of color to take these roles and doing so helped in the diffusion and validation of the artists. AAWAA pursued these goals, actively including them in their discussions and meetings. Kano recalls the participation of Asian American journalists like Chiori Santiago, who participated in the distribution and promotion of Asian American art, and of art historians, such as Margo Machida, and Elaine Kim among others, who participated equally and have maintained this effort.[22]

Betty Kano and Flo Oy Wong continued their political involvement in the arts outside AAWAA. In 1991, Flo was the first artist of color elected to serve on the National Board of Women's Caucus for the Arts. She served for several years promoting the arts of women of color and of AAWAA. Betty Kano created Godzilla West, the counterpart to a New York-based organization dedicated to increasing awareness of contemporary visual art, media, and writing by Asian, Asian American, and Pacific Islander artists. She also was director of Pro Arts, an art organization in the San Francisco East Bay area dedicated to the promotion of the arts through their art exhibits, promotion of regional artists, annual Open Studios, professional career services to artists, and community services.

AAWAA has sponsored numerous exhibits in California, created catalogues, and prepared slide packages that have been purchased by several educational institutions. In 2007, AAWAA legally became a non-profit organization in order to have a stronger presence at the local and the national level, and to show its growth as a mature and stable organization dedicated to its mission. Practical reasons

also guided this change, such as qualifying for grants and funding, and to allow donors to give tax-deductible gifts directly to AAWAA instead of going through fiscal sponsors.[23]

I will next examine two projects organized and sponsored by AAWAA that created opportunities for participants to engage in the creation of a pan-Asian female heritage, and for reflection on identity. The projects are *Cheers to Muses*, and *A Place of Her Own*.

Cheers to Muses

This 2006 exhibit and catalogue honored Asian American women as muses and showed the diversity of visual and literary works of AAWAA members.[24] The artists submitted visual and literary works dedicated "to a non-familial Asian American woman whose life or work resonates with the contributor, influencing her life, be it her creativity, spirituality, activism or aspiration."[25] This project emphasized inclusiveness by showing sixty-seven artists of a wide range of ages (fourteen to eighty-five), a diversity of ethnic backgrounds, and including both immigrants and US born. The works were shown at the Chinese Cultural Center of San Francisco in June 2007, and the exhibition catalogue was published the same year.

The request for a written dedication to a muse encouraged the artists to reflect upon Asian American women who influenced their lives. Artists responded with a wide range of well-known Asian American women in the arts. Interestingly, 39 percent of the artists selected muses outside their own ethnic background. For example, I chose Maxine Hong Kingston, a Chinese American writer, and her book *The Woman Warrior*.[26] When I first read this book I felt an immediate sense of kinship with the author in that I had also as a child created an imaginary martial arts character who avenged and protected the weak. Writing the dedication and seeing it mounted next to my paintings at the exhibit, I felt a connection that went past the ethnic lines and connected me with a larger group of Asian American women. The effect was magnified when I saw the rest of the exhibit and the catalogue with the multiple dedications to Asian American women muses (see Plate 13).

The catalogue described the muses as courageous individuals who overcame obstacles from their families, peers, and the public, and took on the larger challenges created by their professions and activities. The dedications remind us that this struggle continues among Asian American women, and emphasize the meaningful connection created between the muses and the artists.[27] This project helped to build an Asian American female heritage among the AAWAA artists. The process itself made artists choose muses outside the traditional art canon, and created the seeds for an alternative art tradition in which artwork is influenced directly from an Asian American source instead of the established Western European art tradition. Furthermore, the activity of reflecting and selecting muses

outside one's Asian American ethnic group helped to dissolve ethnic boundaries and connected the participants directly with a pan-Asian kinship. Viewing the exhibit and reading the catalogue produced and reinforced in the audiences a pan-Asian women artists' heritage by providing a collective vision of Asian women muses, artwork, and Asian American artists. Including artists of different ages and ethnicities underlined how Asian American muses unite the group.

A Place of Her Own

A Place of Her Own is the latest project sponsored by AAWAA. AAWAA uses the idea proposed by Virginia Woolf that for a woman to practice her craft, she needs to have a room of her own, and extends the room to a place in which the limitations are bound only by the imagination. This project is planned to last several years and involve a large number of women who will produce individual artworks in the company of each other. It asks artists to respond to this question: if you had a place of your own, what would it be? AAWAA aims, through exhibitions, readings, publications, and performances, to "define what is important to women, claiming their metaphorical and/or physical space."[28] *A Place of Her Own* was born out of a conversation between Cynthia Tom, the current president of AAWAA, and Nancy Hom about mounting an exhibition of room size installations where women artists could re-create their own physical place without outside influences. Cynthia Tom has been the artistic director of the project as it adapts to venues and situations. All media and sizes of artwork are encouraged, including literature and performance. This project broadens the scope of AAWAA by involving women's social service and social justice agencies.

The first phase was conducted in January of 2009, in conjunction with the Artists in Residence Program of the De Young Museum. Ten AAWAA members, including myself, created installations answering the question posed by the project. My answer to the question was to create a place that would honor the migratory journeys of my Japanese and Spanish grandparents whose fates were a consequence of historical events over which they had little control, and my own journey from Chile to the United States. I created a map which traced the journeys of migration of my grandparents, father, and me with the inscriptions of the historical events that triggered these journeys, and ships and airplanes decorated with drawings depicting each traveler. By making visible all the invisible lines created by these journeys, I felt that the fragility and fragmentation of my family history acquired a solidity and purpose that I had not felt before, and at the same time provided a reflection on my own identity. Though participants addressed the question in different ways, creating our responses together engendered an atmosphere of solidarity and at the same time raised individual issues of self and identity. In addition, the project empowered women by providing them a place to produce anything they wanted, without any restrictions, while at the same

time reminding women that society has placed restrictions on them due to their gender.

This project emphasizes the inclusive aspect of the organization and extends the scope of AAWAA by incorporating women who do not see themselves as artists. Women are given aid in identifying and articulating their "place" in salons where women discuss, in a group situation, issues in their lives. Cynthia Tom recalls many situations in which women at these meetings confided domestic situations of abuse and made decisions about their future with the support of the attending members. The process demands much self-reflection and women are given guidance prior to attending the salons. Nancy Hom, a writer and visual artist, explains: "Participants will have to find the time and willingness to reflect. That is the transformative nature of this project. It's not just a matter of what do I want for myself in *A Place of Your Own*, but rather a matter of letting go of external influences and discovering what remains."[29] By encouraging women to reflect on their own identity and to express it artistically, AAWAA expects that women will become self-sufficient and confident.

Many of the artists attending these salons find that the experience itself has a transformative effect on them. Vivian Truong, a young photographer whose work

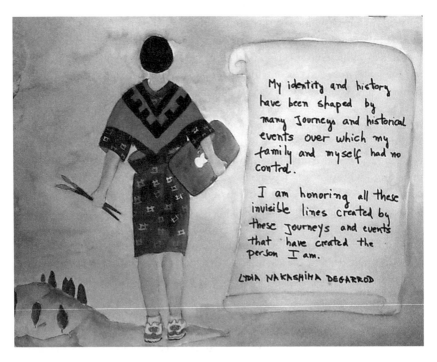

FIGURE 17.1 Lydia Nakashima Degarrod, detail of map, *A Place of Her Own* (2009). Reprinted with permission of the artist.

addresses issues of identity, describes her first attendance at a salon organized about *A Place of Her Own*:

> Going into the salon I was extremely nervous. Not only was I younger than most of the artists, I felt like I had nothing worthy to show. The thought quickly disappeared when I was greeted with an indescribable affection. For once I wasn't seen as a rival and making friends seemed so natural. (Which I feel never comes easy to me because I see myself as timid.) The stories shared were inspiring and one couldn't help but feel envious. Yet leaving the salon I had a better understanding of myself. There's a general feeling of respect among the women but most importantly a space for personal growth. Rarely are these two found so readily available. Artists my age seem so concerned with networking on an economic level. With AAWAA I've found something much more valuable.[30]

Images of a Pan-Asian Women's Art and Artists

What is Asian American women's art? I asked twelve members of AAWAA to define the art produced by Asian American women. While they all acknowledged its existence, most of the AAWAA members interviewed had difficulty defining what Asian American women's art is. The consensus was that this art is unique because it is shaped by historical references, and by the cultural and individual experiences of Asian American women living in the United States. Some like Lenore Chinn and Lori Chinn (not related) found that there were some similarities between the art created by Asian American women and that created by women of color generally. Lenore Chinn, a portraiture painter, stressed that the art created by Asian American women, as with other groups, has "a collective voice, not one single artist is representing the entire community." She believes that each artist brings her art to the narrative of her culture as a thread or a part of a mosaic. "One has to consider the breadth and depth. Then one finds that there are commonalities between the art created by Asian American women with the work created by women of color because of their relationships to mainstream America," says Chinn.[31]

All of the artists interviewed found that the art produced by Asian American women is unique in that it expresses the cultural and gender experiences of Asian American women. The main difficulty seems to be to define a common style or a common aesthetic. Betty Kano finds that though the art produced by Asian American women is difficult to define, it possesses its own language. Lori Chinn, a musician and writer, finds that when Asian American women artists address gender along with social and cultural issues their work becomes evident as having been produced by Asian American women.[32] Nancy Hom stresses the role of gender in shaping some of the topics addressed by Asian American women:

I believe our experience as women, nurturers and care-givers gives us a different approach to our artwork, and our subject matter may be more about topics that men would not dwell so much on, such as the plight and psyche of women and children. This is a generalization, and I know there are men who are very feminist in attitude and artistic methods, and there are women whose work is not readily distinguishable from a man's, but for the most part I feel there is a difference.[33]

In answering my question about the differences between Asian American men's and women's art, most of the artists found again that style was not the marker, but rather that the unique experiences created by gender are expressed in the artwork. Most of the artists interviewed recognized however that Asian American men's art was more visible than women's, while at the same time Asian American artists in general aren't fully represented in American art venues.

Images of Asian American Women among AAWAA Members

When I interviewed the members about the reasons for the existence of an organization like AAWAA in today's world, varying images of women emerged that show the different realities created by age and ethnic background. All of the artists interviewed, with the exception of one, view Asian American women as invisible in the art world. They believe that males, including Asian Americans, are given preference in the art world. Males are more often featured in museums, represented in major galleries, and have their shows reviewed by major journals and papers. Shizue Segal, a second generation Japanese American visual and literary artist, believes that it has been primarily sexism that put a hold on her art career for several decades until, at the age of sixty, she finished raising her three children as a single parent while working as an art director making almost 40 percent less than her male colleagues. She still experiences sexism in the art world, and believes that ageism is prevalent there as well.[34] All of the members I spoke with were inspired by the image of the strong and resourceful woman artist who creates networks and is empowered by working with other women. Yet they also acknowledged the image of the Asian American woman artist whose work remains unseen, and who is limited by the values and expectations placed on her by her community, and the sexism experienced within it. Pallavi Sharma, an installation artist who migrated from India eight years ago, finds that in South Asian communities in the United States there is little support for women who pursue a career in the arts whereas men who do so tend to be fully supported. Women in South Asian communities are encouraged to place themselves at service to their families and to place their needs as secondary to their families. She says:

> Women are still struggling to venture beyond the pre-defined allotted roles and face great pressure to pursue stereotypical mainstream professions in Asian communities. According to my own experience, if a woman chooses to be an artist, it is not taken very seriously in the South Asian communities as she is considered secondary in the family. The perception reverses if the male member who is considered the sole bread earner of the family chooses to be an artist.[35]

Images of the strong Asian American woman also appear in these narratives. Vivian Truong, whose father was born in Vietnam, and whose mother is second generation Japanese American, believes that sexism has been part of her upbringing, but at the same time she was raised by strong women in her family. She compares AAWAA with her own family: "AAWAA's a bit like my upbringing, there's a strong support system of women who encourage each other to better themselves, even though they know there's a very strong male presence at the top."[36]

Most AAWAA members relate that values fostered in Asian American communities hinder women from succeeding in the competitive contemporary art world. They also spoke about the need to fight this, to be strong and to create solidarity among Asian American women. Pallavi Sharma says:

> Yes, it is true that in the South Asian Community women are seen as an embodiment of love, modesty, quietness, etc., all the so-called good traits. Even in the adverse situation they are expected to solve the problems through their patience and love and not expected to raise their voice. There are a great many women who are suffering from domestic violence, and denied the right to live their lives to the fullest. In my view, as an artist, if we are scared or intimidated to speak our mind and negotiate with our own identity, then it is a big problem. It's a battle within, which we all as women artists need to fight for ourselves and for each other.[37]

Cynthia Tom, a painter and installation artist, explains some of the difficulties in overcoming some of the traits cherished in her Chinese American community:

> I spent most of my life feeling like I was upsetting my family, the society I existed in, not knowing that it was coming from an artist's soul until later in life. The young girls, then women that followed the rules, kept their heads down, didn't draw attention to themselves, [and] didn't speak loudly were the pretty ones, the ones that got picked first, etc. I became that way after puberty until my late twenties/early thirties I found out that it did not serve me at work, and definitely not as an artist that needed to get my work out there.
>
> I have aspired to speak in front of large groups, drawing attention to myself and my work. I still feel awkward about it, but try nonetheless.

Cynthia Tom sees AAWAA as a place that does not encourage these traits, and emphasizes confidence and self awareness: "The quiet, modest, martyr type of person creates an unsafe environment for an Asian American women's group to thrive and grow sustainably."[38]

Last Words

As a mixed blood Asian Hispanic, I have many identities which tend to emerge in different settings influenced by my values and sources of power. I acquired and accepted many of my different identities during my life in this country. The process of becoming each one has been primarily unconscious. I have become consciously aware, however, of understanding and being an Asian American woman artist as a member of the Asian American Women Artists Association. I directly participated in this process while making art and answering specific issues that forced me to address identity, space, and tradition in art. While the images may or may not be the same as for other AAWAA members, the basis for an Asian American woman heritage has been sown.

Notes

1 Japanese Chilean in Japanese language.
2 *A Place of Her Own*, a project created by the Asian American Women Artists Association, was part of the Artist in Residence Program at the De Young Museum of San Francisco from January 3–31, 2009.
3 The artists I interviewed are: Betty Kano (October 16, 2009), Flo Oy Ong (October 26, 2009), Keiko Nelson (November 6, 2009), Cynthia Tom (December 2, 2009, June 25, 2010), Lenore Chinn (December 7, 2009, June 21, 2010) Lori Chinn (January 7, 2009), Shari De Boer (December 4, 2009), Nancy Hom (March 2, 2010, June 25, 2010), Vivian Truong (April 28, 2010 and May 7, 2010, June 22, 2010), MariNaomi (May 3, 2010), Pallavi Sharma (May 2, 2010, June 24, 2010) and Shizue Segal (June 25, 2009).
4 Chile has since its independence from Spain in 1810 kept a racial preference towards white Europeans, discouraging all non-white groups from migrating to Chile. It is only in the last twenty years that Chile has accepted non-white immigrants, primarily from Korea. There has been a large migration of Peruvians in the last ten years who come to Chile to work illegally as domestic maids, and agricultural and construction workers.
5 The Japanese population in Santiago was 900 in a country of eight million when I was growing up.
6 Ted C. Lewellen, *The Anthropology of Globalization: Cultural Anthropology Enters the 21st Century* (Westport: Bergin & Garvey, 2002) 105–106.
7 Naoko Haruta kindly encouraged me to join AAWAA when I met her at the East Bay Open Studios. I have been a member of AAWAA for eight years and have served both on the Board of Directors and on the Advisory Board.
8 Margo Machida, *Unsettled Visions: Contemporary Asian American Artists and the Social Imaginary* (Durham: Duke University Press, 2008) 8–9.
9 Yen Le Espiritu, *Asian American Panethnicity: Bridging Institutions and Identities* (Temple: Temple University Press, 1992).
10 Ibid., 17.

11 Ibid., 52.

12 Ibid., 48.

13 Karen Higa, "What Is an Asian American Woman Artist?" in *Art/Women/California 1950–2000: Parallels and Intersections*, ed. Diana Burgess Fuller and Daniela Salvioni (Berkeley: University of California Press, 2002).

14 See Valerie Matsumoto, "Pioneers, Renegades, and Visionaries: Asian American Women Artists in California, 1880s–1960s," in *Asian American Art: A History, 1850–1970*, ed. Gordon Chang, Mark Dean Johnson, and Paul J. Karlstrom (Stanford: Stanford University Press, 2008).

15 Higa, "What Is an Asian American Woman Artist?" 92.

16 Matsumoto citing Moria Roth writes about the lack of Asian American women artists in major galleries and museums, which continued to exist at the end of the twentieth century. See Matsumoto, "Pioneers, Renegades, and Visionaries," 195.

17 Flo Oy Wong, October 16, 2009.

18 Betty Kano, October 26, 2009.

19 Flo Oy Wong, October 16, 2009.

20 Flo Oy Wong, October 16, 2009.

21 See Higa, "What Is an Asian American Woman Artist?" 84

22 Margo Machida has curated several shows and written extensively about contemporary Asian American art. Elaine Kim has written and edited books on Asian American literature and visual art.

23 I joined AAWAA at this time. The first meeting about this transition was held at my home. Nancy Hom, Wei Ming, Shari DeBoer, Cynthia Tom, Vanessa Merina, Debbie Yee, and I were on the Board of Directors during the year while we applied for the non-profit status. Nancy Hom, who guided the transition of AAWAA to a non-profit status recalls the process: "I suggested that we try AAWAA as a non-profit for a year and see if it works for the group, with me providing ongoing hands-on advice. I helped them form a Board (which I was also on, along with Cynthia, Shari, you briefly, Debbie, others), decide roles and responsibilities, select officers, etc. AAWAA conducted itself as if it were a real non-profit, with regular meetings, financial statements, etc. We developed bylaws and Debbie Yee applied for 501(c)3 status. By the time we got our tax exempt letter, the transition to non-profit was relatively seamless."

24 AAWAA Board of Directors was formed by Shari Aria DeBoer, Nancy Hom, Mary Rose LaFreniere, Kim Mizuhara, Cynthia Tom, and Debbie Yee.

25 Asian American Women Artists Association, *Cheers to Muses: Contemporary Works by Asian American Women* (Malaysia: Imago, 2007).

26 Asian American Women Artists Association, *Cheers to Muses*, 55.

27 Asian American Women Artists Association, *Cheers to Muses*, 9.

28 Cynthia Tom, *Bay Times*, San Francisco, January 29, 2009.

29 Lenore Chinn, June 25, 2010.

30 Nancy Hom, May 7, 2010.

31 Vivian Truong, December 7, 2009.

32 Lorin Chinn: "To answer the question directly, I find that the work by Asian American women that addresses gender, along with social and cultural issues is different from other groups of artists as they express unique stories, experiences, struggles, and issues that are very personal or could be a part of their community."

33 Nancy Hom, June 25, 2010.

34 Shizue Segal, June 25, 2009, e-mail message to author.

35 Pallavi Sharma, June 24, 2009.

36 Vivian Truong, June 22, 2009.

37 Pallavi Sharma, June 24, 2009.

38 Cynthia Tom, June 25, 2009.

Bibliography

Asian American Women Art Association. *Cheers to Muses: Contemporary Works by Asian American Women*. Malaysia: Imago, 2007.

Espiritu, Yen Le. *Asian American Panethnicity: Bridging Institutions and Identities*. Temple: Temple University Press, 1992.

Higa, Karen. "What Is an Asian American Woman Artist?" In *Art/Women/California 1950–2000: Parallels and Intersections*, edited by Diana Burgess Fuller and Daniela Salvioni. Berkeley: University of California Press, 2002.

Lewellen, Ted. *The Anthropology of Globalization: Cultural Anthropology Enters the 21st Century*. Westport: Bergin & Garvey, 2002.

Machida, Margo. *Unsettled Visions: Contemporary Asian American Artists and the Social Imaginary*. Durham: Duke University Press, 2008.

Matsumoto, Valerie. "Pioneers, Renegades, and Visionaries: Asian American Women Artists in California, 1880s–1960s." In *Asian American Art: A History, 1850–1970*, edited by Gordon Chang, Mark Dean Johnson, and Paul J. Karlstrom, 169–229. Stanford: Stanford University Press, 2008.

18

NOTES OF A DUBIOUS DAUGHTER

My Unfinished Journey Toward Feminism

Miriam Schaer

I always wanted to be an artist, but I never expected to be a feminist. Growing up in Buffalo, New York, in a somnolent suburb bearing the name of a brand of kitchen appliance, I could hardly as a youngster have explained what either really meant. Yet in the process of becoming one, I also became the other.

Kenmore was the suburb, a village just outside Buffalo, now inside the city's expanded perimeter. Still a tidy community of single-family houses and trimmed lawns, Kenmore has the good fortune to be a short ride from the Albright-Knox Art Gallery, a jewel-box-like contemporary museum that became my playground the first time I was taken to see its wonders.

And its wonders were many. On every visit, I was surrounded by the works of Louise Nevelson, Marisol, Frieda Kahlo, Joan Mitchell, Louise Bourgeois, and others too numerous to list. I saw the first Eva Hesse retrospective when I was in high school. Hesse, and also Nevelson, showed me that nearly everything could be material to make art. Marisol's quirky humor, her playful sense of scale, showed me one's vision did not need to mimic the real world. Her *Mother and Child* transposes the expected: a super-size baby as tall as I am, with the mother a fraction of the baby's size, standing on her child's knee. Old friends by now, I still visit them when I'm in Buffalo. Because of the inclusive nature of the Albright-Knox collection, it never occurred to me the art world was largely closed to women.

That is, until I tried to attend art school. During my admission interview at Buffalo State College, I was advised to consider art education or art therapy, and handed brochures about those programs on my way out. The school's message: middle-class Jewish girls don't have whatever it takes to be artists. It was the mid-1970s. I was aware of feminism, and a little overwhelmed by the choices feminism was making available. I remember being both excited and terrified. But I was not yet aware of "feminist art."

I did manage admittance into art school, and it proved to be an awakening, though a gradual one. I won one award, for example, for showing the most progress during the three years I studied at the Philadelphia College of Art (now University of the Arts). But when I asked my department head for a recommendation for graduate school, he refused. It was devastating. I never did go to graduate school, and it took some time to realize his refusal had more to do with his issues than with me. But I kept working. I sought out communities and venues in which to continue learning, piecing together my own postgraduate art education. And blessed with a gift for disregarding adversity (and authority), I kept sending work into the world.

Strong Tea, Stronger Women

I come from a line of strong women, all storytellers. When I go home to visit, we still sit around the kitchen table: me, my mother Ida, my sister Susie, even sometimes one or both of my brothers, drinking endless cups of tea, trading stories from our lives, the people in them, stories seen on television or in the news. We would hear Ida's stories about grandparents, especially Yetta, her tyrannical grandmother; about known and reputed aunts, uncles, cousins, a parade of the mostly departed. Our family legacy: salesmen, gardeners, cantors, china painters, scoundrels, and thieves.

Ida recounted her childhood in the 1930s during the Great Depression, growing up on Buffalo's East Side, in a neighborhood whose harshness its buildings still project. I learned how the family lived for years without a place to bathe. How Ida was hospitalized for nephritis when she was eight. How recovering afterward in a gleaming convalescent home showed her she could escape the world she knew. She decided to become a nurse, and live in a cleaner, more orderly world, far from her childhood's reality. And she did become a nurse, and married a surgeon.

When I was a teenager, Ida and I battled over everything about me, especially my clothing, weight, and appearance. Having grown up in poverty, she worried about my ability to earn a living. Though she didn't understand my desire to be an artist, she didn't stop me. But she persisted in making wicked, biting comments about my clothing, art, jewelry, and more. In art school I studied fiber, which included weaving, textiles, and using textiles as a basic material for artworks. I worked a lot with felt: "I hate to say this," Ida would say about one piece or another, "but that looks like something somebody threw up." I hate to admit this but, in retrospect, sometimes it did. Lately, Ida's come to understand my work. Now she only makes fun of my shoes.

Room with No View

I moved to New York in the fall of 1978, landing in a claustrophobic, closet-sized apartment in Chelsea, and started making books. Books, which could be

compactly folded up, were a perfect solution for laboring in a small space. As I became more involved with books, I studied their history. I learned about the girdle book, a medieval type of prayerbook monks lashed to their belts, or girdles, so prayers would always be at hand.

This led me to visualize modern girdles as potential book structures. And, how working with girdles would be an opportunity to explore classic notions of the female form. Girdles are essentially binders, structures to push, press, and mold female figures into idealized shapes. Like books, they could also be used to hold stories, embody ideas. I made several "girdle books" packed with contemplations, prayers, and cultural objects of devotion. Working with the girdle structure also helped me learn to love the femaleness of my body, and be more comfortable in my own skin.

Other garment-based books also took shape. I began to use articles of baby clothing because of their reduced scale, but a broader significance soon became apparent. They became vehicles for memories of childhood, both idealized and painful. The pieces I made using infant apparel explore issues of immaturity and motherhood. Feelings about my infertility live in works created using toddler dresses and baby rompers. Books based on gloves and industrial hand-shaped drying forms explore the hand as a basic signifier of communication, greetings, warnings, surrender, and embrace.

I have to admit I wasn't aware of the feminist art programs in California while they were happening. Yet there was something in the air I must have inhaled. The times vibrated with new ideas about women's rights and equal rights, with the belief by women they had something important to contribute. The choices such ideas presented were exhilarating and terrifying. The draft for the Vietnam War made issues of life and death palpable and immediate. Art was being redefined in ways that issued from feminist influences: performance art, film, even working with craft materials shunned by the traditional fine art world.

Neither at Boston University, where I first studied, nor at art school in Philadelphia, where I transferred after a year, did I find any awareness of women's issues, or that emerging new forms were feminist in origin. While the academic world was the birthplace for much feminist ideology, nearly all my instructors were white males.

When I moved to New York City, I struggled with issues of work, home, and family familiar to any young college grad. I was still finding my voice as an artist, and looking for ways to make art while making a living. But I was also operating pretty much in a vacuum, unaware of feminist and artistic support circles. When Judy Chicago's *Dinner Party* came to the Brooklyn Museum in 1980, my boyfriend (now husband) suggested we go see it.

The Dinner Party was a revelation: a monumental work of art produced using non-traditional materials and processes, like china painting and embroidery, that were completely shunned in the traditional gallery world. The idea of working

collectively and finding support in community opened me to a new way of thinking. I was also amazed and captivated by the controversy *The Dinner Party* inspired, then and still. Any work that can arouse so large a response from so broad a range of perspectives is not to be lightly dismissed.

Artistic community came to me from the worlds of printmaking and artist books. I studied book structures at the Center for Book Arts and won a Special Editions grant from the Lower East Side Printshop, both in New York. Through these institutions, I met other artists, including some who had worked on *The Dinner Party*, and who were knowledgeable about New York's feminist collectives, including the A.I.R. Gallery, the Women's Action Coalition (WAC), and Ceres Gallery.

I was supported and given access to information about exhibit opportunities. I was included in residencies in the United States and abroad, and I was given the chance to grow in my work. In 1997, a large Special Editions print I made at the Lower East Side Printshop was included in *Crossing Over Changing Places*, a US Information Agency-funded show about collaborative printmaking. Curated by Jane Farmer, the show assembled works from the Printshop, the Rutgers Center for Innovative Paper and Print (now the Brodsky Center), the Print Center in Philadelphia, and Pyramid Atlantic, near Washington D.C.

I was invited to travel with the show to its exhibition in Madrid to work with the local curators installing the exhibition, and to give lectures and hold workshops. This was the first time I'd traveled alone internationally and in the service of art. Being entrusted with this dynamic print show was a milestone for me and my work.

Through my involvement with *Crossing Over Changing Places*, I also came to know Judith Brodsky, Gail Deerey, and Eileen Foti, from Mason Gross School of the Arts at Rutgers and the Rutgers Center for Innovative Paper & Print. I became aware of Rutgers as a place for nurturing feminist ideas in art. For example, Rutgers is home to the Feminist Art Project, an online resource that promotes feminist events, and works to ensure the inclusion of women in the art world.

As I learned more about feminism in art, I began to understand my place in it. Because my work often involves female forms, even if at times abstractly, I began to be included in exhibitions with feminist and women's themes. Often the forms serve as housings for books and objects that deal with relationship dynamics, and questions about politics, spirituality, and the role of women within structures like the family and society. For example, *Altars of the Invisible* (2007) is an actual bridal gown, the front panels of which open like giant beetle wings to reveal an inner landscape of embedded objects and text (see Plate 14).

In 1999, I was offered a solo show at the Mary H. Dana Women Artists Series of the Mabel Smith Douglas Library in Rutgers University. The Douglass Library show is the oldest continuously running series in the United States to showcase women artists. I was thrilled to be accepted into the series.

Sign of the Raven

To prepare, I felt it was essential I look at my work more critically. I began by attending the Writing for Artists Workshop, in New York, a three-week intensive with Arlene Raven, who sadly passed away in 2006. Raven had co-founded the Woman's Building in 1973 with Judy Chicago and graphic designer Sheila Levrant de Bretteville.

The workshop met three times a week for three weeks, as well as several additional times as pairs in our individual studios. Arlene's system was both simple and complex. Each artist first gave a ten-minute presentation about her work. After this introductory round, we were all paired with other artists. This time, I spoke about my work for about fifteen minutes, with my partner taking detailed notes. Then we switched roles.

Eventually, we all partnered with each other. After about three or four rounds of this, we began to arrange our notes into new artist statements. We took turns reading the new statements, and getting feedback from the various partners. Midway through the workshop, each of us gave another ten-minute presentation, this time with images.

The feedback was honest and direct, and the process gave us the tools to find the words to describe our work. By the end of the workshop, I had received valuable feedback from everyone present, including Arlene. I also met several women, some of whom are still part of my artistic support circle, and found myself entering into a larger circle of workshop alumni who continue to meet using the format Arlene developed.

The course itself was an eye-opener. It helped me look at my work from new and different perspectives, question where my ideas came from, what its influences were, and where I wanted the work to go. For example, I realized more clearly that I was transforming objects of female clothing—girdles, dresses, aprons, gloves, and the like—into shrine-like constructions, and structuring places within them to house the odd little things I habitually collect: doll arms, toy irons, dressmaker pins, bottles, toddler dresses, beads, vials, as well various notes, leaflets, and fairy tale fragments. Folklorists Peter and Iona Opie's collections of nursery rhymes sits in my studio library alongside copies of *Art News*, books by Martin Buber, Ann Hollander's *Sex and Suits*, Keith Smith's *Non-Adhesive Bindings*, and catalogs of voodoo and fetish art as well as catalogs of work by Meret Oppenheim, Louise Bourgeois, Renee Stout, Claude Cahun, and Yayoi Kusama. These are some of my sources. Everything is my material.

In *Housekeeping* (2000), I transformed a corset into a rigid structure, painted it and enabled its two halves to open to reveal an altered copy of *The Consumer Reports Guide on How to Clean Anything*. The *Guide* appeared in my mail one day, unrequested. I cut and re-sewed it to form a small arc-shaped book that nestled inside the girdle. I filled its pages with line drawings of the tools (or weapons) of housework: buckets, brooms, mops, irons, and the like. Surrounding

the altered *Guide* are three-dimensional niches filled with votive-like offerings of plastic toys, kitchen utensils, the doodads of everyday life. *Housekeeping* is both a shrine to the never-ending battle to meet an absurd ideal, and a meditation on the endless nature of housework.

Altars of the Invisible is a sculptural work for which I tore apart, re-structured and compartmentalized an actual wedding dress. I transformed the front of the garment into doors capable of opening to reveal an interior filled with objects. *Altars* represents for me a new-millennium altarpiece for today's women, who are still being told they can have it all if only they try hard enough. It was partly inspired by the *Virgem do Paraiso*, a thirteenth-century Portuguese altarpiece from Evoria; by Sandra Orgel's *Linen Closet* installation piece, shown at the landmark *Womanhouse* in 1972; and by Maria, the robot provocateur in *Metropolis*, Fritz Lang's great 1927 film.

In *Altars*, the female body is stylized to form a series of compartments bearing the items deemed necessary for a woman to thrive in today's world. The objects reflect every woman's interior trousseau, and the multiple roles thrust upon women by the culture, the media, and women themselves—symbols of love, sex, careers, marriage, households, families, and children.

In 2001, I began to create environments for my sculptures. Using varied modes of display, I found myself drawing on a narrative tradition in which the impossible is probable, in which magic and marvels coexist with things actual and proven.

The Installation Imperative

Solitary Confinements: A Family Portrait (2002) was my first installation. It explores the interior life and its relationship to our public lives, since the family is where we learn who we are, and where we begin to figure out relationships and find our way in the world. Part of this involves the stories we tell ourselves to develop a sense of self, and the stories we keep hidden from ourselves because of what they reveal.

As a viewer enters the space of *Solitary Confinements*, he or she is greeted by four figures standing at a table set as if for a meal. Each figure is a large artist book that dramatizes the place of each individual in family life. Constructed from actual items of clothing, each book represents one member of a family consisting of a mother, a father, and two kids. A brightly colored table, chairs, dishes, and flatware suggest elements of a dollhouse blown up to life-size scale.

Six-feet tall black-and-white wall murals enfold the family with images of affluent, idealized interiors. On the left wall, glamorous partygoers, drawn from mass-market magazine ads, wait their turn at a festive buffet. They are the happy people, marketing entities experiencing the lives real people are expected to admire, the artificial baseline for our dreams and desires.

Each family member tells a different story, and the torso of each opens to reveal a removable book containing a brief narrative. Some of the narratives are

in accord with how the world perceives us, others are not. The books within the books of *Solitary Confinements* are available for visitors to read or examine. Visitors can also sit in the red chairs around the yellow kitchen table, guests and participants, as it were, in the larger family portrait.

Solitary Confinements was first shown in the Ceres Project Room at the Elizabeth Foundation for the Arts in New York City. The space was a satellite of Ceres Gallery, a non-profit, artist-run organization dedicated to the promotion of women in the arts. Founded in 1983 as part of the New York Feminist Art Institute, Ceres is still going strong.

I had previously been in several group shows at Ceres, and discovered the Project Room was receptive to giving artists opportunities to create new work that pushed their boundaries. As a result, I was able to experience the best, most nurturing aspects of an artist collective. *Solitary Confinements* is my most requested installation, and has been shown in a variety of venues.

Chapel of Uncommon Prayers (2005) is an installation of books and book objects exhibited at the Whitewater Gallery in North Bay, Ontario. It features books shaped as hands, built with gloves and industrial glove dryers, employing traditional binding techniques in non-traditional ways. The installation explored personal relationships to prayer and devotion in a world awash with unanswerable questions.

The gallery walls were painted with rich, saturated colors to encourage visitors to think about their dreams and desires. The books deal with a broad range of personal and political subjects, including shelter, nourishment, love, war, and peace.

In 2005, Melissa Potter invited six artists and one curator and art historian to form a women's critique group. I hadn't been in a support group since the 1980s, when I was working as a graphic designer and illustrator. I knew Melissa from her work as program director at the Dieu Donne Paper Mill in New York, and from a 2003 residency we shared courtesy of a grant from the Trust for Mutual Understanding. The residency was to teach book arts and environmentally friendly printmaking techniques at the Faculty of Fine Arts in Belgrade, Serbia.

The group quickly evolved into an egalitarian arena for peers to discuss a problem rarely acknowledged by today's art press—the limited opportunities for female artists in the New York area. The group renews a nearly lost tradition of the female/feminist collective as a means of generating dialogue for women in the arts. The diversity of media, ideas, and backgrounds among its seven members lends the group its multifaceted character.

As I re-evaluate where my work is going, this feminist art collective has given me valuable source support at a pivotal time. It also serves as a constructive way for us to share feedback about each other's work, and defend against the isolation of individual studio practice.

We first met in the conference room of the New York Foundation for the Arts, where Melissa was then employed. Soon, meetings shifted to the studios and apartments of group members, and to hospitable cafés. We are committed

to quality dialogue, intellectual stimulation, and personal growth. At monthly meetings, each member is encouraged to discuss her current work or upcoming projects.

O Pioneer

As the group matured, it considered presenting itself to the public through exhibitions. This introduced a new dynamic, and the need for a name. Melissa suggested Art364B, in recognition of the first art history course about the representation of women in nineteenth- and twentieth-century art. Professor Linda Nochlin, a pioneer in feminist and women's art history, selected the subject for her undergraduate seminar, Art364B, at Vassar College in 1970. Our group held its first public exhibition in 2007. *Art364B: The Collective* was shown at the Kimmel Center Windows at New York University, a streetside venue in the middle of Greenwich Village. Art364B's Jennifer S. Musawwir and NYU's Jovana Stokic co-curated the exhibition.

The name Art364B signals our connection to a historic moment, and a subject central to each member's practice. The group's collegiality and support have been a wonderful addition in my life. Its other members include Marietta Davis (www.mariettadavis.net), a photographer and video artist whose images disrupt society's obsession with perfection to reveal the grotesque reality embedded in our culture's glossy representations of beauty, and Kate Clark (www.kateclark. com), who combines human faces with the taxidermied bodies of wild animals to create strange beings evoking fears, desires, and instincts more often repressed than revealed.

Tiffany Ludwig also collaborates with Renee Piechocki as Two Girls Working (www.twogirlsworking.com). The pair documented the responses of women around the country to the provocative question: "What do you wear that makes you feel powerful?" They published the results in *Trappings* (Rutgers University Press, 2007), and transferred the archive of their work to the Schlesinger Library of Harvard University's Radcliffe Institute.

Melissa Potter explores gender codes, rituals, and discrimination. *Ammunition for the Virgin*, her current project, is a film about one of the last survivors of a Balkan tradition in which a girl in a household with no male heirs is raised and treated as a boy. Melissa is also an Assistant Professor in the Interdisciplinary MFA Program in Book and Paper at Columbia College, Chicago (www.melissapotter. com).

Maria Yoon (www.mariathekoreanbride.com) travels the country as "Maria the Korean Bride," exploring the institution of marriage, and seeking to reconcile an internal construction of self in conflict with cultural expectations. She is working on a feature-length documentary about her fifty weddings in all fifty states.

Finally, Jennifer S. Musawwir is an independent curator whose primary interest is feminist art from the early 1970s through the present. Her projects

probe contemporary issues as they relate to gender, race, and sexuality. *The Wedding Project* (2004), co-curated with Melissa Potter, explored the frenzy that surrounds many marriage rituals. She holds a Master's Degree in Art History from Hunter College, City University of New York.

Art364B continues practices Nochlin and other second wave feminists initiated through artist collectives, and their focus on female subjects. Inspired by recent exhibitions and symposia reviving discussions of feminist art, Art364B is pleased to present itself as a feminist collective expanding the discourse of feminist art. Recently, the group launched *(Pro) Create*, an online exhibition about motherhood and artistic practice from two points of view—women who have had children and those who have chosen not to.

Open Doors

My formal education, I now see, confined me in a cold vacuum of academic despair, nearly convincing me I had no future in the world of art. I well remember graduating with the fear I would not even be able to draw a straight line to some imaginary art director's satisfaction. My sentimental education, begun soon after arriving in New York, felt like a fresh breeze blowing through my brain.

Friends at Ceres and Rutgers introduced me to such classic texts of feminist art as *The Power of Feminist Art* by Norma Broude and Mary D. Garrard, *Art and Feminism* by Helena Reckitt and Peggy Phelan, and *Sexual Politics: Judy Chicago's Dinner Party in Feminist Art History* by Amelia Jones. I bought these and other books for my personal library, and devoured every word, every image.

I found myself especially inspired by artists like Mary Kelly, Lynn Hershman, and the fearless Carolee Schneeman who turned the stuff of their lives into powerful art. As soon as I could assemble a small portfolio of original works, I approached the Kathryn Markel Gallery, then on West 57th Street. They declared my work uncommercial and dismissed the images I'd prepared as "expressionistic, greedy and crude, but good." The put-down made me laugh; at least they'd gotten it.

When the exhibition *WACK! Art and the Feminist Revolution* toured the country in 2007, I was elated by the excitement it was stirring about feminist ideas and influence in the art world. Seeing the show at PS1 in Queens let me experience in person artists whose work I'd only previously seen in print.

Feminism for me is about possibility. It's about allowing women to achieve whatever they might imagine for themselves. In art, feminism has opened the doors of acceptance for an array of materials, techniques, and content that women artists use to create artistic experiences the predominantly male art world had previously neglected or disparaged. Through feminism we have seen the emergence of performance art; a greater attention to pattern, fabric, embroidery, and collage; the use of materials from beads to bottle caps; an emphasis on work about the body, even a greater freedom among men to experiment with unfamiliar forms.

Exhibitions incorporating the above have become part of the art world's visual vocabulary, not the exception. While more remains to be done, much has been done.

And so, midway through life's journey, as I move into the next phase of my work, I'm grateful to have a supportive community in which to be working, and to the artists and feminists and feminist artists who have, knowingly and not, given me so much.

19

"THE WAY THINGS ARE"

Curating Place as Feminist Practice in American Indian Women's Art

Tressa Berman and Nancy Marie Mithlo

Framing a Dialogue

The frame of reference for Native women and the arts is greater than the means we have to conceive of their presence. The concepts currently available to us are inadequate—the literature on the topic minimal.[1] How then to describe an intersection between the dynamism of Indigenous women's artistic practice and the rich legacy of feminist art? What strategies do we utilize to convey our mutual interests, our aspirations, and our struggles?

To speak of Native women in the arts, we articulate the significance of place-based aesthetics in local and transnational contexts. Indigenous arts are informed critically by location and belonging, but are not confined to transmission and interpretation solely within these constructs, especially as they are conceived of in a nation-state apparatus. Indigenous arts, as a component of Indigenous intellectual traditions, attend to unique cultural and political parameters that are essential to the maintenance of sovereign land stewardship, the reclamation of cultural knowledge, and retention of Native languages. These attributes cannot be dismissed, even as mainstream "high art" codes call for embracing hybridity in globalized contexts. An Indigenous spatial belonging may be "out of frame" from Western values and concepts, but is not marginalized, lost, or incorrect.

A key theoretical tool for thinking about geographically situated art practices is the emergent emphasis on a Native feminist spatial discourse. Goeman defines this concept as "imaginative geographies that create the material consequences of everyday existence for Native people."[2] While recognizing the political relationships between Native nations and state powers, we emphasize the symbolic structures that are manifested in aesthetic practices. Drawing from our shared experiences as curators working in international contexts, we attend to the logic of Indigenous wisdoms as grounding for understanding the mental and physical

attachments to place in contemporary Native arts practice. Colonial policies of dislocation, forced migration and theft of material resources inform our analysis, but do not define our explorations. The production, consumption, and circulation of Native women's art are impacted by longstanding material conditions that exert pressures, such as enforcement of federal policies of inclusion and exclusion, appropriation of symbolic icons, and silencing of communal arts discourses. Our intervention reaches beyond these constraints to other codes of reference that powerfully shape the attitudes and circumstances of contemporary art practices. Following Goeman, we "make visible omissions in the settler map"[3] by identifying "alternative methods of reading space, gender and nation."[4]

In this conversation between two academic activists engaged in Native communities—one (Nancy Mithlo) a member of a federally recognized tribe, the other (Tressa Berman) a valued collaborator—we seek a balanced engagement in our own intellectual and spatial territories. We construct a dialogue not only between ourselves as co-authors of this chapter, but with the larger discourse of feminist art, and the shared intersections with American Indian history and art making. We write at a time of great promise and movement. Indigenous people are circulating globally, as always, but now perhaps more visibly, in arts contexts previously assumed to be out of reach. Our writing reflects this movement as we author this chapter together over the Internet, speaking about and from various locations—Canada, Italy, Australia, and the United States.

We begin our chapter without art objects, or art words, but with recollections and stories.

NANCY: *I know of a place in rural Oklahoma where women meet when the moon is full to offer tobacco, give thanks for their mothers and to pray for themselves and their families. As a means of individual and cultural survival, these small multi-tribal gatherings are inclusive of Native and non-Native women, they are collectively organized and they are not advertised. In fact, no institutional, non-profit status, or NGO apparatus is at play in the simple act of remembering the earth as a female being. This is an everyday strength—a place of belonging. As I write this chapter at a computer in a university on the island of Venice in the country of Italy across the ocean from that simple gathering by the fire under a full moon on tribal lands, I can activate that sense of centering, that abandonment of the margins. In my mind, I feel the closeness and reassurance of my family, I recall the way a warm breeze can gently lope across an open clearing, and I sense the thick grasses and trees around me. This fullness is available when I am present to the possibilities.*

TRESSA: *I am standing on a hilltop in northwestern North Dakota, Mandan-Hidatsa-Arikara country, upstream from what used to be the Missouri River. This area forms the shorelines of Lake Sakakawea, named for the Shoshone woman who led Lewis and Clark to this spot more than 150 years ago. Women were the custodians of land in these horticultural societies, the reapers and cultivators of sustenance in the form of corn, beans, and squash, the trinity of trade exchanged across the natural border of*

the mni shoshe, muddy water, Missouri River. They mapped and built the houses of earth and timber, setting them into the open prairie hills. It is within this frame that I stood with my Mandan host, a Turtle Priest, whose offerings still feed the river turtles and nourish the thousands of years old riparian cultural knowledge. Like the remnants of earthlodges bobbing to the surface of the lake, the past informs the present.

"How big is your world?" asks the Turtle Priest. I glide across the map in my mind—from Paris to San Francisco to Sydney and back again to the hilltop in North Dakota. He shakes his head in shame for me and instructs me to hold out my arms, which I do. Then he turns me around, and around myself again. "This," he says, "is your world."

These teachings are reminders that we leave our mark where our feet are planted, and that this imprint upon the earth claims an identity of place. It is the significance of place-making that concerns us, whether enacted on Native homelands or in the cities of the global art world. These reconfigurations of colonized spaces are testimonies to cultural survival despite geographic dislocations and the imposition of state-enforced political governance. We term this action a "push back effect," drawing from related issues in migration studies where populations that were forced from their homelands by land settlement, labor pressures, and warfare resist by exercising symbolic and material strategies. The impulse to "push-back" is applicable in Native movements as resettlement and urbanization pressures are mitigated by artists' interventions—their creative responses to continuing internal colonial practices. The ability of Native artists to build "particular connection[s] between individual and collective histories to the spaces and the landscape they inhabit"[5] is a strategy of survival and a testimony to the endurance and vitality of Indigenous thought in rural, urban, and global geographies.

Our chapter will track this desire to convey a sense of place in real and imagined ways drawing from the work of two Indigenous artists—Colleen Cutschall and Shelley Niro. Our respective curatorial experiences with these artists, in situated places and times, inform our analysis. In following the movement of these artists, we also reflect on their migratory routes, while most significantly, fostering the relationships that make our collaborations possible, even in the act of "writing about." Thus, a concern with processual knowledge-building—attending to the practice of making and theorizing art, rather then the product alone—serves as an entry for engaging with feminist art history.

Charting the Course

Our questions are fairly straightforward. Why are American Indian arts, and in particular contemporary American Indian arts, so rarely included in the dynamic discussions of feminist art practices? Furthermore, why are American Indian arts rarely discussed in critical art theory? How are our activist impulses enacted, and with whom? Where are the most fertile intersections by which we might find

relevance for each other's projects? Our sense is that we may not be so distant to each other's discourses; that a productive conversation is potently waiting and that hidden legacies are undocumented. In this respect, our discussion bears witness and finds parallel with the feminist legacies that charted the course of this book. By taking an experiential approach to articulating these intersections, we provide a ground where a more ambitious agenda might be pursued.

When we teach American Indian art—Nancy, at a state university, Tressa, at a private art college—we begin variously from the vantage points of identity, nationhood, and the law. These are the multiple and contradictory ways of inviting mostly non-Native students to consider Native art as a political construct and as a social register, under conditions of self-designation, and designation by others.[6]

When we teach American Indian art in American Indian contexts of community and tribal colleges, we begin from these vantage points as well, but always in response to the question, "Where are you from?" This question underscores the necessity of locating identity as a standpoint for claiming experiential knowledge, yet as scholars we know that "identity" is a deeply diverse and unfixed position. We experience the placement of Native American art outside of our professional training in anthropology, usually in art history contexts, and always from the canonical assessment of what gets to count as "contemporary art." Furthermore, as Indigenous and non-Indigenous women respectively, we have experienced these categorical constructs differentially.

FOR TRESSA: *The "way things are" is complicated by my non-Indigenous identity in Indigenous art worlds—a field generally sectioned off into academic corners within larger fields of cultural or artistic production. The expectation of me is inversed from many of my Indigenous colleagues, though my knowledge and expertise are likewise marginalized in accordance with the status of the field, "Indigenous Art." The unspoken question often asked of us, and one we are asking here, is how do we place Indigenous arts within the contemporary?*

While recognizing the pitfalls of Federal Indian Law, I maintain that it is not possible to fully comprehend contemporary Native American art without an astute understanding of Federal–Indian relations that have structured social relations and art production since resettlement, as both a target and by-product of United States federal Indian policy.

FOR NANCY: *I get the impression from conversations with my peers that to start a lecture on contemporary art with a discussion on identity somehow automatically places my scholarship as decades old in relevance, thrusting me into a category of a dated and perhaps naïvely politically-oriented intellectual. But get this—if you are a curator, collector, or academic who is not savvy to the political and social realities of American Indian art you could not only find yourself out of a job, you might be publicly humiliated, outcast, or even arrested and serve time for your ignorance. That's the way things are in my field. Perhaps this is why no one is writing about us?*

> *According to the mandates of the 1990 Indian Arts and Crafts Act (U.S. legislation informed by federal-trust relations of Federal Indian Law), an artist may not sell his or her own work as an "American Indian" unless that artist has federal recognition as a tribal member or has received permission from a tribal entity to market the work as a recognized member of the community. Take note—Federal Indian Law and Tribal Law are separate from other laws in America; Native nations are sovereign political entities. That is why you can buy cigarettes cheaper on tribal lands, why you can game there, and why Indian people may have their own tribal license plates. Tragically, this is also why sexual violence against American Indian women is often impossible to prosecute due to the entanglement of tribal, state, and federal law jurisdictions.*
>
> *Back to selling or displaying your work as an American Indian without documentation: if you do this, the penalty can be a fine of up to $250,000 or jail time under a FBI investigation. This does not even address the possession, transport, or sale of American Indian art that is prosecuted under separate legislation to protect religious and ceremonial patrimony. Clearly these legal constructs position Native arts and Native feminist arts differently—outside the frame.*

This chapter is concerned with the intersectionality of these points of construction—law, ethics, and identity—with each point a vital node in a web of social relations and place-making that underpins any meaningful discussion of American Indian women, art, and feminism. The ways in which Native women's agency gives life to these generalized categories of existence—as tribal members, women, and artists—centrally informs these debates. Our concern with place-based aesthetics is mirrored through a feminist ethics, which asserts not only a referenced locale, but also the quality of relationships between people.[7] We are not defending nor defining essentialized categories; we are engaging the categories to unpack them, to shirk off the labels and rename our subject positions.[8]

It is difficult to resist the temptation to structure our chapter with an overview of sovereignty, of colonial impact, or even the extent to which American modernism appropriated stylistic motifs of American Indian forms of abstraction and painting techniques, while relegating Native art to curio markets.[9] Instead, we will bypass re-counting this history, though we invoke it, and enter the conversation by situating it in time and place. In this way, our methodology is consistent with the place-making gestures of the artists that we reference, collaborate with, and whose work is itself a methodological intervention into contemporary feminist art.

Curating Place

The idea of "curating place" draws on Indigenous methodologies of "spatial thinking," articulated by Native scholars, such as Vine Deloria, Jr., as a way of conceptualizing history away from Western timelines. Indigenous spatial ideology honors the wisdom of place-based knowledge as a "way of knowing" that shapes

cultural history.[10] In the context of Native fine arts, this approach is non-linear and constructed through the prismatic network of relationships required to make and circulate works of art. This emphasis on process and social relations forwards the production, movement, and interplay of arts, and forms a central focal point of our analysis. Formal attributes alone are insufficient as the authoritative lens by which we value aesthetic practice. The intersection of "tribal worlds" with the "art world" creates a potent space by which place becomes critically situated.

Indigenous methodology meets feminist methodology in understanding the self as subjective, yet at the same time, interconnected to the social worlds of family, community, and tribe, as well as to the environmental and cosmological worlds to which these inter-*relate*. The relationships of kinship and community mirror feminist imperatives through their emphasis on collaboration as a methodology for "getting things done," and the acknowledgment of women's knowledge, life cycles, and contributions to intergenerational projects of community and nation-building in the larger frame of Native sovereignty and self-determination. In these ways, Native women's art is not *an example* of feminist art; rather, Native women's art informs feminist art as much as it is informed by Native principles of inter-relatedness, such as the Lakota principle of *wakan skan skan* (that which moves through all things).

Curating Place in the Work of Colleen Cutschall

Tressa

I first met the Lakota artist and educator Colleen Cutschall in 1983, when she was an instructor at Oglala Lakota College on the Pine Ridge Reservation and I was a student accompanying my mentor, Professor Luis Kemnitzer, one of the founders of the American Indian Studies Department at San Francisco State University. Part of my rite of passage into community life involved me in the visiting rounds of women, and listening to their stories in the aftermath of Wounded Knee II, stories that continued to reverberate from the previous decade of uprisings and violent government interventions of the 1970s on the Pine Ridge reservation in South Dakota.[11]

The urban/rez boundary is a continuum, blurred in part by the dislocations caused by federal relocation policy,[12] and the subsequent "push back" activities of the American Indian Movement. It was in my own initial travels along these routes that I met Colleen, who was then a young "focalwoman"[13] of the Oglala Lakota community, where our now twenty-five year friendship and collaboration was first situated.

The notion of *in situ* is one that runs through Cutschall's work as a painter and installation artist, and a concept that I will explore here with particular reference to her multi-sited work, *Catching the Sun's Tail* (see Plate 15). This installation piece was created when Cutschall was Coordinator of Brandon

University's Visual Art and Aboriginal Arts Department in Brandon, Manitoba, Canada, in the early 1990s. The installation was commissioned by the Brandon University Foundation and was installed in the John E. Robbins Library at Brandon University in 1992 as part of that institution's public opening, and remained there until 2004. In 1996, it was included in the exhibition *House Made of Stars* at the Winnipeg Art Gallery in Manitoba. Its multiple sites thereby include a temporary installation in a public art gallery, a long-term installation at a university library, and a site tour of the Medicine Wheel National Monument, a joint-use area overseen by the Little Bighorn Battlefield National Monument of present-day Wyoming.[14]

Cutschall was inspired by the ritual function of the medicine wheel and the geographic locale of the Medicine Wheel inter-tribal gathering site in Big Horn, Wyoming. A National Historic Landmark, this cultural and archaeological site is part of a much larger complex of inter-related traditional use areas that express more than 7,000 years of Native American occupancy. The Medicine Wheel, as an historic and national monument, marks an ancient astronomical site, and serves as a cultural center point for a matrix of Plains tribes that joined at territorial junctions in the Big Horn Mountains. As Cutschall stated about *Catching the Sun's Tail* in relation to her other works, "While the piece is permanent and stands on its own, it is part of a larger concern about sacred Place [sic], ethnoastronomy and architecture and other sacred structures such as medicine wheel petroforms and their relationships to each other."[15]

Cutschall's installation mirrors not only the function of the medicine wheel as a vehicle for communal gathering and ceremonial restoration, it also is an art piece that symbolically refracts and conjoins the "pieces" of ceremony and objects associated with the actual ground and place of the Medicine Wheel historic site. The central component of the installation is the medicine wheel itself, formed out of rocks that the artist, her friends, and her family collected.[16] The wheel itself creates a space in which elements from earth and sky (cosmos) are united, thus joining the two in harmony. Monika Sormova described the piece for its 1994 iteration at the Richardson Library of Brandon University:

> In the installation, the human element is manifested in the ordered construction of the medicine wheel and the silhouettes of figures joining in a circle around the wheel in the fresco-styled background. The vertical axis coming from the center of the wheel is a symbol of the world axis that connects the cosmic regions of the underworld, earth and the upperworld. The axis is topped by a buffalo skull, a symbol of life and life generation . . . [The worlds are connected by] the floating white feathers linking the earth and sky. The light beams . . . direct this energy towards the center of the medicine wheel. At this moment the human and the celestial elements fuse into one creating a complete harmonious whole.[17]

As an artistic allusion to the archaeological and historic site of Medicine Wheel, Wyoming, Cutschall is not intending the re-situated art work as a reconstruction, but rather as a re-emplaced gesture that draws from elements of ritual and architectural form, place-based knowledge, and cultural content. The installation was made proportionate to its relocated spaces and re-purposed in the setting of public institutions (e.g., a library and an art gallery). In the public "welcome spaces" of the library and art gallery, it served the purpose of embracing those who entered the arc of the space.

Paradoxically, the healing intent of the installation was put to test in the throes of a controversy led by a small, but vocal group of Native American male art students. They objected to Cutschall's re-contextualization of the buffalo skull—viewed by them as a male-centered object referencing ritual aspects of the Lakota Sun Dance and its inter-tribal variations. The skull itself had never been ritually used; the artist retrieved it from the Museum of Manitoba where it had been incorrectly painted to resemble a Cheyenne Sundance skull. By her action, the artist was re-authenticating its ritual social function (to gather, to heal), while cleansing it of specific tribal or ceremonial attributes.

What was called into question were two things relevant to this discussion:

1. The artist's cultural rights as a woman to invoke the symbolic objects associated with the Sun Dance ceremony (a rigorous cycle of earth renewal rituals involving personal and family commitments of both men and women);
2. An artist's right to invoke, recall and re-vision the real through allegory and artistic form.

In these respects, space is not merely re-located; it is re-located within gendered proscriptions and loaded with cultural expectations—whether accurately lodged or not.

To better understand the context of the art work and its subsequent protests, it is important to note that the genesis of the piece took place during an actual site visit to Medicine Wheel National Monument in 1991, three years prior to the first public installation. Included in the group of students that Cutschall took to the site was a young Cree man who was first inspired by, then later offended by, the re-creation of ritual space. The site visit to Medicine Mountain (Little Big Horn) could thereby be understood as the first iteration of *Catching the Sun's Tail*. As Cutschall reflected about the field trip: "We had a very good experience of the place, of which the circular pink cloud formation was part. Additionally, we left offerings at all our places of pilgrimage."[18]

Student participation included important reckonings for Native students about their cultural histories and use rights associated with the sacred place. Such participation in the process of making and marking place invokes the very kind of "spatialized" approach proposed by Vine Deloria, Jr. cited in our earlier remarks. By excavating a collective meaning from the archaeological site, and

creating personal interpretative forms from it in new cultural frames, something was accomplished. That "something" had deep personal and reverberating effects for many of the student-participants, in a range of their own artistic responses. In the dynamic aspects of its place-based aesthetics, Cutschall's re-creation hit a cultural nerve. Yet this enlivening speaks directly to the possibilities of artistic work to awaken something within, even if initially or outwardly read as reactive.

Cutschall converts the meaning of culturally significant symbols, and also asserts her own personal voice as an artist. Personal narrative runs like a retrospective vein through the body of her work; the "personal" resides in her direct homage to Lakota histories, and the re-connection of women's central roles as ceremonial knowledge keepers and community organizers. Cutschall revisions the cultural narrative by reaching into the collective past, and yet cuts through it by re-shaping the symbol systems of Plains imagery, especially where stereotypes about Sioux Indians persist in the public imagination. Gender claims to these symbol systems have become deeply internalized, and at times even confused with post-colonial "push backs." For example, when Cutschall actively inserts female attributes into the male-dominated mythos of Plains iconography, potent cultural symbols are renegotiated and questioned.

The installation works of Colleen Cutschall, illustrated here by *Catching the Sun's Tail*, inscribe the relationships of people to place. Her processual works enact spatialized conversations with the past and its ongoing effects, made visible through the imprints of the artist.

Curating Place in the Work of Shelley Niro

Nancy

My introduction to the place of Venice, Italy, was tied intimately to the work of strong Indigenous women before me. In the mid 1990s, I was located in Santa Fe, New Mexico, both in terms of my professional research with Native artists and my obligations to my family. I was unversed and uninterested in the language of global biennales. Embedded in the community work I was accomplishing as an educator with American Indian students, I had no desire or interest in what I perceived at the time to be an exclusive setting for upwardly-mobile fine artists. My world had no meaningful connection to the international exhibitions that were beginning to occupy a major role in the interpretation and diffusion of global art currencies.

The tragic 1994 death of my friend and professional colleague Lindsay Croft, a visiting Aboriginal educator, created a chain of events culminating in the adoption of Croft's family into my family.[19] Lindsay Croft's sister Brenda Croft, a noted Aboriginal artist and curator, became a major influence in my life and it was at her suggestion that I attended the exhibit she curated for the Venice Biennale's Australian pavilion in 1997.[20] Brenda's presence in Venice resulted in my

inhabiting the space of the Biennale as an Indigenous representative, first as a guest and later as a curator and collaborator with Venetian colleagues. Since my initial visit in 1999, I have returned numerous times, staging six exhibitions of American Indian/First Nations art on this prestigious global stage. Dozens of Native and First Nations artists have participated in these initiatives that are jointly produced with our Italian collaborators. Over the years, the regional/global divide has transformed into local-to-local relationships that are defined by long-term, collective, mutually meaningful exchanges informed by mentorship. This is the *enactment* of Indigenous curatorial methodologies.

At the 2007 Venice Biennale, I co-curated with Ryan Rice the exhibition *Requickening*, featuring the work of artist/filmmaker Shelley Niro and performance artist Lori Blondeau at the University of Venice Ca' Foscari. "Requickening" refers to traditional Iroquois condolence ceremonies where human relationships are negotiated and brought back into balance after death or trauma. Our curatorial statement was in response to the call by Biennale curator Robert Storr to create exhibitions that spoke to art in the time of war. This cycle of grief and restoration that is enacted in requickening as a traditional knowledge system and as an exhibition platform spoke to larger concerns of global warfare and peace, colonial histories, memory, and importantly, healing.

Our challenge in 2007 was defined by the contingencies of place. How could we demarcate the ideas of life, death, and rebirth that were the central themes of our exhibit within the space of the Venetian lagoon? Our choices were informed by economics, institutions, and politics, but more centrally by the simplicity of belonging in our own stories. Telling stories and re-telling the stories of others became our central focus. In this way, we traced our sense of place while presenting the realities of Indigenous life to others. Our curatorial strategies relied upon a dynamic of creating space within the space of others. This was accomplished by both simple and direct interventions, such as marking off the performance area on the side of the canal with a circle of votive candles, but also by more abstract strategies articulated within the content of the artworks presented. My discussion will focus on the work of Shelley Niro and her film *Tree* that was shown outdoors for five nights during the Venice Biennale 52nd Esposizione Internazionale d'Arte.[21]

In *Tree*, a five-minute video produced in 2006, Niro ruminates on environmental degradation, women's wisdom, and the power of rebirth. The central narrative is a re-appropriation of the 1971 *Keep America Beautiful* campaign that featured non-Native actor Iron Eyes Cody as the Indian protagonist. The original public service announcement, known by the tagline "People start pollution. People can stop it," was such a successful ad campaign that Iron Eyes Cody achieved lasting fame as "The Crying Indian." Niro inverts the original by using a young Native woman (Lena Recollet) as the central character. This female earth mother similarly arrives at an urban area from the water, and confronts the ills of civilization, mourning the loss of respect for the natural world. In contrast to

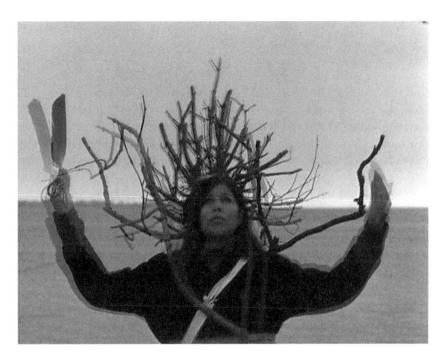

FIGURE 19.1 Shelley Niro, *Tree* (2006). Film still. Reprinted with permission of the artist.

the 1971 commercial that ends with the Native protagonist shedding a single tear, Niro's earth mother is re-born—branches grow from her silhouette until she is no longer of human form, but becomes one with a tree.

Tree is exemplary of Native sensibilities and feminist impulses. In *Women, Art and Society*, Whitney Chadwick identifies re-appropriation as a key feminist strategy and as "work that derives from media images and employs critical strategies of deconstruction, appropriation, and language."[22] Though Chadwick discusses Niro's photography in the same chapter as artists Jenny Holzer, Barbara Kruger, and Cindy Sherman, her analysis confines Niro's contribution as solely one of undermining cultural stereotypes. It can be argued however that Niro's practice exceeds this re-active qualification. Her use of self-portraiture, alterity, performance, humor, and mass media place her squarely within the feminist categories Chadwick describes. Clearly, her films are concerned with addressing the often-negative portrayal of Native women in mainstream media, but more powerfully, Niro's aesthetic sensibilities are aligned with values that speak to feminist concerns and then speak beyond them. Indigenous feminisms thus diverge from mainstream feminisms in their deep connections to place, in their embodiment of the female as an earth-centered deity, and in their conceptions concerning the circulation of knowledge.

Niro's unique visual sensibilities are evident in her depiction of the female figure in urban and rural settings. The earth mother powerfully occupies the frame proportionately according to the visual messages Niro intends. When Niro's earth mother encounters the cityscape, she does not simply stand alongside it as actor Iron Eyes Cody did in the original enactment. She enters it. Her figure becomes as large as the city buildings, with the camera panning backwards away from her imposing frame. This purposeful occupation of space renders the earth mother as a central player in the rampant consumerism and development she witnesses and ultimately critiques. As a visual component, her figure confronts the large urban structures that threatened to engulf the Native character played by Iron Eyes Cody in the original advertisement.

Contrastingly, as Niro's protagonist enters the natural landscape that is the site of her eventual metamorphosis, her figure is encompassed into the frame. She is proportionate to the vastness of the field she enters. As earth mother, she becomes an organic component to the landscape—not standing above it, but within it, similar to the tree she is ultimately to become. Contrast these configurations with Western landscape traditions, including the "master of all I see" convention in which the human figure looms high in the frame, surveying the landscape in an authoritative manner.[23]

It is critical to keep in mind that the land in these instances is not simply metaphoric of a female presence; in an Indigenous reading the land *is* female. Consequently, the audience is seeing the land itself in the close-up shots of the actor Lena Recollet's face. Her grimace at the end of the piece is evocative. We are not entirely sure if she is disgusted, tired, or humorously dismissing the viewer as inconsequential. I read her looking upwards and sideways as a sigh—almost a resignation to the folly of humans in their inability to properly care-take the earth's resources. Niro describes the utility of humor as "not always easy. It's something you have to work at," adding:

> I want the work to be digestible, not mean-spirited. I want it to be a satisfying experience no matter who you are. Sometimes humor has to be the bottom line. And often movies need to contain a surprise; people have to think, *Oh, I didn't see that coming.* You have to talk about the difficult things, and perhaps they're thinking, *Yes, yes, I know that.* But then if you give them something unexpected, that is amazing.[24]

Although *Tree* incorporates violent film segments—the hulks of destroyed Hiroshima buildings and shots depicting the 2006 Caledonia stand-off and protests at the Six Nations Reserve in southern Ontario, Canada—the viewer is not directly confronted with these harsh realities in a sustained fashion. These "difficult things" are balanced with the unexpected return to a frustrated earth mother. In a feminist reading, this disdain is a much more satisfying conclusion than Iron Eyes Cody's tragic mourning as he confronts the camera straight on. Our earth mother avoids

eye contact with the camera, conveying a powerful self-possession. Theoretical analyses vary in the significance attributed to direct eye contact. Does avoidance suggest the subject is superior to the viewer or that she occupies a lower status and must avoid confronting the viewer? An Indigenous reading of Niro's earth mother complicates this discussion, suggesting a third interpretation that offers the viewer a parallel engagement with the actor—not above or below in status but occupying the same space.

Goeman suggests the following aims are at play in Native feminist spatial discourse reading:

> (a) present alternative methods of reading space, race, culture, gender, and nation and thus assert a political practice that razes ongoing ideologies of colonialism; (b) unmoor "truth" maps from knowledge based on imperialist projects and assert Native ways of knowing that incorporate Native women's knowledges into the project of decolonization; (c) provide paths and routes to heal the rifts and borders that maps of difference (such as men's/women's space, rez/urban) continue to construct in the wake of colonialism.[25]

Niro's *Tree* effectively provides this platform for discussion via her critique of warfare and capitalism, her incorporation of Native knowledge, especially as it is expressed in a female-centered format and her use of healing via humor and faith in an earth presence. An alternative method of reading space is made available via Niro's earth mother figure that occupies and then becomes a part of the natural world. This disruption of the standard narrative via Niro's own version of the "push back" importantly relies on parody and humor as a means of coping with colonial legacies.

Discussion

The recounting of relationships formed in the arts via political actions is a critical component of Native feminist spatial practice, which Goeman has articulated, and upon which we build. By centering the relationships of family, friends, things, and beings in place and the cosmos, our "spatialized aesthetic" moves beyond the strictly "relational" as a system of signs or objects as abstract relations.[26] Rather, the development of a Native feminist aesthetic can be found in the systems of relationships centered by women, and through which their social and kin networks are simultaneously anchored in place.

A place-based aesthetic from the standpoints of Native American art and feminism incorporates both visible and invisible traces of history as aspects of strategic design. These are the frames in which we as curators and authors work—staging, writing about Native American art, and re-configuring space (literally, as curators) as the very ground for cultural expression and the making of social relationships. Linking Deloria's spatialized conception of cultural

history with gender as an intersecting nexus of culture, a Native feminist spatial dialogue also conceives of space as unbounded by geo-politics, yet storied and continuous.[27]

In its Native conceptions, a place-based aesthetic is also rooted in language. For example, Navajo scholar Lloyd Lee profoundly pushes for decolonization of space through the philosophies of *hozho* and *sa'ah naaghai bik'eh hozhoon* in his essay "Reclaiming Indigenous Intellectual, Political and Geographic Space." According to Lee:

> present day resolutions have not restored the health and prosperity of all the people. Navajo thought states that *all* Navajo people are integral to the continuance of the nation. Navajo people's spiritual, mental, emotional and physical wellness is dependent on *all* people of society, not just a few.[28]

A dialogue that opens up immutable spaces—such as the reservation as an artifact of colonization—becomes extremely important in developing a Native sovereign spatial discourse that includes the "all" mentioned in Lee's analysis.

This elucidation of Indigenous wisdom in the ways suggested by creative acts of inclusion is evident in the works of Colleen Cutschall and Shelley Niro. In Cutschall's work, it is the gathering of stones, like the gathering of tribes, that creates the nation anew. In a career that spans more than three decades, her paintings, installations, writings, and teachings are themselves a reflexive lineage, embodying the Lakota concept of *tiyospaye*, the discrete groups of relations that together make up the whole of the nation. Niro's film *Tree* suggests that urban and rural landscapes are places of Indigenous belonging. Her "taking, imagining, and re-creating" the city to "construct a sense of place" mirrors the common legacy of relocation and cultural fragmentation that were government policies of the 1950s and 1960s. Precisely because of colonial practices that alienated Indigenous populations from their traditional land bases, a shared sense of identity today must be constructed through re-articulations of meaning within social networks—in cities, reservations, and in our own imaginations.

This use of personal narrative finds deep parallel with feminist methodologies that reclaim the personal—not only as political, but as part of the collective "push back" as a form of "talking back." The larger question we have been asked to address—the relationship between American Indian art and feminist art—attempts to engage the conversation through the feminist methodology of lived know-ledge, noting that the intersections we draw forge a new discourse beyond binary categories that feminist theory also strives to break down (e.g., men/women, traditional/contemporary, and even rez/urban). The values planted and propagated by feminist art-making, such as values of collaboration, are likewise mirrored in Native kinship practices. In exploring these intersections, we not only highlight art-making as a resistance strategy, we consider its forms and aesthetics as extensions of the relationships that give it its impact and meanings.

Notes

1 The following sources may be useful for readers seeking to expand upon the discussions contained within this chapter: Joyce Green, ed., *Making Space for Indigenous Feminism* (London: Zed Books, 2007); Cynthia Chavez Lamar and Sherry Farrell Racette with Lara Evans, eds., *Art in Our Lives: Native Women Artists in Dialogue* (Santa Fé, NM: School of Advanced Research Press, 2010). See also the April 23–24, 2010 symposium, "Unpacking the Indigenous Female Body," at Simon Fraser University, Department of Gender, Sexuality, and Women's Studies, Burnaby, BC Canada moderated by Dana Claxton.

2 Mishuana R. Goeman, "Notes Toward a Native Feminism's Spatial Practice," *Wicazo Sa Review* (Fall 2009): 170.

3 Ibid., 171.

4 Ibid., 184.

5 Max Carocci, "Living in an Urban Rez: Constructing San Francisco as Indian Land," in *Place and Native American Indian History and Culture*, ed. Joy Porter (New York: Peter Lang, 2007): 277.

6 In this chapter, we address the First Nations of Canada and the Native experience in the United States, though these are not the sole locations where our practice is situated. Berman's ongoing curatorial research in Australia equally informs our theory-building in trans-Indigenous contexts. However, in the United States, legal constructs define certain aspects of Native sovereignty in distinct relationship to the state, while at the same time, defining the rules of engagement via treaty-making and its subsequent abrogations.

7 Vicki Bell, *Culture and Performance: The Challenge of Ethics, Politics and Feminist Theory* (London: Oxford, 2007).

8 Cf. Lucy Lippard, *Mixed Blessings: New Art in a Multicultural America* (New York: Pantheon Books, 1990 and New York: The New Press, 2000); Nancy Marie Mithlo, *"Our Indian Princess": Subverting the Stereotype* (Santa Fé, NM: SAR Press, 2009).

9 See Bill Anthes *Native Moderns* (Durham, NC: Duke University Press 2006). Noah Hoffman makes a strong case for the influence of Hopi material culture and motifs in his unpublished work, "Rothko on Route 66." See also W. Jackson Rushing, *Native American Art and the New York Avant-Garde* (Austin: University of Texas, 1995).

10 See Keith Basso, *Wisdom Sits in Places* (Albuquerque: University of New Mexico Press, 1996); and Steve Pavlik and Daniel Wildcat, eds., *Vine Deloria, Jr. and His Influence on American Society* (Colorado: Fulcrum Library, 2006).

11 Mary Crow Dog, Mary and Richard Erdoes, *Lakota Woman* (New York: Harper Perennial, 1991); Stanley D. Lyman, *Wounded Knee 1973: A Personal Account* (Lincoln: University of Nebraska Press, 1993); Tressa Berman, "Women's Voices from Wounded Knee," unpublished paper delivered at the Western Women's Studies Association, Sacramento State University, 1990.

12 The Indian Relocation Act of 1956 (also known as Public Law 959 or the Adult Vocational Training Program) was part of the termination era of federal Indian policy, whereby tribal members were encouraged to leave reservation communities for work training programs in cities throughout the United States.

13 The term "focalwoman" describes a particular form of Native women's leadership that is not always public, but is necessary to "focus" and organize the work of others in the community. Focalwomen are recognized for these leadership skills. See Tressa Berman, *Circle of Goods: Women, Work and Welfare in a Reservation Community* (New York: SUNY Press, 2003).

14 Additionally, Federal Indian Law now allows for the protection of Native ceremonial sites, as well as the rights to practice religious ceremonies closed to the public, and with special use rights for designated tribes. Namely, the American Indian Religious

Freedom Act (AIRFA) of 1978 and the 1990 Native American Graves Protection and Repatriation Act (NAGPRA) as enforcing policies.

15 Colleen Cutschall, unpublished paper, "Farenheit 451 Due North."

16 Michael Boss, "*Catching the Sun's Tail*," *Artscape* 2:1 (Summer 1994).

17 Exhibition gallery statement by Monika Sormova for the Richardson Library, Brandon University, Brandon, Manitoba (1994).

18 Colleen Cutschall, unpublished paper, "Farenheit 451 Due North," and personal communication with author.

19 Australian National University News, "Remembering the Crofts," Winter 2009. http://news.anu.edu.au/?p=1160.

20 Brenda Croft and Hetti Perkins co-curated the exhibit "Fluent" featuring the artists Emily Kame Kngwarreye, Yvonne Koolmatrie, and Judy Watson at the 47th Venice Biennale in 1997. This historic curatorial project continues to produce cultural flows in Australia, one of the subjects of Berman's research there.

21 For more on the exhibit aims, please see Mithlo's forthcoming essay "Silly Little Things: Framing Global Self-Appropriations in Native Arts," in Tressa Berman, ed., *No Deal! Indigenous Arts and the Politics of Possession* (Albuquerque, NM: SAR Press, forthcoming).

22 Whitney Chadwick, *Women, Art and Society*, 3rd edition (London: Thames and Hudson, 1990): 180.

23 Caspar David Friedrich's 1818 *Wanderer above the Sea of Fog* exemplifies this classic Romantic style of landscape painting with its central figure positioned above a rocky precipice.

24 Michael Hoolboom, *Practical Dreamers: Conversations with Movie Artists* (Canada: Coach House Books, 2008): 99.

25 Mishuana R. Goeman, "Notes Toward a Native Feminism's Spatial Practice," *Wicazo Sa Review* (Fall 2009): 184.

26 Nicolas Bourriaud, *Relational Aesthetics* (Paris: Presses du réel, 2002).

27 E.g., Doreen Massey, *Space, Place, and Gender* (Minneapolis: University of Minnesota Press, 1994).

28 Lloyd Lee, "Reclaiming Indigenous Intellectual, Political, and Geographic Space: A Path for Navajo Nationhood," *American Indian Quarterly* 32:1 (Winter 2008): 101.

20

MARGINAL DISCOURSE AND PACIFIC RIM WOMEN'S ARTS[1]

Ying-Ying Chien

> I've lived in Hsin Chuang for twenty some years,
> But never felt anything about it,
> Just want to leave as soon as possible.
> —from "Hsin Chuang Women's Stories" by Mali Wu[2]

> Hsin Chuang is a place where I lost a part of myself,
> What was it?
> Alas, it was my innocent youth!
> —Interview with a female worker, November 1997[3]

A transnational perspective highlights the permeability of national borders and traces themes that transcend the boundaries that delineate nations or states. A "minor" transnational perspective not only locates these themes in metropolitan spaces occupied by minorities but also insists on how these themes in places peripheral to the focus of traditional Western academic discourse, such as Taiwan, can suggest networks of cultures that do not always need to be mediated by, or disseminated through, metropolitan centers (Lionnet 1994, 1995).[4] In a similar spirit, this review essay will focus on the visual artworks of Taiwanese, Korean, and Japanese women artists in their (dis)engagement with metropolitan feminist art, examining in some detail an exhibit called *Lord of the Rim: In Herself/For Herself*, held December 1997–January 1998 in Hsin Chuang, a small textile city at the border of the Taipei Rim in northern Taiwan.[5] Hsin Chuang, the site of this exhibit, an industrialized city once filled with female workers from all over the island, was devoted to the so-called modernization of Taiwan; accordingly, the exhibit's goals include recording the memories, the oral histories, and the development of third-world

countries more generally. Gender, identity, and the representation of marginal subjects are its driving organizational principles.

The title of the exhibit, *Lord of the Rim*, is a reference to the Pacific Rim, although the participating artists come from both sides of the rim: Taiwan, Korea, and Japan on the western edge and, on the eastern edge of the rim, the west coast of North America. Hsin Chuang is itself on a rim within this rim: an industrial suburb of Taipei in northern Taiwan, it perches on the rim of the Taipei basin. Its relation to Taipei is that of a geographical microcosm of the relation of Taiwan to the larger Pacific Rim. Moreover, Hsin Chuang has been traditionally one of the important centers of Taiwan's textile industry, whose labor force even today consists almost exclusively of nameless female workers from remote areas of the island who create brand-name clothing that is marketed worldwide under European or other first-world labels. The theme of the exhibit, then, is closely tied to the Hsin Chuang locale and touches on not only gender and class but marginality and identity. This connection was not fortuitous but, rather, was carefully nurtured by the curator, Rita Chang. She hosted the participating Asian artists for several days' residence in Hsin Chuang before the exhibit so that they could incorporate specifics of the local context into their work and even create some site-specific public collaborative artwork (Chang 1998a). As such, the exhibit is a dramatic demonstration of how minor transnationalisms attend to local particularities through committed engagements among or between peripheral places.

While woman writers in Taiwan had begun to gain some literary and social influence as early as the 1980s, it was not until the 1990s that woman working in the visual arts, long lacking financial and social support, were able to begin to find a forum for their work (Chien 1997b; Lu 2002). In this context, *Lord of the Rim* was one of the first important exhibits of women's art that brought together in the same venue local Taiwanese artists and artists of other Asian countries with those of North America (Chien 1998a). The distinctive and subtly layered significance of the *Lord of the Rim* exhibit rests, however, on a delicate convergence of particularities of cultural, historical, and geographical context. The selection of theme, locale, and participating artists makes the exhibit fertile ground for exploring in some detail not simply Asian women artists or cross-cultural dialogue but issues of gender, class, and identity that arise from the idiosyncrasies of this exhibit's context. One of my purposes here is to reveal some of this contextual detail in the hope that the exhibit's singular contribution will become more visible both to a wider local audience and to an international feminist one. This sort of transnational curatorial work must be encouraged, funded, and reproduced in other propitious locations across the globe.

Within the *Lord of the Rim* exhibit, complementing its attention to the juxtapositions of local settings was the work of one world-famous woman artist from the opposite side of the Pacific Rim in North America, Judy Chicago. To see coherence in this juxtaposition may require some explanation. In the summer

of 1996, I visited an exhibition at the UCLA Hammer Museum of Art titled *Sexual Politics: Judy Chicago's* Dinner Party *in Feminist Art History* (April–August 1996; see Jones 1996), a feminist art exhibit featuring the work of Chicago among many others. Upon returning to Taiwan, I published a review of that show in a literary journal, *Unitas*, suggesting that the time seemed ripe in Taiwan for a large-scale exhibit with a similar theme (Chien 1997a, 2000). Soon after, Chang, an independent art curator, organized an exhibit of works of female artists from Korea, Japan, and Taiwan to be held in the Hsin Chuang City Culture Center in the suburbs of Taipei. That exhibit in Hsin Chuang took place the following year, in 1998, just as I happened to be teaching a course titled "Feminist Aesthetics and Representation in Third-World Women Artists" in the Graduate Institute of Comparative Literature at Fu Jen University. My graduate students and I were thrilled at the prospect of the exhibit. Despite initial reservations about the location of such an exhibit, my students helped during the entire event: collecting data, interviewing local women, participating in related events and workshops, and preparing and recording the roundtable discussion hosted by our institute. And the exhibit included a great bonus—the participation of Chicago herself and the exhibition of her works at both the Hsin Chuang City Culture Center and at the Hanart (Taipei) Gallery. The greatest achievements of this exhibit were the transnational conception of the theme and the organization of participating artists from all sides of the rim.

The UCLA *Sexual Politics* exhibit examined the history of American feminist art from the 1960s through the 1990s, focusing on Chicago's groundbreaking work, *The Dinner Party*, as the centerpiece (Chicago 1993, 1996; Meyer 1997). Here in Asia, despite less extensive exhibition space and fewer participating artists, the *Lord of the Rim* exhibit was a historical breakthrough in terms of the developing contemporary women's art scene in Taiwan. The theme of the show was local women laborers and their life histories, a continuation of one of the Taipei Fine Arts Museum's 228 exhibit subthemes.[6] *Forgotten Women Victims* had focused attention on women who were marginalized or victimized during the social and political persecution of the 1950s.

What viable connection might there be between the work of Chicago from the eastern edge of the Pacific Rim and the exhibit's Asian artists from its western edge? Is it appropriate to include the work of America's preeminent feminist artist for the first time in Taiwan within the framework of an exhibit here devoted to the indigenous and the local? What is the significance of such a move? Could Chicago's historical status in the West and in Western feminist art overshadow the younger generation of Asian artists sharing the same space? And what sort of dialogue is possible for artists and works of such diverse origin? For answers, we have to look in some detail at the work of individual participating artists as well as at the particularities of the setting.

Despite differences in nationality and cultural background, there are striking concordances in choice of subject and materials among the work of these seven

artists. Seemingly by coincidence, all take as their point of departure a rediscovery of the hidden stories of women and, more particularly, reaffirm the importance of women's long overlooked and neglected domestic handicrafts. The exhibit as a whole is a reconstruction and re-presentation of her-story. Thus in materials and techniques, Chicago's use of porcelain painting, embroidery, knitting, and American patchwork quilting finds counterparts in the works of the Asian artists: Chun-Ju Lin's handmade cotton dolls, the traditional women's folk art of Yoshiko Shimada's *One Thousand Red Knots*, as well the shearing, stitching, and machine sewing used by many of the other artists. Content and imagery center around the various contributions of women in domestic "production" (housework, sexual services, menial labor) and "reproduction" (bearing and raising the next generation). Through the repeated use of female iconography such as the womb (Maggie Hsu), menstrual discharge (Lin), flowers (Mali Wu), placenta and condoms (Shimada), and even scissors and mirrors (Ahn Pil-Yun), these artists give voice to the confining female experiences common to their various cultures, recasting women's history transnationally.[7] In one corner of the *Lord of the Rim* exhibit space there runs continuously a video about Judy Chicago called *Womanhouse*, which takes its inspiration from concepts and imagery of a woman's art that Chicago developed in the 1970s; this quiet full flowering in 1990s Taiwan-Hsin Chuang may well have exceeded what Chicago expected to find here.

As far as differences are concerned, while Chicago's work in this exhibit honors important female historical figures of the West (such as the ninth-century German playwright Hrosvitha) and goddesses (such as Mother Earth), the works of the Japanese, Korean, and Taiwanese artists tend to transcend gender, focusing as much on ethnicity and social class as on political colonization and economic development. It is worth pointing out that to incorporate the exhibit's local theme in their works, the four artists from Taiwan, with limited time and budget available, investigated the local women's situation, interviewing female factory workers in Hsin Chuang and using a variety of techniques and forms of expression to represent these histories in their works. Shimada focuses more specifically on the controversial issue of women and war, with compelling works of protest against Japan's inhumane, oppressive use of comfort women and sex slaves (Korean, Taiwanese, and Japanese) during World War II.[8] Moreover, the Asian artists use eclectic modern approaches to engage the local setting of Hsin Chuang's textile industry. Incorporating installation, photography, video, written text, and oral history and juxtaposing machine technology and "cold and distant" elements such as handguns, plastics, aluminum foil, and other machine metals with traditionally feminine, natural, and warm elements such as aprons, handmade dolls, weaving, and clothing, they create powerful visual contrasts.

In fact, the transnationalism of the Hsin Chuang exhibit moves from the "great" female figures of the West to the powerless, marginal women (e.g., female laborers and comfort women) of Asia and Taiwan, and even to aboriginal subalterns. From my perspective, Chicago's participation in the exhibit, while historically and socially

significant, in no way overshadows or dilutes the presence of the Asian artists; rather, it creates a contrast that brings the unique character of their work into sharp relief.[9] A concurrent talk/roundtable discussion held at Fu Jen University's Graduate Institute of Comparative Literature—"Judy Chicago and Women Artists of East Asia"—was a first step toward transnational Pacific Rim dialogue. Had there been more funding and time, providing Chicago with an opportunity to familiarize herself with the industrial ecology of Hsin Chuang and the local women's art scene in Taiwan could have helped her to choose works more suitable to the occasion. To assess appropriately Chicago's contribution to this first exhibit in Taiwan, we need to consider not only the works exhibited at the Hsin Chuang Culture Center show that emphasize women and gender—three smaller pieces from the *The Dinner Party* (1979) and the large-scale *Earth Birth* quilt from her *Birth Project* (1983)—but also the works displayed at Hanart (Taipei) Gallery: pieces from her *Beyond the Flower* series as well as from *Powerplay* and *Thinking about Trees*, the former a series dramatizing male–female power struggles, the latter a meditation on nature, cities, and ecology. Taken together, the two exhibits give a fuller view of Chicago's oeuvre. An unfortunate gap is the regrettable absence from both exhibits of any pieces from her important latest work on the political persecution and genocide of the Jewish people, *The Holocaust Project* (1993). In this third phase of her work, Chicago combines her earlier interest in issues of gender and ecology with more recent concerns about race and ethnicity. Her later work would have related more closely to the themes of the *Lord of the Rim* exhibit, providing greater harmony with the local artists' interest in gender, ethnic, and racial persecution.

Unlike the exhibited works of Judy Chicago, the Hsin Chuang exhibit's installation works by the Taiwanese, Korean, and Japanese artists focus on the various forms of marginalization imposed on women of the third world. Exploring at various levels the issues of house and home, of the body and sex/gender, these artists expand and problematize traditional manifestations of the nuclear family, extending their exploration to the economic forces undergirding it: industrialization, militarism/imperialism, transnational trade, and various facets of patriarchal colonialist systems. They deal critically but in an integrated manner with issues of gender, class, ethnicity, and labor. Mali Wu's work, for example, seeks to represent the oral stories and silent secrets of the women of Hsin Chuang. On one wall she projects a black-and-white video loop of a close-up of a sewing machine needle endlessly stitching seams accompanied by the low audio drone of the pedal-operated machine at work. The loop constructs the exploited women laborers and their invisible social status in a form that mirrors the monotonous repetition of the labor itself. Chun-Ju Lin's *Production* (see Plate 16) and Maggie Hsu's *Yi, Yi* (see Figure 20.1)—the Chinese title a three-way play on homonyms meaning "Clothing/Placenta, She"—each implicitly critiques the objectification of the female worker's body under advanced industrial systems and the "reality" of the reproductive system's progressive dissolution. Self-proclaimed "female art

worker" Lulu Hou, in her thought-provoking photography installation *Labors and Labels*, not only touches on the relationship between women's handiwork and the machine but also, using local and international fashion labels, goes a step further to condemn first-world multinational businesses for their recolonization of third-world women for cheap labor. In Shimada's *One-Month Work*, six hundred condoms are neatly aligned on the milky white wall; on the floor below lies a nude female mannequin, which symbolizes the body of a comfort woman, awaiting visitors who would offer some covering with their own secondhand clothing. A self-acknowledged "descendant of a colonizer," Shimada reflects on Japan's transnational militarism and imperialism, imbuing these impressive, compelling works with critical force.[10]

FIGURE 20.1 Maggie Hsu, *Yi, Yi* (detail, right). Mixed media installation exhibited at *Lord of the Rim: In Herself/For Herself*, Hsin Chuang, Taiwan (1997). Reprinted with permission of the artist.

Through their engagement with the gendered and ethnic histories of Hsin Chuang's textile industry, the Taiwanese artists, under tight constraints of time and space, have presented a highly cohesive body of work. Taken together with the work of the other participating Asian artists (and even of the American), they have constructed an exhibit of remarkable intensity, coherence, and vigor. On the one hand, they affirm and validate the contribution of silenced working-class women; on the other, they criticize at various levels (political, economic, cultural) the "dark hand" (invisible force) of the underlying patriarchal system. The success of this exhibit lies not only in conferring on women of subaltern classes a legitimate subjectivity but also in including rituals and activities that invite the participation of all viewers, thus taking art from its former elitist temples and returning it to the grassroots level of all classes in Hsin Chuang and in Taipei County.

The organizers carefully planned events before and after the exhibit's opening that added a unique flavor to the entire experience, not only giving the works of the visiting artists the chance to sprout some roots in the local soil here but also allowing the art to function publicly and ceremonially, invoking blessings and healing for a wounded land. Mali Wu's purple room and its wall covering—cloth subtly woven of fallen flowers and hidden memories—can be seen as a metaphorical sacred space for the women immigrants of Hsin Chuang. Ahn Pil-Yun's idiosyncratic performance in which she frantically dashed about until she dropped among wandering headless robots in Korean and Western bridal gowns (remote controlled by two men at a distance) entails a critique of both Asian and Western women's subjugation under their patriarchal societies. Her concluding improvised mantra was offered to console the generations of nameless women and to accompany them to their rest in the next world. Shimada's unique collaborative creation, *One Thousand Red Knots*, brought together the collective efforts of hundreds of Hsin Chuang residents and students. Participating women of all ages and social classes wrote their names and wishes onto red cloth strips of the sort Shimada observed in Taiwan's local Taoist/Buddhist temples; the participants then hand stitched these onto an expansive white bolt of cloth as blessings offered to their relatives as well as to earlier generations of comfort women and to all fallen victims. Shimada sets out to subvert the implications of sexual colonization in the traditional Japanese use of the red knot, whereby a Japanese woman would stitch one on her belt as a symbol of protection for her soldier son or husband heading off to battle. But the artist, using this simplest of women's gestures—the stitch—gathers the collective force of will, releasing the women's collaborative mystical powers of suturing, revitalizing, and healing. Hsin Chuang women of all classes formed the core of this work, and it elevated all participants from the role of passive observers to that of "creators." It enticed viewers throughout the exhibit's duration to contribute to its gradual completion. There is an organic, even communal quality to this artwork that emphasizes the inter-action of common viewers and the very process of creation itself. Here, Chicago's idea of women artists in the West quilting together in the 1970s is transformed

transnationally, as a collective of artists and participants of different classes, ethnicities, and races in the Pacific Rim stitch up historical wounds together in the 1990s.

Here again, the particularities of place deserve some elucidation, for they cast Shimada's work in a specific light perhaps undetectable to Western viewers of her piece. Shimada's communal work borrowed symbolism from the era of Japan's colonization of Taiwan and Korea, specifically the red stitch used by Japanese wives to invoke protection of their soldier husbands. But among the hundreds of Taiwanese women collaborating in the communal work in Hsin Chuang, as Shimada clearly must have realized, there were those of the generation that had been enslaved by the Japanese to serve as comfort woman to these very same Japanese soldiers being protected by the red stitches of their wives back in Japan.

In a similar spirit is Taiwan fiber artist Jessica Huang's "Yarns of Remembrance" workshop. Huang gathered mothers and children of Taipei County together to take old clothing and to stitch and knot them in handmade dolls; the dolls were then hung on an old map of Taiwan to represent the sheer tax of toil that mothers have paid for the growth of this land.

As Judy Chicago's quilt shows Mother Earth to be the source of life, light, and power, so this women's art exhibit *Lord of the Rim: In Herself/For Herself* has functioned as a healing source as well. It is a rare and exciting first example of such collective work across national borders, paving the way for more of its kind.[11] In reality, this small collective of artists cannot yet be named "lord" of the rim, nor are they yet free to be completely them "selves," but their collaborative efforts to remember painful gendered experiences in ways that are healing to their communities deserve all the more to be acknowledged, honored, and documented.

Notes

1 I would like to thank Françoise Lionnet and Shu-Mei Shi for their support of and feedback on this article. Thanks are also due to the editors of *Signs* and to David Wible for their comments and suggestions for the revision.

2 The quote is from text appearing in an installation work titled "Hsin Chuang Women's Stories" by Mali Wu, exhibited in the *Lord of the Rim: In Herself/For Herself* exhibition, Hsin Chuang, Taiwan, 1997. Original in Chinese, translated by the author.

3 From an interview with a Hsin Chuang textile worker, quoted in Chang 1998b, 2. Original in Chinese, translated by the author.

4 For the ideas of transnationalism and minor transnationalism, see Lionnet and Shih forthcoming.

5 According to the curator Rita Chang, the title of the exhibit is from a book by Sterling Seagrave. However, since the term *lord* has gender and class implications, the adoption of such a term for the female workers at Hsin Chuang creates a sense of irony and paradox for the exhibit.

6 The Taipei Fine Arts Museum's 228 art exhibits are named in recognition of the February 28 Incident of 1947 on Taiwan that triggered a sweeping political suppression

resulting in the killing of thousands of Taiwanese by occupying Nationalist forces. Subsequently, since the lifting of martial law, its victims have been memorialized in various public venues (e.g., "228 Peace Park" in Taipei). One of these venues is an annual 228 art exhibit held by the Taipei Fine Arts Museum. In 1997 the exhibit included a subtheme titled *Victimized Women*, the exhibit referred to in the text.

7 The imagery of scissors in Ahn's works has double implications. On the one hand, it relates to separation, violence, or restrictions; on the other, it is a symbol of power, energy, and creativity for women. See Chien 1998b.

8 For reviews and an interview about Shimada's work and her reception in Japan, see Friis-Hansen 1993; Brown 1994; Itoi 1995; Shala 1995; and Hagiwara 1996, among others; see also Shimada 1997.

9 Despite some conflicts and tension between Chicago, the curator, and some of the other artists, Chicago's presence did stimulate the media's and the public's interest in this exhibit and hence in women's art as a result.

10 See Shimada 1997.

11 It is worth noting that the *Lord of the Rim* art exhibit has since been followed in Taiwan by two large-scale women's art exhibits in major museums in Taipei and Kaohsiung: *Mind and Spirit: Women's Art in Taiwan*, curated by Ying-Ying Lai for the Taipei Fine Arts Museum, in 1998, and *Journey of the Spirit: Taiwanese Women Artists and Contemporary Representations*, which I curated for the Kaohsiung Fine Arts Museum, December 2000–March 2001. Since then, many smaller local exhibits have flowered.

References

Brown, Azby. 1994. "Fascism in Japan: Yoshiko Shimada on Women in War." *World Art: The Magazine of Contemporary Visual Arts* (March): 24–7.

Chang, Rita. 1998a. "Lord of the Rim: In Herself, for Herself." *Artists* 227 (January): 338–41.

——. 1998b. "Lord of the Rim: In Herself/For Herself." In *Lord of the Rim: In Herself/For Herself* (museum catalog), 9–13. Hsin Chuang City, Taiwan: Hsin Chuang City Culture Center, February.

Chicago, Judy. 1993. *Through the Flower: My Struggle as a Woman Artist*. New York: Penguin.

——. 1996. *Beyond the Flower: The Autobiography of a Feminist Artist*. New York: Viking/Penguin.

Chien, Ying-Ying. 1997a. "Representation of 'Sexual Politics' and Judy Chicago's Feminist Art History: A Review." *Unitas* 13(4): 56–61.

——, ed. 1997b. *Identity, Difference, Subjectivity: From Feminism to Post-colonial Cultural Imagination*. Taipei: Lishu Wenhua.

——. 1998a. "From 'Sexual Politics' to 'Lord of the Rim.'" *Unitas* 14(6): 128–32.

——. 1998b. "Through/beyond the Flower: Roundtable Discussion of Judy Chicago and Women Artists in Taiwan." *Chung-Wai Literary Monthly* 26(13): 102–15.

——. 2000. *Daughter's Rituals: Women's Spirit and Artistic Representation in Taiwan*. Taipei: Fembooks.

Friis-Hansen, Dana. 1993. "News: Feminist Anti-imperialist Show in Japan." *Flash Art* (November/December): 52.

Hagiwara, Hiroko. 1996. "Comfort Women/Women of Conformity: The Work of Shimada Yoshiko." In *Generations and Geographies in the Visual Arts: Feminist Readings*, ed. Griselda Pollock, 253–65. New York: Routledge.

Itoi, Kay. 1995. "Interview: An Artist Shunned at Home?" *Newsweek*, July 31, 64.

Jones, Amelia, ed. 1996. *Sexual Politics: Judy Chicago's* Dinner Party *in Feminist Art History*. Berkeley: University of California Press.

Lionnet, Françoise. 1994. *Autobiographical Voices: Race, Gender, Self-Portraiture*. Ithaca, N.Y.: Cornell University Press.

———. 1995. *Postcolonial Representations: Women, Literature, Identity*. Ithaca, N.Y.: Cornell University Press.

Lionnet, Françoise, and Shu-Mei Shi, eds. Forthcoming. "Introduction." In their *Minor Transnationalism*. Durham, N.C.: Duke University Press.

Lu, Victoria. 2002. *History of (Contemporary) Taiwan Women Artists*. Taipei: Artists.

Meyer, Laura. 1997. "A Monumental Meal." *Gadfly* (September): 6–11, 26.

Shala, Nancy. 1995. "Of Art and War: The Legacy of World War II in Japanese Contemporary Art." *Asian Art News* 5(1): 32–7.

Shimada, Yoshiko. 1997. "Ten-Thousand Knots and Japanese Women's Arts." Unpublished recordings of a lecture presented at the Graduate Institute of Comparative Literature, December 1, Fu Jen University, Taipei.

21

CURATORIAL PRACTICE AS COLLABORATION IN THE UNITED STATES AND ITALY

Jo Anna Isaak, Gaia Cianfanelli, and Caterina Iaquinta

The following was conceived in response to a revival of interest in contemporary feminist art and the histories of feminist politics in the art world. Jo Anna Isaak assesses some of the recent exhibitions held in the United States and Europe, provides a brief history of her own curatorial activity, and then introduces two Italian curators, Gaia Cianfanelli and Caterina Iaquinta, who discuss their curatorial organization START and their 2006 exhibition *Dissertare/Disertare* in the context of the feminist movement in Italy.[1]

Jo Anna Isaak

Recently, there has been an amazing resurgence of feminist art activity. Exhibitions, symposia, and publications have made the past few years a prolific time for women in the arts. *Art in America* devoted its summer 2007 issue to covering this surprising renewal of interest. From 2009 to 2011 the Centre Pompidou in Paris featured works by the women artists in its permanent collection. It was a massive, continuously changing exhibition that presented the history of modern art as told only by women artists, and a surprising testament to the collecting practices at the Centre Pompidou. In 2010, the Museum of Modern Art told the history of modern photography with photographs taken by women, and the Jewish Museum in New York opened an exhibition called *Shifting the Gaze: Painting and Feminism*. Two exhibitions of women artists in the international Pop Art movement opened in 2010—one at the Brooklyn Museum and another in Vienna.

A lot of this activity has been retrospective in nature, recounting or returning to the heyday of the feminist movement. *The Deconstructive Impulse: Women Artists Reconfigure the Signs of Power*, launched at the Neuberger Museum January 2011,

re-examined the period 1973 to 1992. *Global Feminisms: New Directions in Contemporary Art* at the Brooklyn Museum in 2007 was a re-evaluation of international feminist art. *WACK! Art and the Feminist Revolution* (2006–2007) examined the legacy of feminist activism and art making that occurred during the period 1965–1980. *REBELLE: Art and Feminism 1969–2009* in Arnhem in the Netherlands was an international review of forty years of feminist art. In Moscow and St. Petersburg there were several exhibitions, symposia, and publications focusing on women and gender discourse in Russian art from 1989 to 2009, including a re-publication of *Idioma*, the first Russian feminist art magazine, initially published in 1992. And, in spite of its title, the conference, *The Feminist Future: Theory and Practice in the Visual Arts* held in January of 2007 at the Museum of Modern Art in New York City, was redolent of nostalgia for the early days of the women's movement.

I understand this impulse to repeat: I did it myself in 1995 with the exhibition *Laughter Ten Years After*, which was a replay of an exhibition I had organized more than a decade earlier.[2] The first exhibition, *The Revolutionary Power of Women's Laughter*, was organized in the urgency of the moment, when the search for what could break the hold of representation was in high gear. By the early 1980s, fundamental discoveries in modern linguistics and psychoanalysis had radically affected understandings of how signifying systems operate. There was a growing awareness that a lot was at stake for women in these new assessments of how meaning is produced and organized in all areas of cultural practice. A feeling of solidarity developed as women working in various fields looked for "liberation from the prevailing truth of the established order," to quote Bakhtin's notion about the role of carnivalesque laughter.[3] Laughter was as a metaphor for transformation, for thinking about cultural change. It offered an analytic point of entry for understanding the relationships between the social and the symbolic while freeing us to imagine these relationships differently. The revolutionary power of women's laughter is first and foremost a communal response, not some private, depoliticized *jouissance*, but sensuous solidarity. Disparate theories of humor, women, art, power, and subversion leveled the playing field for women—and women artists, writers, curators, activists, and cultural and political workers of all kinds began to play in the new authority-free zone. We organized exhibitions, wrote books, arranged symposia, changed university curricula, changed art history texts, changed the history of art, and changed history.[4]

When I launched *Laughter Ten Years After* it was intended to include a broader range of artistic practices than the first exhibition and, as with all of the recent retrospective exhibitions, it was intended to commemorate the past.[5] By this time we were anxious that the work undertaken and the progress women had made was being lost or forgotten—we had come to see that women's history is written in a faint hand and must continually be re-inscribed before it is erased.

The present moment seems to be the time to take stock of the decades during which so much changed. In the United States it is clear that, in the field of art

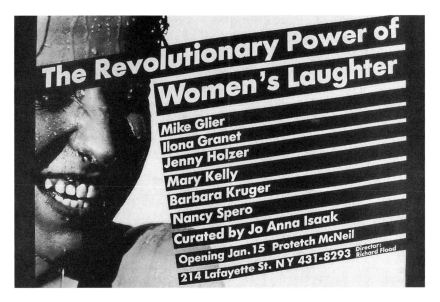

FIGURE 21.1 *The Revolutionary Power of Women's Laughter* (1983). Exhibition poster reprinted with permission of Jo Anna Isaak.

history, the academy is largely populated by women. Most American colleges and universities offer courses in women's studies, many offer courses in feminist art history, and it is not hard to find studio courses taught by women artists. A wealth of books, articles, collections of essays on women artists, and feminist critiques of art are written by women. Women are working as curators in many museums and galleries, and an increasing number of commercial galleries are owned and operated by women. For those of us who have taken part in this feminist campaign there is an enormous pleasure in seeing how much has changed as a direct result of our collective and concerted efforts.

While the heady days of the theoretical 1980s may be over, the influence of the paradigm shifts that took place during that period are very much in evidence today. Feminism's influence on art production, history, and reception in the United States is now so systemic that it is thought of as the norm. It is almost on the verge of being taken for granted. Curator Anne Hollander thinks "because the feminist movement has accomplished what it set out to accomplish, we're no longer forced to take a feminist agenda."[6] Rachel Whiteread acknowledges feminism's liberating force in the UK: "When things change they become part of the fabric of life rather than something one has to constantly fight against."[7]

For many of us in the earlier generation, becoming part of the "fabric of life" may sound a lot like fading into the woodwork. Yet how did we envision the end of the feminist campaign? Probably most of us did not think about our own

obsolescence; indeed, it seems premature to plan our retirement when rank inequities endure. As Anna Chave cautions us:

> Insofar as we imagine that an aggressively activist feminism—a commitment to claiming openly, persistently, a female and feminist subject position— should remain an artifact of the past, we are deluding ourselves about the true extent of the progress we have attained to date.[8]

But things have changed, and it is the project of these exhibitions, symposia, and publications to come to an understanding about what is at stake now for women artists in the new millennium.

Virginia Woolf thought every woman writer needed to have strong female precursors in order to be able to come into their own creative life. Young women artists now have a whole generation of women artists to draw upon and model a career and a viable way of living one's life as a woman artist. The influences from earlier artists at times may come to be felt as a burden. This problem was flatly articulated in *Fusion Cuisine*, an exhibition of young women artists held at the Deste Foundation, Center for Contemporary Art, Athens, Greece, in 2002. "You got a muse?" asks Zoe the girl singer in a band performing in a music video. "I got a fucking sweatshop full of them." Zoe is Zoe Lister-Jones, performance artist and the daughter of feminist video artist Ardele Lister. The lyrics Zoe sings reflect the sentiments of some artists of her generation. This proliferation of strong female precursors may explain why the feminism of the 1980s itself is seen, or *needs* to be seen, by some young women artists as part of an establishment that has to be overthrown, one of the hegemonic "isms" they need to repudiate before they can find their own voices as artists. Like a mantra in the video loop, Zoe repeats: "I refuse to be influenced by anyone who came of age in the sixties."[9] Work done in the 1980s by avowedly feminist artists— work that makes a clear political point, or is influenced by theoretical writings— may now be rejected as didactic, illustrative, or constraining. Egyptian born Ghada Amer, whose work deals with issues of gender and the nude female body and eroticism, found the French theoretical approach to feminism to be as stifling as the growing Islamic fundamentalism back in Egypt. She tells Barbara Pollack in an interview for *Artnews*: "I had to find a way to address extremism—both feminism and religious fanaticism and their parallel problems with the body and its relationship with seduction."[10]

While some of us may have become preoccupied with reliving or rebutting our feminist history, this is not happening in Italy. Italian institutions of higher education and art schools are largely devoid of gender studies. There are no women's studies programs, no courses on feminism in the curriculum, and almost no mention is made of Italian women artists in Italian histories of art. In spite of (or perhaps even because of) this lack of academic and institutional support, young Italian feminist curators are developing innovative methodologies and modes

of organizing collectives of women artists. *Dissertare/Disertare*, an exhibition held in Italy in 2006, managed to engage with the past, give center stage to the present, and gesture in very provocative ways to the future, particularly to the future role of the curator. What they accomplished may, in fact, be what the feminist movement in America has been waiting for. It may lead us out of the cul-de-sac of replay and rebuttal that we have been going around in for some time.

The title of the exhibition is a provocative paradox: "disertare" means "to desert" or "to abandon" while "dissertare" means "to discuss at length," as in, "to write or give a dissertation." The exhibition, the curators explained, intended to explore the ways in which the current generation of Italian women artists had either engaged with, or turned away from, the issues of the early Italian women's movement and to see what issues they were currently addressing. The manifesto explained the spirit and aims of the exhibition, and the curators used the Internet to cast what they called a *ragnatela*—a web, a net, to collect and support a diffuse network of ideas and projects that enabled various artists and organizations all over Italy to connect. The medium of the invitation itself (the Web) helped them in their aim to include a multiple voice dialogue and to diffuse the central, authorial role of the curator. Their invitation said simply, "Whoever wants to understand is invited to play."

Their invitation to play was no ordinary artists' call—it was an invocation of the revolutionary power of women's laughter. The net they cast turned out to be strong enough to support a large-scale, theoretically coherent group show, as well as elastic enough to transcend the political correctness, dogma, and factionalism that so often plague feminist exhibitions. In order to examine how the new generation of women artists have occupied the spaces in the discourse opened by feminist theory, they invited curators and artists' groups from all over Italy to respond. And respond they did! Twelve cultural associations and eleven independent curators brought together over fifty women artists.

For the most part, the artists in the exhibition were in their thirties and the majority of the work had been made in the past few years. The past, both in terms of feminist theory and cultural production, is referenced in the exhibition; it was incorporated in a way that informed and enriched the current work without dominating it. Yet, the exhibition was not a homage to the past. The artists in the exhibition seemed to have adopted the philosophy of Italy's well-known feminist—Carla Lonzi: "There are no goals, there is the present of our here and now. We are the world's dark past, we are giving shape to the present."[11]

A striking feature of the exhibition was the lack of images of victimized or mutilated women or images of motherhood that hark back to discredited essentialist notions of the commonality of female experiences. This marks a sharp contrast to a number of the exhibitions in the United States, particularly *Global Feminisms* where a great deal of the work displayed images of mutilated women's bodies as a symbol of protest. While the work of artists such as Gina Pane, who mutilated her own body to protest the ways in which women have been silenced

and damaged, had a strong influence upon Italian art in the 1970s, the current generation has chosen to abandon (*disertare*) the use of women's bodies as symbols of masochism or martyrdom. Instead, this exhibition shows how important and pleasurable it is for the feminine to be signified in new ways: images of women's bodies represent freedom from all kinds of physical, mental, and social constraint; it is a freedom they may not possess but need to nurture, as an idea or a feeling, as against the weight of gravity or oppression of everyday obligation.

While the strength and grace of women's bodies are celebrated, women's bodies are not "on display" in the same way they were in the generation represented in the *WACK!* exhibition where so many women used their own nude bodies as a courageous first step in self-affirmation. Women are not imaged as "fashion victims" either. The American preoccupation with analyzing, or repeating, the ways in which women's bodies are objectified or exploited by the film and fashion industry, seems to be totally lacking in this exhibition.

While a lot of the work in *Dissertare/Disertare* addresses current social and political issues, oddly enough one political protest that is absent from the exhibition is the protest against women artists' exclusion from the art world. There are no attempts to insert women into the canon of art history. No one seems to be doing the Guerrilla Girls' job of keeping statistical track of the inequities of the art world. This disinterested stance stems perhaps from the fact that Italian feminist thought and practice has long been wary of the paradigm of equality. Historically, the desire for equality has always been at the heart of the American feminist movement, but it seems that sexual equality is not, for many of Italian feminists, a feminist goal. Many would agree with Carla Lonzi's theory that a politics of equality ultimately promotes the continued entrapment of women in patriarchal structures. In her essay "Let's Spit on Hegel," she says:

> Woman's difference is her millennial absence from history. Let us profit from this difference; for once we have achieved inclusion in society, who is to say how many more centuries will have to pass before we can throw off this new yoke? The task of subverting the order of the patriarchal structure cannot be left to others. Equality is what is offered as legal rights to colonized people. And what is imposed on them as culture. It is the principle through which those with hegemonic power continue to control those without.[12]

Instead, Lonzi suggests, "The goal of seizing power should be emptied of meaning." This may explain why contemporary Italian women artists do not stage occupations of major museums, or picket outside them when no women artists are included in major shows, nor do they seem to be looking for a compensation for the way they are excluded from the dominant art world. The revolution that so radically altered the American academy in the last generation has simply not occurred in Italy. Instead of trying to gain access to, or change, outmoded

institutions, Italian feminism has flourished outside the institutions, outside the academy; it has grown independently in small collectives and women's cultural centers. And something similar seems to have happened in the women's art movement.

Women artists all over Italy are working outside the art institutions in small collectives to produce amazingly diverse work. What was needed was only a strategy to enable them to connect. And that is exactly what *Dissertare/Disertare* provided. Although large in scale, this exhibition is a long way away from the feminist blockbuster exhibitions, which emerged (particularly in the United States) from within a fully institutionalized version of feminist art. What these young curators are doing may be a modern version of what the 1863 Salon de Refusés did to the traditional Paris Salon—undermine the institution by organizing and exhibiting outside of it.

When I went with Gaia Cianfanelli and Caterina Iaquinta to see their exhibition we entered a castle filled with an abundance of women's art—fifty women artists from all over Italy working with the ease and grace of a natural force. Here was a haven and a laboratory for women artists examining the social realities, the cultural myths, and the material conditions of women's lives. The works represented an in-depth exploration of the production of women artists working alone or in small collectives in disparate centers in Italy today. Perhaps this exhibition is the answer to Virginia Woolf's question about whether it is better to be locked in to, or to be locked out of, the Oxbridge library walls?[13]

Gaia Cianfanelli and Caterina Iaquinta

Where Dissertare/Disertare all began

Gaia Cianfanelli and Caterina Iaquinta founded START, a cultural association of curators, in Rome in February 2004. START does not have an exhibition space of its own; its location changes according to the needs of its ongoing cultural and artistic projects implemented throughout Italy. It operates as a cultural workshop linking various fields of study to create an interdisciplinary forum and a network. The cultural operators involved in START projects come from different regions of Italy and this necessarily leads, in a preliminary phase of the work, to mapping out the cultural contexts of these partners and understanding their artistic identities. Thus, the duration and progress of START projects are influenced by the time it takes us to establish a dialogue and a proper relationship with these partners. But what does it mean to be a cultural association of curators today?

We established START as both a restricted workgroup (limited to ourselves: Gaia Cianfanelli and Caterina Iaquinta), and also one that is open to the cultural associations and curators involved in our projects. We have transformed the individual role and identity of the curator into a plurality to produce a multiplicity of different perspectives and approaches in both the planning phase and the

operational stage of implementation. This kind of association of curators operating in the visual arts and contemporary culture is a new approach that has established relationships with public and private art institutions in the contemporary art scene in Italy.

The dynamic potential of START derives from a desire to strengthen the relationship between collective curatorial activity and the artist; in some cases the cooperation established between the two creates a new artistic scenario. We are particularly interested in *how* to construct a project (the process) and not so much *what* it constructs (the result) because this involves exploring different points of view, an ongoing dialogue, and the creation and interpretation of the artistic work arising from the cooperation between the artist and the curator.

Realizing a curatorial project that is open to the participation of multiple cultural partners and stakeholders from different disciplinary fields involves in-depth analysis of complex issues. In addition, we aim to secure the involvement of the cultural institutions of our country. We believe that contemporary curatorial practice is capable of multiple forms of organization involving various readings of contemporary culture and it is thus important to define one's own curatorial methodology and approach.

START focuses on various historical and geographical issues, especially aspects of our own artistic culture that are important but have not been examined in enough depth and are not normally included in historical studies. Utilizing our method and structure leads us to propose topics that are freed from the self-celebratory and self-referential choices of curators who work individually because they are the result of a discourse among cultural partners who provide feedback and an overview of the current artistic situation. For example, significant START topics have included the work of women artists and their relationship with memory, as in the project entitled *Dissertare/Disertare* (Dissertating/Deserting), and the artistic situation of the neglected regions of Italy, as in our current project, *La Forza dei Legami Deboli* (The Force of Weak Bonds). The latter project in its first stage gave visibility to the work of several cultural associations of central and southern Italy; the second stage focused on work from the region of Molise.

Dissertare/Disertare presented a facet of new Italian art through an investigation of the legacy and current circumstances of art by women from different Italian regional areas. This project was conceived in 2004 and it concluded in 2008 with the publication of a book.[14] The curatorial approach we adopted emerged from our study of the trends and developments of visual forms of art by women. We demonstrated in this project how a particular curatorial practice brought forward specific themes and features of women's art, such as belonging to a particular artistic and cultural system and the impact of creating art through a network of relationships. In this way we were able to provide a transversal and heterogeneous reading, which was also locally situated.

Let us therefore start from the beginning of *Dissertare/Disertare*. These two words were a "text-manifesto," a project, a networking experiment, an exhibition,

a book, and at the same time an experience and a review of the artistic and cultural scene in Italy. But how were all these linked together? How did each of them develop in sequence? How could an identity emerge from all this? And how could these aspects be articulated in a flowing narration so that an underlying *fil rouge*, or Ariadne's thread, remained? Perhaps through an image that included them all: a network, an archipelago, a thin thread, but also a game of words, a dialogue of many voices, an echo, or a maze of words that we could sew together so as to reach those who spoke them, while allowing them to maintain their multiplicity and diversity.

On July 7, 2006, over fifty artists and twenty-two curators and cultural associations filled the halls of the Colonna Castle in Genazzano, Rome.[15] This opening was the culmination of a project that had been developing over two years. Summarizing, compiling, and comprehensively assessing the results in a catalogue a year later was almost as ambitious and demanding as the project itself, but it was the last effort required so that everything that had been conceived, debated, and organized could emerge in the words of those who had experienced, produced, and finally visited the exhibition.

Dissertare/Disertare was a means for discussing, overturning clichés, and criticizing the stereotypes connected with woman and her role. Thus the word *dissertare* has the sense of discussing, exchanging views, networking, being mobile, and getting involved in proposing new forms of "cultural action," while *disertare* means deserting or abandoning any static position and binding or coercive label. The methodology we chose became an instrument but also the content and subject of the research itself. We started from the word and from writing in order to weave a web made of cultural entities (associations and curators) with whom to activate a dialogue. We sent them a "text-manifesto" as an initial invitation and provocation and asked them to make a contribution to the project in response. We did not intend to simply mount a women's art exhibition but to discuss and monitor the condition of new artistic production in Italy, choosing one aspect of it, in this case that of gender.

This exhibition therefore attempted to present a complex panorama consisting of many different approaches not limited a priori to particular issues. When we saw the many works that were being presented, it became clear that they led us to the margins of the central issues, and thus to positions from which to change people's points of view. Thanks to the exhibition we examined many issues, but especially focused on the many different possible ways of observing, reading, and interpreting them.

The themes examined included illness (Ramacciotti); substance abuse (Rukavina); the mother–daughter relationship (Ricci); the woman in relation to pregnancy and becoming a mother (Alberti); individual history or micro-history and the narrating voice not as *logos* but as *body* connected to physicality and emotion (Cattani); the daily gesture (Salini); the construction of an identity compromised by strict rules and social conventions that always represent the same unchanging

points of view (Ricciardi); the difference between the north and south of the world (Aro), distinctions between the East and the West (Perilli), and the shifting blurred boundaries, names, and identities of these domains (Ferratto); the face (one's own) and the mask (Glorioso); the dream, precariousness, and the search for "balance" (Nicoletta, Gruber, Valenti); violence and the "tragic" aspect of daily life (Mazzoleni); madness and social stability (Romano); the invasion of public space (Paloscia); our perceptions and preconceptions of the female body (Mineva, Panisson, Russo); personal and domestic space (Oravecz, Visani, Usunier); identity

FIGURE 21.2 Francesca Riccio, *Cucchiaini* (2002). Installation, print on steel, aluminium, soil. Reprinted with permission of the artist.

based on food (Cini); the fleeting almost imperceptible aspects and "spaces" of communication (Fadda); trans-sexuality and difference (McGregor); dressing-up, disguise and taking on other identities (Muzi); objects as an expression of cultural identity (Motaria, Torregrossa); social memory (Perrelli); and writing about the Self (Cologni).

These are just some of the elements and issues arising from the works of the artists presented in the exhibition. The many techniques used by the artists are equally multi-faceted and testify to the diversity of means, expression, and intention, and the potential construction or reconstruction of identities, imaginations, and situations.

The text we sent to associations and curators as an invitation to take part in the *Dissertare/Disertare* project includes a quotation from Luce Irigaray's celebrated text *Speculum of the Other Woman*:

> Turn everything upside down, inside out, back to front. *Rack it with radical convulsions,* carry back, re-import, those crises that her "body" suffers in her impotence to say what disturbs her. Insist also and deliberately upon those *blanks* in discourse which recall the places of her exclusion and which, by their *silent plasticity,* ensure the cohesion, the articulation, the coherent expansion of established forms . . . *Overthrow syntax.*[16]

This is an excerpt from a book that quickly became a classic of feminist thought and led to Irigaray's expulsion from the University of Vincennes in 1974. Many years have passed since then and generations of women artists have emerged, forging and mirroring themselves in Irigaray's writings as well as those of other women theorists. What is the effect of these words today? Have the blanks in the discourse been filled and, if so, how?

Historically, women's art production has been burdened by a bias that has prevented its free development and as a result it is often culturally pigeonholed and isolated in a political and ideological ghetto. With *Dissertare/Disertare* we combated these circumstances by presenting diverse, spontaneous, and intentionally non-stereotypical "female" reactions and representations. The reactions solicited from cultural operators working in several areas in Italy generated a novel and different vision of the current art scene.[17]

We chose to apply a curatorial practice which had perhaps never been tried in Italy before. This method is something in between a filing system and a shared working platform, in which the knowledge of various fields is interwoven and stratified. For this reason, and thanks to the quantity of information that can be distributed and collected, the Internet proved to be an excellent tool. In the case of *Dissertare/Disertare*, the Web provided us and the participating contributors with the technical means to give voice, space, and concrete visibility to an artistic project in which a continuous stream of images and information constantly changed the points of reference of dialogue, and provided a basis for the curatorial and creative

roles to shift and oscillate, as the operating modalities shrank and expanded around the artists. The system we adopted proved to be sensitive to certain types of artistic experiences and cultural resources, and optimizing the resources of space and time allowed for the simultaneous progress of a dialogue of many voices, while always offering the possibility for a work in progress that could gradually multiply its sphere of action. The networking approach allowed us to form a map of the contemporary cultural scene, and to show how its protagonists fit into the Italian art system, how they define and evaluate their work, and what tools they use in their work.

When we started thinking about the theoretical aspects of *Dissertare/Disertare*, and then while elaborating its structure, we felt the pressing need to express knowledge that had been buried or not circulated in our country, as well as integrating this knowledge with new modes of cultural production. We therefore chose to engage with both female and feminist art to experience an alternative method of curatorial work as well as to grapple with the ideas and issues that we would present first within the project and then in the exhibition. The creation of a text as a "manifesto" (meant to reference avant-garde features of the 1970s), and the substantial level of participation and the proposals which followed, all pointed toward a different way of working in which the hierarchy and decision-making powers were transformed and fused in the process of an ever-evolving dialogue.

In this way the project and the exhibition as well as the publication of the catalogue constituted our attempt to create a community of purpose, thought, intentions and reflections that converge in a large-scale, yet coherent, exhibition. In *Dissertare/Disertare* the message of a request for change and a new viewpoint within the Italian art system was sometimes explicit, sometimes hidden. The final result was an extended overview of the art scene of young women in Italy that drew attention to their creative potential at work throughout Italy, and that pointed toward the possibility of new avenues and modalities of research connected in a free and non-restrictive way to the traditions and memories of art.

Caterina Iaquinta

The Message of Carla Lonzi: a Dialogue with Feminism and Art in Italy

The main question we explored with *Dissertare/Disertare* was feminism and its historical perception in Italy. Aware of the complexities of raising this question, we wondered how young women artists in Italy were connected with their past and their history. In Italy there has been a prolonged absence of women from the art world, or if they did participate their work was integrated into national historical movements (e.g. Forma1, Gruppo T, Arte Povera, and Pop Art). This has meant that the topics, issues, and actions that they proposed often did not

emerge with any autonomy of meaning, but were scattered and dispersed within the dominant ideologies.

In this perspective, the contribution of Carla Lonzi to Italian feminist art history is of fundamental importance since she opened up the road to a new critical reading of artistic production. With her publication *Autoritratto* (1969),[18] her method of interpreting the work of art re-elaborated the delicate relationship between the critic and the artist. Carla Lonzi's innovation was to express this relationship through a series of interviews she conducted, which become the instrument and the key for the interpretation of both male and female artistic production. This approach draws attention to the method and practice of art criticism, which are discussed by Lonzi directly in the presence of the artists during interviews and dialogues. The voices and words of the artists, together with those of the author, thus take the place of the text by the socially recognized critic. This practice of questioning and "problematizing" the method and role of art criticism opened up new perspectives within feminism.

Lonzi stepped outside of an art system unable to represent the more dynamic and proactive artists of her generation. She had clear ideas concerning the issues of the relativity and responsibility of art criticism as an individual act. Thus she directed her professional activity toward a form of criticism and study based on direct dialogue and proximity between the critic and the artist in order to achieve an analysis that recognizes both their personal motivations and direct experiences of the present artistic moment.

Lonzi pointed out how a critique that omits reception and interpretation of the artist's work ends up as an imposition of power, and thus hinders the liberating attitude of art and a more direct form of communication with the public. Hence her drastic decision, in 1970, to give up the socially recognized role of art critic just after the publication of her *Autoritratto*, and to opt for feminist theory and political activism by joining the Gruppo di Rivolta Femminile (Group of Women's Revolt) for which she wrote the manifesto in 1970. As she wrote in 1973:

> No-one is so conditioned a priori that they cannot free themselves, and no-one will be so unconditioned a priori that they are free. We women are not irremediably conditioned. It is just that an experience of liberation expressed by us has not existed over the centuries. These writings were nothing but a step towards that experience: its premise and its prophecy.[19]

From this moment on, Carla Lonzi transformed her approach to art criticism in her new critical method that emphasized relationships. Lonzi thus became an example and a spokesperson for an entire generation of women and women artists, especially feminists. In fact, if we examine the history of art in Italy from a historical perspective of the political and social events that took place in the 1960s and 1970s, it becomes clear how much contemporary art owes to the work of feminists, particularly in work concerning language and speech. This wave of change initiated

by feminist movements marks the transition between the late 1960s and 1970s in Italy. The period is furthermore characterized by the height of the crisis of the neo-avant-gardes, in their various utopian aspects, as well as that of the more "poetic" artistic movements. Attention was given to overcoming cultural elitism, the liberation and poetic re-use of the means of mass communication, and the radical renewal of society and social relationships through the tools of artistic creativity or better still the attainment of a successful integration between art and life.

In 1971 Linda Nochlin asked, "Why have there been no great women artists?" as she tried to understand in epistemological terms the cultural processes which had produced and reproduced the same cultural stereotypes. In the same crucial year, Carla Lonzi co-wrote the manifesto *Assenza della donna dai momenti celebrativi della manifestazione creativa maschile*[20] (The Absence of Woman from the Celebrative Moments of Male Creative Manifestation), renouncing the traditional role of women in art as idealized muse or passive partner of the male artist. Nevertheless in Lonzi's manifesto the rejection of the social conditioning imposed by tradition is neither expressed as a challenge or protest nor as an "ideological judgment" condemning male creativity as such. Instead, by means of "a liberating and therefore creative act of becoming aware," it proposes a non-submissive and vital alternative to it.[21]

The revolts, demonstrations, political actions, and community experiences realized by feminists in the 1970s also made a large contribution to artistic production. In 1963 Gruppo 70 was founded in Florence by Daniele Piccini and Lamberto Pignotti, who were later joined by Lucia Marcucci, Ketty La Rocca, and then Mirella Bentivoglio, Giuseppe Chiari, Emilio Isgrò, and others. From the 1960s until the late 1970s women artists became ever more directly involved with the group, above all in its exhibitions. In 1975 for example, at the Fortezza di Olofredi on Lake Iseo (Brescia), the exhibition *Magma* with Romana Loda as curator, brought more and less well-known Italian and international women artists together and laid the foundations for a reflection on the proper way to present the issue of women in art, while expressing a specifically Italian position.

The artists involved in *Magma* included Suzanne Santoro, Verita Monselles, Marianne Pitzen, Andreina Robotti, Stephanie Oursler, Valie Export, Iole de Freitas, Lygia Clark, Nanda Vigo, Carla Cerati, Paola Mattioli, Gina Pane, Marina Abramovic, Ketty La Rocca, Hanne Dabroven, Edda Renouf, Dorothea Rockburne, Diana Rabito, and Katharina Sieverding. In 1978 many women artists exhibited their work at the Biennial of Venice in the section *Materializzazione del linguaggio* (Materialization of Language), with Mirella Bentivoglio as curator. This section exhibited work by eighty women from eleven different countries, having as a common denominator expressive means and practices involving the word, the image, and music. Also in 1978, the exhibition *Mezzo Cielo* (Half Heaven) was held in the Gigliola Rovasino Gallery in Milan for six months with a sequence of temporary exhibitions of women artists in order to provide several

coherent group shows as well as solo exhibitions. Among the participants there were Gabriella Benedini, Marcella Campagnano, Fernanda Fedi, Lucia Piscator, Elisabeth Scheffering, and Lucia Sterlocchi.[22]

In those years the first female scholars also started to offer their theoretical contributions to the field of female art, leading the way to the research of the 1980s and 1990s. Foremost among them were Luciana Rubino, with her book *Le spose del vento: la donna nelle arti e nel design degli ultimi cento anni* (The Wives of the Wind: Women in the Arts and Design of the Last Hundred Years—published Verona, 1979), Simona Weller, with *Il complesso di Michelangelo. Ricerca sul contributo dato dalla donna all'arte italiana del Novecento* (The Complex of Michelangelo. Research on the Contribution of Women to Twentieth Century Italian Art—Macerata, 1976) and Elsa Emmy*, Donna, Arte, Marxismo. Con un'autoanalisi sullo sviluppo della creatività* (Woman, Art, Marxism. With a Self-analysis of Creativity—Rome, 1977). One should also bear in mind the critical writings of Anne Marie Boetti, many of whose articles were published in the magazine *Data*, and those of Lea Vergine, published in many art magazines such as *Bolaffi Arte*.

In the 1970s, a number of feminist collectives where women lived and worked together were set up in Rome and Milan, such as Movimento di Liberazione della Donna, Rivolta Femminile, Collettivo Femministe Alternative, and Fronte Italiano di Liberazione Femminile (Women's Liberation Movement, Female Revolt, Feminist Collective Alternatives, and the Italian Front of Women's Liberation). These collectives became the main gathering points for debates about feminism and for the expression of creativity. The first occupations of public buildings took place, such as at Palazzo Nardini on Via del Governo Vecchio in Rome, re-named Casa della Donna (House of Women) on October 2, 1976. These collectives were organized into Self-Awareness Groups (Gruppi di Autocoscienza) and they were engaged in political struggles such as implementing more equitable divorce law (1974) and the decriminalization of abortion law (1978).

But it was in the 1980s that critical theory took on a greater importance.[23] In 1980, theorists Luisa Muraro and Adriana Cavarero introduced the French feminist thought of Luce Irigaray, Julia Kristeva, and Hélène Cixous into Italy. With the foundation of Gruppo Diotima in Verona, the two Italian theorists organized some of their meetings at the Libreria delle Donne (Women's Bookshop) in Milan where they elaborated upon the themes of sexual difference and the construction of a feminist alternative to the language and gender rules of the tradition of male dominance.

In the 1990s many female scholars in Italy started to become increasingly interested in women artists and the role of women in the history of art, and they began planning exhibitions and projects in order to develop new artistic methodologies and encourage young women in the field. New studies emerged, such as "Ragazze: un incontro tra differenti generazioni di artiste italiane" ("Girls: A Meeting between Different Generations of Female Italian Artists") co-written

by Lisa Parola and Ivana Mulatero, and *Arte a parte: Donne artiste fra margini e centro* (*Art on the Sidelines: Women Artists between the Margins and the Center*, 2000) and *Donne d'arte* (*Women of Art*, 2006), both edited by Maria Antonietta Trasforini, who focuses on art, gender, and urban culture. In 1997 Lisa Parola co-founded the A-Titolo association in Turin, together with Giorgina Bertolino, Francesca Comisso, Nicoletta Leonardi, and Luisa Perlo. This association of critics, historians, and art journalists examines local areas and communities in connection with the themes of history and living memory, and the problems of coexistence and the neighborhood. The main instrument of its work has been dialogue with community residents and local institutions.

The work of Laura Iamurri, Carolina Brook, and Sabrina Spinazzè is dedicated to the relationship between women and the visual arts in Italian culture of the twentieth century.[24] Recently they have re-examined the visual models of Carla Lonzi's art criticism. Since 2001 Sabrina Spinazzè has been conducting research into Italian art during the 1800s and 1900s, with a particular attention to the Roman context and women's artistic production. Lia Giachero, who has long been interested in the role of women in the historical avant-gardes, has written essays on the Italian female futurists and the women artists of the Bloomsbury Group, editing the publication of the autobiographical writings of Vanessa Bell in 1997. Martina Corgnati, Emanuela De Cecco, and Francesca Pasini have also investigated contemporary female artistic production in their writings.[25]

In addition to the above mentioned scholars and authors, there are now many theorists and critics working within the sphere of women's studies in Italy, even though there are as yet no specific academic courses in mainstream Italian institutions on the history of artistic production by women, or even on gender studies or the history of feminism. Italian university courses seldom assign texts referring to women, with the exception of literature classes, where women are more frequently considered. Only independent organizations outside official contexts occasionally provide courses and classes on the above-mentioned themes.

What the feminist movement did during the 1970s, with the many practices and strategies of resistance that were developed and brought into public spaces, was to assert and claim not merely the "woman" as a subject, but the existence of a female subjectivity to be explored and discovered as heterogeneous and varied depending on contexts, histories, and forms of life, sex, and gender. Rather than setting up a female point of view in opposition to the Western white male point of view, the fundamental issue and strategy was to challenge all constructions of identity, both male and female, if they were based on absolute, generalizing points of view.

In its own way—and with its own resources, language, and potential—art has often pointed the way toward possible new worlds and new forms of subjectivity. This has occurred especially when art has become part of daily life by addressing the central issues of the age and by affecting through its experimental practices people's behaviors, emotions, and cultural systems. In our view, art should always

go a little beyond the status quo and convention, even by breaking with former experimental practices that might have been incorporated and thus weakened by the established and accepted cultural conventions and systems.

Dissertare/Disertare could be described as the continuation of several decades of feminist work. This exhibition, all that led up to it, and all that it has led to, evokes the moment just before the roll of the dice, when the dice are still being shaken in one's hands. In that moment one can have the illusion that everything is still possible and plausible, trusting to luck and staking everything on the outcome. It is part of that unpredictable movement of preparation and anticipation, when one thinks about each potential outcome and things can be described while they are still in progress. Any result can still emerge and the story of movements, practices, events, voices, and actions is still being told, so that in the end they are not just filled blanks and saturated voids but the living figures and forms of independently operating movements and systems. And this is just the first result before the next roll of the dice.

Notes

1 This chapter is an adaptation of the panel discussion "Curating Feminist Art in Europe and North America," *4th International Conference on the Arts in Society*, Venice, Italy, July 31, 2009.

2 *The Revolutionary Power of Women's Laughter* opened at Protetch/McNeil, New York City in January of 1983 and traveled in the United States and Canada for a period of two years. Included in that exhibition were the works of Mary Kelly, Jenny Holzer, Ilona Granet, Nancy Spero, Barbara Kruger, and Mike Glier.

3 Mikhail Bakhtin's monumental study *Rabelais and His World* reveals that women have historically been aligned with the popular comic tradition of misrule and that they have a political stake in this site of insurrection. Because it existed unofficially, outside the church, the carnivalesque was marked by exceptional radicalism, freedom, and ruthlessness: "carnival celebrates temporary liberation from the prevailing truth of the established order; it marks the suspension of all hierarchical rank, privileges, norms, and prohibitions." Mikhail Bakhtin, *Rabelais and His World*, trans. Helen Iswolsky (Cambridge, MA: MIT Press, 1968), p. 10.

4 Some of the events focusing upon women and laughter include: "Black Sphinx: On the Comedic in Modern Art," UCLA, Hammer Museum, May 20, 2007; "Faces of Laughter—Female Strategies in Art" at the Stedelijk Museum, Amsterdam in 2001; "Vice-Versa-Vice" at the Jan van Eyck Akademie in Maastricht, Holland in 1998; and "Virtue and Vulgarity: A Feminist Conference on Art, Science and the Body," held at the University of Reading in Reading, England in 1997—focused in large part on the body, humor, and the carnivalesque. Even the panel "Trash and the Abject" at the College Art Association in Los Angeles in 1999 focused on women and humor, as did the conference "Representing Hysteria," held at Trinity College, Hartford, Connecticut in 1988, "Exquisite/Corpse" at Artsite, Burlington, Vermont, 1996, and the discussion of primary narcissism at the CAPC Musée d'Art Contemporain in Bordeaux, France, in 1997.

5 *Laughter Ten Years After* included the work of twenty artists from numerous countries: Dotty Attie, Marie Baronnet, Dorothy Cross, Nancy Davidson, Nancy Dwyer, Ilona Granet, Kathy Grove, Guerilla Girls, Jenny Holzer, Mary Kelly, Barbara Kruger, Irina Nakhova, Lorraine O'Grady, Kathy Prendergast, Elaine Reichek, Cindy Sherman,

Jeanne Silverthorne, Nancy Spero, Susan Unterberg, and Carrie Mae Weems. The exhibition toured the United States for three years (1995 to 1998).

6 Ann Hollander quoted in Valerie Steiker, "Goddesses, Heroines & Wives," *Artnews*, September 2001, p. 144.

7 Whiteread cited in Carey Lovelace, "Weighing In On Feminism," *Art News*, May 1997, p. 145.

8 Anna Chave, "Women Artists, Women Art Historians, Women: 'Our Bodies, Ourselves'; Redux" unpublished presentation "Women Artists at the Millennium," Princeton University, November 10, 2001.

9 "Zoe Come Home," a five-channel music video by Guy Richards Smit presented at Team Gallery, New York City, January 2 to February 9, 2002.

10 Quoted in Barbara Pollack, "The New Look of Feminism," *Artnews*, September 2001, p. 134.

11 Carla Lonzi, *Rivolta Femminile* 1, 2, 3, (Milan, 1970) translated by Veronica Newman in *Italian Feminist Thought: A Reader*, eds. Paola Bono and Sandra Kemp (Oxford: Blackwell, 1991), p. 59.

12 Ibid., p. 41.

13 Virginia Woolf, *A Room of One's Own* (New York: Harcourt Brace, 1929), p. 24.

14 Gaia Cianfanelli and Caterina Iaquinta, *Dissertare/Disertare* (Busalla, Genoa: Plug_in, 2008).

15 The artists: Elisabetta Alberti, Alessandra Andrini, Elizabeth Aro, Atrium Project, Fabrizio Basso, Sara Basta, Bianco & Valente, Annalisa Cattani, Silvia Cini, Elena Cologni, Francesca Cristellotti, Simona Di Lascio, Christine De La Garenne, Simonetta Fadda, Mariana Ferratto, Valentina Glorioso, Ulrike Gruber, Alice Guareschi, Goldiechiari, Koroo, Lorenza Lucchi Basili, Sabrina Marotta, Libera Mazzoleni, Amanda McGregor, Dessislava Mineva, Motaria, Sabrina Muzi, Sandrine Nicoletta, Valentina Noferini, Anita Timea Oravecz, Paola Paloscia, Benedetta Panisson, Laurina Paperina, Chiara Pergola, Luana Perilli, Maria Vittoria Perrelli, Michela Pozzi, Giada Giulia Pucci, Arianna Pecchia Ramacciotti, Moira Ricci, Cloti Ricciardi, Francesca Riccio, Fiorella Rizzo, Stefania Romano, Anna Rossi, Ivana Russo, Nika Rukavina, Erica Sagona, Lucrezia Salerno, Guendalina Salini, Maria Salvati, Monica Stemmer, Federica Tavian, Adriana Torregrossa, Francesca Tusa, Sophie Usunier, Marta Valenti, Marcella Vanzo, Anna Visani, Elisa Vladilo, Cristina Zamagni.

16 Luce Irigaray (Catherine Gill, translator), *Speculum of the Other Woman* (Ithaca, NY: Cornell University Press, 1985), p. 142.

17 With reference to the project and the exhibition see Cianfanelli and Iaquinta, *Dissertare/Dissertare* texts by Gaia Cianfanelli, Caterina Iaquinta, Jo Anna Isaak, Carla Subrizi, and Antonio Tursi.

18 Carla Lonzi, *Autoritratto. Accardi, Alviani, Castellani, Consagra, Fabro, Fontana, Kounellis, Nigro, Paolini, Pascali, Rotella, Scarpitta e Turcato Twombly* (De Donato Bari, 1979). The talks with these artists refer to the years between 1965 and 1969.

19 Carla Lonzi, *Premessa*, in *Sputiamo su Hegel. La donna clitoridea e la donna vaginale e altri scritti, Scritti di Rivolta Femminile*, 1, 2, 3 (Milan, 1974), p. 9.

20 In *Rivolta Femminile* (Milan, March 1971), also in *Rivolta Femminile: Scritti di Rivolta Femminile* (3 volumes, Milan, 1974), pp. 63–65.

21 *Rivolta Femminile, Assenza Della Donna dai momenti celebrativi della manifestazione creativa maschile*, in Carla Lonzi, *Sputiamo su Hegel. La Donna Clitoridea e la donna vaginale e altre scritti, Scritti di Rivolta Femminile*, 1, 2, 3 (Milan, March 1971), p. 65.

22 See Elena Di Raddo and Cristina Casero, *Anni 70, L'arte dell'impegno in Italia* (Milan: Silvana Editoriale, Cinisello Balsamo, 2009).

23 For this aspect of the history of feminism see A. Cavarero and F. Restaino, *Le Filosofie Femministe* (Milan: Mondadori, 2002).

24 They organized the conference *Donne e arti visive nella cultura italiana del Novecento* (2001) for the Ministry of Heritage and Cultural Activities. The minutes of the conference were collected in the book *L'arte delle donne nell'Italia del Novecento* (with S. Spinazzè, Rome, 2001).

25 Martina Corgnati, *Artiste* (Milan: Mondadori, 2004); Emanuela De Cecco and Gianni Romano, *Contemporanee. Percorsi e Poetiche delle artiste dagli anni Ottanta a oggi* (Milan: postmediabooks, 2002); Francesca Pasini and Giorgio Verzotti (eds.), *Soggetto/Soggetto, Una nuova relazione nell'arte di oggi* (cat. mostra Castello di Rivoli, 1994, Milan: Charta Ed., 1994).

22
FEMINIST ACTIVIST ART PEDAGOGY

Unleashed and Engaged

Beverly Naidus

Learning the Dance

The steps toward becoming an artist can be precarious. The steps toward being a feminist can be more so. Ultimately, teaching how to be both seems to be the easy part. Maybe it is because you are able to look back for the teaching part and harness the energy that pushed you forward blindly, sometimes uncontrollably into the art part. For the feminist part, you need to let the anger and the grief push you in a boat until you meet another angry, grieving person. When you find each other you either have a support group or two people who cannot stand to hear the other speak—two cracked mirrors blurred by damage and miscommunication or two clear mirrors where the contrast and detail is splendid and nourishing.

First, it is crucial to know that I stepped very gingerly into my art practice.

The family script and class ideology dictated that I was supposed to enjoy art, not *make* it. Only my inchoate rebellion against a narrow life based on secure bank accounts prevented me from hesitation. Perhaps there was a muse or two involved, but I could not hear them very clearly most of the time. My antenna was often set on the static of the early 1970s; what came through and into my art practice was a miracle.

Two of those miracles happened when I was twenty, a junior in college, looking to understand why I had chosen art or why art had chosen me. The first was the gift of my printmaking teacher, who despite his attempts to reinvent me as a queen bee (the one woman distinct from all the others and destined for some form of male-sanctioned greatness), had the insight to introduce me to a book that had been meaningful to him, Ben Shahn's *The Shape of Content* (1957). Although my first reading of this book was superficial at best, I did receive one message deeply: teaching art and making art could be inseparable in the quest for a humane society.

As I learned later, teaching is often seen as a sign of being "less than," implying some sort of mediocrity as an art practitioner. Or it is seen as a career choice reeking of a pragmatism that drowns the spirit of the true artist. This is an attitude I still encounter when I meet artist peers, successful in the high art world, who wonder why on earth I would *choose* not to make art full time.

The second miracle was the first awkward embrace of my female peers, who showed me that queen bee-dom meant a lifetime of alienation and unnecessary suffering. The year was 1973. The work of the Feminist Art Program (facilitated by Judy Chicago and Miriam Schapiro) at the California Institute of the Arts and the startling installations and performances emerging from *Womanhouse* (a site-specific project created by the students of Chicago and Schapiro) had just made their way to our campus via videotape and journal articles. Buoyed by the excitement of these West Coast projects, female art students on my campus began to meet together. In our discussions, we vented our frustration about having no or few female role models as teachers in our art history courses or in the studio classroom. In response, we demanded our own budget from those in power to bring feminist artists to campus, mount a women's art show, and organize women-directed and -written performances of poetry and theater. It was a watershed moment.

This second miracle included a little toxic waste that took me time to purge. The consciousness-raising session, which had been demanded by the female art students and was led by two well meaning, feminist, visiting artists from New York City, turned out to be more like a consciousness-shrinking affair. Their notions of what was liberated art and what was patriarchal were strange and uncomfortable. They critiqued the women students' art show, saying all the work that contained euphemistic "central" imagery was feminist and all other subject matter, be it landscape or portrait, was patriarchal. I was deeply disappointed by this formulaic thinking and swore off the f-word for a time, feeling no home within it.

A year or so later, as a token female student in my Canadian graduate program, I painfully realized I needed to find a way to make feminist thinking fit. I was angry and frustrated. I felt patronized by the male faculty and visiting artists, and the lone female faculty member seemed to be driven to the edge of madness by her male peers. She was joked about as that "neurotic, feminist artist." Is that what happens when you are isolated and attempt to claim your power?

At the time, a few female undergraduate students were discussing how they felt feminist thinking fit their working process, which helped me to see that I could reshape the theories I had found confining. I decided then that real feminist artists need a range of strategies and tools, rather than the woefully limited and sadly essentialist repertoire of images and objects representing boxes, eggs, wombs, vulvas, and openings. Publications such as *Heresies* magazine[1] and the ever-evolving writings of Lucy Lippard[2] also were helpful to me in integrating feminist thinking into my work.

Along with my investigations into gender as a marker of identity and power, I began to look at the history of art for social change. Even though I came from a politically liberal family and had a radical, blacklisted father, I had only limited knowledge of this history. My investigations took me back to the broadsheets visually documenting the peasant uprisings during the Middle Ages[3] to the prints and posters made in response to the civil rights movement in the United States.[4] With this new version of art history and a reading of John Berger's *Ways of Seeing* (1972), I began to build a method for deconstructing images and experiences of the world. This method required some comprehension of how class, race, cultural identity, religion, and other aspects of difference can influence our perception and value system. I was more than a bit mystified by the semiotic theory popular at the time, but I knew in my gut that I needed to raise these kinds of questions in order to offer the perspective my students needed and in order to make the art I needed to make.

Teaching Activist Art

After graduate school, I anxiously entered the job market (many of my early installations dealt with the perils of working life) and the New York art world at the same time. I had been advised that diving full tilt into New York City's art world would save me from a lifetime of academic exile in one boondock or another. Obviously, I had not yet examined the class and regional bias of such an attitude, as I was still invested in the ideal of the fiercely independent artist promoted in art school. Circumstances in the high art world at the time fostered a healthy environment for work with an activist bent, which encouraged my own practice. In 1984, I began teaching at my alma mater and for the first time had the chance to work with students for a more sustained period of time, allowing me to test out new ideas about how to mix content with process. Although the art department that hired me was primarily a traditional one with the standard fare of Drawing 100 and Composition and Color Theory, I was invited to develop some courses directly relating to my own art practice. One such course was Activist Art in Community. Since then, I have modified this kind of course to be a two-week, two-day, or three-hour workshop. Some of the key ingredients are outlined below.

Activist Art in Community

There are many different ways to open up a dialogue with a new group of students. It really depends on how much time you have and the context and the focus of the course. In Activist Art in Community, I introduce students to the history of activist art through a slide show of artists' work, from the past and present. A major goal of my slide shows is to expand the students' notions of what activist art can be. They need to know that all art reveals a value system through what

it depicts, who it is made for, and where it is displayed. I emphasize that even when art appears to be neutral or highly personal it has a political message. The latter is a lesson I learned from early feminist art.

Stereotypes about socially engaged art abound everywhere, but they are most prevalent in traditional art departments and art schools. The students in these programs rarely learn about socially engaged art, and if they do, they may be only presented with the most minimal understanding of it in the form of political posters, social realist murals, and various forms of "agit prop." There is also a deep, unspoken fear characterizing activist art as not really art. A possible source for this view is the old modernist attitude that art is not supposed to communicate a message, bend to any agenda, or be didactic. The pejorative connotation of the word "didactic" is in itself an interesting issue to ponder. When and how did it become inappropriate or out of fashion for art to teach something? Whom does that attitude serve? Often I have found communities of artists and art students to be entrenched in the modernist assumption that art is not supposed to be about anything but beauty and form. So I make it my responsibility to present many alternatives: that art can question assumptions, tell the stories of the invisible, initiate dialogue about polarizing topics, heal traumas, provoke a personal awakening, or transform consciousness. In my slide lectures, I share everything from the anti-war work of Käthe Kollwitz to the interactive installations of Carnival Knowledge, a collaborative project created in the early 1980s to educate audiences about reproductive rights for women through the playing of carnival games. I also include the very intimate, poignant, and sometimes humorous work of Jo Spence that looks at the struggle to fight breast cancer and the challenge of being female in relation to the medical industry. We also look at the less solitary expressions of two polarized communities (Muslim and Hindu) in the Black Country of England by examining the issues of motherhood and daughterhood through dance and poetry, facilitated by the skillful cultural animators, Jubilee Arts, now known as The Public.[5]

After this introduction to the work of a diverse group of artists, I ask the students to think about their own life experiences and choose a social issue that has deeply touched them. I often talk about working from the gut. Without the authority of that gut feeling, students can lose steam and the work lacks the passion that allows others to connect with it. With the story each student selects, we can begin the brainstorming process, leading to each student making an artwork based on her or his gut experience.

In classes that meet regularly over the course of a semester or quarter, I can expose students to a wide variety of forms, from posters to site-specific installations. Students can work on individual projects and also have a collaborative experience in the longer classes. But in a short-term workshop, I have to concentrate the experience, by having the students collaborate right away. I believe the latter process is essential for developing a permeable ego, that is, an ability to maintain one's individuality and creative source while working cooperatively with others.

In the collaborations, students need to discuss how their core issues and stories relate to one another and develop an intention for the work they will create together. They begin by composing a skills inventory, listing every skill each person brings to the collaboration including drawing, writing, cooking, note-taking, sign painting, networking—in other words, the skills both within and outside the margins of traditional artistic practice. From the inventory, they can begin to imagine a form their artwork might take and figure out how to scavenge appropriate materials given the amount of time they have to develop the project. They also need to think about the context in which their work will be seen and the audience to which it is directed.

In the shortest workshops, only a proposal for the project can emerge, which is critiqued and discussed by the whole class at the end of the process. In longer workshops and courses, students have time to create the project and then share it for feedback.

Before we finish the workshop or course, we always discuss how we can bring what we have learned back to our home communities and what students might want to facilitate on their own as a *cultural animator*.[6] The latter term is used within community-based art circles to signify an artist/activist who does not impose her or his story upon the community but rather catalyzes the community to create art about its own stories. It is a powerful process that requires trust and sensitivity, social skills rarely taught in art school.

An Arts for Social Change Curriculum

After fourteen years of full-time teaching in a private liberal arts college and different state universities, eleven years of adjunct work at private interdisciplinary colleges, a community college, a radical ecology summer institute,[7] and a variety of museums in New York City (along the way receiving tenure twice), I now have a position at the University of Washington, Tacoma, which has allowed me to develop my dream curriculum. I teach art to non-art majors within an interdisciplinary context. These are working class, nontraditional students of diverse age and life experience, many of whom are the first in their families to go to college and are often connected with the several military bases in the area. I took this job because I knew I would not be preaching to the choir.

Through the new curriculum I have created, I am able to manifest many aspects of my feminist and activist thinking in more developed ways. In every course, we discuss the deleterious effects of patriarchy, how dominant culture permeates our lives, the ways oppression works, and the ways that art and telling our own stories provides an antidote. My current course offerings include Art in a Time of War; Body Image and Art; Eco-art: Art in Response to the Environmental Crisis; Cultural Identity; Fear of Difference and Art; and Labor, Globalization and Art. A new concentration on Arts in Community, which will include a practicum in community-based art, is currently being developed.

Because the majority of my students come into my classes with few opinions about art, little experience making it, and are largely uninformed about the topic of activist art, I sometimes think I have a unique and formidable challenge. But, in truth, if I am able to make true human-to-human contact with these students, allaying their fears about what they perceive as their artistic and intellectual shortcomings, and inspiring them with an image that speaks deeply to their own particular pain or grief, then my work is not so hard. If in the space of ten weeks I can raise consciousness about the particular social issue we are discussing and empower the students to tell their stories about the topic through art, I have done my job.

In the first week of every course, my students learn something about the various roles art has played in society as decoration, entertainment, propaganda, social and political satire, memorials, or calls for justice. They also learn the basics of visual grammar (line, shape, composition, texture, color), look at examples of historical and contemporary art examining the social issue we are discussing, and develop some rudimentary artistic skills that might include drawing, digital imaging, collage, site-specific installation, interactive performance, assemblage, poster-making, video, and book-making. There are extensive readings in each course to help the students develop critical thinking skills about the topics the course addresses, and we discuss the topics at great length. But the primary goal of each course is to help the student to create art about her or his own experience. If the process does not intimidate students and they are not overwhelmed by the course content, there is enormous potential for them to access their voice.

I sometimes start the students on a project based on a lived or witnessed experience, and they bring the project in for several drafts and feedback sessions. In the latter sessions, we always start with the student's intentions for the work and then point out the strengths, while offering suggestions for how the work might be improved. Students worry about so many things: "am I doing it right?" being of the utmost concern. I often joke that this is not an art class where "you make your drawing of the pumpkin look like mine." Another worry comes from their fear of new materials and techniques, and my encouraging words about diving in and experimenting with them do not always work. Putting up unfinished or unresolved work in front of others is also frightening at first, but usually after the first few critiques, the students develop some resiliency. In our small classes of twelve to seventeen students, they cannot avoid being exposed from time to time.

A student in my Art in a Time of War class in 2006 told me in our conference that she really appreciated the course because it helped her to clarify issues and figure out what was important to her. This student had several generations of military personnel in her family and had voiced some fairly conventional views in class. Earlier in the semester when I asked her what she felt was important to her she said, "No matter what, I support the troops." I responded, "What do you mean by 'support'?" She looked confused so I added, "support can mean many things: are you supporting them by demanding that the government pays

for adequate counseling when they return home, or adequate health benefits? Are you supporting them by protesting to end the war, so that they can come home? Or by insisting that they get adequate protective armor, which the military has not given them, while they are on duty in Iraq?" She continued to look confused, but then replied, "I guess I have more thinking to do."

By the middle of the quarter, the students are ready to work collaboratively and develop a project that will be sited somewhere on campus. One eco-art, site-specific work was a pseudo-garden with furrowed rows for seeds but with labels that listed the heavy metals that "grow" in our superfund soil. An Art in a Time of War project was a chain-link fence into which was woven all the students' attitudes about war. It was quite controversial because the students, several of whom were veterans, decided to use actual US flags as part of the weaving, which included some red paint-spattered dolls. Veterans who were not in class but who were members of the campus community were very upset by the use of the flag in the art. I told the class about this reaction, and they asked for a dialogue to happen between the two groups. It never happened formally because it was the end of the quarter and the students could not make the time, but the impulse was a good one.

Because the content of these courses is often very charged and potentially polarizing, I try to create a safe space in the classroom, so students feel their points of view and their voices can be heard. Similarly, in my Cultural Identity and Art class, the students have to work through some complicated and uncomfortable issues surrounding race and privilege. We read theories of Whiteness, look at racism in our everyday lives that was previously invisible to white people, and discuss the difference between economic and political oppression and emotional damage. Without fail, every quarter, when I start teaching this class, a well-intentioned, white student says, "but I am NOT a racist. I have lots of friends of color." And although there are students of color in each class, they are a minority and often get romanticized by the white ones. The process of making art about each individual's cultural identity allows all of the students to own both their pride and shame (if they acknowledge the latter) and to approach those of other identities with better grounding and respect.

In my Eco-art class, there is a different kind of experiential learning that goes on. On the first day of class, we do a walking meditation that takes students around the campus. They are required to walk in silence, following their breath, and contemplating what is in the air, earth, and soil around them. Our campus is built on a superfund site and the aroma of Tacoma (from the mills and rendering plants) is often unpleasantly palpable.

Altering the students' senses through this first unhurried walk on campus gives them a chance to pause and reflect on the four elements and the toxics affecting them in their own backyards and regions. I have been deeply inspired by the ecofeminist Starhawk in the work I do with students in this class and use some of the exercises from her book, *The Earth Path: Grounding Your Spirit in the Rhythms*

of Nature (2004), to inspire creative problem solving. One week the students create art that investigates water (for instance, where their water comes from, and how it might be affected by pollution), the next week they look at air, the following week at earth, and finally we study fire (energy). These units involve site-specific exercises using scavenged materials. One involves collecting one hundred objects and creating metaphorical statements through their arrangement and placement on campus.

Depending on the quarter, the Eco-art students might look at local public art and write about how it relates to the community and the ecosystem. Alternately, the students will read an ecofeminist science fiction novel[8] and write about how it reflects the content of the course and how the ideas discussed might impact their own work. We read texts by Vandana Shiva (1997), Chaia Heller (1999), Brian Tokar (1997), and Joanna Macy (1998) comparing deep ecology to social ecology and thinking about the feminist role in both movements, as well as other aspects of ecopolitics and history. While much of our discussions have to be cursory, given the time limitations and the amount of terrain we are covering, I have found that these students are so ignorant of this history that any amount of work on the topic helps. Sadly, most of them have never heard of the World Trade Organization (WTO), the World Bank, or Terminator seeds. I also introduce the concept of "green washing" in corporate advertising and discuss the limitations of being merely a green consumer and recycler rather than working actively to change the priorities of our current consumer society.

Media Literacy and Culture Jamming

Important aspects in all of my courses are the media literacy and culture jamming exercises. These exercises are some of the most adaptable to different contexts, so I strongly encourage readers to incorporate something similar in your classes. First, I ask students to bring magazine ads that they find particularly offensive or ridiculous to class. They make note of what kind of magazine the ad came from as well as the audience the magazine is trying to reach. We put the ads up on the wall and deconstruct them in terms of the product being sold, the values the ads are promoting, and the ways visual grammar is used to serve those ends. In regard to the latter, we talk about what grabs our eye and why and how thousands of advertising dollars are spent deciding what visual strategy will be most effective at attracting "mindshare" (a piece of our minds). Our lists of what is being sold usually include sex, power, wealth, beauty, romance, adventure, nature, escape, celebrity, nationalism, patriotism, and safety.

That makes for a perfect segue into a discussion of culture jamming. Culture jamming, also known as subvertizing, involves a practitioner subverting the force of an advertisement through satire in order to reveal its real message. For instance, Ester Hernandez's well-known poster of a skeleton holding a basket of grapes entitled "Sun-Mad Raisins" redirects the original advertisement's message

about the sweetness of Sun Maid Raisins to the issue of the poisoning of farm workers.[9]

The majority of students easily understand this new form and are eager to try out their newfound skills in Photoshop or for the few technophobes, freehand photo-collage created with old magazines or catalogs, a cutting tool, and a glue stick. For a few students, culture jamming is a sluggish process; some don't understand parody, others don't see the need to critique corporations or the American culture of consumerism they are embedded in. My hope, in the latter case, is that someday in the future this project will be of value to these students.

As part of this project, we discuss whether this form of satire will have an impact on anyone or whether it can just as easily be co-opted by art directors from advertising agencies. I ask the students whether it is the form or the intention being co-opted and whether the latter can truly be co-opted. We talk about the value of humor in a socially engaged project and whether certain kinds of parody will alienate rather than attract viewers. Over the past year, I have noticed an increasing interest in media literacy. Both students who plan to become educators and those who are parents have told me they want to bring what they have learned in my class into their teaching, parenting, or volunteering at schools. This is very encouraging news.

Body Image and Art: A Close Up

In Winter 2006, I taught Body Image and Art with one of the most exciting groups of students I had ever worked with. There were thirteen women in the class (in a school that is 75 percent female this is not unexpected). I spent five weeks introducing questions about body image through the process of drawing, and the last five weeks introducing them to media literacy, culture jamming, and photo/text work. Most had never drawn before and/or were wounded by the careless remarks of elementary school art teachers about their creative capacity.

The first day of class they started with a body outline on a large sheet of paper. The work was done in pairs, and while one student drew, the other named what she liked and disliked about her body. They took their body outlines home and filled them in with symbols of how they felt about their body—there were no restrictions.

Then they read a variety of texts examining the history of body image, theories of the gaze, the diet industry, fat oppression, and the fat liberation movement. Readings vary from quarter to quarter but might include excerpts from *The Beauty Myth* (Wolf 1991), *Shadow on a Tightrope* (Schoenfielder and Wieser 1983), *Fat History* (Stearns 1997), *The Body Project* (Brumberg 1998), *Body Wars* (Maine 2000), *Unbearable Weight* (Bordo 1990), *Divining the Body* (Philips 2005), and *Fat?So!* (Wann 1999).

I instructed the students in an abbreviated breathing meditation to connect them with their bellies and asked them to send messages of love to the parts of their bodies they hated. After practicing contour and gesture drawing of their hands, feet, and faces, they had the opportunity to draw Rose, an experienced and self-confident nude model of ample proportions. The students were awed by her ease in her body. They remarked at how drawing her shifted their own body images. A practicing nurse said that before this experience the human body had always been the site of disease and ugliness, and now she saw beauty in folds, sags, and cellulite. She said it was wonderful to draw all of those supposed flaws, and that now she saw them as patterns of light and dark, "jewels in the shadows." The students talked to Rose about her feelings about her body and modeling. They stood in the poses she took and fell in love with charcoal and the sensuality of the whole experience.

Students in this class, as in all my classes, are required to do an oral presentation on a contemporary or historic artist whose work deals with the theme of the class. Their research must include the analysis of critical essays about the artist's work, and they must offer the class a question about the artist's work. Artists who are relevant to this course content are Hannah Wilke, Eleanor Antin, Joan Semmel, Judy Chicago, Ana Mendieta, Lorna Simpson, Vanessa Beecroft, Jo Spence, Carrie Mae Weems, Orlan, Louise Bourgeois, Frida Kahlo, Jenny Saville, Renee Cox, Young Soon Min, Hollis Sigler, Nancy Fried, Nan Goldin, Kiki Smith, Sylvia Sleigh, Shirin Neshat, Lynn Hershman, Carolee Schneeman, Laura Aguilar, Cindy Sherman, Spencer Tunick, and many others.

Using performance strategies to embody the content of the course has been an exciting new addition to the work I do in Body Image and Art. In this regard, I have been influenced by my study of the techniques employed by Theater of the Oppressed.[10] In the course, after a series of warm-ups, I have the students do "machines," exercises representing a celebration of their bodies as well as the ways they have experienced body hate. A machine starts with one student making a movement with a sound, the next student responds by "attaching" herself to the first student while making her own sound and movement, until all the students are making sounds and movements as one machine representing an issue or metaphor. They also get to practice Forum Theater and solve conflicts involving oppression of the body in different public and private situations. Forum Theater is a technique developed by Augusto Boal where performers act out a conflict that one or more of them have experienced, and the audience members (or "spect-actors") improvise ways of solving the conflict. Students also do some role-play about dancing in a club and dealing with unsolicited and unwanted attention and dealing with a cruel experience in a doctor's office. Students who had never acted before dove into this practice with such passion and humor, it made this teacher's heart sing. We were all transformed by the experience. The timing of our performance class was perfect. The students had just seen the *Vagina Monologues* over the weekend (V-day), and they were raring to go.

Exercises for the Women's Studies Context

Just before I started writing this, I had the good fortune to meet the Director of Women's Studies at Indiana University, South Bend, Rebecca Torstrick. Becky invited me to exhibit prints on her campus from my artist's book, *One Size Does Not Fit All* (1993), about women's often-tormented relationship to their bodies and to food, with strategies for healing and responding to this social problem.

As part of my visit, I gave a talk on my own artwork and led a workshop on making art for social change. When Becky introduced me to the audience she told them how my book had changed her life. She told me the content of the images and seeing the photo-collage technique had inspired her to create similar works. She felt that this medium was user-friendly. In addition, she explained how the book influenced her understanding of how art could deepen her students' experience of the topics being discussed and how she now assigns art projects in many of her classes.

Through talking to Becky I saw the usefulness of sharing more exercises that would help women's studies instructors enhance their teaching through a creative process with their students. In addition to projects using the collage technique, instructors might also find the following three projects useful.

1. Have your students introduce themselves in relation to history, thinking of their identities as something in motion. Have them describe the moment in history that we are living in. In this way students can speak about the pain of their lives with authority and as each student speaks in the circle, the discussion gains momentum and velocity.[11]
2. Have your students create a metaphorical bra using scavenged materials that speak of the students' relationship to the body, to patriarchy, to sexuality.[12]
3. Have your students make feminist action figures using scavenged materials or clay. Have them think of these figures as alternatives to what Disney and Mattel offer young girls and women as role models and have a reconfiguring Barbie® party.[13]

Looking Toward the Future

Yes, I get frustrated. Institutions are sluggish. Colleagues with limited vision and layers of insecurity so thick it makes one breathless are often controlling budgets and making poor decisions. Bureaucrats in power are usually frightened of change and lack initiative. Good ideas languish. Teachers with a serious commitment to student learning are often taken for granted.

But there are miracles. Feminist colleagues come together as allies. People with Freirian pedagogical philosophies[14] who want to empower students to find their voices get hired. Occasionally, a person in power has vision, chutzpah, and creates a momentary space for innovation and collaboration.

Also, I have my own visionary moments that keep me sane. I imagine endless platoons of media literacy educators unraveling the consumerist trance and deconstructing mindshare with students of all ages from coast to coast. I see women and men discovering their voices through art and teaching their children and extended families to do the same. I see community potlucks on every block where neighbors shape a new common public space and foster cultural democracy.

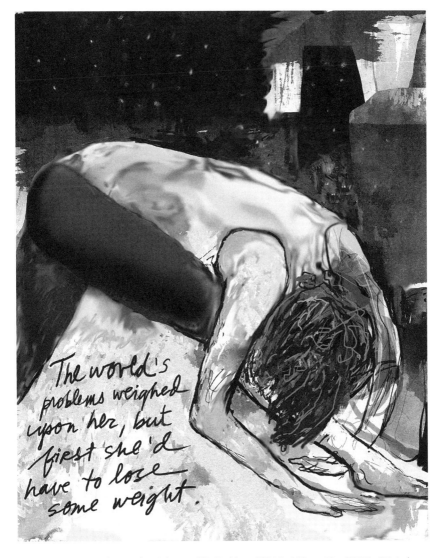

FIGURE 22.1 Beverly Naidus, *The World's Problems Weighed Upon Her* (2010). Digital drawing reworked from original ink drawing published in Naidus, *One Size Does Not Fit All* (Aigis Publications Ltd., 1993). Courtesy of the artist.

And every quarter, the little miracles of my students surprise me. For instance, in my Body Image and Art course a woman in her early twenties responded strongly to the topic of eating disorders in sororities and the brutality of the hazing process. She became animated when talking about a friend who had had these experiences. As we talked more about patriarchy and the effects of dominant culture on our psyches, she listened attentively. In her midterm self-evaluation she wrote: "feminism was always a dirty word to me. I had learned that feminists were extremists. Now I understand why women who claim their power would be seen as dangerous and dismissed by those in power. Now I want to be known as a feminist and own my power."

Feminist Activist Art: A Coda

Outside of the classroom, I don't often consciously think much about my feminist identity. Yet, when I look down from the ferry into the polluted waters of Commencement Bay, when I read about inflated housing prices and the rise in homelessness, when I co-parent my son, when I sit in my studio making feminist action figures for "sand tray" therapists whose collections were limited to the Wicked Witch of the West and the Little Mermaid, when I find a strategy for reaching a student who might not share my world view, and when I stand with my sisters in the local Code Pink chapter to protest war, it is my feminism that informs and frames my response to it all. And it is my art that translates it in image, object, and intervention and puts it back into the world.

Notes

1 *Heresies: A Feminist Magazine on Art and Politics* was published from 1977 to 1993. A newly selected collective of women created each issue, with the founding collective facilitating the process. The contributors came from varying political persuasions and artistic inclinations. The magazine was highly influential in the burgeoning feminist art movement.

2 Lucy R. Lippard is without a doubt one of the most significant writers about feminist and activist art to emerge in the art world. Her most influential feminist and activist works include *From the Center* (1976), *Get the Message: A Decade of Art for Social Change* (1984), *Mixed Blessings: New Art in a Multicultural America* (1990), *The Pink Glass Swan: Selected Essays on Feminist Art* (1995), and *Lure of the Local: Senses of Place in a Multicentered Society* (1997).

3 Ralph Shikes's book, *The Indignant Eye: The Artist as Social Critic in Prints and Drawings from the Fifteenth Century to Picasso*, was the first book I discovered during my graduate school research that looked at the history of art with social content (1969).

4 Paul Von Blum's book, *The Art of Social Conscience*, was one of the few books available in the 1970s that examined why artists would choose to create socially engaged work (1976).

5 The Public, formerly known as Jubilee Arts, is one of the oldest and most successful community-based arts organizations in the world. Based in West Bromwich, England, documentation of some of their projects can be viewed at www.thepublic.com.

6 "*Cultural animation* from the French *animation socio-culturel*, is a term that has gained increasing use internationally to describe community arts work which literally animates, or 'gives life to,' the underlying dynamic of a community. The *animateur* is a community artist who helps people create and celebrate their own culture, drawing freely on the particular aspirations, myths, ethnic or historical heritage that bind them as a community . . . The process, as much as the product, enriches community life and imparts a sense of common identity" (Reynolds 1984).

7 The Institute for Social Ecology, co-founded by Dan Chodorkoff and the late Murray Bookchin, was an extraordinary experiment in radical ecological and anti-oppression pedagogy that existed from 1974 until 2005. Initially accredited by Goddard College, this program educated community organizers, organic farmers, ecotechnologists, international leaders in the global justice movement, alternative health practitioners and educators, anarchist theorists, and activist artists.

8 Among the utopic/dystopic novels I recommend are Octavia Butler's *The Parable of the Sower* (1993), Marge Piercy's *He, She and It* (1991), Margaret Atwood's *Oryx and Crake* (2003), Charlotte Perkins Gilman's *Herland* (1979), Starhawk's *The Fifth Sacred Thing* (1994), Ursula Le Guin's *Always Coming Home* (1985), or Sally Miller Gearhart's *Wanderground* (1984).

9 See http://nmaa-ryder.si.edu/posters/process-noframe.html?/posters/sunmad.html.

10 See http://www.theatreoftheoppressed.org/en/index.php?nodeID=3.

11 This exercise was first suggested by my colleague and mentor, Charles Frederick, a cultural theorist, community artist (formerly with PAD/D), writer, and activist based in New York City.

12 There are many venues and events for creating metaphorical bras, often to support breast cancer research. See http://www.showusyourbra.org/ for an example.

13 The latter exercise was drawn from Susan Cahan and Zoya Kocur's *Contemporary Art and Multicultural Education* (1996).

14 Paulo Freire's *Pedagogy of the Oppressed* and his other works on radical education theory are not only responsible for transforming several generations of educators (literacy and otherwise), but his ideas are seen as a key factor in the sociopolitical shifts occurring all over Latin America today (1970).

References

Atwood, Margaret. 2003. *Oryx and Crake: A Novel*. New York: Nan A. Talese.

Berger, John. 1972. *Ways of Seeing*. London: Penguin.

Bordo, Susan. 1990. *Unbearable Weight: Feminism, Western Culture, and the Body*. Berkeley: University of California Press.

Brumberg, Joan Jacobs. 1998. *The Body Project: An Intimate History of American Girls*. New York: Vintage Books.

Butler, Octavia. 1993. *The Parable of the Sower*. New York: Four Walls, Eight Windows.

Cahan, Susan, and Zoya Kocur. 1996. *Contemporary Art and Multicultural Education*. New York: New Museum of Contemporary Art, and New York: Routledge.

Freire, Paulo. 1970. *Pedagogy of the Oppressed*. New York: Herder and Herder.

Gearhart, Sally Miller. 1984. *Wanderground: Stories of the Hill Women*. Boston: Alyson Publications.

Gilman, Charlotte Perkins. 1979. *Herland*. New York: Pantheon Books.

Heller, Chaia. 1999. *Ecology of Everyday Life: Rethinking the Desire for Nature*. Montreal: Black Rose Press.

Le Guin, Ursula. 1985. *Always Coming Home*. New York: Harper and Row.

Lippard, Lucy R. 1997. *Lure of the Local: Senses of Place in a Multicentered Society*. New York: New Press.

———. 1995. *The Pink Glass Swan: Selected Essays on Feminist Art*. New York: New Press.

———. 1990. *Mixed Blessings: New Art in a Multicultural America*. New York: Pantheon.

———. 1984. *Get the Message: A Decade of Art for Social Change*. New York: Dutton.

———. 1976. *From the Center: Feminist Essays on Women's Art*. New York: Dutton.

Macy, Joanna. 1998. *Coming Back to Life: Practices to Connect Our Lives, Our World*, Stony Creek. Connecticut: New Society Publishers.

Maine, Margo. 2000. *Body Wars: Making Peace with Women's Bodies: An Activist's Guide*. Carlsbad, CA: Gurze Books.

Naidus, Beverly. 2005. "Outside the Frame—Teaching Socially Engaged Art." *New Practices-New Pedagogies: A Reader*, ed. Malcolm Miles. London/New York: Routledge.

———. 2005. "Teaching Art as a Subversive Activity." In *Little Signs of Hope: The Arts, Education and Social Change*, eds. Mary Clare Powell and Vivien Marcow Speiser. New York: Peter Lang Publishing: Lesley University Series in Arts and Education. Volume 9.

———. 2001. "Breaking Out of the Box: The Subversive Potential of Interdisciplinary Arts." *The New Art Examiner*, February.

———. 1993/1996. *What Kinda Name Is That?* Self-published.

———. 1987. "The Artist/Teacher as Decoder and Catalyst." *Radical Teacher*, Fall.

———. 1993. *One Size Does Not Fit All*. Littleton, CO: Aigis Publications.

Philips, Jan. 2005. *Divining the Body: Reclaim the Holiness of Your Physical Self*. Woodstock, Vermont: Skylight Paths.

Piercy, Marge. 1991. *He, She and It: A Novel*. New York: A.A. Knopf.

Reynolds, Peter. 1984. "Cultural Animation." *Art and Ceremony in Sustainable Culture Issue* of *In Context* 5(Spring):32.

Schoenfielder, Lisa, and Barb Wieser, eds. 1983. *Shadow on a Tightrope: Writings by Women on Fat Oppression*. San Francisco: Aunt Lute Books.

Shahn, Ben. 1957. *The Shape of Content*. New York: Vintage Books.

Shikes, Ralph. 1969. *The Indignant Eye: The Artist as Social Critic in Prints and Drawings from the Fifteenth Century to Picasso*. Boston: Beacon.

Shiva, Vandana. 1997. *Biopiracy: The Plunder of Nature and Knowledge*. Boston: South End Press.

Starhawk. 2004. *The Earth Path: Grounding Your Spirit in the Rhythms of Nature*. San Francisco: Harper.

———. 1994. *The Fifth Sacred Thing*. New York: Bantam.

Stearns, Peter N. 1997. *Fat History: Bodies and Beauty in the Modern West*. New York: New York University Press.

Tokar, Brian. 1997. *Earth for Sale: Reclaiming Ecology in the Age of Corporate Greenwashing*. Boston: South End Press.

Von Blum, Paul. 1976. *The Art of Social Conscience*. New York: Universe Books.

Wann, Marilyn. 1999. *Fat? So!: Because You Don't Have to Apologize for Your Size*. Berkeley, CA: Ten Speed Press.

Wolf, Naomi. 1991. *The Beauty Myth: How Images of Beauty Are Used against Women*. New York: W. Morrow.

CONTRIBUTORS

Nancy Azara is an artist who has exhibited her sculpture and collages in New York City, throughout the United States, and abroad. Her work is carved, assembled, and painted wood often gilded with gold and silver leaf and encaustic as well as mixed media collages. In 1979, she co-founded and was on the Board of the New York Feminist Art Institute (NYFAI), where she taught a workshop called "Consciousness Raising, Visual Diaries, Art Making." NYFAI closed in 1990. www.nyfai.org, www.nancyazara.com.

Tressa Berman is a cultural anthropologist who specializes in contemporary Indigenous arts and curation. She has worked with museums, cultural centers, and communities in local and national heritage projects. Berman's books include *Circle of Goods: Women, Work, and Welfare in a Reservation Community* and *No Deal! Indigenous Arts and the Politics of Possession*.

Darla Bjork is a painter who shows at the Soho20 Gallery, one of the oldest women's collectives in New York City. She is also a psychiatrist who has had a private practice for many years. She was a major participant at NYFAI as well as on its Board of Directors. NYFAI closed in 1990. www.nyfai.org, www.darlabjork.com.

Katie Cercone has shown her interdisciplinary video, installation, and performance work in Washington, DC, Portland, OR, New York City and Buenos Aires, Argentina. She has published critical feminist writing in *Bitch Magazine*, the *Utne Reader*, *Women's Art Journal* and *N.Paradoxa* and is a member of the all-female interdisciplinary arts collective The Push Pops.

Judy Chicago is an artist, author, feminist, educator, and intellectual. Her most well-known work, *The Dinner Party*, was executed from 1974–1979 and is now installed in the Brooklyn Museum of Art. Chicago has used an extensive range of media in individual studio work and collaborative series such as the *Birth Project*, the *Holocaust Project*, and *Resolutions: A Stitch in Time*. She has written twelve books exploring both her own artwork and pedagogical approach and the careers of other artists, including *Frida Kahlo: Face to Face*. Chicago remains steadfast in her commitment to the power of art as a vehicle for intellectual transformation and social change and to women's right to engage in the highest levels of art production.

Ying-Ying Chien is a Professor at the Graduate Institute of Teaching Chinese as a Second Language and Department of Applied Chinese Language and Literature at National Taiwan Normal University. She has held visiting positions at UCLA and at the Academia Sinica, and is the author of *Identity, Difference, Subjectivity: From Feminism to Post-colonial Cultural Imagination*, *Daughter's Rituals: Women's Spirit and Artistic Representation in Taiwan*, *Where Is the Daughter's Home? Feminism and Cross-Cultural Comparative Literature*, and *Journey of Healing: Gender, Trauma and Border Writing*.

Gaia Cianfanelli lives and works in Rome. She attended the European School of Economics in Rome where she obtained a degree in Art and Heritage Management. She then began her career as an independent curator. In February 2004 she co-founded the START cultural association together with Caterina Iaquinta. Since 2005 she has been curator of the TEVERETERNO project.

Lydia Nakashima Degarrod is a cultural anthropologist and artist whose work combines ethnographic research and visual art. She has received awards for her work from the Wing Luke Memorial Museum of Art, Ministry of Culture of Chile, Harvard University, the California Council of the Humanities, and the California College of the Arts (CCA). She is currently writing a book about the internal images of migration based on her CCA installation *Geographies of the Imagination*.

Lillian Faderman is an internationally known scholar of lesbian and ethnic history and literature. Her work has been translated into numerous languages, including German, Spanish, Italian, Japanese, Turkish, Czech, and Slovenian. Her honors include six Lambda Literary Awards, two American Library Association Awards, and several lifetime achievement awards for scholarship, including Yale University's James Brudner Award, the ONE National Gay and Lesbian Archives Culture Hero Award, and the American Association of University Women's Distinguished Senior Scholar Award. The *New York Times* named two of her books, *Surpassing the Love of Men* and *Odd Girls and Twilight Lovers*, as "Notable Books of the Year."

Jill Fields is Professor of History at CSU Fresno. Her book, *An Intimate Affair: Women, Lingerie, and Sexuality*, received the 2008 Keller-Sierra Prize from the Western Association of Women Historians. Her collaborative women-centered projects have included the THORN Collective and a feminist bookstore in Santa Cruz, and an alternative band, the Holy Sisters of the Gaga Dada, which was named best underground band by the *L.A. Weekly* in 1987. She is writing *Clothing in World History* for the Routledge series "Themes in World History."

Joanna Gardner-Huggett is Associate Professor of Art History at DePaul University where she teaches courses on twentieth-century art and feminist theory. Gardner-Huggett's research focuses on the intersection between feminism and arts activism. She has published in the journals *British Art Journal*, *Social Justice*, *Women's Art Journal*, and *Women's History Review*. Currently, she is writing a book on the history of the Chicago women artists' cooperatives: Artemisia Gallery (1973–2003) and A.R.C. (1973–present).

Paula Harper is Associate Professor of Art History and Criticism at the University of Miami in Coral Gables, Florida. She is the author of *Daumier's Clowns*, the co-author of *Camille Pissarro: His Life and Work* (which has been translated into German, French, and Rumanian), and has also written numerous exhibition catalogues, articles, and exhibition reviews on nineteenth- and twentieth-century art. She was a founder of the Women's Caucus of the College Art Association, and served on its national board of directors.

Caterina Iaquinta is a PhD candidate in Philosophy, Art and Theatre at the Catholic University of Milan, with a research focus on social action and experimental theater in Italy from 1975 to 1980. She is also part of the editorial office of the magazine *No Order: Art in a Post-Fordist Society*. As a curator with the START cultural association, she developed exhibition projects including *Dissertare/Disertare* (2006) and *La Forza dei Legami Deboli* (2008).

Jo Anna Isaak holds the John L. Marion Chair in Art History at Fordham University in New York City. Her publications include *Feminism and Contemporary Art: The Revolutionary Power of Women's Laughter*, based upon an exhibition she curated, and numerous articles and catalogue essays. Isaak has organized touring exhibitions including *Looking Forward, Looking Black* on representations of African Americans in art and popular media; *H2O*, which focused on water and the human body; and *And For All This, Nature is Never Spent*, an exhibition of works grappling with ecological problems.

Jennie Klein is Associate Professor of Art History at Ohio University. Her areas of research include feminist art, performance, and contemporary art. Klein has published articles and curated exhibitions on feminist artists who worked in the

1970s. She is the editor of *Letters from Linda M. Montano* and the co-curator of *The 21st Century Odyssey Part II: The Work of Barbara T. Smith*. Her current project is on the relationship between feminist spirituality and performance art.

Karen LeCocq is a mixed media sculptor whose work has been shown at contemporary art museums in New York and Los Angeles, such as the Whitney, Armand Hammer, and MOCA. It has also appeared in a number of arts magazines and books, including *Art In America*, *Art News*, *Artforum*, *Time Magazine*, *The Power of Feminist Art*, *Sexual Politics*, *California Artists*, *Through the Flower*, *By Our Own Hands*, and her autobiography, *The Easiest Thing To Remember*. www.karenlecocq.com.

Gail Levin is Distinguished Professor of Art History, American Studies, and Women's Studies at the Graduate Center and Baruch College of the City University of New York. She is the author of many books, including *Edward Hopper: A Catalogue Raisonne* (1995); *Becoming Judy Chicago: A Biography of the Artist* (2007); *Edward Hopper: An Intimate Biography* (1995; 2nd ed., 2007); and *Lee Krasner: A Biography* (2011).

Laura Meyer is Associate Professor of Art History at California State University, Fresno, and has written widely on the feminist art movement. In 2009 she produced an exhibition and accompanying catalogue, *A Studio of Their Own: The Legacy of the Fresno Feminist Experiment*, documenting the United States' first art program based on feminist pedagogical principles.

Nancy Marie Mithlo is Associate Professor of Art History and American Indian Studies at the University of Wisconsin, Madison. Her research topics include Native American identity and arts commerce in Santa Fe, New Mexico. She is author of *"Our Indian Princess": Subverting the Stereotype*, and senior editor for the Ford Foundation-funded *Manifestations: New Native Art Criticism*. A 2009–2010 Woodrow Wilson Foundation Fellow and curator of six exhibits at the Venice Biennale, she is completing a book on indigenous arts at the Biennale from 1999 to 2009.

Beverly Naidus is Associate Professor of Interdisciplinary Arts at the University of Washington, Tacoma, and an artist who works in a range of media. Her artworks on themes such as ecological crisis, healing body hate, consumer culture, and the "other" have been exhibited in New York, Los Angeles, and Europe, and assessed by critics including Lucy Lippard and Lisa Bloom. She is the author of *Arts for Change: Teaching Outside the Frame*, *What Kinda Name is That?* and *One Size Does Not Fit All*. www.beverlynaidus.net and www.artsforchange.org.

Gloria Feman Orenstein is Professor of Comparative Literature and Gender Studies at the University of Southern California. Her books include *The Theatre*

of the Marvelous: Surrealism and the Contemporary Stage, The Reflowering of the Goddess, and *Reweaving the World: The Reemergence of Ecofeminism.* She founded the Woman's Salon for Literature in New York, and has been a student of a Shaman from Samiland (Lapland, northern Norway). More recently, Orenstein has written on contemporary Jewish women artists, and established an archive of student-created video interviews of contemporary women artists at USC.

Phranc has introduced herself as "the All-American Jewish Lesbian Folksinger." As a visual artist she has adopted the moniker "The Cardboard Cobbler." In the late 1970s she was a member of Nervous Gender and Catholic Discipline in the L.A. punk rock scene. She has recorded for Rhino Records, Island Records, and Kill Rock Stars and toured internationally with many acclaimed and notorious artists. Her music and visual work employ humor to raise consciousness, trigger response, and provoke discussion.

Terezita Romo is an art historian, curator, and the Arts Project Coordinator for the UCLA Chicano Studies Research Center. As the former Curator of Exhibitions at the Mexican Museum in San Francisco, she organized the first traveling retrospective for Patssi Valdez as well as numerous other groundbreaking exhibitions.

Moira Roth is Trefethen Professorship of Art History at Mills College. She has edited a number of books, including *The Amazing Decade: Women & Performance Art in America, 1970–1980, We Flew Over the Bridge: The Memoirs of Faith Ringgold,* and *Rachel Rosenthal,* and contributed essays to art journals and works such as *The Power of Feminist Art, New Feminist Art Criticism,* and *Critical Voices in Art, Theory and Culture.* Her current projects include fictional narratives, a series of plays, and poem cycles.

Sylvia Savala is a visual artist, poet, and writer of nonfiction. Among her numerous contributions to the community, she served as President of Gallery 25 and as Vice-President of the Board of Arte Americas. She teaches English at Fresno City College, and is currently writing a memoir and history of Pinedale, a vibrant Fresno Mexican-American neighborhood. www.sylviasavala.com.

Miriam Schaer is a New York-based artist who creates narrative sculptures in the form of books using mixed media, clothing, and found objects. She is also a Lecturer in the Interdisciplinary MFA program in Book and Paper at Columbia College Chicago. http://miriamschaer.com.

Valerie Smith is Dean of the College, Woodrow Wilson Professor of Literature and Professor of English and African American Studies at Princeton University. She is the editor of several anthologies, and the author of *Self-Discovery and Authority in Afro-American Narrative; Not Just Race, Not Just Gender: Black Feminist Readings;*

Toni Morrison: Writing the Moral Imagination (forthcoming), and numerous articles on African American literature and culture, and black feminism. She is completing a book on the cultural memory of the Civil Rights movement.

Faith Wilding is a transdisciplinary artist, writer, and educator, whose work addresses somatic histories of the body, and the intersections of feminist theory, biotechnology, and women's labor. Wilding is a co-founder of subRosa, a cyberfeminist collective, and teaches at the School of the Art Institute, Chicago, and Vermont College of Fine Arts. http://faithwilding.refugia.net.

Nancy Youdelman has been exhibiting her artwork since 1971, has a B.F.A. from CalArts (1973) and an M.F.A. from UCLA (1976). She currently teaches art at the California State University, Fresno, and has been the recipient of numerous awards including grants from the Pollock/Krasner and the Adolph and Esther Gottlieb Foundations. www.nancyyoudelman.com.

PERMISSION
ACKNOWLEDGMENTS

Chapter 1: Gail Levin, "Feminist Class," *Becoming Judy Chicago: A Biography of the Artist*, 2007. Used by permission of Harmony Books, a division of Random House, Inc.

Chapter 2: Laura D. Meyer (with Faith Wilding), "Collaboration and Conflict in the Fresno Feminist Art Program: An Experiment in Feminist Pedagogy" was first published, in longer form, in *n.paradoxa Vol. 26 (Feminist Pedagogies)* July 2010, pp. 40–51.

Chapter 4: Moira Roth, "Interview with Suzanne Lacy," from oral history interview with Suzanne Lacy, March 16, 24 and September 27, 1990, Archives of American Art, Smithsonian Institution.

Chapter 5: Paula Harper, "The First Feminist Art Program: A View from the 1980s," *Signs: Journal of Women in Culture and Society* 10:4 (1985) © 1985 by The University of Chicago. All rights reserved.

Chapter 7: Valerie Smith, "Abundant Evidence: Black Women Artists of the 1960s and 1970s," originally published in *WACK! Art and the Feminist Revolution*, exh cat. (Cambridge, Massachusetts: The MIT Press and Los Angeles: The Museum of Contemporary Art, 2007), 400–413. Essay copyright The Museum of Contemporary Art, Los Angeles, 2010.

Chapter 12: Joanna Gardner-Huggett, "The Woman's Art Cooperative Space as a Site for Social Change: Artemisia Gallery, Chicago (1973–1979)," *Social Justice*, 34, 1 (2007). Reprinted with permission of Social Justice.

Chapter 14: This article was first published, in slightly different form, in *n.Paradoxa: International Feminist Art Journal*, Volume 22 (July 2008), pp. 49–56.

Chapter 15: Material in this article was originally printed in *Our Voices: Art Educators and Artists Speak Out about Lesbian, Gay, Bisexual and Transgendered Issues*, edited by Laurel Lampela and Ed Check (Dubuque, IA: Kendall-Hunt, 2003). Additional material was taken from Chapter 3 of *Spirit Taking Form: Making a Spiritual Practice of Making Art* by Nancy Azara (Red Wheel/Weiser, 2002).

Chapter 20: Ying-Ying Chien, "Marginal Discourse and Pacific Rim Women's Art," *Signs: Journal of Women in Culture and Society*, 29:2 (2004) © by The University of Chicago. Reprinted with permission. All rights reserved.

Chapter 22: Naidus, Beverly. "Profile: Beverly Naidus's Feminist Art Pedagogy: Unleashed and Engaged," *National Women's Studies Association Journal* 19:1 (2007) © *NWSA Journal*. Reprinted with permission of The Johns Hopkins University Press.

INDEX

Page numbers in *italics* denotes an illustration.

Yoon, Maria 264
Youdelman, Nancy 11, 12, 30, 33, *57*,
58, 59, 64–9, *66*, 72, 74–6, 80, 84, 96,
103, 239; *Death Piece 67;* Las *Vegas
Whore, 57; Lea's Room 70; Veiled
Woman* (costume by) Plate 5.

Z Budapest 83
Zakanitch, Robert 98
Zorach, Marguerite 7
Zurilgen, Cheryl 58